IRISH TYPE DESIGN

IRISH TYPE DESIGN

A HISTORY OF PRINTING TYPES IN THE IRISH CHARACTER

DERMOT McGUINNE

IRISH ACADEMIC PRESS

This book was designed by Jarlath Hayes
and set in 12 on 13pt Bembo
by Seton Music Graphics, Bantry
for Irish Academic Press,
Kill Lane, Blackrock, Co Dublin.

© Dermot McGuinne 1992

A catalogue record for this book
is available from the British Library

ISBN 0–7165–2463–5

ACKNOWLEDGMENT

The author would like to thank
Colour Books Ltd, Dublin,
for their generous sponsorship
of this work.

Printed in Ireland by
Colour Books Ltd, Dublin

PREFACE

IN THE COURSE OF MY RESEARCH I have received much support and assistance. For the library facilities made available to me I should like to thank the staffs of the department of Early Printed Books, Trinity College; the National Library of Ireland; the Library of University College, Dublin; the Jesuit Library at Milltown; Marsh's Library; the Gilbert Collection of the Pearse Street Public Library; the Central Catholic Library; and the Library of the Royal Irish Academy; St Bride Printing Library, the British Library, and the Victoria and Albert Museum Library in London; the Imprimerie Nationale, Paris; Columbia University Library, New York; and the Plantin Moretus Museum in Antwerp.

I am grateful to Dr Roy Millington who helped me in my search through the material made available by kind permission of the Directors of Messrs Stephenson Blake Holdings Ltd, and to the Monotype Corporation for access to their records.

The late Father Bartholomew Egan OFM kindly advised me in my enquiries into the Franciscans at Louvain and gave me access to requested material at the Franciscan Library in Killiney.

A number of individuals were particularly helpful to me in their advice and criticism. I wish to express my indebtedness to the late Father Fergal McGrath SJ, Father Diarmuid Ó Laoghaire SJ, the late Liam Miller, Alf MacLochlainn, Hendrik Vervliet, Mary Pollard, Vincent Kinane, Brian Ó Cuív, James Mosley, Father Josef Metzler OMI, and M. Paul-Marie Grinevald.

I am grateful also to those who provided me with original material and evidence of design drawings for certain of the type faces. In this regard I thank the Very Revd C. J. G. Winterton, for providing access to the unpublished letters to J. H. Newman retained at the Birmingham Oratory. I thank also Dara Ó Lochlainn for access to the extensive range of correspondence between his father Colm and Stanley Morison; and C. T. McCrea for related correspondence material of his uncle, H. G. Tempest of Dundalgan Press. I thank also Aodogán O'Rahilly for permission to use the design drawings for Monotype series 117 and the designs for the revisions to Monotype series 24; also William Britton for permission to use his drawings for the Monotype Times Roman Gaelic; and Karl Uhlemann for permission to use his design drawings which represent the early stages in the development of the Monotype Colum Cille Series 121. I am indebted

also to Father Agostino Corbanese for helping to uncover the catalogue recording the presence of the Rome Irish punches at the Tipografia Poliglotta Vaticana.

CONTENTS

LIST OF ILLUSTRATIONS

CREDITS

Thanks are due to the following for permission to include reproductions of material in their possession: Trinity College, Dublin, 1.5, 11.15; Public Records Office, London, 2.1, 8.3; Plantin Moretus Museum, Antwerp, 2.3, 2.5; City of Antwerp, Public Record Office, 2.4; Governors and Guardians of Marsh's Library, Dublin, 2.6, 2.9; American Type Founders Library, Columbia University, New York, 3.3, 3.8, 3.9; Imprimerie Nationale, Paris, 3.4; Tipografia Poliglotta Vaticana, 3.7; Directors of Messrs Stephenson Blake Holdings Limited, 4.8, 7.9; The British Library, 8.2; Aodogán O'Rahilly, 9.7, 9.9; Karl Uhlemann, 10.4; Monotype Corporation plc, 10.5, 10.14, 10.19; Dara Ó Lochlainn, 10.11, 10.15, 10.18; Jesuit Library, Milltown, 11.4, 11.9, 11.10; Franciscan Library, Killiney, 11.8; and William Britton, 11.21, 11.22. Enlargements, as indicated, have been made in certain instances to facilitate comparison.

INTRODUCTION

AS THE VERNACULAR LANGUAGE of Ireland, Gaelic for centuries domi-
nated our sociolinguistic development, both at local levels, with its great
variety of diverse dialects, and at a national level where from time to time
it went through periods of decline and revival, often closely associated
with national, political and religious trends.

It is recorded in the Book of Lecan that the Irish alphabet, unlike the
Latin, did not begin with a, b, c, but in one form with b, l, f, from which
it received the name of *Bobel-loth*, or alternatively with b, l, n, after which
it was called Bethe-luis-nin. John O'Donovan points out in the introduc-
tion to his grammar that "Each of the letters of the Bobel-loth alphabet
took its name from one of the masters who taught at the great schools
under Fenius Farsaidh, and in the Beth-luis-nion alphabet each letter was
named after some tree, for what reason we know not."[1] This unusual
order has contributed to various theories as to the ancient origins of the
Irish alphabet, some of which suggest that it pre-dated the Greek and
Latin. However, it is more likely that it evolved from the roman letter
form which was introduced into Ireland in the course of the fifth-century
conversion to Christianity through the various liturgical manuscript books
which came into use. Two distinct styles of lettering evolved from the outset,
each in its own way destined to have an influence on the shape of Irish
printing types. The half-uncial had full, well-rounded forms with short
blunt ascenders and descenders normally contained within the body height
of the other letters. These rounded letters were more frequently used in
the writing of Latin tracts, as in the earliest known Irish manuscript, the
Catach, attributed to the hand of St Columcille, and later to such great
effect used in the Book of Kells. During the seventh and eighth centuries
as the Irish monastic influence spread throughout Western Europe, manu-
scripts in this style were produced in many religious centres on the continent.
The Carolingian minuscule hand, so admired and supported by Charlemange,
was influenced in part by the Irish half-uncial, and in turn was the model
for the humanistic script of Northern Italy, on which the first roman
lower-case printing types were based. Hence, while the Irish style was
initially derived from roman capital letters, it later helped provide the
model for the roman lower-case which, combined with the capitals, form
the basis for modern roman printing types.

The second script, usually referred to as Irish minuscule, was more angular with a pronounced vertical emphasis. This style was used more frequently for smaller books where space was at a premium, and usually for the transcription of Irish text as distinct from Latin. The Book of Armagh, although for the most part in Latin, is one of the earliest great works to use this minuscule hand. Indeed, whether to use the round or the angular letter form as a model for Irish printing types became, at a later stage, an important issue.

Prior to the early 1960s when the normal existing roman letter was finally officially adopted for use in printing Irish, the Irish alphabet consisted of eighteen letters, the vowels and some consonants of which could carry diacritical marks which extended the range of sounds they represented. The form of many of these letters reflected the style of the handwriting of the early scribes, whose work reached a high standard of calligraphy. It was partly due to a respect for this rich tradition and to an inherent sense of aesthetic conservatism that this form continued in use both as a style of writing and as a source of influence on type design.

The first efforts to print in the Irish character—a result of the influence of the Reformed Church—used a type that was made up from existing roman and italic letters and some specially prepared Irish sorts. Later printing in Irish from centres on the continent of Europe—largely due to those who sought to present the Catholic view and were prohibited from doing so in Ireland—led to the production of a type that was modelled on the current minuscule angular hand. This style was to become the predominating influence on Irish printing types for more than two centuries to follow.

In the early nineteenth century Evangelism resulted in an increase in the printing of religious material in Irish in the Irish character, while at the close of the same century the Irish Revival was responsible for a significant growth in printing of Irish, with great attention being given to the appropriate style of type to be used.

From the earliest stage of printing in Irish there also were those who favoured the use of available roman type. This preference continued as an attractive option because of the difficulties frequently encountered in acquiring specially cast founts of type. The general demand for printing type in Ireland was never consistently great enough to justify the establishment of a significant type founding industry here, many of the requirements of the trade being met by English and Scottish foundries. These were not always receptive to the idea of cutting special founts for a language which attracted a relatively modest demand. Hence, it was frequently as a result of the persistence of interested Irish authors and publishers that such faces were produced. Consequently many of these founts reflected the particular stylistic preferences of these advocates.

It has been the practice to label these different designs after the foundry

responsible for their production—for example, Moxon, Christie, Watts, Fry and Figgins. Where precise information on the foundry is not available they have in some instances been named after the patron—for example, Queen Elizabeth Irish type; and more often after the location in which they appeared—for example, Louvain, Rome and Paris. Sometimes they were named after the societies that used them in their publications—for example, Irish Archaeological Society and Keating Society; and sometimes simply after the printer who first used them—for example, Barlow and Thom. In the belief that departure from this complex practice would only add confusion, I have adhered to this approach with the following exceptions:

1. As has already been proposed by James W. Phillips, a more appropriate title for the frequently called Brooke or Bonham type of 1789 would be the Parker type, since he has established that Parker's was the foundry involved in its production.

2. As has been the practice for some time the Irish Archaeological Society type should be referred to as the Petrie type. However, new evidence would suggest that the type modelled on this style and generally called the Thom type should more accurately be attributed also to Petrie. Of this round style, therefore, I suggest that there are three separate categories which I call Petrie A, Petrie B and Petrie C.

3. The Keating Society type should also be named after its designer, George Petrie, but in order to avoid confusion with the above-mentioned Petrie series the name Newman type is to be preferred, since it was at Cardinal Newman's request and support that this fount was produced for the Catholic University Press.

The development of these printing types has attracted the attention of many scholars over the years, but few have examined it in its entirety. Authors of many of the works printed in the Irish character have, from time to time, fortunately seen fit to comment on their use of this letter-form; this comment represents a valuable source of information.

Talbot Baines Reed expressed his interest in Irish type in his *History of the Old English Letter Foundries.* The Reed material at the St Bride Printing Library in London offers further evidence of his interest, as also do the letters of Henry Bradshaw to Reed. The research of E. R. McC. Dix into early printing in Dublin, particularly with regard to the Queen Elizabeth type, is especially valuable. It was, however, E. W. Lynam who addressed the subject in its entirety, in his article, "The Irish Character in Print 1571-1923" (1924). It was the *order* that Lynam brought to this subject together with the extent of his research that influenced those who followed, notably Colm Ó Lochlainn, P. J. Madden and Seán Jennett. Ó Lochlainn's comments in the *Irish Book Lover*, particularly during the period of his editorship of that journal, are of special interest since he was the last one to produce a text type in the Irish character

QUEEN ELIZABETH'S
IRISH TYPE

VERY LITTLE IS KNOWN of the founding of type in England prior to the beginning of Queen Elizabeth's reign in 1558. It would seem that many of the mechanical aspects of English type-founding at this period were the work of resident aliens and that *design* considerations were largely supplied from abroad. John Day, the Elizabethan printer, had facilities for casting type on his premises: Matthew Parker, Archbishop of Canterbury, mentions having "spoken to Daie the printer to cast a new Italian letter which he is doing, and it will cost him xl marke".[1] Talbot B. Reed states that Day "occupies an important place in the history of early English letter-founding. What is mainly conjecture with regard to most of his predecessors we are able to state on the authority of historical records with regard to him, namely, that he was his own letter-founder".[2]

After being arrested on 16 October 1554 for printing "noythe bokes" of a heretical nature, Day escaped in the following year and it is thought that he took refuge on the continent.[3] He returned to England in 1556, where on the accession of Queen Elizabeth, with whom he found favour, he became an important printer. Early in Elizabeth's reign he found a generous patron in Archbishop Parker for whom he cut some types, notably his fount of Anglo-Saxon, used for the first time in Ælfric's homily, *A Testimonie of Antiquitie*, edited by Parker and printed in 1567. This type was used in a number of works and subsequently in the archbishop's edition of Asser Menevensis' *Ælfredi Res Gestae* in 1574 (see ill. 1.1), in the preface to which, attributed to Parker, it is stated, "And in as much as Day, the printer, is the first (and, indeed, as far as I know, the only one) who has cut these letters in metal; what things have been written in Saxon characters will be easily published in the same type."[4] John Strype states of Parker that "He made Day the Printer to cut the Saxon Types in Brass; who was the first Person that did it."[5]

In the pursuit of his study of the Scriptures, Archbishop Parker had collected both Anglo-Saxon and Irish manuscripts. His study of the Anglo-Saxon character led him to Irish. He considered that a knowledge of the Saxon character would be useful to the understanding of the Irish. "For though the language was different, yet the letters, in which the books of the Irish were writ, were the same."[6]

4

DOMINO MEO VENERABILI
PIISSIMOQVE OMNIVM BRI
TANNIÆ INSVLÆ CHRISTIA-
NORVM RECTORI ÆLFRED
ANGLORVM SAXONVM RE-
GI: ASSER OMNIVM SERVO-
RVM DEI VLTIMVS MILLE-
MODAM AD VOTA DESIDE-
RIORVM VTRIVSQVE VITÆ PROSPERI-
TATEM.

Anno Dom. incarnationis, 8 4 9. natus est Ælfred angulsaxonū rex in villa regia quæ dicitur Vuanating in illa paga; quæ nomi-natur Berrocscire, quæ paga taliter vocatur a Berroc silua v-bi buxus habundantissime nascitur; cuius genealogia talis tali serie có-texitur. Ælfred rex filius Æðelpulfi regis qui fuit Ecgbenhti; qui fu-

Whenever possible, Queen Elizabeth enjoyed speaking to the various foreign visitors to her court in their own language. To facilitate her in this regard, in the period c.1560–5, Christopher Nugent, 9th baron of Delvin, prepared a manuscript at her request, an "Iryshe-Latten-Englishe Primer", which set down the Irish alphabet, together with some words and phrases in Irish with Latin and English translations (see ill. 1.2). In this, Nugent pays tribute to the queen for her interest in the Irish language: "Among the manyfold actions . . . that beare testymonie to the worlde of your maiestyes great affection, tending to the refformation of Ireland, there is noe one (in my opinion) that more euydent showithe the same, then the desyer your Highnes hath to vnderstande the language of your people theare."[7]

There is a reference in the Fitzwilliam MSS. to a payment for the making of Irish type: "to the archbishop of Armaighe and the bishop of Methe for the making of Carecter to print the New Testament in Irish lxvjl xiijs iiijd [£66. 13s. 4d.]".[8] This payment must have been made some time before the end of 1567, since a note in another document, dated

1.1 Example of John Day's Anglo-Saxon type, from *Ælfredi Res Gestae*, 1574.

1.2 The Irish alphabet as prepared for Queen Elizabeth by Christopher Nugent in his Primer of the Irish Language *c.*1560–65, from a facsimile reproduction printed by J.M. Kronheim and Co. in 1888.

1.3 Day's Anglo-Saxon type (above) and the Queen Elizabeth Irish type (below) enlarged to 200% approx.

1567, demands the repayment of this sum unless the bishops publish the (delayed) Irish Testament.[9] The project appears to have been abandoned and there is no record as to whether or not the money was ever repaid.

In 1570 attention was again turned to the production of an Irish type. By an agreement of 23 October 1570, John Kearney, clerk and treasurer of St Patrick's Cathedral, Dublin, undertook to provide the 'stamps, forms and matrices' necessary for printing 200 or 300 catechisms at the cost of £22. 13s. 4d.[10]

Kearney kept to his word, for the Queen Elizabeth Irish type was available in 1571. Sir James Ware states in his *Annals of Ireland* under the year 1571: "This year the Irish characters were first brought into this kingdom by Nicholas Walsh, chancellor of Saint Patrick's in Dublin, and John Kerne, then treasurer of the same; and it was ordered that the prayers of the Church should be printed in that language and a church set apart in the chief town of every diocese, where they were to be read, and a sermon preached to the common people, which was instrumental to convert many of the ignorant sort in those days."[11]

The link between Parker and Day, together with the archbishop's interest in Irish, and the resemblance of some of the Irish letters of the Queen Elizabeth fount to those of the Anglo-Saxon, have led some bibliographical historians to argue that the Irish characters were taken directly from Day's fount. Influenced, perhaps too literally, by the handwritten statement at the top of the broadside (*Tuar ferge foighide Dhe*, the poem for which the type was initially used):[12] 'This Irishe balade printed in Irelande who belike use the olde Saxon carecte', E. R. McC. Dix wrongly maintained that the Queen Elizabeth type was the same as Day's Saxon. He states that: "I venture to submit that this type was simply Anglo-Saxon type cast by John Day in 1567 for Archbishop Parker, and used as if Irish type."[13] This view was shared by the Irish scholar Osborn Bergin, by Joseph Hammond, and later by the typographer and publisher Liam Miller, who states: "This Anglo-Saxon font provides Day's first important link with Ireland, because these characters were adapted to form the first type devised for printing in Irish and were introduced into Ireland in 1571 by William Kearney, Queen Elizabeth's printer in Dublin."[14]

A comparison between the two types, however, clearly establishes the inaccuracy of these opinions. While both types combine traditional script-like forms with existing roman letters, the roman and the newly cut special characters differ in the Anglo-Saxon from the Irish fount significantly, as may be seen from the enlarged samples of both faces in ill. 1.3. The Saxon fount had special sorts, many based on an uncial model, for lower-case d, f, g, i, r, s, t, y and z; and upper-case E, H, M, S and X. This influence is particularly noticeable in the upper-case special characters of the Anglo-

Saxon E, H, M, characters which would have been suitable for use in the Irish but were not so used. Of the lower-case, the d, f, g, r, s and t could similarly have been easily transferred to the Irish, but on close examination it is clear that they were not: the Anglo-Saxon d has a more pronounced flick to the tip of its extending top stroke; f has a turn to the left at the bottom of its descender; g has the curve of its upper bowl less full, while the horizontal stroke has a distinctive upturn at the left; r has a broader curve to the upper section together with a turn to the left at the bottom of its descender; s is perhaps the most like its Irish counterpart, but it also has the distinctive turn to the left at the bottom of its descender, although in this case not as pronounced as in the f and r; and the t has the upturned flick on the left of its horizontal stroke. In addition, the Irish type had special characters cut for its lower-case e, i, and p, and for its upper-case B, D, E, F, G, I, M, N, T, and U, which are different from the Anglo-Saxon.

While it may seem surprising that no effort was made to use of the Anglo-Saxon special characters for the Irish, the fact remains that the Irish characters were cut independently, and it is unlikely that Day had any part in this operation, for if he had he would most probably have used some of his Anglo-Saxon sorts.

This hybrid Irish fount, consisting chiefly of roman letters, to which the italic capital and lower-case a and the distinctively Irish forms were added, also included a range of special ligature sorts.

Despite this mixture the type forms into a highly legible text, and partly as a result of the presence of the roman it has an even and orderly appearance on the page. The roman type was borrowed from the existing popular fount of Pierre Haultin (see ill. 1.4). The capital letters were taken from Haultin's St Augustin or english fount (14 point) with the lower-case taken from the cicero (12 point) size of the same face. The Irish type was accompanied by a smaller brevier (8 point) size which was quite compatible with the larger english fount, with the following exceptions: in the brevier the capital G has a narrower upper curve, more like that used in the Anglo-Saxon faces; B does not have as pronounced an angle to the down stroke; M has an inward curve to its left limb, similar to that version of M which was later to appear in the larger size; R is very different from the larger R. Of the lower-case letters, in the brevier size, only the r and s, being more extended, show significant differences in their shapes to those of the larger size (see ill. 1.5).

There is very little firm evidence regarding the origins of those characters which were specially prepared for the Queen Elizabeth type. Two people, however, already referred to, feature prominently in this development—John Kearney and Nicholas Walsh. Kearney had graduated from Cambridge in 1564; Walsh had graduated there in the previous year and had been a fellow student and close friend of Kearney. Apparently Kearney had

ting his poſſible Enemies, ſmake his Paſtymes, ſo Roy-
Triumphántly : with ſo many Thowſand Ships: And
tymes ſo many Men, as Ships : And that, yerely ?
not aſſured of ſuch Neighbours frendeſhips , as may

already been engaged in translating the catechism of the Reformed Church while at Cambridge, and, when he returned to Ireland, he continued in the effort of spreading the reformed doctrine in the Irish language. Nicholas Walsh commenced his MA at Cambridge in 1567 and was appointed as chancellor of St Patrick's Cathedral, Dublin, where Kearney was appointed as treasurer.

With their academic backgrounds and administrative positions it is unlikely that either of these men became directly involved in the manufacture of this first Irish type; yet, indirectly at least, Kearney would seem to have had a supervisory role in its production. Among the works in which the type first appeared was *Aibidil Gaoidheilge agus Caiticiosma,* a 56-page book printed in 1571 "at the expense of John Usher, alderman, [at his house] over the bridge" and translated and prepared by John Kearney (see ill. 1.6). In his preface, Kearney mentions the type (in translation):

1.4 Example of Haultin's St Augustin or english (14 point) type, from *General and Rare Memorials pertaining to The Perfect Arte of Navigation,* 1577. This fount provided the roman characters for the Queen Elizabeth Irish type.

1.5 Example of text showing the St Augustin or english (14 point) size together with the brevier (8 point) size of the Queen Elizabeth Irish type, from *Leabhar na nUrnaightheadh gComhchoidchiond* (Book of Common Prayer), 1608.

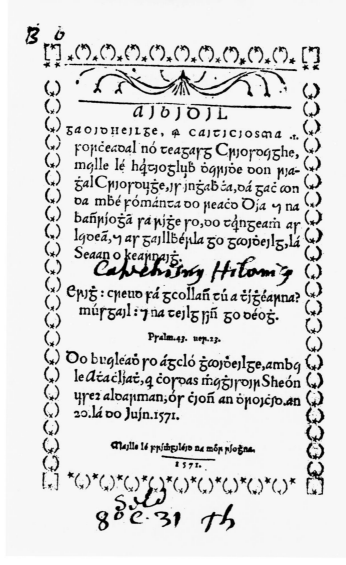

1.6 Title page of *Aibidil Gaoidheilge agus Caiticiosma*, 1571, the first book to use the Queen Elizabeth Irish type.

1.7 The poem *Tuar ferge foighide Dhe*, by Pilip Bocht Ó hUiginn, 1571, one of the first uses of the Queen Elizabeth Irish type; reduced to 50% approx.

Here you have, O reader, the first fruits and progeny of that good and very laborious work which I have been producing and devising for you for a long time, that is, the true and perfect type of the Gaelic language which will open to you that road which leads you to knowledge and which, moreover, has been closed to you formerly. . . . I have undertaken (as I saw no one else who would do so) the labour and toil of bringing this type to the form in which it is now seen, at the expense of our pious, all-powerful supreme prince, Elizabeth, and with the consent of the noble illustrious knight and our lord deputy, Sir Henry Sidney, and of the other members of the most honourable council of the queen's realm in this island of Ireland. And, moreover, since every beginning is in itself feeble, and since it is very easy to add to things newly acquired when they are deficient, I pray each one of you individually who will be a just judge of this work (which I began in order to proclaim the glory of God and to illuminate and adorn well this public good with this treasure) not to revile or

10

insult or disparage it nor myself because of it as a recompense, but wherever you find a fault or blemish in it to do your utmost to correct and improve it so that it may be more perfect than it is.

Possibly prior to the printing of this book, also in 1571, the type was used to print *Tuar ferge foighide Dhe*, a poem on the Last Judgment by Pilip Bocht Ó hUiginn (see ill. 1.7), a Franciscan friar who, according to the Annals of Ulster, died in 1487. The only copy known to exist of this printed broadside was sent to Archbishop Parker, which fact adds further to the evidence of Parker's interest and possible involvement in the first attempts to print in the Irish character. Bruce Dickins points out that the broadside, "one of the many treasures bequeathed to my college [Cambridge] by Archbishop Parker . . . , was extracted from Corpus Christi College, Cambridge MS. 12, a copy of the Anglo-Saxon version of Pope Gregory's *Cura Pastoralis*." He suggests that it was inserted by Parker, or one of his assistants, since it contains the inscription in the hand of the archbishop's son John: "This Irishe balade printed in Irelande who belike use the olde Saxon carecte"; it was, he continues, "probably printer's waste, since the same poem is printed on both sides, one of which is deplorably under-inked".[15] Henry Bradshaw describes it as "A poem on the last judgment, printed at Dublin in 1571, on a broadside sheet. I have before me, borrowed from Corpus Christi College, the copy which was apparently sent over to London to the Abp. of Canterbury as a specimen of the press." [16]

Apart from the fact that they were produced at the house of John Usher, there is little firm evidence regarding those involved in the printing of the broadside and the catechism. One such candidate, however, is William Kearney, a kinsman to John Kearney and a printer; but 1571 is a little early for William to have been practising his craft in Dublin. William is first mentioned as a printer in the Acts of the Privy Council of England, 1587,[17] in which he is recommended as printer of the long-awaited New Testament in Irish; the record describes how his training as a printer and his knowledge of Irish type had developed over the previous fourteen years. Calculating back fourteen years takes us to 1573, very near to 1571, the year in which the catechism appeared.

It would appear, however, that nothing was done about printing the New Testament in 1587, nor for some years afterwards, for Kearney, it seems, was still in London in 1591. On 13 January of that year a record is entered in the court proceedings of the Stationers' Company involving him in a dispute concerning two sermons.[18] A warrant dated October 1591 records permission for William's passage to Ireland and exhorts all to facilitate him in the printing of Irish bibles.[19]

An undated letter from the Irish privy council intended for the attention of all bishops throws further light on William Kearney's qualifications with

regard to his familiarity with Irish type.[20] This draws attention to official interest in the printing of the New Testament and confirms William as a suitable printer who had trained in this regard over the previous twenty years. This letter was probably written sometime shortly after the above-mentioned warrant of 1591, at a time when Kearney had travelled to Ireland and was available there to work on the printing of the New Testament.

Before Kearney, Humphrey Powell is the only printer known to have operated in Dublin; the last work to bear his imprint is the *Brefe Declaration of Certein Principall Articles etc.* printed in 1566. William Kearney uses the next individualized dated imprint, namely on the *Proclamation against the Earle of Tirone*, printed in 1595, of which it is thought that an Irish version was also printed at the same time. It is recorded in a letter dated 18 May 1595 from the lord deputy and council to the privy council: "Have stayed the publishing of the proclamation against Tirone till Sir John Norreye's repair. It is being printed in English and Irish."[21] Furthermore a letter dated 24 June 1595 from Sir Geff Fenton to Burghley states: "I have sent your lordship herewith one proclamation in English and another in Irish." It is noted in the *Calendar of State Papers* that "The proclamation in Irish is not with this letter", while the English version is described as being imprinted in the cathedral church of the Blessed Trinity, Dublin, by William Kearney.[22] Regarding this, Dix comments: "It is interesting to note here that there is a statement written, I believe, in pencil upon the original Proclamation in the Public Record Office in London, that there was an Irish edition of this proclamation. No doubt William Kearney was fully competent to execute such printing."[23] Indeed, written in pencil and dated 12 January 1895 on the back of this proclamation is the comment, "There was an Irish one sent." Many have searched for this item, without success.

Kearney worked as a printer at the newly established Trinity College after 1593, during which time he encountered certain problems. It would seem that he performed his duties in an unsatisfactory manner, for in a proposed set of terms for his re-employment there, issued in 1596,[24] a list of complaints against him is set down which include: 1. that he had caused "The close conveyance out of the house without their knowledge and consent of the press ponntions and characters. 2. The taking away of the stoles shelves bords etc. which were in the chamber and study, the first of which at least was the Colledges". It is of interest that, according to this list of complaints, Kearney had punches among his equipment, which suggests that he may have been able to strike and cast his own type.

The document goes on to list a set of conditions for re-employment, which include as item 3: "The allowinge you a boy his lodginge and his diet among the loer scholars you paying for it when you are able" and later "That you will follow your callinge, and trad therein in the best and fittest manner for this Church and country during your life trayne up in your art

some other boy before spoken of who being your prentise shall be bound to serveunder you and after you in the said College to maytayne that trad for this country." It is interesting to speculate as to the identity of this trainee, for John Francton, whose imprint appears on a proclamation in 1600, was an apprentice of Kearney. It is possible that he accompanied Kearney to Dublin about 1592, and, after serving his time, succeeded him as government printer here. T. Percy Kirkpatrick suggests that Francton came to Dublin before 1590, since during 1612–13 his daughter Elinor "was admitted to the freedom of the city. We have not been able to find the date of Franckton's marriage with Margery Laghlin, but if she was the mother of Elinor, it would appear that they must have been married at least twenty-one years before their daughter was admitted to the freedom of the city. If that were so Franckton must have come to Dublin before 1590."[25] A more precise calculation of the above would still allow Francton to have accompanied Kearney to Ireland in 1591.

Before leaving the college with the "press ponntions and characters" and before his subsequent re-engagement in 1596, Kearney must have been at work printing the Irish version of the New Testament, as it is recorded in the *Calendar of State Papers, Ireland* for 1595 that the New Testament was being set up and printed in Irish: "Mr Nehemias Donnelan to be recompensed. He has translated the New Testament into Irish which is now being printed. Assured hope that he will do much good in the see of Tuam."[26]

The New Testament, printed in Irish, for which the Irish type was initially provided, finally issued in 1602 (see ill. 1.8 and 1.9). In the preface, William Ó Domhnuill explains that, having completed the translation into Irish, it was set in Irish type up to the sixth chapter of the gospel of St Luke, and that five years elapsed before the setting was completed. This places the initial setting in type of the New Testament at about 1596-7, at which time William Kearney had been offered the proposed terms of re-employment by the college.

The *Proclamation against the Earle of Tirone* printed in 1595 is the last known evidence of Kearney's work. Sometime after this date and before 1600 he apparently ceased to work in Dublin, for his assistant John Francton continued as the government printer. The latter's imprint appears on a proclamation "Printed in Dublin at the Bridgefoote, by John Francke, 1600"[27], while reference to another proclamation printed also by Francton is found in the *Calendar of State Papers, Ireland,* 1600: "John Franke, for printing Proclamation set forth touching the restraint of powder and arms in Ireland, to be sold to any person or persons, without special warrant 66s. 8d. By Concordatum, 10 August 1600."[28] Francton completed the printing, begun by Kearney, of the New Testament in 1602-3, and the final work carries Francton's imprint "from the house of Master William Usher beside the bridge". The New Testament (which is dedicated to King James, who did

1.8 Title page of *Tiomna Nuadh* (New Testament), translated into Irish by William Ó Domhnuill, 1602.

TIOMNA NVADH

AR DTIGHEARNA AGVS
AR SLANAIGHTHEORA IOSA
CRIOSD,

AR NA TARRUING GU FIRINNEACH
ar Ereigir gu gáoioheilg,

RE HUILLIAM O DOMHNUILL.

Tit. Cap. 2.

Uerr. 11. Do foillsigh grás De gu reallpuigteach, do beir slánughadh fir do chum na nuile dáoineaoh:

Uerr. 12. Agus do beir teagurg dúinne, fá neamhdiághacho, agus fá an miánuib an tráoghalfa do feachna, agus fá an mbeatha nbo chaiteaih oi ún gu mearairrgá, agus gu coinepom, agus gu oiága, fá fáoghalfa do Lithair.

ATA SO AR NA CHUR AGCLO AMBAILE
atha Cliath, a otigh mbaigireih Uilliam Uiréih Chois an Droichdio, ré Seón Francke. 1602.

CAP. I.

SOISSGEUL NAOMH-THA IOSA CRIOSD DO REIR EOIN.

CAP. I.

76

1 O bí an bríaċaɲ anɒ ɲa ɼoɲach, agus ɒo bhí an bɲíaċaɲ a bɼochaɲ ɒé, agus ɒo buó hí an bháiaċaɲ ɼín Oia.

2 Do bí ɼo aɲ ɼúɲ a bɼocaɲ Ohé.

3 Aɼaio na huiɾe neiɼe aɲ ɒa noéunam ɼɲí ɼan mbɼéiɼiɲɼ: agus ní ɼuil ní aɲ bioɼh ɒá noéaɲnaoh aɲ na oéunam na ɼéugmuiɼ.

4 Iɼ aɲ ɼa mibɼeiɼiɲ ɒo bí an beaċa, agus ɒo buó hí an beaċa an ɼoluɼ úo na noaoine:

5 Agus ɼoilliɼiɼio an ɼolus ɼoin aɲ ɼa oɲchaoas, agus níɲ ɼab an oɲcha-oas chuige hé.

6 Do bí ouine aɲ na chuɲ ó Ohia ɒáɲ bainm Eoin:

7 Cainic an ɼé ɼo ɒo chum ɼiaonuiɼ, ɒo chum gu noiongnao ɼé ɼiaonui-ɼi ɒon ɼrolus, ɒo chum gu gcɲeio-ɼioiɼ cách uiɾe éɼio.

8 Niɲi bé ɼúo an ɼ oluɲ úo, acho [ɒo cuiɲeao hé] ɒo chum gu noiongnao ɼé ɼiaonuiɼe ɒon ɼrolur úo.

9 Do buó hé ɼo an ɼolur ɼíɲinneach úo ɼoilliɼiɼeaɼ gach uiɾe ouine ohá ɒɼig aɲ an nooman.

10 Do bí ɼé aɲ an nooman, agus aɼá an ooman aɲ na oéunam ɼɲio: acho níɲ aiéin an ooman hé.

11 Do chum a ɒáoine ɼéin ɼainic ɼé, agus níɲi ɼabaoaɲ a ɒáoine ɼéin cu-ca é.

12 Achɒ an méio ɒo ɼab cuca hé, ɼug

13 ɼé ɼa cuṁachoa ɼo ɼóib beiɼ ana gcloiɼi ag Oia,[eaohónioonoɼoiɲg chɲeioeaɼ aɲ a ainmɼean;

13 Nách ɼuil aɲ na ngeineamɼain ó ɼhuil, na ó ainmián ná colla, ná o ɼoil ɼíɲ,achɒ ó Ohia.

14 Agus ɒo ɼɲiɼeao ɼéoil ɒon ɼreiɼiɲ úo, agus ɒo chomnuiɼ ɼí eaɒɼuiɲe, (agus ɒo chuṅcamaɲ a ɼlóiɼɲi, maɲ ɼloiɼ éiɲɼeine meic ón aɼ ɼaiɲ) lán ɒo ɼɲái uib agus oɼiɼɲie.

15 Do ɼinne Eoin ɼiaonuiɼi ɒó, agus ɒo éiɼ ɼé, aɼá ɼáo, aɼ hé ɼo an ɼé aɲ aɲ labuiɲ ɼé é,an ɼé ɼig am ɼea-ɼaióɼ, ɒo bí ɼé ɲc man:oiɲ ɒo buó ɼaoɲɼa hé iɲá meiɼi.

16 Agus ɒo ɼal amaiɲ uiɾe chugaiɲn aɲ a lán ɼan, agus ɼɲáɲa aɲ ɼon ɼɲáɲ.

17 Oiɲ aɼá an ɼeacho aɲ na ɼhabaiɲɒ ɼɲé Mháoiɼi: achɒ ɼainic ɼɲáɲa ⁊ ɼiɲɼie ɼɲé Ióɼa Cɲioɼo.

18 Ní ɼhacaioh ɲeach aɲ bioɼh Oia ɼiáṁ: an áoinɼein meic úo aɼá an uchɒ an aɼaɲ, aɼ hé ɒo ɼoilliɼiɼ [hé ɒúiɼie.]

19 Agus aɲ hí ɼo ɼiaonuiɼi Eóin, an ɼan ɒo chuiɲeaoaɲ na hiuoaiɼhe ó Ieɲúralém Sagaiɲɒ agus Lébiɼi,ɒo chum gu bɼiaɼɲóchaoaoiɼ ɒe, cia ɼúɼa?

20 Agus ɒo aoaiṁ ɼeiɼon, agus níóɲ ɼheun ɼé: ɒo aoaiṁ ɼé [a ɒeiɼiɲi] náɲ bé ɼéin an Cɲioɼo úo.

21 Agus ɒo ɼhiaɼɲuiɼeaɒaɲ ɒé, cɲéo eiɾe [thú?] an ɼú Eliái? agus a ɒu-baiɲɒ ɼeiɼon, ní mé. An ɼaioh ɼú? Agus ɒo ɼreagaiɲ ɼeiɼon, ní heaoh.

22 Aɲ a naóbaɼɼin a oubaoaɲ ɼiɲ, cia ɼú ? ɒo chum gu oɼiobhɼamáoiɲ ɼreagɲa aɲ an noɼeim úo ɒo chuiɲ úaɼa ɼiɼ :cɲéo a ɒeiɲ ɼú aɒ ɼimíceall ɼéin?

16

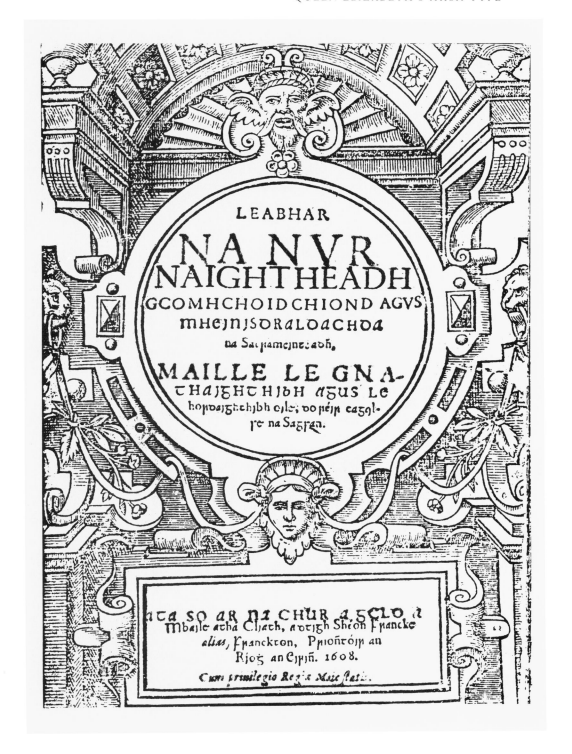

not come to the throne until the end of March 1603) makes further mention, in the dedication, of the Irish type and its patron Queen Elizabeth, of whom it is recorded that "even in the beginning of her most happie raigne (out of her motherly care, and princely bountie) provided the Irish characters and other instruments for the presse, in the hope that God in mercy would araise up some to translate the Newe Testament into their mother tongue."[29]

The next work to use the Queen Elizabeth Irish type was *Leabhar na nUrnaightheadh gComhchoidchiond*, the Book of Common Prayer (see ill. 1.10), translated into Irish by William Ó Domhnuill, which bears the imprint, "Dublin, at the house of John Francke *alias* Francton King's Printer in Ireland 1608", while the dedication to the lord deputy, Sir Arthur Chicester, who had commissioned the translation in 1605, is dated 20 October 1609. An entry under William Daniel in the *Dictionary of National Biography* refers to Francton in this regard: "In 1608 he [Daniel] put it to the press, employing the same printer as before, who now had an establishment of his own, and called himself John Francke, *alias* Francton, printer to the king of Ireland. The type is the same, with one new character the dotted c." The dotted c, however, had already been used in the *Aibidil* (see ill. 1.6) in 1571. The Book of Common Prayer uses a distinctive capital M with its left-hand stroke incurved like the form of M found in the brevier size. It appears alongside the more usual capital M from signature s onwards. It is possible that the punches and matrices of the original Queen Elizabeth M had been lost or broken and new ones cut locally reflected this change, while the original M continued also to be used.

Francton, who was never a member of the Company of Stationers of London, was specially appointed for life on 31 March 1604, as king's printer in Ireland. In 1608 he was paid £40 "for his enabling to buy paper and other necessaries for printing the Book of Common Prayers in the Irish tongue".[30] A printed proclamation by the lord deputy and council dated 15 July 1620 describes the conditions by which the grant of the office of printer general was given to John Francton "together with full sole and whole power and authority to imprint all and all maner of bookes, statutes, grammars, almanackes, acts of parliament, proclamations, injunctions, bibles and bookes of the New Testament, and all other bookes whatsoever, as well in the English tongue as the Irish, or in any other language . . ."[31]. However, the New Testament of 1602 and the Book of Common Prayer of 1608 are the only known works, printed by Francton which use the Irish type. He continued as a printer until 1617, at which time it would appear that he was well advanced in years, and in poor health.

The Company of Stationers in London, possibly envious of Francton's privileges in printing in Ireland, were anxious to acquire control of this market and sought to have him removed from that office and replaced by three of their members, Felix Kingston, Matthew Lownes and Bartholomew

Downes.[32] Accordingly these three members of the Company of Stationers bought out Francton—at a high price, it is alleged in their petition of October 1628—and on 23 March 1618 a patent was granted to them under the privy seal. On 6 May 1618, the lord deputy issued a warrant approving them in the office of printer general for Ireland for the period of 21 years.[33] John Francton died two years later. His death is recorded in the funeral entry of the office of arms, Dublin Castle: "John Francke or Francton, printer and sometime shrife of Dublin, deceased about the 7 or 8 of October 1620."[34]

Little is known of the three men who took over from Francton. Archbishop James Usher, in a letter to William Camden dated 8 June 1618 writes: "The Company of Stationers in London are now erecting a factory for books and a press among us here: Mr Felix Kingston and some others are sent over for that purpose."[35] The records of the company include an entry dated 15 June 1620: "Tho: Downe. It is concluded vpon, at a general meeting of the ptnors in the Irish stocke, that Thomas Downe shall goe in to Ireland, and be the Companies factor in [*the said*] stocke, and he is to haue 100*l*. p Anum for himselfe, and ten pounde a yeare for an appr', and besides to bee allowed as much as will hire a Jorney man vntill he hath brought vp a prentice fitting for the busines and then to be allowed 20*l*. for two prentizes, and one hundred pounde p annu for himselfe as aforesaid."[36] Accordingly Downes proceeded to Ireland and commenced printing.

While the Queen Elizabeth types were in the hands of the Company of Stationers only one book was printed that put them to any considerable use—*The A, B, C. or The Institution of a Christian/Aibgitir .i. Theaguisg Cheudtosugheadh an Chriostaide* (Dublin, 1631; (see ill. 1.11). This work presents us with a number of oddities: the Queen Elizabeth capital U is frequently used as a roman capital, and is used upside down as a capital N as on page 4, while the normal capital N continues to be used as on page 6. Dickins identifies that "Another odd typographical feature at page 4 is the presence of a hideous two-horned cap. T [Ʊ] quite foreign to the Queen Elizabeth types and looking like a coarse imitation of the Anglo-Saxon T of some continental founder."[37] It is possible that this, the only instance of this T, was the result of a damaged or distorted cross bar to the regular Queen Elizabeth capital T.

The Irish type was further used to print names and odd words in a number of books printed by the Company of Stationers; however, the next printer to play a significant role with regard to it was William Bladen. He may have been apprenticed to the company's factor of the newly formed 'Irish Stock' about 1620, although it is generally thought that he came on the printing scene in Dublin at a later date. Henry Plomer draws attention to a document dated 30 June 1653[38] in which "The defendants state that 'about five and thirty years since' (i.e. 1618), an agreement was

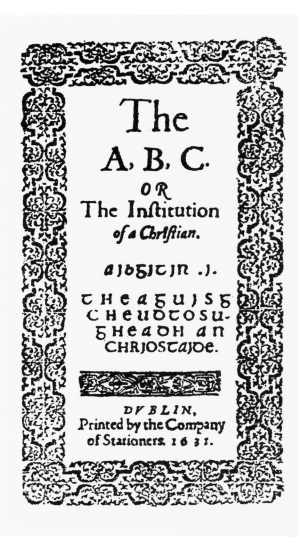

The A, B, C.
OR
The Inſtitution
of a Chriſtian.

αιbᵹιτιη .ι.

τheαᵹυιꞇᵹ
cheυꝺτοꞇυ-
ᵹheαꝺη αη
chrιꞇταιꝺe.

DVBLIN,
Printed by the Company
of Stationers. 1 6 3 1.

1.11 Title page of *The A, B, C,*
or The Institution of a Christian, by
William Bedell, 1631.

1.12 Example of the Irish alphabet
using the Queen Elizabeth Irish type,
from *The Christian Doctrine*, translated
by Godfrey Daniel, 1652.

Brief and plain RULES for the
reading of the *Iriſh* Tongue.

Αιⅿ	Αα	a
δειꞇ	δ b	b
coll	Cc	c
Oⁿⁿ	Ꝺꝺ	d
eαbᵹα	Ꞇe	e
ꝼⁱⁿⁿ	Ꝼꝼ	f
ᵹoⱷꞇ	ᵹᵹ	g
Uαⱦ	Hh	h
jóᵹα	Ji	i
Luⱷ	L l	l
Myη	ⅿ m m	m
ηιoη	ηn	n
oⁿⁿ	Oo	o
Peιꞇbⱦoᵹ	P ⱷ	p
Ruⱷ	R ⱷₖ	r
Syl	Sⱷ	ſ
τιⁿe	τ ꞇ	t
Uιⱷ	U u	u

THe Iriſh *hath* 🌸 *five*
vowels, viz. *α,e,ι,o,u, ai-*
vided into two ſorts : the firſt
called ᵹυⱦαιⱦe caola : *or vow-*
els of a ſmaller accent , as e, ι.
The ſecond called ᵹυⱦαᵹe
leαꞇⁿα, *or vowels of a broader*
accent, as α, o, u.

Note that α,o, u, *are often*
taken, or written in Iriſh , *one*
for another indifferently.

Note that there is neither
v,*nor* j, *conſonant in* Iriſh,*but*
bh *muſt ſupply the place of an*
v,*conſonant.*

Neither is k,q,x,y,z *of any*
force in the Iriſh *Alphabet ,*
but ſupplied *by other letters of*
an Eſſential denomination , as
q,*with* collúⱷⁱ, *alias* cú; *and* k,*with* collαlⁱm,*which*
is cα; y *with* uιllυηυⱷ, *viz.* u:; Stⱷαⱷ, *viz.* x,*with*
a double cc; z *with an* ⱷ.

Note further, that in pronouncing of your vowels,
you pronounce your ι, *like* ee, *in* Engliſh, *and* u, *like*
oo *in* Engliſh, *and your* α, *far broader than in*
M 2 Engliſh:

entered into amongst certain stationers of London 'to trade in the city of Dublin by vending and selling of books and other commodities . . . to be transported out of England thither, and there to be sold'." Plomer suggests that "This document tells us that the factor was William Bladen, and he probably went over to Dublin either in 1618 or 1619, though he may not have taken up his residence permanently there until some years later."[39] The document, a bill of complaint, was lodged in chancery by Walter Leake, who was perhaps a son of William Leake, one of the first rank investors in the Irish Stock, a venture which failed. The partnership of the Irish Stock was dissolved in October 1639 when William Bladen bought the stock for £2,600, of which he had only paid a sum of £974. 5s. 8d. up to the year 1642, and apparently nothing after that.[40]

It is interesting that this date of the dissolution of the Irish Stock coincides with the end of the 21-year period of the patent granted to Kingston, Lownes and Downes.

After the purchase of the Irish Stock, Bladen became, *de facto*, the government printer in Ireland. He too made significant use of the Queen Elizabeth type on one occasion only—in *The Christian Doctrine, or the Foundation of Christian Religion, Gathered into Six Principles, Necessary for every Man to Learn,* translated into Irish by Godfrey Daniel, and printed in 1652 (see ill. 1.12). Like the previously mentioned work, this also presents us with some peculiar typographical features: the Queen Elizabeth capital U appears as roman in the word "Foundation" on the title page, and is inverted on several occasions and used for N on page 5 and elsewhere, while the normal capital N also appears; both the larger 14 point and smaller 12 point lower-case h are used; furthermore, the capital M with the incurved first limb is used together with the more usual M.

Regarding this book, there is a letter attached to the British Library copy, written by Talbot B. Reed to R. Martineau, in which he incorrectly states that this was the fourth, and not fifth, work to use the Irish type: "The fourth and latest work printed in Queen Elizabeth's Irish type is *The Catechism with the Six Points of W. Perkins* translated into Irish by Godfrey Daniel (Dublin, 1652) [incorporated in the above-mentioned *Christian Doctrine*]. After this date I believe the types were brought over to London and appeared in some of the works of Sir James Ware printed by Tyler in 1656–58."[41] Martineau promptly replied, pointing out that the British Museum had a copy of the Perkin's Catechism of 1652, and also the *ABC* (Dublin, 1631) "which you evidently have not seen".[42]

Dickins further states that "It was for long believed that this was the last occasion on which the Queen Elizabeth types were used before their disappearance." He points out that the Irish capital U is used in a number of works printed between 1654 and 1656 by Bladen, and continues, "It is not of course certain that the rest of the Queen Elizabeth types remained

in Bladen's hands till 1656. Only the capital U is recorded in use in Dublin after 1652, and it may be that the examples noted are strays that had been 'distributed' into the corresponding roman case."[43]

Bladen died in 1663 and was buried at St Werburgh's Church, Dublin, on 1 August 1663. Under his will, which was proved in the prerogative court at Dublin[44] his wife Elinor was the chief beneficiary. Kirkpatrick states that: "All his stock in his shop, printing-house, and warehouse, both in London and Dublin, was to be sold to some person who had served seven years to a printer, a stationer, or a bookseller—a provision which showed his adherence to the principles of his old Company. . . . We have not found any record of the purchaser of Bladen's stock or printing-house."[45] Bladen had continued to print under his own name up to 1662, but some time before this, it would seem, the Irish types left his possession.

On 31 July 1660 the king granted a patent to John Crooke, a stationer of London, establishing him as king's printer for life. After his appointment in Ireland he retained his business in London, and it is not certain how much of his time he spent in Dublin. It is likely that he brought what remained of the Irish type to London, for he used it in Sir James Ware's *S. Patricio . . . adscripta Opuscula* (1656) to print two words on pages 98 and 114. Despite some uncertainty about its last recorded appearance, the type does in fact occur on page 113 of Ware's *De Hibernia . . . Disquisitiones* (second edition, London, 1658), to print the word *clairseach* (harp). That the type was taken to London may be further supported by the fact that J. Crook also printed a number of Ware's works in Dublin—*Rerum Hibernicarum* (1662); *Venerabilis Bedae* (1664); *Rerum Hibernicarum Annales* (1664); and *De Praesulibus Hiberniae Commentarius* (1665)—none of which make use the Irish type despite the fact that, had the type been available, it could have been employed usefully, at least in an occasional manner.

On 4 August 1680, Henry Jones, bishop of Meath, wrote to the hon. Robert Boyle telling him that he had Bedell's manuscript translation of the Old Testament into Irish and giving his account of the unavailability of the Irish type for his purposes of going to print: "As for the Irish letters stamped for the first printing here of the common prayer and new testament; they have passed from hand to hand of many of his Majesty's printers in *Dublin* successively, until by covetousness of one, into whose hands they fell unhappily, they were by the Jesuits gotten away, and are now at Doway, for Irish prints; some of which I have seen to my grief, sent hither, further corrupting the people. So as there is nothing left of what was formerly, towards the printing of Irish here, if it should be required."[46]

No evidence has ever been recorded of the Queen Elizabeth type being used on the continent, and in this regard Bishop Jones was surely mistaking the Queen Elizabeth type for the Franciscans' Irish types in use at the Irish College of St Antony in Louvain up to this time.

THE LOUVAIN IRISH TYPE

RELIGIOUS AND POLITICAL considerations continued to be the primary influences on the development of early printing types for use in the Irish language.

After the destruction of their monastery at Donegal in 1601, many of the Irish Franciscans sought refuge on the continent of Europe where they established centres for the training of their novices and students. These included the College of St Anthony at Louvain. Permission for its foundation had been granted to Father Florence Conry in 1606 by Philip III of Spain[1], and papal recognition was given by Paul V the following year.[2] As early as 1593 Conry had prepared a catechism in Irish, which was not printed until modern times. This manuscript may have inspired Bonaventure O'Hussey, one of the early Louvain Franciscans, to write his Irish catechism, *An Teagasg Criosdaidhe*.[3] O'Hussey, a native of the diocese of Clogher, had gained his MA from Douai and entered the Franciscans at Louvain on 1 November 1607. He died as guardian of the college on 15 November 1614.[4] It was for the printing of this catechism in 1611 that the first truly Irish type was prepared. Franciscan authorities generally have accepted that the type was modelled on the handwriting of O'Hussey himself. Indeed, examination of his writing as demonstrated in his letter to Robert Nugent[5] (see ill. 2.1) dated 19 September 1605 does reveal a number of features which are evident in the printing type—the capital letters A, N and R; the distinctive left stroke of the lower-case a; and the different angles of the r and s. While some of these characteristics were not uncommon in other contemporary hands, there are some grounds for making the association between O'Hussey's writing and the Louvain Irish type. The type was used for the first time to print *An Teagasg Criosdaidhe* at Antwerp "apud Jacobum Mesium" (see ill. 2.2). The approbation on the verso of the title-page is dated 20 June 1611. Regarding this date, it is interesting to note that Kearney's Reformed Church catechism, which O'Hussey's was probably designed to counter, was dated 20 June 1571.

There has been some confusion among scholars regarding the date of first publication of O'Hussey's catechism: Luke Wadding was first to mention a 1608 edition in his *Scriptores Ordinis Minorum*,[6] where he states it was printed in Irish characters at that time in the college of the Irish Franciscans at Louvain. Since the college press was not established until 1611, Wadding

2.1 Letter from
Bonaventure
O'Hussey to
Robert Nugent,
19 September
1605.

would seem to have been mistaken. No evidence has been uncovered to suggest that there ever was a 1608 edition.

On 15 April 1614, O'Hussey petitioned the Archduke Albert for permission to print Irish material at the college, alerting Albert to the fact that the Reformed Church in Ireland had already issued a translation of the bible and warned him that other religious works in the Irish language, intended to convert the Irish from their Catholic faith, were "daily appearing".[7] In May 1614 permission was granted to establish a press at the college.[8] However, according to Father Francis Matthews, the press with the Irish type had already been set up there as early as 1611.[9] The English authorities

were clearly concerned about this development and in June 1614 William Trumbull, the English agent at Brussels, wrote to the archduke expressing English concern and requesting that he refuse the Franciscans the licence to print at the college.[10] Later, on 9 July 1614, Sir Ralph Winwood wrote from Whitehall to Trumbull indicating that James I had protested strongly to the ambassador of the archduke about the Franciscan printing press, and demanded that they not only be prohibited from printing in Irish but that all copies of their books already printed be collected and burnt.[11] The archduke refused to interfere. The king of Spain, perhaps unknowingly, was further connected with the Irish press at Louvain, for the will of Father Robert Chamberlain, made on the eve of his profession on 7 February 1611, stated that he left what the king owed to him to the Irish publishing efforts of the Gaelic press at the college.[12] It was perhaps because of his interest in the printing of such Irish material that Chamberlain was assigned to examine *An Teagasg Criosdaidhe* prior to its publication; on its last page the book carries the imprimatur of the archbishop of Malines, stating that it had been read and approved by Hugh MacCaghwell and Robert Chamberlain.[13] A later undated edition of O'Hussey's catechism was printed at the college

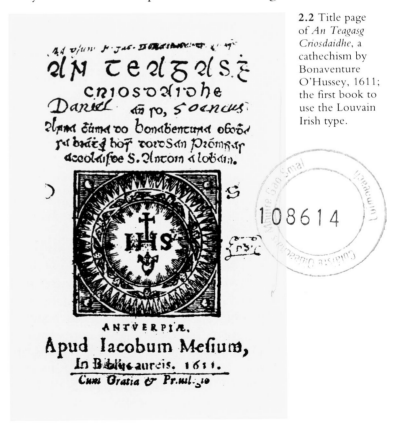

2.2 Title page of *An Teagasg Criosdaidhe*, a cathechism by Bonaventure O'Hussey, 1611; the first book to use the Louvain Irish type.

2.3 Reference in 1604 to "Thomas Strong letter founder, from Ireland".

press sometime between 1611 and 1619. Henry Bradshaw in a letter to Talbot Baines Reed suggests 1614 as the date, for he points out that the copy that he had bought in its original binding was given to the Franciscans at Toulouse in 1619, and since O'Hussey died in 1614 as guardian of the college and is referred to in this edition as "poor brother of the Order of St Francis", this suggested, for Bradshaw, a date prior to his becoming guardian.[14]

In a possible reference to the Irish type, Thomas Walsh, archbishop of Cashel, in a letter to Luke Wadding dated 1 September 1628, mentions Moretus of Antwerp in the context of the publishing of the works of Brother Patrick Fleming "in the letters of Plantin".[15] This letter, which according to Brendan Jennings, is badly frayed and difficult to decipher, may suggest that there was a connexion between the Plantin works and the printing efforts of the Irish Franciscans at Louvain. It is of particular interest that there was an Irish typefounder, Thomas Strong, working at the Plantin foundry during the period when the Louvain Irish type was probably produced. Leon Voet refers to Strong, who supplied the Plantin press with cast type until October 1624,[16] as having been employed by the

Moretuses from 1600 to 1624 and having worked in the Plantin house itself from 1620 to 1622 (see ill. 2.3). From 1601 to 1608 his name appears regularly in the Plantin accounts and to a lesser extent up to 1614. It is interesting to note that during this period under the Moretuses, fewer new sets of punches were ordered at the Plantin works, resulting in the necessity for the occasional cutting of punches by their staff type-founders to replace those lost or damaged. Hence, Thomas Strong would probably have had some experience of punch cutting. Further reference to Strong appears in the city of Antwerp records[17], where it is entered that the letterfounder Thomas Strong wrote a letter of recommendation dated 10 December 1598 for another Irishman, Thomas White of Dublin (see ill. 2.4), while another record[18] indicates that Thomas Strong, son of Jacob, from Ireland, letter-founder, was residing in Antwerp as of 1 July 1603. Thomas would appear to have had a son and daughter. His son Jacques was also employed at the

2.4 A letter of recommendation dated 10 December 1598, in which Thomas Strong acted as co-guarantor for a Thomas White of Dublin.

27

2.5 Letter of
recommendation
dated 9 April 1620,
written by Balthasar
Moretus on behalf
of Thomas Strong's
son-in-law,
Christian
Calammus.

Plantin works, initially from 1615 as an apprentice, and later, like his father,
as a typefounder from 1624 to 1626. After a time Jacques absconded, leaving
a large debt unpaid.[19] His daughter married Christian Calammus who,
according to a testimonial by Balthasar Moretus dated 9 April 1620, was
employed at the Plantin works to take care of the collection of type. In
this letter Moretus refers to the father, Thomas, as being an honest man[20]
(see ill. 2.5). It is assumed that Thomas died about 1624, leaving a wife
Margaret Verham, since no further mention appears of him in the Plantin
records after that date.

There is also record of a Thomas Strong among the Franciscans at the
Irish College in Louvain (a mere 50km from Antwerp) at this time, which
would seem to provide either a remarkable set of coincidences or further

information regarding the above-mentioned Thomas Strong. In June 1607 a Brother Thomas Strong, subdeacon of the province of St Jacob in Spain, had come to the college.[21] In 1622 the Irish College at Douai published the names of its past students, among them those who had become Franciscans.[22] This list includes the name Thomas Strong. An examination of the University College, Dublin copy of this rare book reveals the words "alias Nicholaus" handwritten in the margin opposite the name of Thomas Strong, which suggests, that he may have used either first name. The *Fourth Report* of the Royal Commission on Historical Manuscripts shows that a Fr Nicolaus Strong of Waterford was received into the college on 16 March 1614,[23] while the Malines ordination registers 1602-1794 indicate that Nicolaus Strong OFM received tonsure and minor orders on 27 May 1616.[24]

There is a considerable amount of information concerning Friar Thomas Strong (sometimes called Strange) in Franciscan manuscript records and in the *Calendar of State Papers, Ireland.* Earlier in his career he was actively involved as a courier for the Irish rebel forces and their supporters on the continent. A particularly interesting account of him in 1608 describes him as being short and stocky, about 40 years of age, with dark hair and a yellow skin complexion, and mentions that he suffered from an eye condition.[25] Strong was later appointed as guardian of the order in Dublin[26] and acted as collaborator with his cousin Luke Wadding in the research work for his *Sacred History of Ireland.* In this connexion he was given access by Archbishop Usher to his library.[27]

Searches for information regarding the Franciscan Thomas Strong are confused by the presence of a Thomas Strong who was bishop of Ossory between 1582 and 1602, spending much of this period in exile in Spain. He died on 20 January 1602 at the age of 55.[28] Harry Carter implies that there was a connexion between the typefounder Strong and Bishop Strong, whom he incorrectly suggests was one and the same as the later Franciscan Strong. Carter's brief reference to Strong is contained in a paper published in *De Gulden Passer*[29] after a lecture given by him in which he added, in what may be taken as a despairing note, "The question I cannot answer, and that is the end of the Irishman as far as I am concerned."[30]

It is interesting to speculate as to the possibility of Thomas Strong the typefounder, with experience at the Plantin works in 1601-8, joining the Franciscans at Louvain in 1607, being released from there to the Plantin works to help in the preparation of the Irish type in 1608-11 and possibly being involved in the establishment of the printing press at the college in 1611-14. However, despite the many coincidences, it must be said that the name Thomas Strong was not uncommon at the time, and no firm evidence has been uncovered to link the typefounder with the Franciscan.

Modelled as it was on a rather undisciplined handwriting style, the type retains many of the irregular features of this source. There is a noticeable

suim riaghlachas phroin_

ſṁ go hadʒunɼ a ngaoiḋig.

Aɼ nachɼ a ca ɼ nɼṁ. 7c. Cɼercim a
nʒia uɛɼ uileʒuṁ: 7c.

Al caɼo ceɼʒne ḃ ɼʒgala ʒɼ iny ccnei
ʒṁ ·i· rɼṼ muɼrʒ ala ʒiuḃ ḃṁaɼ ɼné oia
ʒaɼ an ʒiʒṅina luɼa Cɼioɼo, 7 rɼṼ nɼʒ_
ʒṼia eile ḃṁaɼ ɼné na oḣanɼoaɼ.

Na hʒeʒgail ḃṁaɼ ɼiɼ an nɼiaʒoaɼ.
Cneiɼṁh a ncomʒia, a ʒɼeiɼṁ ʒ· ḃ é an
caʒaiɼ uilʒʒuṁchoaɼ, a ʒɼeiʒṁ ʒ ab é
loɼa Cɼioɼo mac Oé, a ʒɼeiɼ ṁ ʒ Oia an
Spioɼao naṁ, a ʒɼeiʒṁh ʒ ab é Oia ʒia
ɼuʒhɼḃni nimḋ ɼ 7 calṁain, a ʒɼeiʒṁ ʒ
ab é ɼ Slanɼʒḃoin, a ʒɼeiʒṁ ʒ ab é aɼ
nʒlénʒḃɼ.

Ni hʒaineʒʒ ni ḃṁaɼ niɼan noaṁaɼ.
a ʒɼeiɼṁ ʒ ʒ ʒaḃaɼ Cɼioɼo ɼn Spioɼaɼ
(✝) naṁ

2.6 First page of
*Suim Riaghlachas
Phrionsiais* (Rules of
St Francis), undated.

lack of consistency in the length and angle of many of its strokes, and a general lack of proportion to its elements gives this type a spiky and uneven appearance on the page.

The Louvain Irish type continued in use to print a number of works including an undated twelve-page pamphlet of prayers, blessings and summaries of the Franciscan rule, entitled *Suim Riaghlachas Phroinsiais*, the only known copy of which is in Marsh's Library, Dublin (see ill. 2.6). Father Canice Mooney in his article on St Anthony's College suggests 1614 as the date of printing.[31] The type was next used in 1616 to print *Sgáthan an Chrábhaidh* (Mirror of Religion) translated from Spanish by Florence

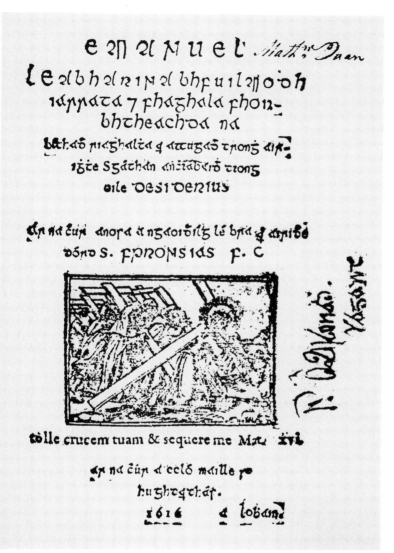

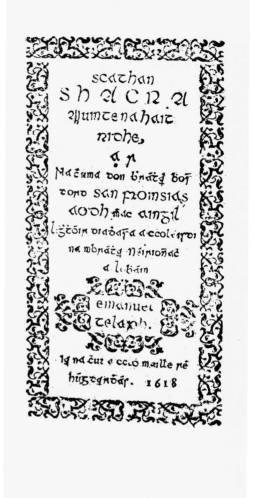

Conry, archbishop of Tuam (see ill. 2.7), a work often referred to as *Desiderius*. In his 1941 edition of it Thomas O'Rahilly refers to the absence of capital vowels with length marks in the original Louvain type.[32] In 1618 this Louvain A type was used again in *Scathan Shacramuinte na hAithridhe* (Mirror of the Sacrament of Penance) by Aodh MacAingil, archbishop of Armagh (see ill. 2.8). After this work the college press was inactive in Irish printing until 1641, by which time a second Irish type, the Louvain B type, was available. The preparation of this new type is mentioned in a letter of 23 October 1638 by a 'Frater Ant'. addressed to Father Brandon Ó Connor OFM at Louvain,[33] in which he urged that special symbols be made

2.7 Title page of *Sgáthan an Chrábhaidh* by Florence Conry, 1616.

2.8 Title page of *Scathan Shacramuinte na hAithridhe* by Aodh MacAingil, 1618.

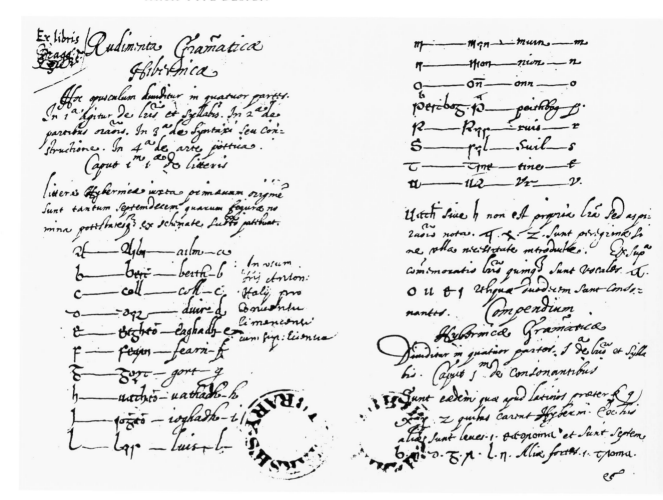

2.9 The Irish alphabet as written out by Fr Anthony Haly for the Irish Grammar of 1634.

for ligatures and for letters with suprascripts while the type was being remade. A fund-raising appeal, launched by Father Bernard Conny in 1639-41 to help finance the college press, mentions that a new Irish type had recently been prepared.[34] It is unclear who the author of this letter was, since there were several Franciscans using the name Anthony at the time, among them a Father Anthony Haly at Louvain, the scribe involved in the production of an unpublished manuscript grammar, *Rudimenta Grammaticae Hibernicae*, in 1634 (see ill. 2.9). Haly's handwriting in the Irish sections of the grammar resembles most noticeably the new Louvain B type, particularly in the letters G,R,e,p,r,s, and t. It is a distinct possibility, therefore, that Haly's handwriting was used to provide a model for some of these new letterforms.

The Louvain B type differed from its predecessor in a general manner in

Sgáthán ofp chrabhuigh. **11**

15

[Two columns of Irish Gaelic text set in the Louvain types shown as facsimile images]

2.10 Examples of text using the Louvain A type from *Sgáthan an Chrábhaidh*, 1616 (left), and the Louvain B type from *Riaghuil Threas Uird S. Froinsias*, 1641 (right).

2.11 The Louvain A type (above), and the Louvain B type (below), enlarged to 250% approx.

2.12 Title page of *Riaghuil Threas Uird S. Froinsia*s (Rule of the Third Order of St Francis), by Bernard Conny, 1641.

2.13 Example of text using the Louvain B type from *Acta Sanctorum Hiberniae*, by John Colgan, 1645.

2.14 Title page of *Parrthas an Anma* (Paradise of the Soul), by Anthony Gearnon, 1645.

that it appeared somewhat bolder and slightly larger (see ill. 2.10 and 2.11), with some of the sorts being more upright and condensed; a notable exception is the letter R, whose capital has a wider base with its diagonal tail stroke taking a distinctively different line to the earlier form and whose lower-case descender has a significantly greater angle to the perpendicular.

It should be noted that certain characters with aspiration marks differ in shape from their corresponding basic sorts without such marks.

The new type was used to print *Riaghuil Threas Uird S. Froinsias* (Rule of the Third Order of St Francis) by Bernard Conny in 1641 (see ill. 2.12). It was next used together with the earlier A type in Michael Ó Cléirigh's *Focloir no Sanasan Nua* in 1643. In this work page 64 is set in the early type while page 65 is set in the later (this also happens elsewhere in the book). It was again used to print a few brief tracts of Irish in John Colgan's *Acta Sanctorum Hiberniae* in 1645 (see ill. 2.13). In the introduction to the fac-simile edition of that book Brendan Jennings incorrectly suggests that the new type had been especially cast for use in a book compiled by Colgan and printed in 1647 "apud Cornelium Coenestenium" entitled *Triadis Thau-maturgae seu Divorum Patricii, Columbae et Brigidae*.[35] In fact the Irish type used in *Triadis* was the earlier Louvain A type, although in a few isolated instances the later B type is mixed in with this fount; for example, on page 2 verse 19 line 1, the later lowercase r appears, while on line 2 of the same verse the later lowercase e is used. Despite the fact that the two founts appear to have been somewhat mixed at this stage, apart from in *Riaghuil Threas Uird* the new type was not used alone in any significant way. Henry Bradshaw, who was not impressed by this new version, suggests that it would not have been used at all if the earlier fount had been still available.[36] Interestingly, for Anthony Gearnon's *Parrthas an Anma* (Paradise of the Soul) the college press in 1645 reverted to the earlier A type (see ill. 2.14). Almost 15 years passed before the next work to include Irish was produced for the Franciscans, namely *Sancti Rumoldi* (a life of St Rumold) by Hugh Ward and published after the author's death by Father Thomas O'Sheerin at Louvain "Typis Petri Sasseni, ante Hallas" in 1662. In this work the later Louvain B type was used merely to print a list of names on a tipped-in fold-out leaf between pages 366 and 367. In this, a number of the earlier Louvain A characters, particularly the lowercase g, were mixed in with the later fount. This is the last recorded use of the Louvain B type. The earlier A type was used again a year later in 1663 in *Suim Bhunudhasach an Teaguisg Chriosdaidhe* by John Dowley.

The above-mentioned Father Thomas O'Sheerin (Sirinus) succeeded Father John Colgan in the work of the college press. A number of his letters to Francis Harold, a nephew of Luke Wadding, written between 1669 and 1671, give some indication of the financial difficulties he was encountering. In connexion with the publishing of a planned dictionary Father O'Sheerin

2.15 Example of the re-cast Louvain A type from *The Elements of the Irish Language*, by Hugh MacCurtin, 1728.

comments that the Irish type had been scattered and only the matrices remained, from which, he points out, new founts could be cast as required.[37] Hugh MacCurtin's *Elements of the Irish Language* printed in 1728 was the last work to use either of the Louvain Irish types. In this the early A type appears composed with a more reduced line- spacing than before, a feature which may have resulted, as Father O'Sheerin had suggested was possible, from the type having been re-cast from the remaining matrices on a smaller body, resulting, when set, in a more orderly and even appearance on the page (see ill. 2.15). This book was printed at Louvain by Martin van Overbeke. The van Overbekes, a renowned printing family, continued to work in Louvain, and it is quite possible that the Irish type was passed to them and through disuse melted down.

THE ROME IRISH TYPE

IN 1625 LUKE WADDING was instrumental in establishing the College of St Isidore in Rome. Many of the early community came from Louvain, bringing with them an interest in research into Irish history and in publishing in the Irish language. At a time when the printing of such material was on the decline at Louvain, due to a lack of finance, the Franciscans at Rome had a number of books published through Propaganda Fide. The Sacred Congregation of the Propagation of the Faith was established by Pope Gregory XV in 1622, and an important adjunct to its work was its Polyglot printing-press, set up four years later. Father Bartholomew Egan records various developments regarding the involvement of Propaganda Fide in printing Irish material.[1] On 24 May 1638 approval was granted for the casting of Irish type, mentioning the work done by "John the Teuton"; "the Sacred Congregation ordered that the usual puncheons of Irish type be made up and that reward be paid to the same John and that the above-mentioned puncheons be sold later if that was possible."[2] Various requests to have books published in Irish were made in 1640 and 1652, but it was not until 1674 and the following year that petitions by Francis Molloy OFM to have his Irish catechism passed for printing[3] met with any positive results; this delay suggests that the Irish type of the Polyglot press may not have been available prior to then.

Similar influences to those that affected the Louvain types can be detected in this Rome Irish type. It features many improvements, however, and for its time met many of the requirements of a good printing type. It is more vertical and upright and has an orderly and even appearance on the page, while retaining the distinctive scribal qualities of the Irish style.

Molloy's first book to be printed with this Rome Irish type was *Lochrann na gCreidmheach* (Light of the Faith), more commonly referred to by its Latin title, *Lucerna Fidelium*, published in 1676 (see ill. 3.1). The book carries a title page in Latin followed by an Irish title, one probable reason for this being that it was presented as having been translated into Irish, to conform with the Propaganda requirement that all works printed by their presses in foreign languages be accompanied by a Latin version.

Father Egan further records a "petition of Francis Molloy OFM to have his Irish grammar printed, 4 May 1676"[4] and later that "Francis Molloy OFM wished to expedite the printing of his Irish grammar, 19 January

lochrann na
gcrejomheach. j.

Oioʒgan oioglomża, aʃ na pʃiomuʒ-
oaʃʃib lɛ ɞʃaċoan ʃ lejʒeaṅ na bɫżaioh,
ʃanża a ɞʃi ccooċʃb; a ɞɛʒaʒ ċʃioʃ-
oʃoe, á miniuʒao na naiʃɞɛʒal, ʃa
mbi lvʃ ainbʃiʃ oeaʃbaio á ɞʃʒʃiona,
aʒ żabżaṅ na ccʃejomheach; ʒ á ccomh-
ʃao ʒeaʃ ʃimplioe, lɛ cclaoiożʃʃ ʒaċ
ʃoʃɞ ejɞʃice ʒo huʃaʃoa, ʒ lɛ noaingni-
żʃ na caɞoilici ʒo lejʃ vle ʃan ccʃeioṁ
coiʃ. Aʃ na chʃʃ a cclo ʃan Romh,
maille ʃe vʒhoaʃaʃ San Dhʃopa-
ʒanoa, le bʃaɞʃ boʃ ooʃo
S. Fʃojnʃiaʃ. Fʃojnʃiaʃ
ó Maolṁuaio, 1676.

CRIOSOAIOhe. 109

AN 5: CAJb.

Oon cʃʒɫo haɞʃnʒio.

AAITH NA COIN-
The. 7c.

Tʃaʃɞ ano ʃo aʃ an ccuiʒɫ
haɞhchuinʒio oon paʃoin .i.
Maiżh ohuiṅ aʃ bʃéiaɞa, maʃ ma-
iɞmio ʃein oáʃ bʃéiblṁinaib. Aʃ
niaʃ aio ż anuile maiɞʃʃa ʃioʃoaioe,
ʒ iaʃaʃa ohuiṅ ʒonuiʒeʃo, iaʃʃmcoio
iʃ na ċʃi haɞċuinʒibʃi inʒ noiaiʒ aʃ
ʃcoʒao aʃ annuile olc oá ɞáiniʒ,
oá bʃoil oo laɞaiʃ nó oáɞiocʃa:

3.1 The Irish title page of *Lochrann na gCreidmheach* (Light of the Faith), 1676, the first book to use the Rome Irish type.

3.2 Example of text using the Rome Irish type, from *An Teagasg Criosdaidhe*, 1707.

1677",[5] which appeared in that year. The type was next used in a reprint of O'Hussey's catechism in 1707, referred to on its title page as *Secunda Aeditio*, though in fact this was its third edition (see ill. 3.2). The type was also used for a small eight-page booklet on the house of our Lady at Loreto, *Tosach agas aistriugha miorbhuileach Theampoill Mhuire Loreto*, usually found bound into the back of the O'Hussey catechism. Father Philip Maguire arranged for the O'Hussey reprint and was the author of the booklet on Loreto. The type next appeared in a specimen book of Propaganda Fide in 1773, the date pencilled into the Columbia University copy, which has no title page (see ill. 3.3). This example, which appears to include the full range of characters, contains an indication of the number of punches and matrices involved.

Ponzoni, Madri, & il Carattere Hibernese Soprasiluio messo per ordine Alfabetico.

Li sudetti Ponzoni sono n. 132. e vi mancano n. 18.
Le sudette Madri sono num. 149. e vi manca vna.

Maiu-

3.3 Sample of the Rome Irish type from the specimen book of Propaganda Fide [1773].

39

IRLANDOIS.

3.4 The complete range of characters of the Rome Irish type from the specimen book of M. Pierres, Paris, 1785, in which it is stated that this type was acquired by Pierres in 1779.

A sample of the complete fount, which included a set of large capitals together with a range of ligatures and contractions, with alternative characters containing various aspiration marks, appeared in the specimen book of the Paris printer M. Pierres in 1785[6] (see ill. 3.4). The introduction to the section in which the specimen appears states that the samples were "characters of the ancient languages, extracted from the printing works of the Propaganda, in Rome, and sent to M. Pierres through Cardinal de Bernis in September 1779". This sample also contained a number of additional small capital letters, which combined with those lower-case letters shaped like the capitals to provide a complete set of small-capitals in this size. With the exception of the long lower-case r, both sets of capitals had the additional characters needed for use as a lower-case alphabet, rendering them useful in a flexible manner as capitals, lower-case or small-capitals, as required. In the sample the large P is placed upside down, with a somewhat irregular order to the sequence of the letters, as if the compositor was not familiar with their values. This specimen is of particular interest in that it shows the condition of the complete range of characters prior to the adjustments made later.

Possibly resulting from this showing of the specimen of Irish type, the Imprimerie Nationale in Paris sought to include this novel face in its collection. Father Willi Henkel has discovered in the archives of Propaganda Fide reference to the removal of the Irish type to Paris (heretofore its removal had generally been attributed to Napoleon's plundering): "On April 25, 1797, Cardinal Antonelli received a note from the Secretariate of State saying that the Pope had given permission for the Polyglot to send some alphabets to the Exposition of Oriental Letters in Paris, as requested by the French Minister, Cacault."[7] An accompanying letter by the director of the Imprimerie de la Republique, Duboyraverne, and by l'Hoengle, curator of oriental manuscripts at the National Library in Paris, was even

IRLANDAIS. 45

OBSERVATIONS.

Les caractères Irlandais n'ont pas toujours suivi l'ordre dans lequel ils sont maintenant placés. Les lettres étaient différemment rangées dans l'ancien alphabet, qui était nommé ᵬoᵬeloꞇ *Bobeloth* ou ᵬoᵬelloꞇ *Bo-belloth,* (1) parce qu'il commençait par les lettres ᵬ, *l*; comme son nom moderne (2) indique qu'il commence maintenant par les lettres 𝔄, ᵬ.

Ces anciens caractères se nommaient aussi

(1) Voyez *Ogyg.* p. 235. On a aussi donné à l'alphabet le nom de ᵬeⱫꞇ-lⱱⱼr-nⱼon, *beith-luis-nion*, qui n'est autre chose que la réunion des noms des trois lettres par lesquelles il commençait alors.

(2) Outre le nom d'𝔄ⱼᵬᵹħⱼꞇⱼn *Aibghitir* par lequel on a vu ci-dessus *(pag. 43)* que les grammairiens Irlandais dési-

3.5 A page from *Alphabet Irlandais,* which shows how Marcel made use of the Rome Irish type in two sizes.

3.6 The 24 point Rome Irish type (above), showing the revised capital A and lower-case a and r, enlarged to 130% approx. The 16 point fount (middle), enlarged to 200% approx., and the 12 point Old Irish type modelled on the Rome fount and produced in Vienna *c.*1845 (below), enlarged to 200% approx..

more explicit: the commissioners of the French government were to take the necessary measures to obtain from Propaganda Fide an example of all foreign letters in order to complete the magnificent collection at Paris. So "39 boxes of Arabic, Armenian, Brahmanic, Chaldaic, Coptic, Hebrew, Georgian, Greek, Irish, Illyrian, Indian, Malabar, Persian, Ruthenian, Syriac, German, and Tibetan letters and three printing presses were transported to the French Academy in 1799."[8]

In 1804 the type was used by the director of the Imprimerie Nationale in Paris, J.J. Marcel, in his book *Alphabet Irlandais* (see ill. 3.5) and later in *Oratio Dominica* (1805). Marcel's account of the Imprimerie's acquisition of the Rome Irish type is of interest; he states (in translation) that: "The punches for the characters used to print this alphabet [in his *Alphabet Irlandais*], were in two different sizes, and were part of the founts of the printing works of the Propaganda in Rome; they were included in a number of punches and

matrices sent from Italy to the printing works of the Republic, by the orders of Heros [Napoleon], whose genius as protector and whose armies were always victorious, elevating France to a high degree of celebrity and enriching her with the most precious masterpieces of all types of art. The printing museum gloried in the benevolence and honour, a large increase in its stock rendered it a unique establishment, with which the whole of Europe has nothing to compare."[9] In his footnote to the above Marcel states that "A collection of exotic punches arrived from the printing works of the Propaganda to the printing works of the Republic at the commencement of Pluviose year 9 [January 1801]. Another consignment was sent at the commencement of Thermidor year 7 [July 1799]. And another, composed solely of matrices, at the commencement of Germinal year 6 [March 1798]". As to the condition of these punches and matrices on their arrival in Paris, Marcel states (in translation):

> But whether in the confusion of their transport, or the inconvenience of the long journeys involved, or perhaps on account of the important events to which Italy was always a theatre, it was not possible to apply to their conservation in that vast store, all the care which is indispensable for a collection of types so precious and of such diverse exotic characters as were found therein. They were found mixed up with other characters amongst which it was necessary to search for and extract them. One collection was in bad condition; some were broken or flattened, others mutilated or badly finished. I repaired and re-established all those which had been broken, perfected those which had been unfinished, struck the necessary matrices, and brought them to a usable state. The largest of the two characters, or the first group, is that which was used in the text of this alphabet [book]: it is composed of 56 punches, forming 85 matrices and was founded on the Gros-parangon (24 point) size.

He continues:

> The second Irish character possessed by the printing house of the Republic is smaller and is comprised of 80 punches forming 92 matrices; it is apt to be founded on the Gros-romain-Grand-Jean (16 point). It was used in the footnotes which accompany this treatise.[10]

In his notes Marcel explains that "the Irish matrices, having been struck, as it appeared, in haste, in crude unpolished copper, by workers little accustomed to the scrupulous precision required for that type of work, some even having received the imprint from broken and defective punches, could only produce a very basic type, of a badly finished contour. All the matrices in which the characters had been founded, which served for the impressions of that alphabet, have been newly struck after the repair of the punches." And, with regard to the smaller size, he explains that the lower-case letters of the larger size were used as capitals for the gros-romain.

In fact, the reverse (that is, that the capitals of the 16 point were used by Marcel for the lower-case of the 24 point), would seem the more accurate account, for in their original form there would seem to have been capitals only for what was to become the larger 24 point fount, and capitals and lower-case for the smaller 16 point. This different usage of the type by Marcel has led to considerable confusion as to the number of founts involved. In restriking the 16 point capital sorts for the lower-case of the 24 point fount, Marcel found it necessary to cut the two new letters a and r, since, unlike the rest of the alphabet, it was not possible to use these two letters in their capital form as lower-case (see ill. 3.6), despite the fact that a suitable lower-case form of a was already available in this size. He also had re-cut the 24 point capital A which was modelled on the 1732 Paris Irish type (to be discussed in a later chapter). This would explain the inclusion of the out of character 24 point capital A and lower-case a and r in Marcel's 24 point fount. In restriking the new matrices, many of the characters took on a more pronounced angle than that in the original fount, particularly in the lower-case 16 point size, to such an extent that the new version appears almost as if it were an italic for the old.

It is recorded in *Cabinet des Poincons de l'Imprimerie Nationale* (in translation): "The national printing works conserves in copper matrices the Irish types which were used in printing works of the Rome Propaganda in 1676. It is, moreover, with these ancient forms that the 'Our Father' which is contained in the work [*Oratio Dominica*] was printed in 1805 on the occasion of the visit to the imperial print works by his Holiness Pius VII."

E.W. Lynam states that he was unable to obtain any information from the Imprimerie Nationale about these founts: "There is little doubt that both these Rome founts, with punches and matrices, are still lodged there. . . . Whatever we may think of Napoleon's heroism in plundering the printing-presses of Rome, it is probable that but for his act both these types would have disappeared, as the other Irish types produced on the Continent have done."[11]

Writing in 1936, Colm Ó Lochlainn described the difficulty of obtaining up-to-date information regarding the type: "In all probability these types and matrices are in the Imprimerie Nationale, but it seems impossible to get any information. My friend, Mr E. W. Lynam, wrote three times without result, and when I visited the Imprimerie in 1931 nothing was known of them and there seems to be little interest in the matter. The present home of the Imprimerie at rue de la Convention is quite a new building, and it is possible that in rebuilding or moving many antique characters may have disappeared or been placed in a general store room or museum."[12]

In July 1987 I searched unsuccessfully for the Rome Irish punches among the collection of rare punches at the Imprimerie Nationale; but I did examine two sets of matrices of this type labelled as follows: "*Matrices*

Irlandois sur 16 points Rome—41 matrices" and "*Matrices Irlandois sur 24 points Rome—91 matrices*". These would appear to be a new set struck in Paris, possibly by Marcel or after him by Anisson-Duperron, since the physical outer shape of the matrices of the revised letters show no difference to those of the original characters.

As to what happened to the punches and original matrices, Father Willi Henkel states that "in 1815, the Secretary of State, Cardinal Consalvi, asked the pontifical commissioner in Paris, Msgr Marino Marini, to request in the Pope's name the restitution of those letters necessary for the missions." He continues: "Although the permission was granted, it remains uncertain, in the sources, what actually happened after that."[13] In a footnote, Henkel states that "A further request was made by Pius VII."

There is a copy of a letter at the Imprimerie Nationale, Paris, dated 14 August 1820, and certified correct by De Laigues, chief of the Archives of the Ministry of Justice, and by Anisson-Duperron, director of the Imprimerie Royale, which throws light on the fate of the punches and matrices. The original letter of 17 November 1815, signed by Msgr Marini, stated that Marini, the Commissioner of the Pontifical Archives "charged with reclaiming the objects of science from the Government of France, acknowledges having received from the Director General of the Imprimerie Royale, the punches and matrices which came from the Propaganda in Rome, the Director being authorised to return them by the Guardian of the Seals". He goes on to explain that "This discharge comprises the characters which exist at the moment at the Imprimerie Royale, such as those which have been remitted to me, and those which had been appropriated by Bonaparte, notably those which he had taken in the expedition from Egypt which have not been returned." A list entitled "State of the Punches and Matrices of the Oriental Types of the Imprimerie Royale, comprised in an Inventory on 1 January 1815, and of which the restitution was made in October and November 1815" accompanies this letter and is also certified by Anisson-Duperron. This list includes "Irish, forming two founts" and "Irish, latin letters with accents", and under the heading *Matrices* "Irish on 11 and 15 points". In what appears as a disclaimer of responsibility for these events, another statement is attached, also signed by Anisson-Duperron; under the title "Removal of the punches and matrices of the types of the Propaganda" it states ". . . brought from Rome under Government direction in 1798. . . . I declare that according to a decision taken by His Majesty on 15 November 1815, on a complaint from the Holy See, having been authorised by letter from the Guardian of Seals of the 17th of the same month, to have restored the punches and matrices of the collection from the Propaganda to the Commissioner for His Holiness, I have complied with that order. . .". He further explains that a second collection which had come from Florence in 1811, "that of the Medicis, infinitely richer and more complete [than that

3.7 Catalogue entry of Tipografia Poliglotta Vaticana showing the Rome Irish punches contained in their archives *c.*1937.

XIX

HIBERNICA.

———

Hibernica (15 1/2 p.)

mollvige an Ciapna, anapvin ville
2l poblvigte ville, mollvige é
Oip ca agpocaine co neapcvigte oppvin
2lgvp mainean finean an Cigeapna go bpac

3.8 Sample from the Propaganda Fide *Specimen Characterum Typographei*, 1843.

of the Propaganda] was taken back by force under threat of violence by the commissioners of the Tuscan Government on 7 October 1815." The punches, he continues, "were mixed and confused with the ancient ones in the Imprimerie Royale and the operation was carried out with little order or discernment on the part of the Commissioner." He states furthermore that he had at his own expense "struck fine matrices in copper from all the punches which I was obliged to return, both to the Propaganda as well as to the Medicis" and therefore he can confirm that "the Imprimerie Royale continues to hold in this form in totality these two beautiful collections, which together with their own collection of ancient oriental punches represents the richest, most complete and most precious in existence."

The original punches and matrices, with their adjusted sorts, were returned to the Propaganda Fide Press in Rome, and remained there until 1909, when the stock of Propaganda Fide was transferred to the newly established Tipografia Poliglotta Vaticana. At the same time part of this stock was sold to the Societá Tipografia Editoriale Romana.[14] The Irish material, however, became part of the stock of the Tipografia Poliglotta Vaticana, and about 1937 a young employee of this press, Mr Sebellin, prepared a detailed record of the punches received in 1909, using impressions taken directly from the punches to identify the various sorts. The Irish are shown on page 52 of

XXVII

HIBERNICE

Aꞃꞃoıꞅ aꞃ a náꞟóḃꞰꞃoıꞃ éıꞅꞇıᵹ, ó a Iꞃꞃáeꞁ,
ꞃıꞅ Ꞟá Ꞟéaꞇꞝꞃᵹḃ 7 ꞃıꞅ Ꞟa ḃꞃeıꞇeaṁꞞꞰꞃᵹḃ, Ꞟoꞟ
ꞝo ṁꞟꞞ mé ꞝáoıḃ, ꞟꞰm a ꞞꞝeꞞꞇa, ꞟoꞃ ᵹo Ꞟa-
ıꞃꞮꞟꞝe, 7 ᵹo ꞃaꞟꞇáoı a ꞃꞝeaꞟ 7 ᵹo ꞃeꞁḃoꞟꞇáoı
aꞞ ꞝáꞟaıᵹ ꞝo ḃeıꞃ aꞞ **CIᵹꞞEꞀꞃꞃA** Oıa ḃꞰꞃ
Ꞟaıꞇꞃeaꞝ ꞝáoıḃ. Ꞟı ꞟꞰꞃꞅꞮꞟꞝe a ᵹꞟoꞟ a Ꞟꞃoꞟaıꞁ
aıꞇᵹꞞaꞃ mıꞅı ꞝıḃ, Ꞟı móꞁaıᵹꞝeoꞟꞇáoı éꞅꞟıꞝ ꞝé,
ꞟoꞃ ᵹo ᵹꞟoꞅṁeaꞝᵹꞃꞝe aıꞇᵹꞞꞇa aꞞ **CIᵹꞞEꞀꞃꞃA**
ḃꞰꞃ ꞞOıa Ꞟoꞟ aıꞇꞞıᵹımꞅı ꞝıḃ. Oo ꞟoꞞꞟaꞝᵹ ḃꞰꞃ
ꞃꞰꞁe ꞃéıꞞ ꞟꞃéꞝ ꞝo ꞃıꞟe aꞞ **CIᵹꞞEꞀꞃꞃA** a ꞇꞇáoḃ
Ḃáaꞁ-ꞃéoꞃ: óıꞃ a ꞞꞰꞁe ꞝꞰꞞe ꞝaꞃ ꞁeꞞ Ḃáaꞁ-ꞃéoꞃ,
ꞝo ꞃꞟꞃıoꞃ aꞞ **CIᵹꞞEꞀꞃꞃA** ḃꞰꞃ ꞞOıa aꞃ ḃꞰꞃ
mᵹꞃꞟ ıaꞝ. Aꞟꞝ ıḃꞃı Ꞟoꞟ ꞝo ᵹꞃᵹmꞰᵹ ꞝoꞞ **CIᵹꞞE-
ꞀꞃꞃA** ḃꞰꞃ ꞞOıa aꞇóꞇáoı ḃeó ᵹaꞟ éaꞞꞰꞞe aᵹꞰḃ
a Ꞟıúᵹ. ꞞeꞞꞟaıꞝ, ꞝo ṁꞟꞞ mé ꞝáoıḃ ꞃéaꞟꞝa 7
ḃꞃeıꞇeṁꞞꞰꞃ, ꞝo ꞃéıꞃ mᵹ ꞝo aıꞇᵹꞞ aꞞ **CIᵹꞞEꞀꞃꞃA**
mo ꞟOıa ꞝıom, oꞞꞰꞃ ᵹo ꞞꞝéꞰꞞꞇáoıꞃı ꞅ Ꞟ aꞞꞃꞰ
ꞇıꞃ a ḃꞃꞰꞁꞇı aᵹ ꞝꞰꞁ ꞝó ꞃeꞁḃꞰᵹaꞝ. CoıṁéꞞoꞰᵹ
Ʞme ꞃıꞞ 7 ꞝéaꞞꞰꞝ ıaꞝ; óıꞃ ıꞅ í ꞃo ḃꞰꞃ ꞟꞃıoꞞaꞟꞝ
7 ḃꞰꞃ ꞇꞇꞰᵹꞅꞞ a ꞃáꞝᵹꞟ Ꞟa ᵹꞟıꞞᵹꞝaꞟ, Ꞟoꞟ ꞟꞁꞰꞞꞅeꞃ
Ꞟa ꞃéaꞟꞝaᵹo Ʞꞁe, 7 a ꞝéaꞃa, ᵹo ꞝeıṁıꞞ ıꞅ ꞝá-
oıꞞe ꞟꞃıoꞞa 7 ꞇꞰᵹꞅꞃeꞟa aꞞ ꞟꞃꞞeꞝ móꞃꞃa.

3.9 Sample from a
Propaganda Fide
specimen book
[1865].

this catalogue (see ill. 3.7). The punches remain in the Poliglotta archives.[15] This interesting record contains 145 characters, many of which are shown in other than an upright position. Included are the revisions made by Marcel in Paris, together with a number of sorts which are clearly not part of the Irish fount.

Samples of the Rome Irish type are included in two specimen books produced by Propaganda Fide after the return of this material to Rome. However, since these examples do not include any of the adjustments made by Marcel in Paris, it would appear that they were printed from a type retained in Rome cast from the original matrices. The first appeared in *Specimen Characterum Typographei S. Concilii Christiano Nomini Propagando Sanctissimo Domino Nostro Gregorio XVI Pont. Max.* in 1843 (see ill. 3.8), and later a sample appeared in the Propaganda Fide publication entitled *Pio IX Pont. Max. Officinas Librarias Collegi Urb. Christiano Nomini Propagando Novis Operibus* etc. (no date). The Columbia University catalogue dates this work at 1865,[16] a date confirmed by the fact, as Henkel points out, that "The Pope's [Pius IX] visit to the Polyglot, on May 23, 1866, was an expression of his personal interest in its development. On this occasion, the Pope was offered a book containing examples of a variety of letters; more specifically, it contained verse 7 of the fourth chapter of Deuteronomy in 250 languages"[17] (see ill. 3.9).

An interesting type which was modelled on the Rome Irish design was produced in Vienna and appeared in the alphabet section of *The Bible of Every Land*, printed in London in 1851. This book illustrates a number of foreign alphabets regarding which the publishers note the difficulties that they experienced in collecting examples of the various required printing types:

Every effort was made to procure a complete series; but as it was found that very many alphabets could not be obtained, the design of supplying the comparative Tables was about to be relinquished. It being however well known to philologists that in the Imperial Printing Office at Vienna there exists an unrivalled collection of foreign types, formed by the skill and untiring diligence of the Imperial Commissioner, M. Alios Aver, the Publishers ventured to represent to the Imperial Government the difficulty experienced in enriching the Bible of Every Land with the necessary alphabets, and solicited permission to purchase from the Imperial Print-office the Alphabets not procurable in England. This appeal was immediately responded to; and with great liberality, His Majesty the Emperor at once directed a complete series of the Alphabets of all the types used throughout the work, together with the powers of each letter, to be prepared and forwarded free of cost for the use of the present work. The Alphabets, therefore, which the Publishers have the satisfaction to include in their work, are printed from types cast and prepared in the Imperial Printing-office at Vienna, and presented by the Emperor of Austria as a contribution to the completion of the Bible of Every Land.[18]

3.10 Example of
text using the 12
point Old Irish
type modelled on
the Rome fount
and produced in
Vienna *c*.1845,
from *Geschichte
der Schrift*, 1880.

Ꮓ aċaıɲ ꝗıl hı nımıb, Ꝺoemċhaɲ ċhaınm. Ꞇoɼc ꝺo
ꝼlaıċhıuɼ. Ꝺıꝺ ꝺo ċoıl ı ꞇalmaın amaıl aꞇa ın nım. Ꞇabaıɲ
ꝺuɲ ınꝺıu aɲ ɼaɼaꝺ laċhı. Ocuɼ loꞅ ꝺuɲ aɲ ꝼıachu amaıl
loꞅmaıcɲe ꝺıaɲ ꝼechemnaıb Ocuɼ nıɼ lꞅcea ɼınꝺ ı ɲ-amuꞅ
ɲ-ꝺoꝼulaċꞇaı. Ꮓaċꞇ ɲon ɼoꞅɲ o cech ulc. Ꮓmen ɲoɼꝼɲ.

This type, in cicero size (12 point), appears later as "Keltisch (Alt)" in the type specimen book of the State Printing House (Vienna, 1910). It also appears as a sample in Carl Faulmann's *Das Buch der Schrift* (Vienna 1880), page 196, as Alt Irisch, and also in his *Geschichte der Schift* on page 558, of the same year (see ill. 3.10). The sample in *The Bible of Every Land* incorrectly shows a large form of the lower-case s as a capital R, while Faulmann shows the lower-case s along side the capital R as if it were an alternative form of that character.

Dr Anton Durstmuller states that Alois Auer, who was appointed director of the Imperial Printing House on 24 January 1841, had a great interest in foreign printing types. He prepared a much praised Turkish type in 1844, which led to a directive from the Imperial Court to prepare a range of foreign types for the Third General Austrian Trade Fair in 1845, for which the printing house prepared 5,500 steel punches and 10,000 matrices in 60 foreign alphabets, which are reproduced in Auer's *Typenschau des gesamten Erdkreises* (Wien 1844). He states furthermore that this range of types was loaned to foreign printers, who included the publishers of the *Bible of Every Land*. The typefaces were designed, the punches cut, the matrices struck, and the type cast by the State Printing House with the co-operation of local and foreign experts.[19]

THE MOXON IRISH TYPE

BY 1639/40 WILLIAM BEDELL, bishop of Kilmore, had completed his translation of the Old Testament into Irish. Intending to have the work printed, and either unhappy with the Queen Elizabeth Irish type as it appeared in his catechism of 1631, or due to an unsufficient supply, Bedell sought to have a new type prepared. His associate and biographer, Alexander Clogie, states that at his own expense he had already done so, "the stamps being sent for to Holland"[1]. This project was interrupted by the outbreak of the rebellion in 1641 and later abandoned after his death the following year.

No further progress was made until Robert Boyle, earl of Cork, became involved over thirty years later. Boyle's keenness to propagate knowledge of the Scriptures (the 1602 New Testament in Irish was out of print) is evident from a letter written by Boyle's secretary, Robin Bacon, in August 1675, which indicates the things that he considered "are fit to be done in the Kingdom of Ireland . . .", which included as the fourth item, "That the Bible and Common Prayer Book be translated into Irish and printed in the vulgar character."[2] For this Boyle engaged the assistance of Andrew Sall. A former Jesuit and professor of divinity at the Irish College in Salamanca, Sall had joined the Reformed Church and was chaplain to the Lord Deputy.[3] He was a keen Irish scholar and a Gaelic speaker, which made him well suited to assist Boyle in this matter. In a letter to Boyle of 17 December 1678 he agreed to help, and further correspondence between Boyle and Sall clearly indicates that Sall committed himself fully to the task of preparing various religious texts for print in Irish.

When Boyle sought the Queen Elizabeth type for the printing of his catechism, he discovered that this Irish fount was no longer available. The bishop of Meath, Henry Jones, in a letter to Boyle implies mistakenly that the Jesuits were responsible for its disappearance.[4]

Whatever the fate of the Queen Elizabeth type, a replacement was needed. Consequently Boyle had a new fount of Irish type cast. He refers to this fount himself as "the letters I caused to be cast",[5] concerning which he explains: "all the designe I had in having them cut off was that they might be in a readiness to print useful books in Irish."[6] He recalls this event later in another letter: "I caused a font of Irish letter to be cast, and the book to be here re-printed."[7] In the preface to the *Tiomna Nuadh* printed in 1681 Sall writes:

God has raised up the generous spirit of Robert Boyle Esq., son of the Right Honourable Richard, earl of Cork, lord high treasurer of Ireland, renowned for his piety and learning, who hath caused the same Book of the New Testament to be reprinted at his proper cost; And as well for that purpose, as for printing the Old Testament, and what other pious books shall be thought convenient to be published in the Irish tongue, has caused a new set of fair Irish characters to be cast in London, and an able printer to be instructed in the way of printing this language.[8]

This type was modelled on the Louvain A type of the Irish Franciscans, and the designs were most likely supplied by Sall, who was familiar with the various printing efforts in Irish on the continent, for in addition to assisting in the translation work Sall was involved in certain typographic considerations. Apparently he preferred the use of existing italic type for printing Irish, as is evident from his letter to Boyle written two years before the new type was cast:

I leave to your own better judgement to consider, whether it may be convenient to face the *Latin* or the *English* with the *Irish*, in two columns of the same page, and the *Irish* to be put in *Italic* character (as was done in a catechism I saw by *Stapleton* a *Romanist*) which may be a means of learning the *Irish* by *Latin* or *English*, for those of the College and others. The change of characters is but the same done by our ancestors of the *Saxon* character (which is the same with the *Irish*) to that brought in by their conquerors and civiler times: well may the *Irish* bear the like.[9]

The manufacture of this new type was undertaken by Joseph Moxon, author of *Mechanick Exercises on the Whole Art of Printing*, who produced a set of characters which contained 60 punches of small pica.[10] Edward Rowe Mores in his *Dissertation* states that "The Hibernian was cut in England by Mr Moxon for the edition of Bp. Bedel's translation of the Old Testament in 1685, the only type of that language we ever saw. . . . The punches and matrices have ever since continued in England. The Irish themselves have no letter of this face, but are supplied with it by us from England, though it has been said, but falsely, that the University of Louvain have lately procured a fount to be cut for the use of the Irish Seminary there."[11]

Individually each character of Moxon bears a striking resemblance to its counterpart in the Louvain type (see ill. 4.1). It is an interesting feature of typeface identification that the capital letters tend to be examined in particular for their distinguishing characteristics, yet the true measure of a given type is its appearance in a page of setting, and in this the lower case letters predominate and control the visual impression (see ill. 4.2).

In this regard the Moxon Irish type has a more uniform x height to the body of its lower case letter than the Louvain model, resulting in a more

2lbcoefɜhɪl2ɲNOpRStu

ɑbcoefɟɡhɪlmnopɲrtu

2lbcoefɜhɪl2ɲNOpRStu

ɑbcoefɡhɪlmnɲopɲrtu

even appearance to each line of setting. This evenness is further achieved by the more perpendicular angle of its strokes, as in the lower case i, and in the s and r whose descenders are less conspicuous than their counterparts in the Louvain. Indeed, superficially, the Louvain type seems a compatible italic for the Moxon.

The Moxon Irish type was used for the first time in a catechism, *An Teagasg Criosduighe*, a 14-page booklet, printed by Robert Everingham in 1680 (see ill. 4.3). It was used the following year for the second edition of William Ó Domhnuill's translation of the New Testament (see ill. 4.4) and in 1685 for Bedell's first edition of the Old Testament in Irish (see ill. 4.5). After this, Moxon's type became the standard Irish type for books printed in Ireland or England for well over a century. It makes another brief early appearance which has gone unrecorded, in Richard Parr's *Life of James Usher*, printed at the King's Arms, St Paul's Church Yard, in 1686, where it is used to print the word "Corcerr" in the publication of a letter from Dr Gerard Langbaine, who says apropos of two borrowed manuscript items: "what character the ancient *Britains* used, whether that which the *Saxons* after, as your Lordship (if I remember well) is of opinion, or the same with your ancient *Irish* (which I conceive to be not much different from the *Saxon*, and to which this Monument of *Corcerr* [in Moxon type], &c. both as to the form of some letters, and the Ligatures of them, seem to come nearer than to the Saxon)."[12]

In a 1706 list of the matrices in the foundry of Mr Robert Andrews published in Mores' *Dissertation*, the Moxon type is recorded as an "Hibernian

4.1 The Louvain A type of 1611, above, and the Moxon type of 1680, below, enlarged to 270% approx.

an dara leabhar na riogh, da ngoirthear go coitcheann, an ceathram-hadh leabhar na riogh.

caib. 1.

croioy tú teʃa ofiafruiʒ do bhaal-rebub dia Ccron? ar a naobaryin ni tiucfa tú a nuay ar an lebrō-yin ar a nogcaio tú ruay, ar do ʒeba tú báy go deimin.

Nyin do cuaio Móab a gco-gao a nagaio Iyrael, * tar éiy báiy Ahab.

2. Aguy do tuit Ahayiah yioy tre laitiy a reompla uaʃanac do bi a Samária, aguy do bí ʃé tiñ, aguy do cuir teʃa uao, aguy a dubʒt riu, éirigioe, fiafruiʒio do bhaal-rebub dia Ccron an ttiucfa mé ón ttiñioy yo.

2. Af a dubʒt aingel an Tiʒ-enna re Heliay an Tiybitʒech, éirig, imtiʒ ruay do teʒmáil re teʃaib Riʒ Samária, aguy abʒ riu, an do cioñ nac bfuil Dia añ Iyrael atáḋáoire aʒ dul ofiafruiʒ yʒéul do bhaal-rebub dia Ccron?

4. Anoiy ar a naobaryin iy mayyo a deiy an Tiʒenna; ni tiucfa tú a nuay ar an lebrō yin ar a nogċrō tú ruay, ar do ʒeba tú báy go deimin. Aguy dimtiʒ Cliay.

5. Aguy a nuáir ofilleodar na teʃa ar a naiy cnʒe, a dubʒt ré riu, cned fán filleʒbʒ an buy naiy?

6. Aguy a dubyadaryan riy, táinic oyne ruay an ccoiñe, aguy a dubʒt ré riñ, imtiʒio, eirgio a riy cum an Riʒ ó ttangabʒ, aguy abirrō riy, iy mayyo a deiy an Tiʒenna, an do cioñ nac bfuil Dia añ Iyrael

7. Aguy a dubʒt reiyion! riu, cred an gné oyne an té yin táinic ruay buy ccoiñe, aguy oiniy na briáṫyaya oib?

8. Aguy do fregradoaryan é, oyne fionaoṁac, aguy crioyluiʒ le cyioy leʒ́ timcioll a cáoil. Aguy a dubʒt y eiyion, iyé Cliay an Tiybitʒe é.

9. Añ yin do cuir an Riʒ cnʒe, caiptin cáogaio maille re na cáo-gao: aguy do cuaio ʃé ruay cnʒe, (aguy féuc, do bi yeiyion na ʃnʒe ar mullac cnrc) aguy do labʒ ʃé riy, tuya a óglaic Dé, dubʒt an Riʒ riot teʃ a nuay.

10. Aguy do fregʒ Cliay, aguy a dubʒt re caiptin an cáogʒo, may óglac do Dhia miyi, añyin tiʒeoh teine a nuay ó neim, aguy loiyʒeo ri tuya, aguy do cáogao. Aguy táinic teine a nuay ó neim, aguy do loiyʒ ri eiyion, aguy a cáogao.

11. Al riy may an gcedna do cuir an [Riʒ] cnʒe caiptin oile ʒ cáo-gao maille re na cáogao: aguy do freʒʒ yeiyion é, aguy a dubʒt riy, a óglaic Dé, iy mayyo a deiy an Riʒ, tárr a nuay go tayrō.

12. Aguy do fregʒ Cliay, aguy a dubʒt riu, may óglac do Dhia miyi,

4.3 Title page of *An Teagasg Criosduighe*, 1680, the first work to use the Moxon Irish type.

pica". Andrews succeeded Moxon about the year 1683 and the greater part of his foundry was made up of Moxon's equipment.[13] When this foundry was purchased by Thomas James in 1733 he acquired "not only a large number of Roman and Italics, but also several Oriental and curious founts (some of which had formed the foundry of Moxon)".[14] James died about 1736 and the business was continued by his son John. An advertisement announcing this change of management states that John James "casts all other sorts from the largest to the smallest size. Also the Saxon, Greek, Hebrew, and all the Oriental types, of various sizes."[15] Oddly there was no mention of the Irish type in this advertisement. Mores lists the matrices of the learned languages in the foundry of Mr James in 1767 as including the "Hibernian pica".[16]

At John James's death in 1772 his foundry passed by purchase into the hands of Mores, who found himself the owner of a confused mass of matrices, many of them unjustified and others imperfect. These he began to catalogue and arrange in order. He detailed this effort in his *Dissertation*

4.2 Example of the Moxon Irish type, from *Leabhuir na Seintiomna* (Old Testament), 1685.

TIOMNA NUADH

AR

OTIGHEARNA

Aguy an

SLANUIGHEORA

Iora Chioro

Ar na tairrng go fiminedc ar Greigis go goideilg.

RE

huilliam o domhnuill.

A LUNNDUIN,

Ar na cur a gcló ré Robert Ebheringeam, an bliadain dóir an
Tigerna, 1681

4.4 Title page of *Tiomna Nuadh* (New Testament), 1681, translated by William Ó Domhnuill.

LEABHUIR

na

Seintiomna

ar na

ττaιιριτης go ξaιδlις τρe cúραm ⁊ δúτρας an δοccúιρ

UILLIAM BEDEL,

Roiṁe ro Carbug Chille móιre a Néιrιñ,

2lgur anoιr aρ na ccuρ a ccló ċum maιċιor ρɲliḃhe ña Tιρeɲιñ.

The BOOKS of the

OLD TESTAMENT

Tranſlated into IRISH by the Care and Diligence of

Doctor WILLIAM BEDEL,

Late Biſhop of *Kilmore* in IRELAND,

AND,

For the publick good of that Nation,

Printed at *London*, Anno Dom. MDCLXXXV.

4.5 Title page of *Leabhuir na Seintiomna* (Old Testament), 1685, translated by William Bedell.

in which he hoped "to preserve the memory of this foundry".[17] Mores, unfortunately, did not live to see the publication of the *Dissertation*. He died in 1778 and four years later the foundry was put up to auction. The auction catalogue[18] lists the punches for an Hibernian pica from the Moxon and Andrews foundries. Item 338 of the fourth day's sale was "punches for Pica Hibernian", described as "very good punches". Talbot Baines Reed notes that "Though the matrices of this fount do not appear in the catalogue, they were evidently in James's foundry, as they are mentioned in the list drawn up by James in 1767 and are not specified among the matrices lost."[19]

The list of lost matrices, however, does include three founts of Saxon. Since it is a distinct possibility that the Irish may have been mixed up with the Saxon, it is likely that some of the Irish matrices suffered the same fate. Reed continues: "[the matrices] were acquired at the sale by Dr Fry and may have been included with the Saxons or with the imperfect lots."[20] Reed specifically states that "the matrices were in a somewhat defective condition". However, Carter-Ricks in their foreword to the specimen in Mores's *Dissertation* state that "The omission of Moxon's Irish, there being, for some reason, no matrices, is not serious, because the punches survive."[21]

The condition of these punches at the sale is of interest, for about this time the face takes on a new appearance which has gone unrecorded. A sample of the Irish type in the 1794 and 1795 Fry specimen books demonstrates a significant change from the Moxon of earlier use. A similar, but not identical, specimen of this type, in *Pantographia* by Edmund Fry (1799), carries the caption, "This letter was cast at the Letter Foundry in Type Street."[22] That the Irish type did not appear in any of Fry's specimen books until 1794 (many of which included samples of their other foreign faces), together with the fact that Fry had moved to a new bigger plant in Type Street in 1788, would indicate that between 1788 and 1794 (most likely just shortly before 1794), work was done on completing the Moxon matrices and casting a new fount of type.

Pantographia, which displays upwards of 200 alphabets, many of which were cut especially for this publication by Fry, may have provided the incentive to sort out the Moxon punches purchased at the Mores auction. In 1887, an interesting three-line sample of the Fry/Moxon type appeared in *Reed's History of Old English Letter Foundries* with the caption "Moxon's Irish fount, [f]rom the original punches"[23]; while the same sample, in the later edition of this work, is described by Johnson as "Moxon's Irish. From the original matrices"[24] (see ill. 4.6).

The changes which occurred between 1788 and 1794 led some observers to identify this "new look Moxon" as the Graisberry type. This type was much used in Ireland from 1814 onwards and took its name from the printer Graisberry who was most associated with its use. Séamus Ó Casaide (who

4.6 Range of text samples showing variations of the Fry-Moxon Irish type.

SMALL PICA HIBERNIAN.

Ⱥꞃ natꞇ ata aꞃ neam, Naomtaꞃ hainm: Tiᵹeaꝺ ꝺo ꞃioᵹaꞃ: Ꝺeuntaꞃ ꝺo toil aꞃ an ttalam, maꞃat ꝺo niteꞃ aꞃ neam. Ꝺꞃ naꞃan labtamail tabaiꞃꝺ ꝺꞃꞃ a niu. Ꝺᵹuꞃ mait ꝺuin aꞃ bꞃiaca, maꞃ mi maitmione ꝺaꞃ bꞃeiteamnꞃb ꝼein. Ꝺᵹuꞃ na leiᵹe ꞃin a ccatuᵹaꝺ, Ꝺꞃ ꞃaoꞃ in o olc. Oiꞃ iꞃ lea ꝼein an ꞃioᵹaꞃ, aᵹuꞃ an cumaꞃ, aᵹuꞃ an ᵹloiꞃ ᵹo ꞃioꞃꞃiᵹe. Ꝺmen. Ꝺꞃ natꞇ ata neam, Naomi

Ꝺꞃ natꞇ ata aꞃ neam, Naomtaꞃ hainm: Tiᵹeaꝺ ꝺo ꞃioᵹaꞃ· Ꝺeuntaꞃ ꝺo toil aꞃ an ttalam, maꞃae ꝺo niteꞃ aꞃ neam. Ꝺꞃ naꞃan labtamail tabaiꞃꝺ ꝺꞃꞃ a niu. Ꝺᵹuꞃ mait ꝺuin aꞃ bꞃiaca, maꞃ mi maitmione ꝺaꞃ bꞃeiteamnꞃb ꝼein. Ꝺᵹuꞃ na leiᵹt

HIBERNIAN.

Ciꝺh bē ꝺuine cuiꞃeaꞃ ꞃoꞃme Seancuꞃ no ꞃꞃnnꞃꞃꝺáct cꞃꞃce ꞃan mbꞃt ꝺo llnmaiꞃn no ꝺo loꞃᵹaꞃꞃlet, iꞃ lò ꝺꞃ ꞃᵹly cꞃnnlꝺ aꞃꞃ an ꞃlꞃᵹe iꞃ ꞃoléꞃꞃe noctaꞃ ꝼꞃꞃꞃꞃe ꞃtaꞃꝺe na cꞃꞃce, ꞇ léꞃꞃ ꞃꞃoꞃ; aᵹ ꝺo ꝺénam aᵹaꞃ cuꞃꝺ ꝺa ꞃltꞃao

Ꝺꞃ ttúꞃ ꝺo cꞃútaiꝺ Ꝺꞃa ngꞃm aᵹuꞃ talam.· Ꝺꞃ ꝺo bꞃ an talam ᵹan cumaꝺ, aᵹuꞃ ꝼolam; aᵹuꞃ ꝺo ꝺoꞃcaꝺuꞃ ꞽ aᵹaꞃꝺ a naiᵹéꞃn. Ꝺé ꞽ aᵹaꞃꝺ na nꞃꞃ

Ꝺꞃ ttúꞃ ꝺo cꞃútaiꝺ Ꝺꞃa ngꞃm aᵹuꞃ talam. Ꝺꞃ ꝺo bꞃ an talam ᵹan cumaꝺ, aᵹuꞃ ꝼolam; aᵹuꞃ ꝺo ꝺoꞃcaꝺuꞃ ꞽ aᵹaꞃꝺ a naiᵹéꞃn. Ꝺé ꞽ aᵹaꞃꝺ na nꞃꞃ

45. Moxon's Irish fount, rom the original punches.

Ꝺꞃ ttúꞃ ꝺo cꞃútaiꝺ Ꝺꞃa ngꞃm aᵹuꞃ talam. Ꝺꞃ ꝺo bꞃ an talam ᵹan cumaꝺ, aᵹuꞃ ꝼolam; aᵹuꞃ ꝺo ꝺoꞃcaꝺuꞃ ꞽ aᵹaꞃꝺ a naiᵹéꞃn. Ꝺé ꞽ aᵹaꞃꝺ na nꞃꞃ

FIG. 38. Moxon's Irish. **From the original matrices.**

4.7 The Moxon Irish type (above), and the revised Fry-Moxon type (below), enlarged to 270% approx.

together with E. R. McC. Dix compiled the *List of Books, Pamphlets, etc., printed wholly, or partly, in Irish from the earliest period to 1820*), writing in the *Irish Book Lover* about the first edition of the poem *Crioch Deigheanach don Duine*, states that it "was printed (by Graisberry?) in Dublin (without any printer or publisher's name) in 1818, with the Graisberry Irish type, which appears to have escaped Lynam's notice",[25] this being the same type that Reed stated had come from Moxon's original punches.

This confusion is quite understandable and raises the question as to whether or not a typeface having undergone such change should retain the same name as before. Being clearly derived from the Moxon type, however, it is perhaps appropriate that this variation be called the Fry/Moxon type rather than the Graisberry type as suggested by Ó Casaide.

Close examination of the Moxon Irish punches that remain in the archives of the Stephenson Blake foundry in Sheffield helps to confirm that later additions or corrections to the originals were indeed made (see ill. 4.7 and 4.8). In all, 32 punches remain which are contained in a box, the label on which states: "Moxon's Irish/Old Punches/Boyle's New Test 1681." It is of interest that in this the word "old" is crossed out, as if to reflect the fact that some new punches were added. Of these punches, 13 capitals, 6 lower-case, and 2 ligatures from the original set remain, all of which show clear signs of having been cut on similar steel shafts. In addition there are 5 capital and 6 lower-case punches of the Fry/Moxon type. Of these, the

4.8 The surviving punches of the Moxon type, showing the original punches of 1680 (above), and the revised Fry/Moxon punches (below). The impressions are taken directly from each punch.

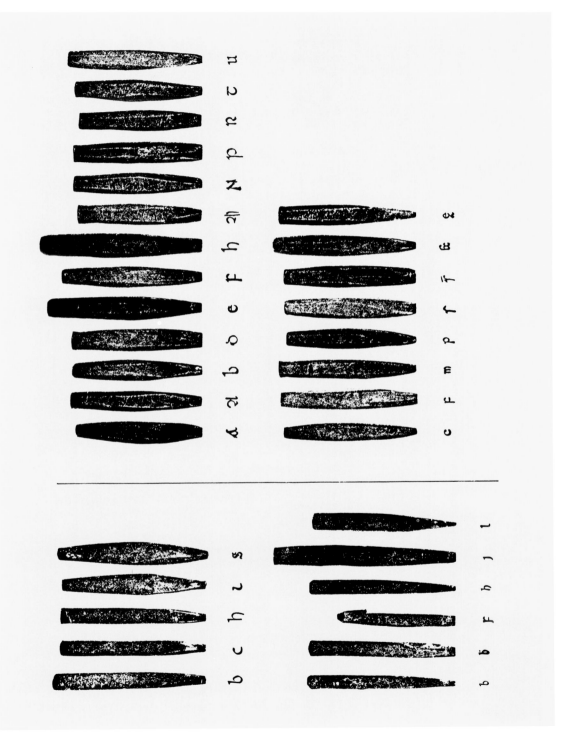

Seanṗaiṫe.

ṙin nj cojżeola ṙe a lo an
ḃjoġaltajṙ.
35 Nj ḃjaḃ ṙiṁ ajże a
ḃṙrayżlaḃ aṙ ḃjt: nj mó
ḃjoṙ ṙe ṙjaṅta ḃá mḃejt żo
ttjṙbaṅta jomaḃ ḃṙontaḃo.

Caḃ. VII.

Aṁjc cojṁéaḃ mo ḃṙjaṫṙa,
ażṙy crjn majteanta a
ttajṙżjḃ ażaḃ ṗéjn.
2 Cojṁéaḃ majteanta,
ażṙy bj béo; ażṙy mo ḃljż-
eaḃ maṙ rḃall ḃo ṙrl.
3 Ceanżajl jaḃ aṙ ḃo
ṁérṙjḃ, ṙṙnjoḃ jaḃ aṙ
cláṙ ḃo cṙojḃe.
4 Aḃajṙ ṙjṙ a neażna,
jṙ tr mo ḃejṅḃṙjṙṙ, ażṙy
żojṙ ḃo bean żaojl ḃon tṙ-
jżre.
5 Choṙ żo ccojṁeaḃṙjḃ
tr ajṙ an mnaoj cojṁjżjḃ,
ajṙ an ccojṁtjżeaċ ṙrple-
aḃṙjżjoṙ lé na ḃṙjatṙajḃ.
6 Ojṙ a ḃṙṙjnneojż mo
tjże ḃṙérċ mé amaċ tṙe
mo cáṙmajnt.
7 Ażṙy ḃo connajṙc mé
a meaṙc na nḃaojne ṙjm-
pljże: tṙż mé ḃom ajṙe a
meaṙż na nożánaċ, ożan
żan tṙjżrj.
8 Až jmteaċt tṙjḃ an
tṙṙájḃ lajṁ ṙe na cojṙné-
rlṙa, ażṙy ḃjmtjż ṙe an
tṙljżċ crm a tjże.

PROVERBS.

will not spare in the day of
vengeance.
35 He will not regard
any ransom; neither will he
rest content, though thou
givest many gifts.

CHAP. VII.

MY son, keep my words,
and lay up my command-
ments with thee.
2 Keep my command-
ments, and live; and my
law as the apple of thine
eye.
3 Bind them upon thy
fingers, write them upon
the table of thine heart.
4 Say unto wisdom,
Thou *art* my sister; and
call understanding *thy* kins-
woman:
5 That they may keep
thee from the strange wo-
men, from the stranger
which flattereth with her
words.
6 ¶ For at the window of
my house I looked through
my casement,
7 And beheld among the
simple ones, I discerned
among the youths, a young
man void of understanding,
8 Passing through the
street near her corner; and
he went the way to her
house.

4.9 The Fry/Moxon type from *The Proverbs of Solomon*, 1815.

capitals L and S, which are clearly new sorts, are cut on similar steel shafts to the originals,[26] while the remaining new sorts are cut on steel shafts composed and shaped differently from the originals. Also in these archives is a set of matrices for the Moxon Irish type mixed in with those of the later Fry Irish type (*c*.1819). The Moxon matrices, which were struck from both the original and the later punches, appear to have been made at the

same time, for they are all consistent in their outward appearance, with a distinctive notch at the end of each matrix. This would seem to confirm that a complete set of matrices was struck about 1788–94, perhaps in preparation for *Pantographia,* and probably the matrices referred to by Reed in a letter to Blades in which he says, "I have put a paper mark in the 1795 spec. where the Hibernian type is shown which was cut by Moxon for Bedel's Old Test. 1685. We have the matrices here."[27] James Mosley states in this connexion: "Now Reed does indeed say that Fry bought 'punches and matrices' for Moxon's Irish in 1782, but I think this must have been a slip on his part: no matrices are listed in the sale catalogue, which is no doubt why it is not shown in the specimen."[28]

Of the eighteen capital letters nine (A, B, C, G, H, I, L, O and S) would appear to have had new punches cut, eight (D, E, F, N, P, R, T and U) would appear to have had new matrices struck from original punches, with M having been supplied from the Saxon fount acquired by Fry with the Moxon Irish. Of the lower-case letters eight (b, c, f, h, i, l, n and o) seem to have had new punches cut, five (a, m, p, r and s) were either cast from original matrices or had new matrices struck from original punches, while five (d, e, g, t and u) were supplied from the Saxon fount. It is interesting to note that of the nine new capitals, four show some signs of influence from either the Paris or the Parker Irish types (to be discussed later).

Possibly the last use to which the uncontaminated fount was put was in Edward O'Reilly's *Grammar* of 1821. Apart from its appearance in specimen books, the Fry/Moxon type made its initial appearance in *An English Irish Dictionary,* printed in Dublin by Graisberry and Campbell in 1814, and it continued to be used in Dublin, particularly by Graisberry (see ill. 4.9), and also in London, as in *An Essay on the Antiquities of the Irish Language,* 3rd ed. by Charles Vallancey, and printed by Brettell, at Haymarket, London in 1818. It appears as late as 1841 when it was used in the first volume of the *Proceedings of the Royal Irish Academy,* printed by Graisberry. It is interesting that in many of the books in which the Fry/Moxon type was used, it is accompanied by the Parker Irish type as a display face (which, as has been noted, was a possible of influence on some of the revised letters).

THE PARIS AND PARKER TYPES

THE IRISH ABROAD continued to play a significant role in the development of printing in the Irish character, and in the early part of the eighteenth century it was the turn of the community of the Irish College in Paris. In 1732 *The English Irish Dictionary* compiled by Conor O'Begly was printed in Paris by Jacques Guérin (see ill. 5.1), using a new Irish type which shows a major departure in style from all of the preceding typefaces. In the introduction it is indicated that O'Begly provided the new Irish type: "Do dhail glanchlodh Gaoidheilge" (a clear Irish type was provided). It has been suggested that O'Begly provided his own handwriting as a sample for style. O'Begly states in his preface that he "familiarized the Irish characters to those of the English as much as I durst without departing from the form of them; so that I hope the perusal of this book will afford no harsh or unpleasant amusement" (see ill. 5.2). He continues with a reference to the printer: "As to the errors of the press I must beg the indulgence of my reader, and desire him to make some allowances for escapes of such a nature; especially in a work under the hands of a printer equally ignorant both of the English and the Irish."

The *Dictionary* was published at a time of great strife in the Irish College in Paris, which had much to do with its severe shortage of funds and with differences over finances between the clergy and the clerical students resident in the college. This in turn had some bearing on the use of the Irish language in the establishment, for those supporting the priests involved claimed that "many students who came to Paris before ordination were attracted into the Irish Brigade, while others joined the medical profession or became merchants. Moreover, as the younger men had to spend a long period in France, it was not unusual for them to lose all fluency in the Irish language when they had acquired a good grasp of French. This made them less inclined to return to Ireland."[1]

In his catalogue of the archives of the college, Liam Swords points out that in 1736 "Joseph Perrotin . . . remitted the sum necessary to acquire a contract for 12,000 L. giving 300 l. annual *rente* to be employed as follows: Conditions 1. to establish a school in the college for the teaching of the Irish language to the students of the other sciences who do not know how to read or write it and to print from time to time catechisms and other little works of piety in Irish, which will be given free to the students and eccle-

5.1 Title page of O'Begly's *English-Irish Dictionary*, 1732.

64

THE

ENGLISH IRISH

DICTIONARY.

An Focloir

bearla Gaoidheilge.

ar na

chur a meataр

Le Concobar O beaзlaoic mar aon le conзnaṁ
Aoḋ buiḋe mac Cuirtin aзur fór.

A bParis;

Ar na curp acclod le Seamus Guerin, an bliadain dlois an
tiaзrna.

M. DCC. XXXII.

Le hlonta an Riji.

Uajrle éjpeañ ájle. a cpú na ccejmeañ ccombájbe ;
 tréjxjò bṙp ttpomṙuan Jan on. Céjmjò lómluaò bṙp leabap,
Tṙóm an téjòmṙe táplajò òḟojḃ. jojn ṁnájḃ aʒaṙ ṁacḃojṁ,
 Aṙ ṙéanaò ṙeanpáò bṙp ṙean. Compáò ṙolṙṙ bṙp ṙjṁṙeaṙ.
Njoṙ òealb an òoṁan ṙjle. Teanʒaò jṙ mjllṙe móṙjṙvjle
 Do bṙjatṙajḃ jṙ bṙjoṙṙṁṙte blaṙ. Cajnt jṙ cjajntjlte cṙntṙṙ.
Ma tṙájʒteaṙ tjobṙṙjo an ḟjṙ. Leabajṙ uama jṙ jṙjṙ
 ṙalaċ bṙp ṙʒéal nj ṙjṙjoṙ Jañ. Jan ṙjoṙ bṙp ccéjmeañ ccomtpom.
Na òṙéaċta Dṙuaò njoṙ léjʒ bṙat. Aṙ ʒéjʒ òap Jejneaò pomat,
 ṙʒjò maṙḃ aṙ nuajṙle ā njoʒ. òáṙ nʒuajṙne njoṙ òájl òejṙjoò.
Jṙò cjan cajtṙéjm ċlajñe cṙṁ. Séan ṙleaṙa Ojljll ólṙm
 Jan béjṙ le buaò ʒaċ bjle. Tájo le luaò ṙʒaċ léjṙljṙe. ·
ṙjoṙ ʒaċ ṙjajlḃjle ṙoṙajʒ. Sʒaċ tṙjajċṙne tṙojṁteaʒlajʒ.
 ṙuajṙ clṙ le cajtṙéjm ʒo mbuaò. ba ṙjṙ a majṁṙéjṙ móṙluaò.
Anojṙ cjò leṙn na lṙjʒe. Claña ṙjoʒa Rṙjʒṙjòe
 Móṙ leabajṙ ljonta òā ttṙeojṙ. Meabajṙ a bṙjonta ṙa bṙleaòojl.
Claña·nejll na nʒejṁjol nʒlaṙ. Don ṙéjñ ba ṙlojṙe ṙeancaṙ,
 Lḃojċ ṙṙa ba tṙéjṙe tejṙò. ba tṙom tṙéjòe aʒṙṙ tuajṙjṙʒ.
An cjñeaṁṙn ċlḃon oo ṙaò. Aṙʒéala òḃoṙ aṙ òeaṙṙṙo,
 . Na tṙéjṙṙjṙ ba teañ attṙojò. Cjṙe ṙan aṁṙo a naṁbṙojò.
Nj ljñe naċ tṙuajʒ an tlāṙ. Anojṙ ʒo nuajò a neaṁċáṙ
 Clañ bṙjoʒṁaṙ bṙjajṙ mac Caċaċ. An eanʒ ljonṁaṙ lájṙbṙeataċ.
Sljoʒ laoʒajṙe lṙṙe an ajʒ. A ṙeancaṙ cjan aṙ conʒbájl ,
 Aecáta, āʒcoʒta aò ċloṙ. ó ṙʒolta ṙṙoṁta ṙuajṙṙṙ.
Sljoʒ Moòa nuaòatt na neaċ. óṙ cjn móṙċṙan na Mṙṁṁneaċ
 Jan cṙṁṙne oṙṙa jaṙ néaʒ. Oṙéṙa bṙṙ cjan Jan cojṁéaò.
Ajtéjṙ ṙóṙ na Jajll ʒlana. le bṙṙjt ṙjoṙ ʒaċ ṙoʒlṙma
 Soo ṙṙajṙ ṙéjṙ le ṙṙṁ ājʒé. òṙṁ aʒcṙṁ ṙa ccombájbe.

siastics who return to Ireland, for distribution among those who instruct the young."[2]

This type, which shows little influence from any of the preceding styles, was supplied by the typefoundry of Loyson in Paris. It appears in the type specimen book of Loyson and Briquet in 1751[3] (see ill. 5.3). Briquet had started a foundry in 1720, which, when he died, passed on to his widow, who married Monsieur Loyson, a partner in the firm. In 1728 Loyson issued a type specimen which does not contain any reference to the Irish type. Madame Loyson's son by her first marriage joined his stepfather, and together they brought out a type specimen in 1751, *Epreuve des Caractères de la Fonderie de Loyson & Briquet*. After Loyson's death, Briquet continued the foundry alone, producing in 1757 a further specimen, *Epreuve des Caractères de la Fonderie de Briquet*. Both specimens contain a sample of the Paris Irish type and a note to the reader which states (in translation): "As for the other types which have been bought in Holland, seeing them is enough to judge as to their merit." The fact that the Irish type was included among these "other types" suggests that, sometime between 1728 and 1732, Loyson purchased the punches and/or matrices of this type in Holland and cast founts as required by Guérin.

Fournier makes further comment regarding this foundry in his *Manuel Typographique*: "Another foundry, inferior, it is true, to that which I have just mentioned, but which nevertheless is not devoid of merit, was begun by M. Loyson about 1727. He had married a widow, Mme Briquet, who brought him in marriage a very small foundry, which he increased by some types which he purchased from various sources, and by others which he caused to be cut. He made it over to M. Briquet, his stepson, and the latter sold it in 1758 to M. Cappon, letter-founder."[4]

After O'Begly's *Dictionary*, the Paris Irish type was next used in *The*

5.2 Example of text showing the Paris Irish type from O'Begly's *English-Irish Dictionary*, 1732.

5.3 Sample of the Paris Irish type from the specimen book of Loyson-Briquet, 1751.

67

Catechism or Christian Doctrine by way of Question and Answer, by Andrew Donlevy (1742), printed also by Guérin (see ill. 5.4). In his introduction to the catechism, Donlevy states: "It is the great scarcity of those large *Irish Catechisms*, published upwards of an hundred years ago, by the laborious and learned *Franciscans of Louvain*; and the consideration of those great evils, which arise from ignorance, partly for want of instructive books; together with a great desire of contributing to the instruction of the poor *Irish* youth; that gave birth to the following *Irish Catechism*." And later, regarding the printer Guérin, he echoes O'Begly's note of explanation: "An absence of upwards of 31 years from one's native country, and the profound ignorance of the printer, who understood not one word of either language, will be sufficient apology, for the faults of both the languages, and the press." He pays tribute to the above-mentioned Perrotin by asking prayers for "a very worthy gentleman, Philip-Joseph Perrot, lord of the manor of Barmon, and other territories, knight of the Royal Order of S. Michael &c. who, of a long time, is well affected to the *Irish* nation; and has often given proofs of his affection to several of them: And without whose concurrence, this little work would never come to light."

Donlevy makes an interesting comment regarding the Paris Irish type: "to such as have no better, nor much time to spare: They will likewise see, that the print is large, and much waste occasioned, through the necessity of placing the questions and answers, of both languages, directly opposite to each other; and that some paper is taken up by quotations from Scripture."[5]

These two titles are the only works known to have been printed with this Irish type. However, it does feature in Fournier's *Manuel Typographique* in 1766 with a sample passage of text on page 150, and showing the alphabet on page 196 (see ill. 5.5). Regarding the specimens in the *Manuel* Fournier states: "Here I must express my obligations to a number of my professional brethren, Messrs Breitkopf at Leipzig, Herissant, Cappon, and my elder brother at Paris, who have been good enough to lend me some types from their foundries to make this collection more complete and worthier to be presented to the public." A footnote states that "F. G. I. Breitkopf, at Fournier's request, sent the forms for the pages of flemish, fraktur, schwabacher, german script [pp. 145–148 of vol. 2 of the *Manuel*], samaritan, syriac, arabic, coptic, armenian, and ethiopian [pp. 157–162]".[6]

The above-mentioned Vincent Cappon had been a student of Loyson and bought the stock of that foundry in 1758, which would have included the Irish type. Hence it is most likely that it was through Cappon that Fournier acquired the type for the Irish sample in his *Manuel*. Marius Audin records that Cappon's foundry passed to Pierre Louis Wafflard.[7] Jean Lottin also states that Wafflard acquired the foundry of Cappon in 1785;[8] D.B. Updike suggests that the Cappon foundry was carried on by his widow

An

TEATAST

CRíosDUjÐe

DO RÉjR

CEASDA ATUS FREATARTA,

ajn na tappvinz to brnvÐatac ar

bRÉjTjR hSOjLLÉjR Ðé,

atrr

AS TOjbREACAjb FjORT-LANA OjLe.

Éjro ne Comajnle , atrr tlac Teatjrt, crm
to mbja tr tlje ann vo Chpjc Ðéjtjonvjt.
Prov. 19. 20.

A bPAjRjS,

Ljr na cvp a tClóv ne Sevmvr TUeRN , at
San-Tomar ó Acvn, a Snajv Sajn-Serm.

M. D. CC. XLII.
Ré Cenv an Rjt, atrr ne Ðéjtten na
nOllamrn ne Djatact.

5.4 Title page from Donlevy's *An Teagasg Críosduide*, 1742.

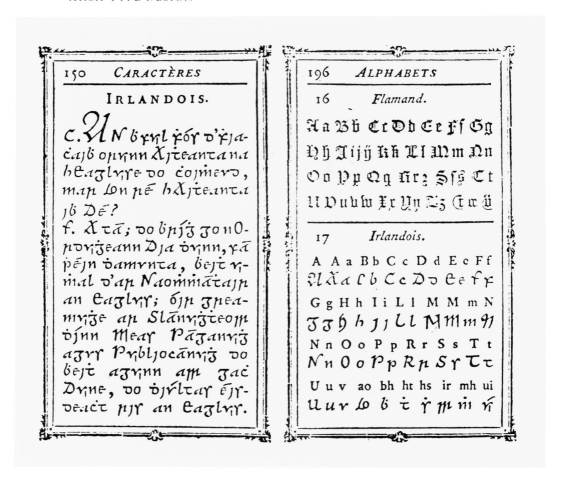

5.5 The Paris Irish
type from *Manuel
Typographique*, by
Fournier *le jeune*,
1766.

after his death in 1783 and that "it ultimately became part of the stock of the distinguished Parisian printer, Pierres."[9]

There is no reference to the Irish type in the undated specimen produced by Vincent Cappon, nor does it appear in that of M. Pierres, *Caractères de l'Imprimerie de M. Pierres, Imprimeur Ordinaire du Roi* (Paris, 1785). It is not clear what became of Pierres' stock after his death in 1788. Updike suggests that "this collection later went to the printer Pasteur."[10] However, Pasteur's *Epreuves des Divers Caractères, Vignettes et Ornements de la Founderie de J. A. Pasteur* (Paris, 1823), a copy of which is held in the library of Columbia University, New York, contains no reference to the Irish type.

A typeface influenced in a major way by the Paris type and generally referred to as the Brooke and sometimes as the Bonham type (see ill. 5.6) was produced in Dublin in 1787, and as such is the first Irish fount known to have been cut and cast in Ireland.

Bradshaw referred to it, albeit rather briefly, in answer to a suggestion by Reed: "I think you mean the Trans. of the Gaelic Society (Dublin, 1808, 8°), which has the large type in question . . . now, on looking at E. O'C's [Haliday's] Irish Grammar, printed at Dublin in 1808 by Barlow, I notice two founts, one much larger than the other. . . . the larger one bears some distant resemblances to the Paris Fournier type; but any comparison shows that the letters are wholly different, though memory might lead one to identify them. I have them both before me at this moment (E. O'C. and Donlevy), so there is no doubt. To have found some one who will aid in carrying the matter back beyond the printers to the letter-founders is an advance which I hardly expected to live to see."[11] Not alone did Bradshaw notice this type, but in the above statement he was one of the few to comment on its similarity to the Paris type.

This fount should more correctly be called the Parker type, for, as James Phillips points out, the Stephen Parker foundry produced it: "It is of interest to identify an Irish font which has long defied those who have attempted to trace it to its source. . . . It was mysterious because the obvious sources were overlooked. This type was unquestionably that cut by Stephen Parker, which he advertised for sale in 1787"[12] (see ill. 5.7).

Record of the commendation by the Royal Irish Society (Academy), mentioned in this advertisement,[13] is not to be found, but it would appear that the academy had shown some interest in the type, for the first publication to use it was in fact the second volume of its *Transactions* (1788) printed by George Bonham, printer to the academy, which used it to print "The Ode of Goll, the Son of Morna", together with other Irish poems in the Antiquities section. Phillips states that "It was probably intended that Miss Brooke's book should be the first in which this type appeared, but

5.6 The Paris Irish type (above), and the Parker Irish type (below), enlarged to 200% approx.

Irish Letter Foundery,

No. 47, Grafton-Street,

STEPHEN PARKER, Letter-Founder, the only perſon carry-
ing on, and regularly bred to the profeſſion, returns his moſt
grateful thanks to the gentlemen of the Printing buſineſs.
The experience of more than twenty years has enabled him to
bring this uſeful art to a degree of perfection equal to any foun-
dery in Europe.-----By a punctuality and beauty of execution he
ſhall endeavour in future, as he has ſucceſsfully done for the paſt,
to deſerve favour.

His Founts, of which Specimens may be had, are Roman
and Italic

Pearl---Nonpareil	Engliſh
Brevier, 1 and 2, alſo Saxon	Great Primer, alſo Black
Burgeois, 1 and 2	Double Pica, alſo Script
Long Primer, 1 and 2, alſo	Two-line Engliſh
Greek and Saxon	Two-line Great Primer
Small Pica	French Cannon
Pica, 1, 2, 3, and Black, alſo He-	Four, Five, Six, Seven, Eight,
brew with or without points	Ten and Twelve-lines Pica.

A complete Fount of beautiful IRISH CHARACTER---
commended by the Royal Iriſh Society.

Accented letters of all denominations---two-line letters of every
ſize---an extenſive variety of pleaſing Flowers---Metal Scabbard-
ing of all lengths and thickneſſes---Quotations, Juſtifiers, Space
and Metal Rules, Braces, Middles and Corners, Fractions, double
and ſingle; Cancel Figures, Aſtronomical and Mathematical Signs,
Coronets for the different degrees of Peerage, &c.----Orders receiv-
ed at the eſtabliſhed Letter Foundery, No. 47, Grafton-ſtreet.

her book was a subscription publication, and such were, and are, notoriously
slow in making their appearance."[14]

Proposals for the printing of *Reliques of Irish Poetry* mentions the intended
use of a "beautiful type" with "the original Irish at the end of the book".[15]
Phillips further states: "It seems in the light of the foregoing information
that it is hardly fair to call this type anything other than the Parker font.
George Bonham was merely the printer who used it. It is suggested that
Mossop may have been the designer of this particular font."[16] Parker's
daughter Letitia had married William Mossop, the well known Dublin
medallist in 1782. Before he began to strike medals, Mossop worked as a
seal-cutter and engraver for the Linen Board. In an advertisement issued by

him in 1777, he describes himself as "die sinker, seal and letter cutter".[17] It is a distinct possibility, therefore, that Mossop may have been employed by his father-in-law, Parker, to cut the punches.

This Parker type, together with its model, the earlier Paris face, represents an isolated and unique departure in the development of Irish type design, which owed more to this particular style of handwriting than to any previous typestyle. The following characters contribute most noticeably to this unusual appearance: the capitals A, C, D, F, G, H, M, N and R, and the lower-case a, f and g in the Paris, and the capitals C, D, F, M and N, and the lower-case c and f in the Parker fount. Muiris O'Gorman, who is mentioned in the introduction to Brooke's *Reliques* as as one who had contributed material for that publication, may also have contributed to the design of the new Parker type. He was an accomplished scribe and keenly involved in the

5.7 The advertisement in the *Dublin Chronicle*, 31 May 1787, announcing the availability of "A complete Fount of beautiful Irish Character" from the Parker "Irish Letter Foundery".

5.8 The Parker Irish type from *Reliques of Irish Poetry*, by Charlotte Brooke, 1789.

73

language movement. He offered classes in Irish to the public "in his own apartment (at the Sign of the Mashing Keeve in St Mary's Lane, Dublin), every morning, from ten to two, for the instruction of youth and others"[18] and counted the distinguished Colonel Vallancey among his students. A close examination of his calligraphic style in the manuscripts at Trinity College shows some similarity between his hand and the Parker type, but none so specific as to provide any firm evidence of his involvement in its preparation. Indeed it has features that bring to mind the so-called Watts type also, which was shortly to follow, and which will be described in a later chapter.

The wide set of this type made it an expensive face to use: compared with the Moxon type, for example, it used over 10% extra space. This contributed to the fact that, apart from Brooke's *Reliques* (see ill. 5.8), this type was not extensively used as the main text face in further books, but was more frequently used for display headings and titles, as in the *English-Irish Primer* by Connellan (1815). Warburton and others had little praise for the Parker type in their description of Neilson's *Introduction to the Irish Language* of 1808 which uses this type in its third part. They state: "In the third part are comprised extracts from Irish tracts, for habituating the student to the perusal of the language in its original Irish character However judicious the adoption of the diacritical dots, yet it must be acknowledged that placing the dagesh or dot in the body of the English letter would have been more striking to the eye."[19]

THE BARLOW AND CHRISTIE
TYPES

AS HAS BEEN NOTED, the Parker type, due to its size and proportions, was a "paper hungry" face. Partly for this reason, it lost its appeal for text use. This prompted the development of a distinctly different typeface generally referred to as the Barlow type, named after the printer first to use this unusual face. This fount was prepared in 1808 for the Gaelic Society of Dublin, which held its inaugural meeting in January of the previous year. While the only official publication of this society was its *Transactions* printed in 1808, which used the Parker type for the Irish tracts, one of its most active members, William Halliday, was associated with the first use of this Barlow type in *A Grammar of the Gaelic Language* (1808) (see ill. 6.1), which carries the attribution E. O'C. With regard to the true identity of its author, John O'Donovan states: "In 1808 was published, in Dublin, an Irish grammar, in octavo, entitled Uraicecht na Gaedhilge, 'A Grammar of the Irish Language', under the fictitious signature of E. O'C., which, in the prospectus, is given in full as Edmund O'Connell; but the author, as many living witnesses can attest, was William Halliday, Esq."[1]

Like the first Irish type of Queen Elizabeth, the Barlow type borrowed some of its sorts from existing roman letters. This, together with its size (long primer), made it appear particularly well ordered in text setting and attractive from a printing point of view (see ill. 6.2). In addition it made use of a variety of aspiration marks described in detail by P. McElligott, who concludes: "So much for improvement in the letters, which will be adopted in a new and elegant type now cutting for this Society."[2]

Halliday's name is further associated with the Barlow type through three different engraved plates: the first appears as the frontispiece in *An Introduction to the Knowledge of the Irish Language* by Patrick Lynch, secretary to the Gaelic Society of Dublin (1815) and later in appendix lxxxv to the second volume of *History of the City of Dublin* by Warburton, Whitelaw and Walsh (1818) (see ill. 6.3); in this plate entitled "Facsimiles of the Types used in Irish Books" an alphabet which contains the same use of some roman capital and lower case letters and the same distinct features of the Barlow type is shown hand-lettered under the title "Dublin Halliday". The second plate appears in Halliday's *Grammar* of 1808 opposite page 178 listing various contractions used in Irish (see ill. 6.4); the hand lettering of this plate

úraiceċt

na

gaeḋilge.

a

GRAMMAR

OF THE

GAELIC LANGUAGE.

Est quidem Lingua Hibernica, et elegans cum primis, et opulenta.

USSER. EPIST. I.

Níṗ ḃelḃ aṅ voṁaṅ uiṫe,
Cenga iṗ milliṗe móṗċuiṫe,
De ḃṗiatṗaiḃ iṗ ḃṗiċṫṗṅuiṫe blaṗ,
Caint iṗ ciaṅċuilte cuntaṗ.

H. M'CURTIN.

PRINTED BY JOHN BARLOW,
29, BOLTON-STREET.
1808.

ᴛ ᴀᴊʀ Lᴀᴊᴏ́ Nᴀ ᴛᴀᴊꙅꙅe.

. . . ṗaiḃ Páṫṗic aᴄ aḋṗaḋ Dé 'ṗ aṅ n-
. . . ċuaiḋ Oiṗíṅ mac Fhinn �̃o nuiᴄe;
Páṫṗic ṗáilte ṗoiṁe. Aᴄaṗ v'
Páṫṗic v' Oiṗíṅ, cav é aṅ cáṗ iṗ
buḋ ċṗuaválaiᴄe 'n-a ṗaḃavaṗ aṅ
ṅ. Inṅeoṗaḋ ṗéiṅ ṗiṅ vuiṗ, a Chṗéim ṗáṁ, aṗ Oiṗíṅ. Aṅ cáṗ iṗ cṗuaiḋe
vaṗ aṅ Fhian, ó vo ṗinneḋ Fjana
Fṗeḋ acaṗ ṗéṗta vo ḃí aᴄ Finn mac
ṗeċt ccata na ᴄnaṫ-Fhéine a n-Ailtṁaiṗ láṅ-aiḃin Laiᴄenn, acaṗ vo
leiṗ táin ve 'ṅ Fhéin, ᴄaṅ cuiṗiḋ
ᴛ vóiḃ; maṗ a ᴛá, mac Cṗonċaiṗ,
iṅ, acaṗ 'Aile mac Cṗiṁṫaiṅ. Do
ṁóṗ na Fiṗ uime ṗiṅ, inṅuṗ ᴄo
luiᴄe acaṗ móiʋe ᴄaṅ ᴛeċt a Fiano cenn bṗiaᴄiṅ. Iaṗ ṗiṅ vo ċuiṗ
ınᴄ aiṗ muiṗ, acaṗ níṗ ṗᴛavaḋ leo,
ᴄo ṗancaᴛaṗ cṗíc Loċlan. Iaṗ mbeiᴛ ṗelaḋ
ann ṗiṅ vóiḃ, ᴛuᴄ beṅ ṗíᴄ Loċlan ᴄṗáḋ éᴄṗaṁail vo 'Aile mac Cṗiṁṫaiṅ, ᴄuṗ eiaiḋ leiṗ

resembles most closely the distinct features of the Barlow type and is signed "Kersting sc. Clanbrassil Bridge." The third plate is of a map of Ireland contained in the 1811 edition of Keating's *Forus Feasa air Eirinn*. This map is mentioned on the inside title page of Lynch's *Introduction to the Knowledge of the Irish Language* (1815), in an advertisement for other works by this author: "The remaining numbers of Keating's Ireland, in which the new translation into English is accompanied on the collateral page with the author's original text, in the native Irish character, and now continued by Mr Lynch and published by Mr Barlow. N.B. The new translation of the first volume of Keating's history, though originally published in Mr Lynch's name, was begun and nearly completed by the late William Halliday, Esq., one of the vice-presidents of the Gaelic Society. As an additional embellishment to the work, he drew up and delineated an accurate map of Ireland, with the ancient names engraved in the Irish character" (see ill. 6.5). The lettering on this engraving, which reflects in detail the character of the Barlow type, combines the same roman capital and lower case letters with the more traditional Irish forms. The similarities are particularly notable in lower case r (same parallel vertical strokes), and g (slightly squat with full rounded curves to bowl), and in the capitals M (gothic style), and E (broad set as in its lower case form); the plate shows a rounder more extended form of capital D, a feature which appears in the revised capitals of the Barlow type in O'Reilly's *Dictionary* of 1817.

It is likely that the roman characters in this fount (capitals B, C, F, N, O, P, R, S and lower case b, c, e, o, p, u) were not included just as a matter of convenience, but rather to make it more legible for non-native readers. The only two authors in whose works the type was used, Halliday and O'Reilly, were committed to extending their readership to as wide an audience as possible. Halliday's *Grammar* is dedicated "to the learned and illustrious members of the Highland Societies of London and Edinburgh",[3] while in his introduction he states: "For the convenience of foreigners, as well as for the guidance of natives, long estranged from the correctness of their native idiom, new marks of orthoepy, lately introduced, have been adopted", and later states: "To the literary men of England it is only necessary to express the words of M'Curtain: . . . 'I pray, moreover, the generous English, who have attained the knowledge of all literature, and who have arrived at eminence in the most abstruse sciences, to give us their confidence and affection'."[4]

Bound into the back of the above-mentioned *Introduction to the Irish Language* by Patrick Lynch is another attestation to this commitment to the non-native reader. In an advertisement for Edward O'Reilly's *Dictionary of the Irish Language* which uses the Barlow type, it is stated: "It will be comprized in one volume, 4to, and printed on elegant type, and good paper", and continues: "In order to familiarize the learner to the Irish letters, and

6.1 Title page of [William Halliday's] *Grammar of the Gaelic Language*, 1808.

6.2 The Barlow Irish type from *A Grammar of the Gaelic Language*, 1808.

Fac similes of the Types used in Irish Books.

	at Lovain & Rome. Molloy		Paris. Dondevy		Dublin. Vallancey		Dublin. Halliday		Proposed Alphabet.		No
A											1
B											2
C											3
D											4
E											5
F											6
G											7
H											8
I											9
L											10
M											11
N											12
O											13
P											14
R											15
S											16
T											17
U											18

6.3 Section of the frontispiece from Lynch's *Introduction to the Knowledge of the Irish Language*, 1815, showing "Facsimiles of the Types used in Irish Books".

for the accommodation of foreigners, the Irish words will be printed both in the Irish and Italian character; the explanation will be in English, printed in the Roman letter."[5] In the preface to this dictionary printed in 1817, O'Reilly refers to "the late William Halliday, Junior, of Aran-Quay. That young gentleman, after acquiring a knowledge of the ancient and modern languages usually taught in schools, enriched his mind with the acquisition of several of the Eastern languages, and made himself so perfect a master of the language of his native country, that he was enabled to publish a Grammar of it in Dublin, in the year 1808, under the fictitious signature of E. O'C. and would have published a Dictionary of the same language, if death had not put a stop to his career, at the early age of 23."[6]

He later states that the *Dictionary* was intended also for the use of Scottish Gaelic. The title page also records that "The Irish words are first

given in the original letter [Barlow type], and again in italic, for the accommodation of those who do not read the language in its ancient character."

The fount included a different lower case i and l in its second use in *Forus Feasa* in 1811 from that used in 1808, while later in 1817 in O'Reilly's *Dictionary* it appeared with a full set of Irish capitals to replace the roman capitals B, F, N, P, R, and S. Capital C remained as the roman, while capitals D, L, and G, which were as the Irish letters in their original form, were altered: D takes on a rounder shape, while L has a longer lead in

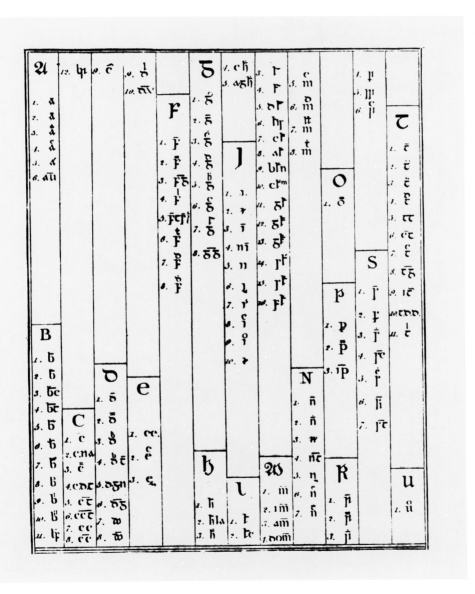

6.4 Plate depicting various contractions used in Irish, from Halliday's *Grammar*, 1808.

79

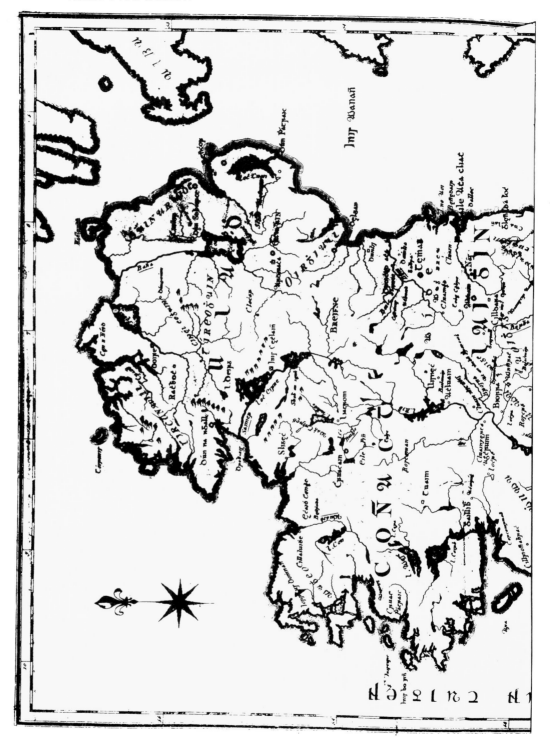

stroke with a shorter base curve. The revised G is slightly larger and more extended than the original (see ill. 6.6). Many of the new Irish capitals show little sign of having been influenced by any of the preceding designs. They were rather crudely formed with poor individual proportions and had little regard for their lower case counterparts. However, they appeared upright, with the revised B a truly vertical form for the first time.

An examination of these revised Irish capitals suggests James Christie as the typefounder responsible for the cutting of their punches. Christie, a Dublin printer and typefounder, cut a new Irish type in 1815, which was used for the first time in *The Proverbs of Solomon*, printed in 1815, and then a year later for the second edition of Charlotte Brooke's *Reliques of Irish Poetry*. While overall this type appears very different from Barlow's, a close inspection of its capitals reveals striking similarities with the later additions to the Barlow face (cf. ills. 6.6 and 6.7).

The Christie type, while some of its individual capital sorts seem awkward and ill-conceived (for example, capital N), nonetheless appears striking in body setting, even, vertical and well ordered, and was, perhaps, the most readable Irish type to date, retaining those traditional calligraphic qualities particularly associated with the "true" Irish style. However, the calligraphic quality is particularly forced in some of the letters. This face required special care in printing, for its boldness and extreme contrasts of weights became all the more emphasized with over-inking.

A sample setting appears in the *13th Report of the Hibernian Bible Society* in 1819 on page xii as part of the "Specimens of the Types on which the Bibles and Testaments sold by the Society are printed". Séamus Ó Casaide writing in the *Irish Book Lover* draws attention to a passage in James Hardiman's *Irish Minstrelsy* on page xxxiii of the introduction: "The first Irish type that found its way to Munster was sent in 1819, by the writer hereof to his worthy friend Mr Denis O'Flyn of Cork, an excellent Irish scholar, who erected a small printing press in his house."[7] Alf Mac Lochlainn notes that "The [above-mentioned] type is that of James Christie, according to Lynam probably the only one cut and cast in Ireland."[8]

The Christie type was used in T. Connellan's *The King's Letter in Irish and English* printed in 1822, which carries the imprint on page 36, "Printed, and type cut, by Christie, Dublin" (see ill. 6.8). It is interesting that T. Connellan used the Christie type at this time although the Fry Irish type (to be discussed), the design supervision of which was attributed to himself, was available. The Fry type was used for his second edition of *The King's Letter* in 1825.

An interesting feature of this type is its use of an enlarged form of the long lower case s for capital S, a feature which remained until about 1844 when it appeared with a more usual capital S as in John Daly's *Reliques of Irish Jacobite Poetry* (see ill. 6.9). Christie's type was in many respects the

6.5 Section of the map of Ireland from the 1811 edition of Keating's *Forus Feasa air Eirinn.*

6.6 The Barlow Irish type from 1808 (above), with later revised letters from 1816 (below), enlarged to 240% approx.

6.7 The Christie Irish type, enlarged to 240% approx.

forerunner of what was to become the popular modern style. It was, however, somewhat too large for the smaller format book work. As a printer and typefounder Christie would have been aware of the financial consequences that large type presented for extensive text setting; it is possible, therefore, that he was unable to produce a face with such complex variations to its line in a smaller size. Incidentally, W.G. Strickland in his paper on Irish typefounders did not mention this foundry at all. Christie's name appears in the *Dublin Directory* of 1815 and 1816 as "Printer publisher, and Type-founder, 17 Ross Lane" and in the 1817 entry he is listed only as "printer, 170 James's Street".[9] This suggests that his foundry may not have been a very sophisticated establishment.

The printers Goodwin and Nethercott used the Christie type for *Sermons and Hymns in Irish* (1847) and *An Irish English Dictionary* (1849) compiled by Thomas deVere Coneys. It was occasionally used in *An t-Európac*, a journal printed in 1899-1900 by Pádruig Ó Briain of Cuffe Street, who, it would seem, used it for the last time for the running heads of a prayer book, *Leabhar Urnuighe do'n Aos Og*, printed in 1903.

DÁN-MHOLADH NA GAOIDHEILGE.

'Sí 'n teanga Ghaoidheilge ir gleanta cló,
 Go blarda léigtéar i mar ceol:
Sí canad bríatra bín-gujt beojl,
 'Sur fjojl gujt mór a h-ájtreab:
Nj'l teanga ajr doṁan dá breagtact j,
 Le blar ir fojn 'nár rájujd fj,
'Sur ceajt do labra Dájne ljn:
 Dánta ir Ceol, d'fágajl na cójr;
Ir reanacar na Rjg-flajt mór,
 Ir raojte cróda Clajr-lujjc.[1]

Da ṁbead rjgte ejrjon fór,
 'Na rjge ran rjgeara g-cejm,[2] 'ra g-corjóin
Ba bjn rjollajde na Ghaoidheilge leo,
 Ujr caojn-crujt ceojl, ir tájblejr:[3]
Beadfjleada léjgin go rárda rógac,
 Ujg deana raotajr dánta dójb;
Gac ejgre djob ran ájrur mór,
 Ujg molad an Rjg 'ra majt-gnjoṁ,
Ir a fjnreajr treuna grojde,
 'Sa g-crjocajb Fóbla 'n árract.[4]

36

tajrgeac, lubdarac,
nuájleac, ir
forcarac.
Táid trj cénneaña a
glejre; .j. dearbtac,
cojbcenreg, ir rájr-
cejneac.
Tájd ré cméjl noṫ-ájr-
gjollad; .j. coṁujr-
ac, car-clejtge, gd-
alac, treóireadac,
eajdrajdg, ir nejṁ-
crotac.
Tájd ré duájrgjoll-
ajde coṁujrraca; .j.
méne, túne, éne, rjn-
ej rjṁe, ir jadne.
Tájd cejtre cméjl
mbrjatajr; .j. gnjojr-
ac, fulajngtec, ngf-
rac, ir ejrjcgjollac.
Tájd cújg mood; .j.
gnájtberac, tárgac,
ojlbénneg, jrreact-
ac, ir jajrdajgeac.
Tájd trjrjáe; .j. frjec-
najrc, eaccnajrc, ir
fajrtjne.
Tájd bá fjod; .j. fujd-
jrgnjte ir fulajng-
teac.
Tájd bá fojnnéjr; .j.
cáol jr leatan, mar
atá léjg, ir rgrjob.

sive, neuter and im-
personal.
There are five moods;
viz. imperative, indi-
cative, potential, con-
ditional, and infinitive.
There are three tenses;
viz. the present, past,
and future.
There are two voices;
viz. active and passive.

There are two conju-
gations; viz. broad and
slender, as read & write

Printed, and the Type cut, by Christie, Dublin.

6.8 (left) The Christie Irish type from *The King's Letter*, translated by Thaddaeus Connellan, 1822.

6.9 (above) The Christie Irish type from *Reliques of Irish Jacobite Poetry*, 1844.

83

THE WATTS, FRY AND FIGGINS
TYPES

THE END OF THE EIGHTEENTH and beginning of the nineteenth century was a particularly active period in the production of Irish printing types. This reflected an increase in a scholarly awareness of the Irish language. Vallancey, who had studied the language under Muiris O'Gorman,[1] in 1773 produced his *Grammar,* and in 1774 he began his *Collectanea de Rebus Hibernicis,* which contained some controversial and novel theories on the origins of the Irish language. Warburton states: "The exertions of the late General Valancey tended in an eminent degree to render the study of Irish also fashionable. Private tutors were employed, many of the clergy of the establishment, some of the junior and senior fellows of Trinity College applied themselves to the study of Irish."[2] The formation of the Gaelic Society of Dublin in 1807 represented a particularly significant interest at another level, for it brought together a group with an intimate knowledge of the language and a fervent dedication to its promotion. As has been noted, three Irish type faces were produced about this time—Parker's in 1787, Barlow's in 1808, and Christie's in 1815.

The Act of Union in 1801 led to some increased awareness of Irish matters in England, and the turn of the century was a time of renewed enthusiasm for the promotion of the Reformed Church in Ireland. In 1792 a society was formed in Dublin called the Association for Discountenancing Vice, and Promoting the Knowledge and Practice of the Christian Religion. A letter to the British and Foreign Bible Society in 1804, after giving an account of the books distributed by the association, points out that "the demand for them is progressively and rapidly increasing". They formed a distinct society, the Dublin Bible Society, and solicited the help of the British and Foreign Bible Society, who recognised the new group as an allied institution with similar aims. The Hibernian Bible Society, as the association came to be called, announced in its address to the people of Ireland in 1810 that "The demands on the committee for Bibles and Testaments during the last year were so great that had it not been for the liberality of the British and Foreign Bible Society, they would have been compelled to put a stop to their operations."[3]

Reaching the Irish-speaking population was of prime importance to the Hibernian Bible Society; in this regard the support of the British and Foreign

Bible Society was particularly helpful. The *Annual Report* of the Hibernian Bible Society recorded that in January 1815, after eight months consideration, a sub-committee recommended to the British and Foreign Bible Society that an edition of the New Testament be published containing an Irish translation in the Irish character.

Henry Monck Mason, who was very involved in the Hibernian Bible Society during this period, states that after much consideration the society decided that it should publish all the Scriptures in the Irish language and character. The report of the committee examining this appears in the appendix to their Annual Report for the year 1824. "The necessary funds were promptly supplied—the committee of the British and Foreign Bible Society subscribed £300—public contributions furnished the rest, and on a scale which enabled the committee to enlarge their plan, to stereotype the work, and to place upon each copy a price that was considerably below that of its original cost. . . . The committee bespoke a new type from Mr Watts, of London, and procured, with great care, the most correct and beautiful models from ancient MSS."[4] A footnote states: "This type has been everywhere approved." Edward O'Reilly states: "In the year 1818 a new edition of the New Testament was published in London, by the British and Foreign Bible Society, on beautiful Irish types; but either through the ignorance or the negligence of the editor or perhaps through both, the errors of this edition are innumerable."[5]

The above-mentioned plate which appeared as the frontispiece to Lynch's *Introduction to the Knowledge of the Irish Language* (1815), and later reprinted in Warburton's *History of the City of Dublin* (1818) is of particular interest in connexion with to this Watts type (see ill. 6.3). The accompanying explanatory text to the plate in the *History* stated: "The form of the characters used in Irish books has varied like that of other nations, with the age in which they were written. The annexed plate exhibits that which has been used at different periods. The first compartment shows that which has been already used in printed books, with an alphabet proposed to the Gaelic Society, by their Secretary, as a model for their future publications."[6] This alphabet, which appears under the column "proposed alphabet" (three years before the first use of the Watts type in the New Testament, 1818), represents the early designs for this style. This proposal is attributed to the secretary of the Gaelic Society. The position of secretary had been filled initially by the Revd Denis Taaffe, who died in August 1813.[7] Theophilus O'Flanagan succeeded him some time before Taaffe's death, and after O'Flanagan's departure from Dublin (prior to 1812), Patrick Lynch became secretary and retained that position for as long as the society survived.[8] It follows, if Warburton's attribution is correct, that Lynch, who had a long established interest and knowledge of printing,[9] was the proposer of this so-called Watts type. His talent in this area is further identified in an obituary tribute

7.1 The Watts Irish type *c*.1818 (above), the Ballhorn copy *c*.1861 (middle), and the *Irish Echo* version *c*.1881 (below), enlarged to 280% approx.

7.2 The Watts Irish type from Neilson's *Introduction to the Irish Language*, 1845.

D'aṁṁḋeóṁ ṁṁ cuaiḋ an Seoiżeaċ ḟa ḋéṁ aṁ ṫrażaiṁṫ a ṗoṁ é ḟéiṁ iṁ Ꝏaiṁe ṁaṁ áiṫ a ṁużaḋ 'ṁ a beaṫużaḋ í. Bḣí ṁṁ ḋeiċ ṁíle ḟiṫċeaḋ oṁ áiṫ a ṁḃíaḋ ṁiaḋ ṁa żcoṁṁaiż. D'aiṁiṁ ṁe ḋoṁ ṫrażaiṁṫ ṁṁ, żuṁ iṁṫiż Ꝏaiṁe ṁa Ruaiṁe 4 ṁiubaḷ uaḋ, ḟa ḋá bḷiaḋaiṁ o ḟoiṁ; żo ṁaiḃ ṁe 'ż a ṫóṁuiż-eaċṫ, żo ḃḟuaṁ aṁaċ í ṗóṁṫa aż ḟeaṁ eile, a żcoṁḋae aṁ Ḋúiṁ; ażuṁ ṁaċ leiżḟeaḋ ṁażaṁṫ ṁa ṗaṁaiṁṫe ṁṁ ḋo a ḟażaiḷ, ṁuṁa ḃḟuiżeaḋ ṁe cṁuṫużaḋ ḟaoi a laiṁṁaṁ, żuṁ leiṁ í. Niaṁ aiṁiṁ ṁe aṁ ḋaḋaṁ ḟa báṁ Ꝏaiṁe; ażuṁ ṁí ṁaiḃ ḟioṁ aż aṁ ṫrażaiṁṫ ṁṁ uiṁe, oiṁ ḋ'éuż ṁuiṁṫiṁ Ꝏaiṁe ṁul aṁ ṗóṁaḋ í, ażuṁ ṁí ṁaiḃ moṁáṁ iomṗaḋ uiṁṫe, ṁaṁ aiṁṫ ṁṁ.

Chuiṁ aṁ ṁażaiṁṫ liṫiṁ leiṁ, ḟa ḋéiṁ Earbuiċ Dhuiṁ "żuṁ ṗoṁ ṁeṁeaṁ caiḷíṁ, ṫa ṁżoiṁṫí Ꝏaiṁe ṁí Ruaiṁe, a ṫáiṁic o ḋaoiṁiḃ cṁeaṁḋa, aṁa ṗaṁaiṁṫe ḟéiṁ, le buaċaiḷḷ ṁacáṁṫa, ṫa ṁżoiṁṫí Séaṁ Seoiżeaċ, a ḃí ṁa coṁṁaiż laiṁ le ċṁoc Ꝏaża; ażuṁ żo ṁabaiṁ ṁe leiṁ żuṁ iṁṫiż ṁí uaḋ, 'ṁ żo ḃḟuiḷ ṁí ṁa coṁṁaiż maṁ ṁṁaoi aż ḟeaṁ eile, laiṁ le Ḋúṁṗaṫṫṁuic; ażuṁ żuṁ ċóiṁ a cuṁ ṁa baiḷe leiṁ."

Leaḃar Sgeulaigeaċda.
An "Craoiḃín Aoiḃinn."

Níl aon leaḃar Gaeḋilge do clóḃuailead in Éirinn air ḟead je an meud ḃ⁊ a'⁊ do .aiȝeaċda" naċ leiʃ an Iʃ fíor naċ ʃ rʃn air ʃm ceunta Fáȝail air o no ealaair le fáȝ- a ḃainear a, aȝuʃ a n neiȝeaċ Ȯeiʃn an ṫ- . ȝo ḃ-Fujl 'ʃnna eolaʃ Féiȯiʃ lʃnn na cʃuinne ó Fíoʃ-eol- ʃȝʃḃinne Fáȝail ó do ʃȝʃoḃ ʃnaiȝe a ȝ- ʃʃʃm ȝo ḃ- -cʃaċaiʃn ȝeaċo an ċo an doṁ- ʃ a ċuʃ a

no ḃ' Féiȯiʃ ȯá ṁʃle punc ċum an "Leaḃaʃ Sgeulaigeaċda" do ċuʃ a ȝ-cúlaiṫ ḃeuʃla.

Iʃ coʃáṁuil naċ ʃaiḃ aon ċeann do na ʃȝeulcaiḃ acá inʃ an leaḃaʃ ʃo, clóḃuailce ʃiaṁ ʃoiṁe. Do ċʃuinniȝ an c-úȝȯaʃ aʃ beul na ʃean daoineaċ iad. Iʃ ʃóiléiʃn ȝo leoʃ naċ ḃ-Fujl ceann aca anʃean, aȝuʃ naċ m-baineann ʃiad le h-aoiʃ Oiʃín. Sí baʃaṁuil an úȝȯaiʃ ȝuʃ cumaḋ an ċuiȯ iʃ móʃ ȯioḃ cimċeall ȯá ċeud ḃliaȯan ó ʃoin; aċc iʃ coʃáṁuil ȝo ḃ-Fujl cuiȯ ȯioḃ móʃán níoʃ ʃinne. Do ċʃuinniȝeaḋ iad uile a ȝ-cuiȝe Connaċc, ʃaoḃ aṁuiȝ cúpla ceann do Fuaiʃ ʃé a ȝ-conȯae Dún-na ŋ-Ȝall. Aċc ȝiḋ a ȝ-Connaċc do Fuaʃaḋ an ċuiȯ iʃ mo ȯioḃ, ná meaʃcaʃ é le aon Ṁújṁneaċ no Ulcaċ a leiȝeaʃ Ȝaeḋilȝ naċ Féiȯiʃ leiʃ iaȯ cuiȝ- ʃin. Tá ʃiaȯ ʃȝʃioḃca, ní a ŋ-Ȝaeḋilȝ Connaċc no Ṁúṁan, aċc a ŋ-Ȝaeḋilȝ Eiʃeann aiʃ Faȯ. Iʃ Féiȯiʃ liom an ʃiȯ ceuȯna ʃáȯ a ȯ-caoiḃ na Ȝaeḋilȝe ann a ʃȝʃioḃcaʃ "Seaʃc Leanaṁaiʃn Cʃíoʃȯ." Da Ṁúṁneaċ an Feaʃ leʃ cuiʃeaḋ a ŋ-Ȝaeḋilȝ é, aċc ní a ŋ-Ȝaeḋilȝ Ṁúṁan ʃȝʃioḃcaʃ é, aċc a ŋ-Ȝaeḋilȝ Eiʃeann. Iʃ

A	ʌ	a		2l) ıɲ	m
B	b	b		N ɲ	n
C	c	ck		O o	o
D	d	d		P p	p
E	e	e		R ʀ	r
F	f	f		S ʃ	s
G	ȝ	g		T c	t
I	ı	i		U ʋ	u
L	ι	l		ɦ ɦ	h

LIGATURES.

Irish MSS. contain contractions of which the following are the most usual.

f̄	chd		ġ	gh
aḋ	adh		jȯ, jȝ	i
aē	e		lɲ	ll
ᵱ	air		ɲɲb	m
ᵮ	an		ɲɲf	m
ᴀ̃	am		ıɲ	w
7	agur		ɲo	n
ᵮ	ar		ɲɲ	nn
ḃ	v w		ṗ	f
bḟ	v w		pp	b
bp	b		ɲlɲ	rr
cc	g		r̄	h
ċ	ch		ḣc	si
oḟ	d		ṫ	h
oc	d		cɲ	t
ea	ea		cc	d
eao	ea		ᴐ	i
ḟ	h		ᴐḃ	i
ȝc	g		ᴐḃc	ie
			ɲɲȝ	i

7.3 (left) Sample alphabet modelled on the Watts Irish type from *Grammatography: A Manual*, 1861. This was probably printed from a letterpress block prepared specifically for the purpose.

7.4 (above) The American Irish type modelled on the Watts fount, from the *Irish Echo*, 1890.

to him: "His peculiar attention was directed to the study of his native language, in which he had made great proficiency. He had not only spoke it fluently, as his vernacular tongue, but he was well skilled in its written character, which he read and wrote with such elegance and facility as often to make it the medium of communication in his correspondence with his equally gifted friends; he had also made collections of Irish MSS. in different parts of Ireland, and some of them of great antiquity, which he read and translated with equal ease."[10]

The Watts type contains an unusual form for capitals B and D, which are modelled more on a cursive letter than on the Irish (see ill. 7.1). The lower case letters are upright and form an orderly line and were cast in small pica (11 point), a suitable size for many text setting requirements. It was employed for the first time to print the New Testament for the British and Foreign Bible Society in 1818 and was used extensively both in England and Ireland during the remainder of the nineteenth century. It was used also by the Achill Mission Press to print *An Introduction to the Irish Language* by Revd Wm. Neilson in 1845 (see ill. 7.2). Reed states that under the patronage of the Bible Society Watts had "produced the punches of a large number of languages hitherto unknown to English typography. He received

7.5 Advertisement announcing "Irish Type for Sale" from the *Irish Echo*, 1888.

the assistance and advice of many eminent scholars in his work, some of whom personally superintended the execution of certain of the founts."[11]

An example of the type appears in the W. Watts specimens of 1850 and 1862; in Gilbert and Rivington's specimens of 1878 and 1880; and finally in William Clowes' specimen of 1931, where it is shown together with a smaller 10 point size.

A sample of the Irish alphabet was printed in Leipzig in 1861[12] (see ill. 7.3), which was modelled on the Watts face; however, many differences can be detected on close examination (see ill. 7.2). It is not known if this version was available in a form suitable for text setting as no known work, other than that cited, used it. It may simply have been prepared in the form of a block specifically for the purpose of showing this alphabet example.

Another typeface directly modelled on the Watts face appeared in the United States, where it was used for printing the Irish text in the first issue of *The Gael* published in New York in October 1881, and for subsequent issues up to 1900. This type also appeared from September 1887 in the *Irish Echo* published in Boston (see ill. 7.4) and was used regularly up till the turn of the century in that journal as well.[13]

In reply to an exhortation to use only the Irish character and not the roman for printing Irish, the editor of the *Echo* states: "Our readers who want nothing but the old characters should remember that there is only one professional printer in Boston that can 'set' up Irish type. We have to 'set' up the Irish type ourselves, and it is often a great help to be able to get someone to 'set' up a page of Irish now and again in the Roman."[14] In a report to the readers the editor states that matrices were available for the casting of Irish type, and in the December 1888 and following issues of the *Irish Echo* an advertisement appeared promoting the sale of this Irish type (see ill. 7.5).

This raises yet again the question of the status of a type which clearly imitates another, yet is sufficiently different to make it a distinct type. In that era of typesetting machines, stereotype plates and electrotyping it had become relatively easy to duplicate the design of other faces. James Figgins remarks: "To the printer it [electrotyping] has been a great advantage, enabling him to produce much excellent work, and to preserve, in case of need, the power of reprints and reproductions that without the aid of that process could not be possible, but to the type founder it has been disastrous . . . ; it has been used against him by an unscrupulous and disreputable crew to pirate his productions and appropriate his designs, not only for the purpose of casting type from matrices so obtained, but also making a trade of selling matrices and duplicates to others, while the original designer and producer, no matter what expenses he may have incurred, is thus plundered without a shadow of redress."[15]

THE

TWO FIRST BOOKS

OF

THE PENTATEUCH,

OR

BOOKS OF MOSES:

AS

A PREPARATION FOR LEARNERS TO READ

THE

Holy Scriptures.

THE TYPES CUT BY DR. EDMUND FRY,

LETTER FOUNDER TO HIS MAJESTY,

FROM

ORIGINAL IRISH MANUSCRIPTS.

UNDER THE CARE AND DIRECTION OF

MR. T. CONNELLAN,

AUTHOR OF

The English Irish Dictionary, and Irish English Elementary.

Printed by Messrs. Graisberry & Campbell, Dublin,
In the Years 1814 and 1815.

FOURTH EDITION.

Printed at the Apollo Press, London.

BY J. JOHNSON,

BROOK STREET, HOLBORN.

1820.

7.6 Title page of
*The Two First Books
of The Pentateuch*,
1820.

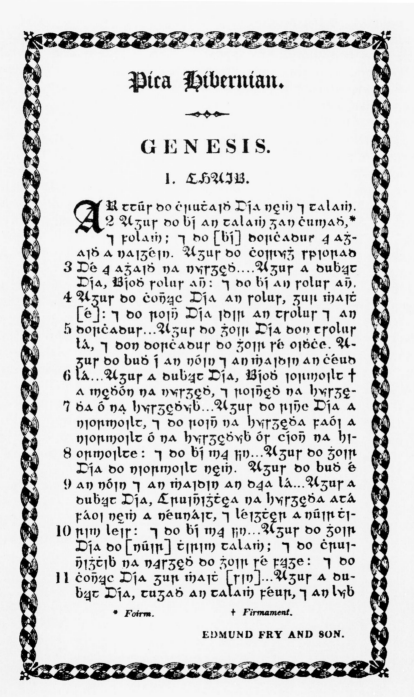

7.7 The Fry Irish type from their specimen book of 1820 which uses the gothic form of capital letters.

The co-operation between the two bible societies resulted in two different typefaces being produced. The second type commissioned by the British Bible Society was cut by Dr Edmund Fry and is generally referred to as the Fry Irish type. It first appeared in 1819, one year after the Watts type. Reed mentions that Fry's "excellence as a cutter of Oriental punches led to his selection by the University of Cambridge to execute several founts for that learned body; in addition to which he was employed to produce types for the works of the British and Foreign Bible Society, and similar biblical publications."[16] This type was used in *The Two First Books of the Pentateuch*, printed at the Apollo Press (London, 1820) (see ill. 7.6). The title page states: "The types cut by Dr Edmund Fry, Letterfounder to his Majesty, from Original Irish Manuscripts under the Care and Direction of Mr. T. Connellan author of *The English Irish Dictionary*, and *Irish English Elementary*." With regard to this clear statement of origin, an advertisement for *The Two First Books* contained in *The King's Letter* (1825), stated: "The types are copied from the best Irish manuscripts. This work is now in stereotype plates, and has passed through several editions."[17]

J. Johnson, the printer who first used this type in London, issued his *Typographia* in 1824, in which he also used the Fry type to illustrate the Irish character. He explains: "Before we proceed to a brief account of the *Ogham* characters of the Irish, we shall inset one specimen of their language in connection, executed in the Bethliusnion character, which was cast by Dr Fry, for the purpose of printing the Irish version of the Pentateuch, of which Genesis and Exodus have already been finished and stereotyped, under the title of The Two First Books of the Pentateuch, from the original Irish manuscripts, under the direction of T. Connellan, Lond. 1820."[18] T. C. Hansard in his *Typographia* provides further information, when he describes the Fry Irish pica type as being "From collations with original MSS. in the Irish language in the possession of Dr Fitzgerald."[19] Connellan makes an interesting reference to the type in his "Case of Thaddeus Connellan" regarding the printing of the Scriptures in Irish: "In order to aid in supplying that urgent want, his late Majesty George IV graciously bestowed on me some assistance for the purchase of paper, and soon after procured me a fount of Irish types."[20] However, Connellan was wont to associate himself and his efforts with George IV, which may put in doubt whether or not the king was in fact the patron of this type.

The Fry Irish types appear in the Fry type specimen book of 1820 (see ill. 7.7), and later in the E. Fry and Son specimen of 1824. It quickly became very popular, as is evident from the large number of printers who stocked it. Initially it was used with a set of gothic capitals. Later, it was frequently used with the Watts capitals, as in *A Grammar of the Irish Language* by Henry J. Monck Mason (Dublin 1830). In 1836 the smaller size had its own set of capitals (see ill. 7.8), and in 1838, a primer, compiled

7.8 The Fry Irish type from its earlier use in 1819, together with the later revised capitals c.1836, enlarged to 280% approx.

and published under the patronage of the Ladies Gaelic Society, Belfast, and printed by Goodwin Son and Nethercott, Dublin, used the Fry type with both the gothic and a new set of Irish capital letters.[21]

Both the Fry and Watts types appear together in the Wm. Watts specimen book of 1862 and later in the Gilbert and Rivington foreign types specimen of 1880, to which foundry the Watts stock passed. They appear together as late as 1931 in the Clowes specimen book of that year, William Clowes having acquired the Watts collection through his purchase of Gilbert and Rivington in 1908. The Stephenson Blake archives contain a set of punches for the Fry pica lower case letters together with punches for the gothic capitals used in the early castings. They also house a drawer of matrices of Fry pica Irish, mixed with some Watts and earlier Fry/Moxon matrices. The Fry and Fry/Moxon matrices are of a similar outward appearance with a distinctive flat notch at the top of each matrix, while the Watts matrices have a different, more rounded notch, clearly indicating a separate origin. A record of these appears in an inventory book of the Reed letter foundry at the Stephenson Blake archives (see ill. 7.9), which Dr Roy Millington, archivist to this collection, dates at 1905. The entries show the Fry/Moxon, and a Fry small pica Irish No. 2, as being "Marked F H" [Fry Hibernian], while the Watts is listed as "Lg [Long] Primer Irish Not Marked", further indicating that these had perhaps come from an unrecorded outside source.[22]

The third typeface to make its appearance about this time was a most unusual one from the Figgins foundry and generally referred to as the Early Figgins type. There is some dispute as to its date of origin, many being of the view that it had been prepared for the second volume of Charles O'Conor's *Rerum Hibernicarum Scriptores*, in 1825.

This unusual face, with its somewhat condensed proportions, has a strong vertical appearance, resulting from the pronounced difference in weight between the thick vertical strokes and the thins. It represents a sophisticated development in the design of Irish type, for it permitted a degree of experimentation that departs in an bold and striking manner from previous forms (see ill. 7.10).

7.9 Pages from an inventory book of the Reed Letter Foundry, *c*.1905, showing a record of the Irish punches in their collection at that time.

Volume I of O'Conor's *Rerum Hibernicarum Scriptores*, which issued in 1814, was printed in Buckingham by J. Seely, using italic type for the Irish text. In the introduction to his edition of *The Annals of the Four Masters* O'Donovan says of this volume: "His text, however, is full of errors; it is printed in the italic character, and the contractions of the manuscript, which in many places Dr O'Connor evidently misunderstood, are allowed to remain, although without any attempt to represent them by a peculiar type."[23]

The Figgins type, small pica in size, while it may have been prepared for the second volume of O'Conor's work (1825), in fact first made its appearance ten years earlier in the Figgins specimen book of 1815. There it is described as having been "copied from the engravings in Vallancey's Irish Grammar" with the note "The abbreviations are complete" (see ill. 7.11). The same sample appeared in the 1821 specimen, and later in their 1824 and 1828 specimen books. The type was first used for continuous text

setting in the second volume of O'Conor's *Rerum Hibernicarum Scriptores* in 1825. It was not, however, used for volumes III and IV, which suggests that there may have been dissatisfaction with it. The similarity of the type to the above mentioned engravings in Vallancey's *Grammar* is most noticeable.

Séamus Ó Casaide says that "This 'Figgins' type was modelled on the Irish lettering (by Muiris O Gormain?) reproduced by copperplate in Vallancey's *Irish Grammar* (1773)."[24] O'Gorman, who was clerk of St Mary's Chapel, has already been mentioned as the Irish tutor to Vallancey and as one who may have had an involvement in the design of the Parker type. He had a keen interest in Irish letterforms, both as a scribe and as a collector of manuscript material. Describing O'Gorman's library, Warburton's *History of Dublin* says that it "filled five large sacks", and that "Mr O'Reilly purchased [it] from Wright, and on examination found himself possessed of a collection of the rarest MSS., for one of which he has since refused fifty guineas."[25] An examination of O'Gorman's hand does show many similarities with the lettering in Vallancey's plate (see ill. 7.12)—particularly in the lower-case a

7.10 The early Figgins type, *c.*1815, enlarged to 200% approx.

7.11 The early Figgins type from the Vincent Figgins specimen book of 1815. Note the remark that the type was "Copied from the engravings in Vallancey's Irish Grammar". Indeed a copy of the *Grammar* is among the effects of the Figgin's foundry now in the St Bride collection.

Plate VIII.

Samaritan from			Phoenician from	Irish	
Durctus	Ambrosius	Dr Bernard	AbBarthelemy		
[glyph]	[glyph]	[glyph]	[glyph]	[glyph]	A
[glyph]	[glyph]	[glyph]	[glyph]	[glyph]	B
[glyph]	[glyph]	[glyph]	[glyph]	[glyph]	G
[glyph]	[glyph]	[glyph]	[glyph]	[glyph]	D
[glyph]	[glyph]	[glyph]	[glyph]	[glyph]	E
[glyph]	[glyph]	[glyph]	[glyph]	[glyph]	V
[glyph]	[glyph]	[glyph]		ʒ (Ss)	ſs
[glyph]	[glyph]	[glyph]	[glyph]	[glyph]	H
[glyph]	[glyph]	[glyph]	[glyph]	T
[glyph]	[glyph]	[glyph]	[glyph]	[glyph]	I
[glyph]	[glyph]	[glyph]	[glyph]	[glyph]	CK
[glyph]	[glyph]	[glyph]	[glyph]	[glyph]	L
[glyph]	[glyph]	[glyph]	[glyph]	[glyph]	M
[glyph]	[glyph]	[glyph]	[glyph]	[glyph]	N
[glyph]	[glyph]	[glyph]	[glyph]	[glyph]	S
[glyph]	[glyph]	[glyph]	[glyph]	[glyph]	O
[glyph]	[glyph]	[glyph]	Ph: F	Ph.F
[glyph]	[glyph]	[glyph]	[glyph]	ts
[glyph]	[glyph]	[glyph]	[glyph]	[glyph]	Q
[glyph]	[glyph]	[glyph]	[glyph]	[glyph]	R
[glyph]	[glyph]	[glyph]	[glyph]	ſh
[glyph]	[glyph]	[glyph]	[glyph]		T

The Samaritan and Phoenician Alphabets Compared with the Irish.

7.12 The plate from Vallancey's *Grammar*, 1773, the model for the early Figgins Irish type.

OID DO CHLAЧЧAIЬh MILEADh.

Aonzhuſ mÁc Doizhſí Uí DhÁlÁizh ſó chÁn.[1]

———

DiÁ libh Á lÁochſÁiDh ZhÁoiDhiol,

ЧÁ cluinteÁſ clÁoiDhteÁcht oſſÁibh,

ſiÁmh níoſ' thuilleÁbhÁſ mÁſlÁDh,

Ʉ n-Ám cÁthÁ nÁ cozÁiDh.

DéuntÁſ libh coinzhlic cÁlmÁ

Ʉ bhuiDheÁn ÁſmzhlÁn ſÁoilteÁch,

ſÁ cheÁnn bhuſ bh-ſeÁſÁinn DúthchÁiſ

Puiſc úſ-zhoiſc iſſe ZÁoiDhiol.

MÁDh Áil libh ÁzſÁDh EiſeÁnn,

Ʉ zhÁſſÁiDh céimeÁnn z-cſóDhÁ,

ЧÁ ſeÁchnuiDh éucht nÁ ioſzhuil,

ЧÁ cÁthÁ mioncÁ móſÁ.

ſeÁſſ bheich Á m-bÁſſÁibh ſuÁiſ-bheÁnn,

Ʉ bh-ſeitheÁmh ſhuÁn zheÁſſ zhſinnmheÁſ,

Ʉz ſeilz cſoDÁ Áſ ſéÁin eÁchtſÁnn,

'ZÁ bh-ſuil ſeÁſÁnn bhuſ ſínſeÁſ.

7.13 The early Figgins Irish type from Hardiman's *Irish Minstrelsy*, 1831.

and in the capital M, as in MSS. 1324, 1294 and 1359, in Trinity College, Dublin. However, there does not seem to be sufficient likeness to lead to a conclusive identification of O'Gorman as the scribe involved. It is of particular interest that in this plate the letter M is rendered in a way similar to the form used in the gothic capitals with the Fry type, and the N in a unique and distinctive shape more like a capital M. This seems to have confused the Figgins punch cutter, for in the type the capital M is as N in the plate, and capital N as M in the plate, and were so used in setting (cf. ill. 7.12 and 7.13).

The Figgins type, while it seems not to have had many admirers in its day found favour, however, among some later typographers and printers. Colm Ó Lochlainn describes it as "A very laudable attempt to regularise the Irish fount. . . . Its obvious faults, the lower case a, for instance, with the unnecessary prolongation of the left-hand stroke, the ugly capitals D, G, S, etc., could easily be remedied, and it seems to have possibilities of development."[26]

After *Rerum Hibernicarum*, the type was next used in 1831 in James Hardiman's *Irish Minstrelsy* (see ill. 7.13), and for this reason it is often referred to as the Hardiman type. This book was printed by Robins and Sons, Southwark. Generally it had been accepted that these two works were the only ones to use the Figgins type. However, Séamus Ó Casaide discovered its further use in a religious poem *Críoch Deigheanach Don Duine* (Man's Final End) by Revd John O'Connell, printed in 1851. He states: "E. W. Lynam thought that the type was used only for the above- mentioned works of O'Conor and Hardiman. I think I have seen cuttings and 'off-prints' from the *Drogheda Argus* in which the 'Figgins type' was used for printing the contributions of Ó Tomaltaigh and other local Irish scholars about the forties or fifties of last century. I think Patrick Kelly, who printed the Drogheda (1851) edition of the *Críoch* was the proprietor and printer of the *Drogheda Argus*."[27] A sample of the Figgins type appeared later in the V. and J. Figgins specimen book of 1895. The punches and matrices passed to Figgins' nephew, R. H. Stevens, who merged the business with P. M. Shanks and traded later as Stevens Shanks and Sons.

THE PETRIE TYPES

IN THE EARLY NINETEENTH century, Ireland was fortunate to have had a number of Celtic scholars who contributed greatly to a general appreciation of her cultural past. Among these were George Petrie, John O'Donovan and Eugene O'Curry, who in the early 1830s shared many scholarly interests and whose combined talents had a major influence on the design of Irish printing type. In addition, there occurred at this time a number of events conducive to this typographic development. In 1830 Petrie purchased a holograph copy of the Annals of the Kingdom of Ireland by the Four Masters from 1172 to 1616 at the sale of Austin Cooper's library, and read to the Royal Irish Academy in 1831 a paper, "Remarks on the history and authenticity of the autograph original of the Four Masters." This acquisition was generously transferred by him to the Academy.

After George Smith of the publishing firm of Hodges and Smith undertook to finance the publication of the Annals, O'Donovan immediately set about editing and translating it. In the course of his work with the Ordnance Survey he lost no opportunity to collect relevant material. He began the translation in 1832 and from that time he constantly kept the Annals' publication in view.

It was shortly after this that thoughts were turned to the preparation of an Irish type suitable for the printing of the *Annals;* this resulted in the production of the first typeface in Irish to have been produced modelled on the round half-uncial letterform. Many bibliographical historians have referred to this type as the Irish Archaeological Society type because it was used so widely in that society's early publications, while in more recent times it has correctly been accepted that Petrie was its designer. There is, nonetheless, considerable confusion about its origins and early use, and also about the number of founts involved. Petrie, a keen student of early Irish manuscripts and one who had devoted much time to the study of Irish stone and metal inscriptions, was well suited to the task of type design. As one who was actively involved in writing, proof-reading and supervising the various stages of the publishing of his work, Petrie would have been conscious of the qualities of a type that contribute to its readability and effectiveness. In addition, as an artist of significance himself and as one

used to commissioning the production of metal and wood engravings for print, he possessed a sound understanding of the mechanics and technology of print production.

Various pre-publication notices for the Annals mention the Irish type as having been prepared by Petrie specifically for this purpose. The prospectus bound into the back of some copies of John O'Donovan's edition of The Book of Rights (1847) states: "The work has been printed at the University Press of Dublin; the type for the Irish text, which is interpaged with the English translation, was specially designed for the Publishers, from the best manuscript examples. The matrices were executed under the care of the editor, Dr Petrie, and Mr Eugene Curry, whose names will be recognised as sufficient guarantee for accuracy."[1]

Furthermore, the incentive for the preparation of this type is recorded in the *Subscription Book for the Annals of the Four Masters* edited by O'Donovan, which says that:

> It is intended that the edition shall consist of five hundred copies, forming two volumes, 4to., of about sixteen hundred pages, price to subscribers Six Guineas, to non-subscribers Eight Guineas. The work will be put to press as soon as two hundred copies are subscribed for, a list of which will, from time to time, be published. Considerable expense and trouble have been incurred in selecting models for the Irish type, from the best written and most valuable of early Irish manuscripts. The publishers are happy to say that their selection has met with the full approbation of all persons capable of forming a judgement on the subject; and has been adopted by the Royal Irish Academy, and the Irish Archaeological Society. A specimen of the Type, Translation, and Notes will be found in the following pages. Hodges and Smith, 21 College Green, Dublin.[2]

The most convincing first-hand statement about the authorship of the designs, however, is given by Eugene O'Curry in his *Lectures on the Manuscript Materials of Ancient Irish History,* in which he says of O'Donovan's edition of the *Four Masters*: "the text is given in the Irish character, and is printed in the beautiful type employed in the printing office of Trinity College, and the forms of which were carefully drawn from the earliest authorities by the elegant hand of my respected friend, Dr Petrie." He goes on to praise "the singular public spirit of Mr George Smith at whose sole risk and expense this vast publication was undertaken and completed".[3] This statement firmly and unquestioningly identifies Petrie as the designer of the early pica and long primer type. Further first-hand evidence of Petrie's involvement in the design is contained in the editor's introduction to Eugene O'Curry's translation of "The Sick-bed of Cuchulainn" in *The Atlantis*, in which it is mentioned that "two forms of type cast within the last few years. The first of these was that designed some years ago by Dr Petrie for the Ordnance Survey, a form which, with some improvements

in the detail of execution, has been carried out in the beautiful type used by Mr Gill, at the Printing Office of Trinity College, in the printing of Dr O'Donovan's *Annals of the Four Masters* (7 vols.), and in the publications of the Irish Archaeological and Celtic Society, etc." The second type referred to is that which to date has generally been called the Thom's Archaeological type (to be described later in this chapter). The editor continues: "Both these types are perfectly accurate so far as regards authority for the forms used, which have been in every case taken without alteration from MS. forms preserved in the earliest known MSS., some of them of a date so early as the sixth century, and in the inscriptions upon stone tombs, some of them of the ages immediately succeeding the introduction of Christianity into Ireland."[4]

Writing in the *Celtic Records of Ireland*, John Gilbert comments that "The most elaborate care appears to have been taken by the publishers [of the *Annals*] to produce a work perfect in every department, both literary and artistical. . . . A peculiarly exquisite Irish type, modelled from the characters in the venerable Book of Kells, was manufactured expressly for this work."[5]

M. H. Gill mentions the Petrie types in correspondence, on a number of occasions, which are of particular interest, in so far as he refers to his involvement in their financing. On 23 February 1853 he sent an estimate of the printing costs for an Irish prayer book to the Revd D. Foley, which included printed samples, in which he states:

The Irish used is a very handsome type, modelled after the Book of Kells which, as you are aware, is admitted to be the most beautiful specimen of the Irish character extant. The drawings were made with the greatest care by Dr Petrie who, as an artist and an Irish scholar, is sufficient security for accuracy of form. This form was highly approved ten years ago by a committee of gentlemen in this city, who were most conversant with the subject, and gave as their opinion that the beauty of the characters cannot be excelled. It is as easily read as the roman letters by those who understand the language, and it would be a pity to lay it aside now and use the other letters in its stead in printing Irish.[6]

Later Gill also sent a printed sample to the Revd Evans, pointing out:

I have gone to considerable expense for the drawings, cutting of punches and matrices for three founts of Irish of different sizes,[7] being the form of Irish character approved by a committee of the first Irish scholars in the country, who were aware of the many imperfections of the founts in use. I applied also to some respectable type founders to undertake the work and sell me and others the type, but they declined on the grounds that the mere casting of the founts that would be required by the printers of the United Kingdom would not repay them for the outlay, which I believe to be the fact. I therefore had to go to all the expense myself or it would not have been done.[8]

CITY OF LONDONDERRY.

Cach ꝼath o ꝼꝛith aınm aꞃ Oıleach cona ꝼaıꞁꞁe.
Іꞇa ꞃuno ına ꞃeao chuınoꞃıo ꝼeaꞃ ca ꝼaıobe.
Eochaıo ollaꞇhaıꞃ ꞃoınoꞃaıo Еꝛınn uıle
Ꞃo bo leẻı na leaꞇh muıꞃı oꝛech ın ouıne
Ꞇꞃı mıc ın oeaꞃ ouıne Еchach can ꝼuaıꞃ ꝼoꞃmaıo
Aenꞃuꞃ ıꞃ Aeo ıꞃ Ceꞃmao na caencompaıc
Coıꞃꞃꞃeno mao Faıꞇheamaın Fenoıch oeaꞃaıb oomaın
Oclach o Eachaıo oo uaıꞃ oebaıo ꞃe ꝼuaıꞃ nomaın,
Ꞃeıꞃ ꞃıllı moıꞃ a muıꞃ Chꞃuachan co ceıb noꞃꞁaın
Co naıb naıꞃnıꞃ co nuchꞇ nan
Aꞃ ꞃa ꝼao ꝼıꞃ oo ꞃıꞃ Еꞃıno ꞃo
Ꞇanıc Coıꞃꞃceano o chꞃuaıch
Ꞇeaꞇhꞃa baınꞃel ꝼa bean Coꞃ
Нoĉoꞃ baıllı ouꞃı ıaꞃ noılıno
Оo ꞃao Ꞇeaꞇhꞃa aꞃ ꞇochꞇ a ꞇ
Aeıb a haıꞃı aꞃ Aeo ꞃen coꞃ
Оo chuaıo Coıꞃꞃceno oꝼıꞃ a ꝼ
Оo chaꞃ Ꞇeaꞇhꞃa ꞃeꞃ ꞇhaem
Іꞃ ano ꞃın oo ꞃıꞃne Coıꞃꞃꞃeno
Ꞃuın ın mıc ꞃo mıll a eneach
Оo chuaıo Eochaıo oıaꞃꞃaıo o
Co ꞃuꞃ ꞇımaıꞃc ꞇꞃeolınm nuo
ConꞍebaıꞃꞇ each cꞃochchaꞃ C
Ma oo ꝼınoı uaıll na uabaꞃ a
Нocho oenaım aꞃ a Оaꞃoa ꞃ
Aꞃınach oıꞃıꞃnach olıꞃeo nıo
Нı oleaꞃaꞃ aınım ıꞃ enech a ꞃ
Нı heaobeaꞃaꞃ o bꞃeıth nean

8.1 The Petrie A long printer (10 point) type, used for the first time in *The Ordnance Survey of County Londonderry*, 1837.

8.2 Impression of the Petrie A types prepared in 1844 for the purpose of entry of copyright at Stationers' Hall by the owners, Hodges and Smith.

Indeed John J. O'Kelly, who compiled an account of the House of Gill which quotes this correspondence, attributes design credit for the type in part to M. H. Gill: "In 1848 came the first volume of Michael O'Clery's *Annals of the Four Masters*, a second in 1851. The classic type for these scholarly volumes, edited by O'Donovan . . . , and printed at the University Press, was designed by Dr George Petrie and M. H. Gill, and the publication of the entire seven volumes put Gaelic printing and publishing on a new and highly creditable plane."[9]

It is perhaps appropriate to point out at this stage that this important series of types, based on the original designs of Petrie, can in fact be placed into three categories:

1) The Petrie A type of 1835, produced in two sizes, pica (12 point) and long primer (10 point).

2) The Petrie B type of 1850, also produced in two sizes, long primer (10 point) and brevier (8 point).

3) The Petrie C type of 1856, produced in four sizes, english (14 point), pica (12 point), small pica (11 point), and long primer (10 point).

While the eventual publication of the *Annals* did not take place until 1848, there is much evidence to suggest that the early version of the type was planned concurrent with the initial publication developments in 1832–33.

The early Petrie A long primer type in fact appeared for the first time in *The Ordnance Survey of County Londonderry*, vol. 1, "The Parish of Templemore", published by Hodges and Smith in 1837 and printed by Graisberry. Advance copies of this work in which this Petrie type appears were prepared for a meeting of the British Association in 1835. The *Freeman's Journal* in its obituary of O'Donovan states: "After the publication of the Ordnance Maps of the County of Londonderry in 1833, the preparation of the Ordnance 'Memoir' of the Parish of Templemore was commenced and prosecuted with so much assiduity that the preliminary portion of it was printed and presented to the British Association when it met at Dublin in 1835."[10] A copy of this advance printing in the National Library of Ireland has on the inside front cover a pasted-in label indicating that "This copy has been struck off previously to the final revision of the Book for the purpose of being laid before the British Association, on its meeting in Dublin" (see ill. 8.1). Further reference to the use of the Irish type at this time is contained in two documents, one held at the British Library, and the other at the Public Records Office, London. Glued in to the last page of John O'Donovan's *A Grammar of the Irish Language*, of 1845, in the British Library is a printed single sheet titled: *Irish Hibernian, cut and cast from original drawings executed for Messrs Hodges and Smith*, which shows the early Petrie A pica and long primer alphabets (see ill. 8.2). This design sample was entered at Stationers' Hall, and the *Form of Requiring Entry of Proprietorship* held at the Public

FORM OF REQUIRING ENTRY OF PROPRIETORSHIP

We John *Hodges* and *George Smith* — of 21 *College Green Dublin* — , do hereby certify, That ~~I am~~ *we are* the Proprietor of the Copyright of a Book, intituled *Irish Hibernian, &c.* — ; and ~~I~~ *we* hereby require you to make entry in the Register Book of the Stationers' Company of ~~my~~ *our* Proprietorship of such Copyright, according to the particulars underwritten.

Title of Book.	Name of Publisher, and Place of Publication.	Name and Place of Abode of the Proprietor of the Copyright.	Date of First Publication.
Irish Hibernian, cut and cast from original Drawings executed for Messrs Hodges & Smith	John Hodges and George Smith of 21 College Green Dublin —	John Hodges and George Smith 21 College Green Dublin —	December 1837

Dated this *Eleventh* — day of *April* — 1844 -

Witness, *John Byrne*
20 College green — N.B. *Office Hours from Ten to Four.*

(Signed) *John Hodges*
G. Smith

8.3 Form of Requiring Entry of Proprietorship submitted by Hodges and Smith in 1844 in execution of their claim of copyright regarding the Petrie type design.

Records Office, Kew (ref. Copy.1.569), indicates that the copyright of the alphabet samples was taken out by John Hodges and George Smith of 21 College Green, Dublin, on 11 April 1844 (see ill. 8.3). This form also indicates that the type was first published in December 1837. As we have seen, it was in fact used as early as 1835. It is of interest that formal copyright was claimed on this type face in this manner, and that nine years had elapsed from the time of its production to the application for copyright.

The early long primer A type next appeared in volume XVIII of the *Transactions of the Royal Irish Academy* printed by Graisberry (1839), where it was used in Petrie's account of the "Book of Mac Firbis", and in his account of an "Ancient Irish Reliquary called the Domnach-Airgid" in which Petrie mentions the type: "It should be observed," he states, "that the type in which the following fragments are printed is not to be considered as a fac-simile of the MS., in which the letters are larger, but it will give a very good general idea of the character, having been cast from the best specimens of Irish MSS. of the sixth and seventh centuries."[11] The

early long primer is also used in the same publication in the footnotes to Petrie's "History and Antiquities of Tara Hill" in which also appears, for the first time, the early Petrie A pica type, which is introduced with a similar statement: "The characters used in the text will give a good general idea of those in the MS., and the ornamented capital is a fac-simile of the original one"[12] (see ill. 8.4).

To the eye more appreciative of the qualities of roman type it is immediately evident that this style is more readable, orderly and even. It forms a truly distinguished printable character with well proportioned elements. In the smaller long primer size many of the capitals have a slightly wider set than the corresponding sorts in the pica size, with this feature being most pronounced in the letters D, N, and P. Notwithstanding the four-year gap

8.4 The Petrie A pica type used for the first time in the *Transactions of the Royal Irish Academy*, 1839.

8.5 The Petrie A long primer type enlarged to 340% approx. (above), with the pica size (below), enlarged to 240% approx.

between the first use of the two sizes, they are undoubtedly formed from the same design (see ill. 8.5).

The early Petrie A long primer and pica types were used in the first volume of *Tracts Relating to Ireland* (Irish Archaeological Society, 1841, printed at the University Press by Graisberry and Gill), in which, it was suggested by many, the type first appeared.

The early Petrie A type, which continued to be employed by the Royal Irish Academy and the Irish Archaeological Society, was used to such great effect in the *Annals of the Kingdom of Ireland* (see ill. 8.6), that a *Dublin University Magazine* review of the *Annals* states: "We have his book, three quarto volumes in matter, in learned use of it, in method and in typographical excellence—though the last is but a small merit in comparison with the others—fit to take its place in any shelf, of any European Library, beside Camden, Mabillou, or Muratori."[13]

The early pica A type continued in use and was employed in *Clann Lir*, printed by Colm Ó Lochlainn as late as 1922. It was used for the heading in the National University examination papers until 1947. One line of this type appears on the title page of the Dolmen Press privately printed edition of Brian Merriman's *Midnight Court* in 1953. The colophon states that "the Gaelic Title in Petrie type was lent by the Dublin University Press". This early pica A type appears in the Dublin University Press type specimen booklet of 1961.

8.6 The Petrie A pica type from *The Annals of the Four Masters*, 1851.

an tpeap la picheat do mí lun. Cath Dpoma Lochmaighe pia Laignibh pop Uib Nell.

Copbmac a Cpic in epnaide eppcop Apda Maca, comapba Patpaicc, do faoidhfoh a gpiopaicce.

Aoir Cpiopt, cfitpe céd nochat a peacht. A naoi décc de Lughaid. Cath Inde Moipe hi cCpich ua nGabla pop Laignib, ⁊ pop Iollann, mac Dunlaing, la Muipefptach mac Eapca.

Aoir Cpiopt, cfitpe céd nochat a hocht. An pichftmad bliadain do Lughaid. Fepgup Mop, mac Eipc, mic Eathach Muinpeamaip, co na bpaitpib do dul ino Albain.

Aoir Cpiopt, cfitpe céd nochat a naoi. A haon pichft do Lughaid. Ceapban eappoc, ó Fiopt Cfpbain oc Teampaig, décc.

Cat Seagpa pia Muipefptach mac Epca pop Duach Tfnguma, pi Con-

The fate of the early long primer A type is not as easily traced. It fell into disuse about 1852, and statements that it was still available at the University Press in the 1950s with the above pica A type seem to be inaccurate. It does not appear in the press's 1961 type specimen booklet.

The title page of the *Annals* uses a double pica 24 point Irish letterform at the head of the page in a style which points to the second category of Petrie type referred to above as the later Petrie B type. This line was in fact an extremely well prepared wood block, cut for this particular purpose, the varying widths of the A being the only discernible indication that this line was not set from type. Correspondence between M. H. Gill and the Revd D. Foley and the Revd Evans adds interesting comment in this regard. In reply to a request to use two-line letters to begin each prayer in the planned publication of an Irish prayer book to correspond in appearance with an English edition ("each prayer or collect must begin with a 2-line letter"),[14] Gill points out that "With respect to the two-line letters . . . there is no type so large in the Irish character as would answer the purpose. . . . If these letters are to be inserted in this edition, it will involve the expense and delay of getting another, and for all other purposes a useless, fount of Irish type cut and cast."[15] Gill sent a printed sample to the Revd Evans, stating that "The larger letters in specimen 2 were cut in wood, in one block, for the work in which they were used, there being no fount of that size."[16] Two days later, on 22 April 1853, Gill again wrote to Evans: "It would make a great improvement in the appearance of the Prayer book to have two-line letters to correspond with the English, but there are no Irish letters large enough, and the cutting of the punches and casting of the type of a new fount for this special purpose (as it will be of little use for any other) would be expensive and would take three months to be completed."[17] Gill suggests that, in order to expedite matters, an initial print run be made without these letters during which time the large letters could be prepared for a later, more complete edition, which was to be stereotyped. On 29 April Evans replied that "We should be unwilling to incur the extra expense of casting a new fount of two-line letters. The larger letters in specimen 2 would do quite well; but if these cannot be had, then the work may be printed as in specimen 1."[18] A long delay followed, during which time it would appear that Gill obtained the two-line type. He informed Evans on 15 November 1854: "I have taken advantage of the delay which has arisen to procure a fount of two-line letters of the Irish characters for the commencement of the Prayers, to correspond in size with those used at the commencement of the English Prayers, as I felt that want of uniformity in this matter would not be creditable to the book or to the press."[19] Gill recorded having been paid for this fount on 24 December 1853: "Messrs Hodges & Smith Paid for cutting on wood [blank], stereotype casting

abcoeꝼᵹɩꝇmnop sꞇu

abcᴅeꝼᵹhɩʟmnopᚱsꞇu

a b c ᴅ e ꝼ ᵹ h ɩ ʟ m n o p ꞃ ꞃ ꞇ u

abcᴅeꝼᵹhɩʟmnopᚱsꞇu

a b c ᴅ e ꝼ ᵹ h ɩ ʟ m n o p ꞃ ꞃ ꞇ u

8.7 The 2-line drop initial capital letters from Riobeárd Ó Catháin's translation of the New Testament, 1858.

8.8 The Petrie B type, with the brevier (8 point) size above, enlarged to 320% approx., and the long primer (10 point) size below, enlarged to 280% approx.

mounting on types 17/3, and cutting down to type height, 138 two-line Primer Irish Capitals, for initial letters in Irish Prayer-Book."[20] These two-line letters were used to great effect as drop initial capitals in *Leabhar Imuinn* in 1855 and later in Riobeárd Ó Catháin's translation of the New Testament printed by Gill in 1858 (see ill. 8.7).[21]

In addition to this two-line set the later Petrie B type was also produced in two text sizes, 8 and 10 point (see ill. 8.8). The 8 point B type first appeared in the fourth volume of the *Proceedings of the Royal Irish Academy* (1850), printed by Gill, where on page 358 this revised fount is used in an illustration of the Ogham alphabet in a paper by the Revd Charles Graves (see ill. 8.9). The early long primer A type also appears in this work. Similarly the 8 point B type was used in the footnotes of *The Celtic Records of Ireland, An analysis of O'Donovan's edition of the Annals reprinted from the Irish Quarterly Review,* printed by Browne and Nolan in 1852, which also used the early long primer A type on page 48.

About this time the later 8 point Petrie B type replaced the early long primer A type, and was much used in the publications of the Royal Irish Academy and the Irish Archaeological Society. In *Leabhar Imuinn* (1855), the later 8 point B type is used to great effect, which prompted Lynam incorrectly to remark, with regard to the all-capital setting: "The Uncial type was used as an experiment in Dr Todd's *Leabhar Imuinn* and has never

been used since. Though a delight to look upon, it is, of course, only suitable for fine books of a special kind"[22] (see ill. 8.10 and 8.11).

What Lynam appears to have overlooked is that this "experimental" type in *Leabhar Imuinn* is in fact, with the addition of revised longer letters for L and B, the capital letters of the same type used in the body of the text of the same book, and much used in other works printed by the University Press at that time. The use of this type is mentioned in the introduction to *Leabhar Imuinn* with the now familiar statement: "This part of the work has been printed in a type which, although it does not pretend to be a facsimile, will give the reader a very correct idea of the characters in which the MS. is written."[23]

The later 10 point Petrie B type which, like the 8 point B type, shows many improvements on the earlier A version, first appeared in the fifth volume of the *Proceedings of the Royal Irish Academy*,[24] printed by M. H. Gill in 1853 (see ill. 8.12), which also uses the 8 point B type in the footnotes. With a possible reference to this later Petrie B type, Thaddeus Connellan states in a letter to M. H. Gill on 14 July 1848: "I hope you will take my request in good part, and labour to help me so that I may employ your *new* Irish type as soon as you get it . . .".[25] John O'Kelly, in his account of the Gill publishing firm, comments: "This was the new type for the Annals of the Four Masters."[26] However, as we have seen, the type used for the *Annals* was the earlier Petrie A style which was already available in 1835-39.

The later 10 point Petrie B type had a most refined appearance, with a

From this the transition was an easy one to the form in which it is commonly presented, viz.:

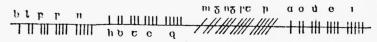

In fact, all that was necessary was to make the stem-strokes of the letters in the primitive alphabet continuous.

The next change made seems to have consisted in the addition of characters denoting diphthongs:

8.9 An example of the Ogham alphabet, 1850, which uses the Petrie B brevier (8 point) type to identify the Ogham strokes.

parce ōīe. Muʒint pecit hunc ꝯmnum hi putſṗna. Cauſa .ı. Pinnen maiʒe bile exit do poʒlaim co Muʒint, ⁊ Rióc, ⁊ Talmach ⁊ ceteri alii pecum. Dpurt pex bretan tunc, ⁊ habuit piliam .ı. Dpurtice nomen eiuſ, ⁊ dedit eam leʒendo co Muʒint, ⁊ amauit illa Rióc, ⁊ dixit Pinniano, Tribuam tibi omneſ libṗoſ quoſ habet Muʒint ꝛꝓibendum, ſi Rióc dediṫſeſ mihi in matṙimonium. Et miſit Pinnen Talmach ad ſe illa nocte in poṙman Rióc, ⁊ coʒnouit eam, ⁊ inde conceptuſ ac natuṙ eſt Lonán theote. Sed Dpurtice eṙtimauit quod Rióc eam coʒnouit, ⁊ dixit quod Rióc pateṙ eſſet pilii. Sed palſum eſt, quia Rióc uiṙiʒo puit. Iratuſ eſt Muʒint tunc, ⁊ miṙit quendam pueṙum in templum, ⁊ dixit ei ſi quiſ pṙiuſ in hac nocte ueniat ad te in templum peṙcute eum ſecuṙe. Ideo dixit quia pṙiuſ Pinnianuſ peṙʒebat ad templum. Sed tamen illa nocte, Domino inſtiʒante, ipſe Muʒint pṙiuſ eccleſie peṙuenit, ⁊ peṙcuſſit eum pueṙ, pṙopeta dicente, Conueṙtṙuṙ doloṙ eiuſ, ⁊ in ueṙticem ipſiuſ iniquitaſ eiuſ deſcendet. Et tunc dixit Muʒint, Paṙce, quia putauit inimicoſ populum populaṙi. Uel comad aiṙe do ʒnet in immunṙa aṙ na tanta a chin pṙon in popul. Uel Ambroṙiuſ pecit dia mbai i nʒalur. Uel Dauid pecit, ut alii dicunt, ſed non ueṙum, act iſ huad tucad Dic anʒelo tuo peṙcutienti, uṙque populo tuo.

8.10 An example of text using the Petrie B brevier (8 point) type, from *Leabhar Imuinn*, 1855.

8.11 The all-capital use of the 8 point Petrie B type, with alternative sorts of B, H and L, from *Leabhar Imuinn*, 1855.

cauimus tibi domine et tu iratus es nobis et non est qui

4 eppuʒiat manum tuam. Sed supplicemus ut ueniat super nos misericordia tua domine qui in ninuen pepercisti inuocantes

5 dominum. Exclamemus ut respicias populum tuum concul-catum et dolentem et proteʒas templum sanctum tuum ne ab impiis contaminetur et misereais nimis afflicte ciuitati

6 tue. Exclamamus omnes ad dominum dicentes.

7 Peccauimus tibi domine peccauimus patientiam habe in nobis et erue nos a malis que quotidie crescunt super

8 nos. Dimitte domine peccato populi tui secundum multitu-dinem misericordie tue.

9 Propitius fuisti patribus nostris propitius esto nobis

10 et implebitur ʒloria tua in uniuersa tua. Recordare domine dic anʒelo tuo percutienti populum tuum sufficit. contene manum tuam et cesset interfectio que ʒrassatur in populo ut non perdas omnem animam uiuentem.

11 Exurʒe domine adiuua nos et redime nos propter N. T.

balance in the weight of its strokes. It stood upright and had an even colour on the page. This size, if noted, would have pleased Lynam, for he stated regarding his figure 16 of the 8 point B type: "It is a great pity that the design of the Long Primer type was not attempted on a Small Pica body, for its smallness is the only fault this type possesses."[27]

It is little wonder that these types, particularly the later version, attracted such praise, for it was a face which, for the first time, compared favourably with the refined qualities of some of the better roman faces of the time, while retaining the unique and distinguishing features of the Irish form. Johnson, in his edition of Reed's *History of the Old English Letter Foundries,* states towards the end of his chapter on Irish typefaces: "It is impossible to enumerate all the new founts cut subsequently in the nineteenth century, but mention must be made of the fine design used by the Irish Archaeological Society from 1841."[28]

The 8 and 10 point B type continued to be a popular choice for the printing of Irish in many of the publications of the Royal Irish Academy and the Irish Archaeological Society, and for many books, primers and grammars on the Irish language. The 10 point B type was used to print the New Testament translated by Riobeárd Ó Catháin.[29] The early pica A type was also used on the title page and for chapter heads throughout. Concerning this work the following comment appeared in *Notes and Queries:* "In enumerating Irish versions of the scriptures, I venture to call the attention of collectors to the Irish New Testament (Munster dialect) by Robert Keane, of Eccles St., Dublin—or, as he subscribes on the title page, adopting his ancient tribal surname, O'Catain. Only a few score copies of this uncommonly beautiful edition were printed, the expense being considerable . . . ; it is a small 4to. on good paper of even quality, substantially bound, and printed by Gill of Trinity College, Dublin, in Irish type, the clearest and easiest to the eye I have ever seen."[30]

The 8 and 10 point B type was used by the University Press for the setting of Irish examination papers for Trinity College and the National University of Ireland, which reveal some interesting features. The Trinity papers from 1860 to 1957 use the later 8 point B type which is set sometimes in conjunction with the so-called Keating Society type and with the later Figgins type (to be discussed in the following chapter), and also frequently with roman type used for setting Irish. There seems to have been a pattern in the use of the Petrie type in so far as the later 8 point B was consistently used for the Irish entrance examinations. It was often set together with roman type in the freshman term examinations, while the senior and degree papers were more often set in roman type alone from the 1920s onward. In some instances the Petrie type was set together with the later Figgins and roman types in the same examination paper, while the papers in the Celtic languages department were consistently set in the roman

ṁaṗḃċa ċum mo ṫiże, ażaṗ ażcáṗ naċ mbiaḋ na baċ ṗin aṗ ṗażail ḃeaṗaiḋ an ḃṗian huaṗ ażaṗ a oiżṗioż ḋaṁṗa ażaṗ ḋom oiż-ṗiḃ am ḋiaiż ḋa ṁaṗż ⁊ ḋá ṗiċiṫ maṗż aṗ ṗon na mbo céaḋna huaṗ. Ażaṗ aṗ na haḃaṗuiḃ ceaḋna aṫaimṗe ḋom ċeanżal ṗéin ⁊ aż cceanżal moiżṗioż um ḋiaiż żo ḋeiṗioż an ḃeaċa na ṗeaṗainn ṗin moille le na ḋtoṗċuiḃ maṗa ażaṗ ċíṗe ḋo ṗeaṗaṁ ażaṗ ḋo ċoinnṁeil ḋon mbṗiain ḃiocaiṗe Mhażaoḋ huaṗ ḋo ṗéin ⁊ ḋa oiżṗiḃ na ḋiaiż żo ṗioṗċuiże ażaṗ żo ḋeiṗeaż an ḃeaċa: ażaṗ aṗ iaḋ ṗo na ṗeaṗainn ṗin ḋo ċużaṗ ḋo ṗéin ażaṗ ḋá oiżṗiḃ na ḋiaiż żo ṗioṗċuiże ṗuċain; [eaḋon], baile bioṗṗa, Maċaiṗe leaṗża ṗiaḋoiże, Cionnṫṗaża, Żṗaṗṫol, Tocamol, Wreggoge; Da żleann aḃṗṫol, Cṗacoḃuṗ, Coṗnuḃuṗ, aż.iṗ baile Néachtain. Ażaṗ ionṅuṗ żo mbiaiḋ bṗiż neaṗṫ ażaṗ láiḋi-ṗeaċṫ aż an mbṗonṫanaṗ ṗo ḃeiṗiom ḋon mbṗian ṫuaṗ ażaṗ ḋá oiżṗiḃ na ḋiaiḋ, ceanżlam aṗíṗ me ṗéin ⁊ moiżṗioż mo ḋiaiż żo ṗioṗċuiże an cunṗaż ⁊ an bṗonṫanaṗ ṗo ḃo ṗeaṗa ⁊ ḋo ċuinn-ḃeil aṗ buil ḋon mbṗian ṗeiṁṗaiṫe ⁊ ḋa oiżṗiż na ḋiaiḋ żo ḋeiṗioż an ḃeaċa le cuṗ mo láiṁe ⁊ mo ṗeala annṗo ṗíoṗ a laċaiṗ na ḃṗiażainn ṗo ṗíoṗ; ażaṗ an ṗeiṗeaṁ lá ḋo ṁíṗ na bealṫuine ażaṗ an ḃliaḋanṗa ḋo ḃṗeiṫ Cṗioṗṫa Mile ceiṫṗi ceaḋ ażaṗ a hoċṫ.

Mac Doṁnaill,

character. In 1939 the Church of Ireland Training College examinations made an unusual use of the 8 point Petrie B type for the setting of the Algebra paper through Irish, in which the traditional lower case r and s were replaced with a different fount capital R and S, as though the compiler had anticipated difficulties on the part of those taking the examination in understanding these characters. The uncontaminated fount was used in the same year for the Trinity College entrance examinations. In 1942 a taller version of the capital B was used, and in 1951 the later 10 point Petrie B type made a rare appearance in the junior freshman Hilary examinations. From 1953 the Intertype Modern (to be discussed in the next chapter), frequently appeared, again often in conjunction with roman type. The later 8 point B type continued to be used, particularly in the entrance examinations, until 1957 when it seems to have been used for the last time.

Similarly the National University of Ireland used the Petrie type for the setting of its examinations in Irish. It preferred to use the later 10 point B size. The University College, Dublin, papers made use of the earlier A pica size for the title heading reading "Coláiste na hOllscoile", which continued

to be used until 1947. Like in the Trinity College papers, the Petrie type was often mixed with later Figgins, Intertype or roman faces. University College, Dublin, last used the 10 point Petrie B type in 1952.

The later 8 point and 10 point B, and earlier A pica types remained at the University Press and were shown in its type specimen booklet of 1961. The fate of this excellent series of type remains somewhat unclear. Colm Ó Lochlainn, writing in *Progress in Irish Printing* in 1936, says that "the Punches and Matrices . . . are still in the possession of the University Press".[31]

Liala Allman, who returned from England to work at the University Press for her father in 1945, recalls having seeing a box of punches of the Petrie type at that time. The point size of these punches is unknown and Ms Allman suggests that they were destroyed in the fire at the University Press in 1965, for she is quite certain that they were not recorded in stock checks after the fire. Desmond Ryan, who was an apprentice compositor in the University Press in the late 1940s, also remembers seeing the box of punches at that time. Liam Miller of the Dolmen Press, who used the pica type in 1953, recalled having seen two cases of the Petrie type at the Brunswick Press at Gilford Road, Dublin to which location the University Press transferred in 1975; however, searches for these types in the stores of the Brunswick Press at Gilford Road in 1986 were unsuccessful. Brian Allman, a director of the press, is of the opinion that the cases of Petrie type may have been discarded in error during a clean-up operation. Hence the only remains of this excellent type is one fairly well stocked case of the later 10 point B size held at the Trinity Closet Press in the Old Printing House in Trinity College.

Regarding the preparation of the punches and matrices for the early Petrie A type there is no firm evidence that identifies those originally involved. As mentioned above, the matrices were said to have been executed under the care of Petrie. Later, in June 1845, the foundry of Messrs Figgins replied to a query by M. H. Gill, concerning the production of Irish type which establishes that this firm was at least consulted on this matter at a time when the production of the later Petrie B types may have been under consideration by Gill. The reply states: "The letters printed on the slope are the ones we have. We do not find any like the 7 [the abbreviation for *agus*] used at the side, nor do we know where to procure them. Ours is the fount used at Oxford and Eton as well as by Mr Taylor and the other classical printers in London, and we shall be glad to know whether we are to cast what we have. The German printers have an almost unlimited number of accents and marks, a great many of which, in roman and Greek, have lately been introduced here."[32] Colm Ó Lochlainn and later Liam Miller were of the opinion that the firm of Vincent Figgins was involved in the punch cutting.[33] The only foundry listed as being active in Dublin at the time of the production of the early A founts was that of James Christie,

abcᴅefʒhilmnoᴘʀsᴄu
a b c ᴅ e f ʒ h i l m n o p ꞃ ꞅ ᴄ u

while the Wilson foundry, which began trading in 1840, is listed in *The
Almanac of Dublin* for 1841 as "Wilson Alex. and Sons, Typefounders, 9
Liffey St.", and in 1842 and 1843 as "Wilson Alex. and Sons, Irish letter
Foundry, 9 Liffey St." However, the firm of James Marr, which had
acquired the Wilson foundry, in 1845 and was joined in partnership two
years later by Alex. Thom, was involved in the production of punches and
matrices for at least some additional replacement sorts for the early pica,
and for some of the later long primer and brevier founts, as is indicated in
the "Account Book" of the Dublin University Press in an entry dated 17
March 1854: "Cr. Marr, Thom & Co. Cutting Punches for Pica, L. Primer,
& Brevier Irish sorts (chiefly accented letters) & justifying Matrices from
May 17th to Dec. 6th 1853 £25–19–0."[34] Marr also provided the Univer-
sity Press with cast type,[35] and this service was later continued by William
Miller who succeeded Marr in 1864. Unfortunately the present management
of Wm. Miller and Sons have no record of work done by them involving
the Petrie type.

The third category, identified above as the Petrie C type (see ill. 8.13),
has been generally referred to as "Thom's Archaeological Society Type"
because it was used mostly for the Archaeological and Celtic Society pub-
lications printed by Alex. Thom. Petrie was in fact the designer of this type
also, as is indicated in the above-mentioned editor's introduction to Eugene
O'Curry's translation of "The Sick-bed of Cuchulainn", in which "two
forms of type cast within the last few years" are mentioned, the first of
which, the Petrie A type, is described earlier in this chapter. He continues:
"The second is a new type, differing very little from the last named, and
also cut from drawings by Dr Petrie, which has been lately manufactured
for Mr Alexander Thom, the Government Printer."[36] That this type was
available as early as 1856 is established in a letter from John Pigott to Dr
Newman. On making enquiries into the availability of suitable Irish type
for the printing of O'Curry's lectures, Pigott makes interesting reference to
the origins of this so-called Thom's type. He states: "I have ascertained
that Thom *has already* procured a new Irish type,—cut from drawings by
Dr Petrie,—which is undoubtedly, a very good type, although not what
Dr O'Donovan and Mr Curry would consider the *best* in form, being

[Aʒ loıʒe meıch, oċt nðuıꞃn a tımcomac, ꞃlan o cull,
la blıchtu ı ꞃeoꞃ, ðo emeat a ða lon a ðıa aꞃaınð, acht
moð ꞃoꞃtallaınn tꞃı meꞃ, nacha tꞃaetha teıðm ꞃıch-
naıꞃı na ʒalaꞃ, acht aıðıð ꞃıuꞃ ı nalaꞃ; ocuꞃ taꞃꞃ
loıʒı meıch laıꞃ, naoı nðuıꞃn a' ꞃot, aıꞃtem a leıthet
aꞃꞃuı ıaꞃ naıꞃċuꞃ, ðoꞃn leıthet aꞃꞃaı a nıaꞃthuꞃ, tꞃı
ðuıꞃn a leıthet aꞃ a meðon, tꞃı meꞃ a tıʒet a meðon;
ocuꞃ mıach bꞃacha, ðo bꞃach eoꞃna a aꞃðtꞃeıchem;
talman ðo mıntıꞃe tꞃı mecon, cona tuꞃ, techta aꞃtaıꞃ
ın tꞃı laıthe a mı maꞃta.

Mac Sʒaꞃtʒıl aꞃ Coꞃco Moʒa; aʒuꞃ O'Bꞃaoın aꞃ loch nʒeal-
ʒoꞃa; O'Maılle aꞃ ða Umall; O'Talchaꞃaın aꞃ Conmaıcne
Cuıle; aʒuꞃ O'Caola aꞃ Conmaıcne maꞃa; Mac Conꞃoı aꞃ
Ꞡnomóın; aʒuꞃ O'hAðnaıð aꞃ Ꞡnombıcc; Mac Aoða aꞃ Cloınn
Coꞃꞃꞃaʒ; O'Flaıtbeaꞃtaıʒ aꞃ Muıntıꞃ Muꞃchaða; O'hEıðın,
aʒuꞃ Mac Ꞡıollacheallaıʒ, aʒuꞃ hUı Cleıꞃıʒh, aꞃ Uıð Fıachꞃach
Fınn; aʒuꞃ O'Ðuıbʒıolla aꞃ Chenel Chınðʒamna; aʒuꞃ Mac
Fıachꞃa aꞃ Oʒaıð beathꞃa; aʒuꞃ O'Cataın aꞃ Ceñel Séðna;
aʒuꞃ O'Maʒna aꞃ Chaenꞃaıʒe; O'Seachnaꞃaıʒ aʒuꞃ O'Cathaıl,
ða tıʒeaꞃna Ceneoıl Aeða.

ın taıʒe ıꞃıꞃ ða tech, aċt ına ðo ꞃuaċt aıʒe a comaıt ðon
ꞃlaıt cu tꞃath ꞃeıꞃı ıꞃlan. Maıne toꞃaċt aınꞃeın, ocuꞃ ðo
ꞃuaċt maꞃ aon ꞃe ꞃuıʒéll aꞃ maıtın, ıꞃ ðıablað ocuꞃ nocò nꞃuıl
ın ıꞃ mo ına ꞃın annı, no coꞃo ꞃuıꞃʒıthuꞃ tꞃe ꞃaıll ꞃꞃıchnuma;
ocuꞃ o ꞃuıꞃıechtuıꞃ, ıꞃ cumal annı ocuꞃ ðıablað ocuꞃ eıneclunn.
Ꞁo ðono ċena, ıꞃ ðıablað annı ma ðo ꞃuaċt tꞃat ꞃeıꞃı, ocuꞃ muna
toꞃaċt annı ꞃeın ıꞃ cumal ocuꞃ ðıablað; ðo ꞃuaċt maꞃ aon ꞃe
ꞃuıʒell aꞃ maıtın, ocuꞃ maıne toꞃaċt, ıꞃ ꞃıach ꞃaılle ꞃꞃıchnuma
annı o ꞃın amach, cumal ocuꞃ ðıablað ocuꞃ eıneclunn.

Aʒ loıʒe meıch, .ı. aʒ ðanað loʒ mıach cꞃuıtneaċta, ꞃꞃeapall
a loʒ, ocuꞃ tꞃı ꞃamaıꞃcı a ꞃath. A tımcomac, .ı. a tımceall ın aıʒe.
O cull, .ı. o buaın aꞃ. la blıchtu, .ı. còmcuınað ðo ꞃıꞃ na buaıb
bloaċta ac ʒleıt ın ꞃeoıꞃ. Ðo emeat, .ı. ðo emeat no tuıʒıt a ða
lon a ða aꞃaınn. Foꞃtallaınn tꞃı meꞃ, .ı. meıt Ꞁo, nað, .ı. ınað
cınn tꞃı meꞃ ıꞃꞃeð ꞃo ðıtuınn a bıt ðo caċ aꞃaınn ðıb, .ı. tıc met aꞃ
a aꞃaınn lethet tꞃı meꞃ. Nach tꞃaetha teıðm, .ı. nocu mıllenn hı
teıðm, .ı. bꞃꞃtı na ʒalaꞃ naꞃın bı uıꞃꞃı. Acht aıðıð, .ı. acht
maıðeð ꞃıꞃın haıleð he; ın tuað ða maꞃbað. Taꞃꞃ loıʒı meıch,

8.14 Examples of
text using the range
of Petrie C types in
14, 12, 11 and 10
point sizes. The
12 point sample
was taken from the
*Topographical Poems
of O'Dubhagain and
O'hUidhrin*, 1862,
and the other
samples from the
*Ancient Laws of
Ireland*, 1869.

αδcδεϝ ʒhιℓℾⱮNOpRSCU

a b c δ e ϝ ʒ h ι l Ɱ n o p ᵱ ᵲ ᴄ u

8.15 The Vienna
Keltish (New) Irish
type modelled on
the Petrie A fount,
enlarged to 320%
approx.

8.16 Example of
text using the
Vienna Irish type of
1845, which was
modelled on the
Petrie A fount,
from *Geschichte
der Schrift*, 1880.

Cn Nachaíp acá ap neaṁ, Náoṁċap ċainm. Cigeaḋ ḋo píoᵹaḋ. Ḋeṽn-
·ᴄap ḋo ċoil ap an ᴄᴄalaṁ, map ḋo niᵺᵱ ap neaṁ. Cn napán laéᴄaṁail ᴄaḃaip
ḋṽnn a niṽᵹ. Cᵹᵲ maiᴄ ḋṽnn ap ḃpíaᴄa, map ṁaiᴄṁḃne ḋap ḃᵱéiᴄeaṁnᵹḃ
(ᵱein). Cᵹᵲ na léiᵹ ᵱinn a ccáᴄᵹᵹaḋ, aᴄḋ ᵱáop iṅ ṽ olc: Oip iᵲ leaᴄḋ ᵱéin an
píoᵹaḋ, aᵹᵲ anċṽṁaḋ, aᵹᵲ an ᵹloíp, ᵹo píóṁᵹᵱe. Cmen.

nearly that of the type now used by Gill at the printing office of Trin
Coll." He continues: "I saw Thom and he told me that he did not intend,
anymore than Gill, to sell his new type,—but he also said he 'would not be
found churlish about it', if asked for a small quantity for any particular
purpose."[37]

The appearance of this type represents a step backwards in the develop-
ment of this round Irish style, with its complicated and ornamental forms,
awkwardly attempting to accommodate the pen stroke of the scribe with
the mechanical order of a printing type. This version of the type was
available in four sizes, 14, 12, 11 and 10 point; but because, unlike the
Petrie A and B styles, the ascenders to the capital letters B, H and L extend
beyond the height of the other capitals, these founts seem small and
appear, therefore, as if in 12, 11, 10 and 8 point sizes (see ill. 8.14). The 12
point had a number of characters E, L, b and l different in form from the
other sizes.

It is appropriate to mention here that another type modelled on the
early Petrie design was produced in Vienna in 1845 (see ill. 8.15), and
appeared in the alphabet section of *The Bible of Every Land* in 1851. This
book illustrates a number of foreign alphabets regarding which the pub-
lishers note the difficulties they experienced collecting examples of the
various required printing types[38] (cf. page 49 above).

This type (8 point size) appears as Keltisch (New) in the type specimens
of the State Printing House, Vienna, 1910 and it would seem that a set of
matrices may have passed to Gilbert and Rivington, typefounders, for it

appears as Brevier Irish in their *Specimens of Foreign Types* in 1880. Dr Anton Durstmuller confirms that Alois Auer who was made Director of the Imperial Printing House on 24 January 1841 had a great interest in foreign printing types. He prepared a much praised Turkish type in 1844 which led to a direction from the Imperial Court to prepare a range of foreign types for the Third General Austrian Trade Fair of 15 May 1845. For this the printing house prepared 5,500 steel punches and 10,000 matrices in 60 foreign alphabets, which are reproduced in Auer's *Typenschau des gesamten Erdkreises*, Vienna, 1844. This range of types was loaned to foreign printers including the publishers of *The Bible of Every Land*. The typefaces were prepared by the State Printing House with the co-operation of local and foreign experts.[39] Two Irish types were produced there, one based on the Rome type of 1676 and referred to as Old Irish, and the other based on the early long primer Petrie A type. Specimens of these types appear also in Carl Faulman's *Das Buch der Schrift,* Vienna, 1878, and *Geschichte der Schrift,* Leipzig, 1880 (see ill. 8.16).

THE NEWMAN IRISH TYPE

IT IS PERHAPS IRONIC that the term "modern" should be used to describe a number of Irish types, which, in the wake of the rounder form of the earlier Petrie faces, in fact looked to the more angular minuscule influence for some of their key letters—a feature more typical of the traditional faces. The first typeface in this style was prepared specifically for the Catholic University of Ireland in 1857 by George Petrie, further establishing the significance of his contribution to Irish type design (see ill. 9.1). It was commissioned by John Henry Newman (later Cardinal), the rector of the university, and therefore, in order to avoid confusion in name with the earlier round Petrie designs, it seems more correct and appropriate that this type, heretofore generally referred to as the Keating Society type (because it was much used by that society for its publications), be called the Newman Irish type. Detail of this development is contained in a series of unpublished letters to Newman from his associate, John Edward Pigott. In a letter of 22 April 1856, giving an account of plans for the publishing of Eugene O'Curry's lectures, Pigott writes:

> In the course of his lectures many examples and extracted passages occur in the old Gaedhilg language; and it is to the correct printing of matter in that language that he feels (and I too, who have been for some years interested [in] the reprinting of ancient Irish MSS, and pretty well conversant with what has been done and what at present can be done in Dublin in this department), some anxiety There are accordingly in Dublin several different founts of Irish type, and I believe some 7 or 8 printing offices are supplied with one or more of these. Unfortunately all the founts in use are (with one exception) not only very ill designed, as regards elegance of form, 'face' . . . , but even seriously incorrect in so far as they all contain many letters wholly barbarous and quite wide of the Irish form. Such type would of course be open to objections of several kinds, which would render it quite unsuitable to publications issued from a "University Press"—and which issuing thence must be expected to bear a character of being as much as possible models of correctness in detail, and even of a certain grave elegance in general effect.

He continues

> The one exceptional fount I have alluded to is one constructed some years ago after drawings made by Dr Petrie (I believe for the authorities of the Ordnance

Survey), and which is the property of Mr George Smith of Grafton Street, the publisher to the Protestant University. That type is not suffered to be used except in the College Printing Office [TCD]—where the publications of the Archaeological Society, and the first volumes of the Celtic Society, as well as O'Donovan's Annals of the Four Masters were printed from it. In the case of the publications of a society lately established under Dr Petrie's presidence for the investigation of ancient Irish *Music*—in whose volumes but so much Irish type is required as may suffice for the text of a *very* few songs,—even Dr Petrie himself was unable to procure, either for money or as a friendly loan, *any* part of this fount of Mr Smith's: and that Society was eventually *driven* to make arrangements for printing, though at a greatly advanced price, in the College Printing Office.[1] The use of that type is therefore of course out of the question in works to issue from the Catholic University Press. The conclusion has therefore forced itself on Mr Curry and myself that for the new University Press a *new* fount of good Irish type must be specially cast. . . . If what I have stated with reference to the use of Irish type, and the deficiencies of all procurable type in that character, be correct (and of this I can take it upon myself to assure you very confidently), it must be quite clear that the possession of a new fount of Irish type would be indispensable to the intended establish-

9.1 The Newman type from *The Atlantis*, 1858.

ment of a University Press. Fortunately the expense need not be very great at first: and it is probable that a permanent demand for the improved types, cast in the matrixes which you would cause to be cut, would reduce the risk of even this first outlay. What occurs to me to propose for your consideration, there, as the most economical mode of making a beginning is this. To consider and settle at once what is to be the size, "face", and character of the *Roman* type to be employed in the text, and in the notes (say two sizes only), of the volumes to be issued,—I presume they would be uniform in style and form,— by the Catholic University Press. And having settled these sizes exactly, to procure accurate designs for a perfect Irish type, and cause matrixes to be made of it in two sizes corresponding perfectly with the selected sizes and 'face' of the Roman: contenting yourself for the present with *only* these two sizes of Irish type, which would be, I think, abundantly sufficient in practice, for at least a considerable time to come. I believe the cutting of matrixes for so much type would cost in round numbers from about £150 to £180. The forms adopted by Dr Petrie for the type I have referred to are all very even and rounded. They are I believe the correct forms of the letters used for *Latin* writing,—and for the capitals on stone inscriptions,—in the early Christian times. But they are not the forms of *any* of the good *Irish* writing (even of those early times) now known to us. The best forms of Irish writing are in many respects very different in design, and of these there is an abundance of exquisitely perfect examples in the *Leabhar Breac*, at the Academy, and in some other cele- brated vellum MSS accessible to us. I should then take the liberty of suggesting that a series of forms should be selected from these authorities by Mr Curry, that these should be submitted for the opinion of Dr Petrie, of Dr O'Donovan, and others if desirable,—(and this I could myself undertake to have done),— and that working drawings should be made of those selected, also under Mr Curry's direction, for the type founder. Including the expense of making these drawings I believe the whole may be properly completed within £200. Perhaps it may appear premature to lay before you these suggestions just now. But I beg you to remember that the necessary preparations for the Irish type must occupy some 2 or perhaps 3 months, at least; and that these preparations should be commenced now, *at once*, if you would have Mr Curry's most valuable and suggestive lectures printed early enough to be before the world before your November Term, and made use of (as I hope they effectively may) as a substantial advertisement of the solidity as well as the Nationality of the University. If the plan I have taken the liberty to suggest should meet your approbation I should be happy to make all the preliminary enquiries myself,— if this could save you any trouble,—and to ascertain for you as early as possible by estimates the exact expense that would be necessary.[2]

Following on these suggestions Pigott again wrote to Newman on 20 December, 1856 (mentioning, as indicated above, the availability of the Petrie C or so-called Thom type).

Under these circumstances I think we may count on procuring enough of this

type at least to print what of Irish will occur in Mr. Curry's Lectures. And a little later the subject of procuring a new and better fount may be considered, when a larger supply of type shall become necessary,—and when perhaps a University Printer, seeing his way, may be inclined to go large share in the expense, if not to take it all on himself.[3]

Pigott goes on strongly to recommend Browne and Nolan for the position of University Printer. A month later Pigott again writes to Newman:

I called on Fowler His estimate [for the printing of O'Curry's lectures] was . . . rough, yet quiet precise enough for my purpose. However I thought it in some respects rather too high, and as regards the use of Irish type, extrava-gant . . . Neither Fowler nor B & N have at present Irish type. But Fowler would procure as much as might be necessary . . . As to [setting] *Irish,* he said the introduction *of three or four words* to the page, here and there, would cause an increase of about 3/- or 4/- a sheet, and he insisted that if several lines (suppose half a page or a page) of Irish were inserted in a sheet he should charge as if the whole *sheet* were in Irish type. As to the price of composition of *Irish* type, he told me it was to that of English (according to Printer's scale) in the proportion of 16 to 11. . . . I should remind you that the first step must be to apply to Mr Thom for some type, and that there should be no unneces-sary delay in doing this. If Mr Thom should refuse it, again, the subject must again be discussed of getting new type manufactured. I have, however, had enquiries made as to this (through Browne and Nolan, who were kind enough to write to Sheffield and London for me) and find that *matrices* can be cut, by the best cutters, for about 13/6 each: so that, as I calculate, for *Two Alphabets,* cut to order, including Capitals and small letters, and the eight *dotted* letters used in Irish, the whole could be cut for about £86. or say (including the expense of the *design and drawings*) in round numbers £100. The printer would obtain, at his own expense, as much type *cast* from matrices so purchased by you, as you should order: that being the practice of the trade, and he would probably bear part of the expense of the cutting itself.[4]

It would seem that the Thom type was not made available, for Fowler, who was the printer selected for the university, states in an undated note to Newman: "M. Pigott called on me last week, and left me designs for the Irish types. These I at once gave to the type-founder, and they are now in the hands of the punch-cutters. I hope soon to be able to send impressions of some of the letters for your inspection and I trust approval".[5] In this regard, Newman wrote to W. K. Sullivan: "Mr Currie's [article 'The Sick-bed of Cuchulainn' for *Atlantis*] should go to the printer as soon as the type is ready";[6] and later: "I have a portion of Mr Curry's [article] send to me by Fowler, and was very much pleased with it. The Irish type is a very beautiful one, but I do not understand its merits, and my praise is worth nothing."[7] Later, recalling these events, in his account of his efforts in

Ireland, Cardinal Newman made an interesting reference to the Irish type: "Also, in the course of a year or two, I went to the expense of having a font of Irish type cast for the use of the University; there being up to that time only the Trinity College type, and I think one other."[8]

In the introduction to the Eugene O'Curry's translation of "The Sick-bed of Cuchulainn", in the first volume of *Atlantis* (1858), a detailed account of the type and its origins appears, which hitherto has gone unnoticed. It further identifies George Petrie as the designer of this type also: "In printing the following article in the Atlantis, it is right to call the particular attention of the reader to the beautiful Irish type here for the first time employed— a type expressly cut for the Printing Office of the Catholic University, and the forms of which have been selected from the earliest original authorities. For the designs of these forms for the founder, the editors, J. H. Newman and W. K. Sullivan, are indebted to the kindness of one of the most accomplished of Irish artists, as well as our most learned of antiquaries, Dr George Petrie, PRHA."

After criticizing all other existing Irish types, with the expressed exception of the early and later Petrie round types and that type later produced for Alex. Thom and Co. which was also designed by Petrie, the editors continue: "These [early Petrie] forms are much more rounded than those of the beautiful letters now for the first time employed, and the use of them in Irish writing is considered by some antiquaries prior in point of date. Other authorities, however, are of opinion that the more angular forms of the letters from which the present types are designed, are quite as ancient. . . . The rounded form seems to have been almost always used in the transcription of Latin pieces, and for writing in what we should now call capital letters. On the other hand the angular form seems to have been always preferred, if not invariably used, in transcribing pieces, and even mere occasional sentences, in the Irish language. . . . The forms adopted in the present type have been carefully drawn by Dr Petrie from those of the Book of Hymns, in which will be found the exact facsimiles of every form among them; and this was done after a critical examination by Dr Petrie and Mr Curry, not only of the various forms used in the Liber Hymnorum (which is one of the most beautifully written MSS. in existence), but of those occurring in all the other early vellum MSS. in Dublin more particularly remarkable for careful calligraphy." The editors identify the specific manuscripts studied by Petrie and O'Curry as Liber Hymnorum, Leabhar Breac, the Astronomical Tract (18.5. R.I.A.), a fragment of the Laws, bound up at the end of a copy of the Felire Aengus (43.6. R.I.A.), together with other MS fragments (35.5 and 46.6. R.I.A.), and (H.3.18 T.C.D.), and they conclude: "These are then the authorities for every letter of the present type, which may perhaps be regarded as the most perfect, if not the first perfectly correct, Irish type ever cut."[9]

Ceal-airm—*a hiding place,*
Run-airm—*a council-chamber,*
Feur-airm—*a hayloft,*
Sun-airm—*a sleeping place,*

[1] There is another form cnuaraig—*collect,* and from this is, perhaps. derived the English word *nosegay,* which has nothing to say to the word *nose,* to which it is generally referred.

Dála an iarṁair do clannaib Neiṁead, do fuiriġ aġ áitiuġad Éireann d'éir na dtaoireać roin; bádar aġ a [12] ġcoṁṁbuaidṙead aġ Foṁórćaib ó aimrir ġo haimrir, ġo rioćtain do flioćt Simeoin bric mic Staipn mic Neiṁead i n-Éirinn ó'n nġréiġ. Seaċt mbliadna deuġ ar dá ćéad ó [15] teaċt do Neiṁead i n-Éirinn ġo teaċt fear mbolġ innte, [16] aṁail dearbar an rann ro :—

Seaċt mbliadna deuġ ir dá ćéad—
Re a n-áireaṁ, ní hiomairbréġ,—
Ó táinig Neiṁead a n-oir,
Tar muir ġo n-a ṁór-ṁacaib
Ġo dtángavar clanna Staipn
Ar an nġréiġ uaċṁair, aġġairb.—

9.2 The re-cast
small pica and
brevier Newman
type, produced by
Sir Charles Reed
and Co. for the
Dublin University
Press *c.*1874, from
Erunda, 1875
(above), and from
Keating's *History
of Ireland,* 1902
edition (below).
Note the odd angle
of the lower-case a
in the larger size as
compared with the
original Newman
fount.

This typeface, modelled by Petrie on the more angular minuscule forms which were the inspiration for most of the types produced to date, was the first in this style to achieve a neutral remove from the calligraphic idiosyncrasies associated with many of its forerunners. It is orderly and upright with well proportioned individual letters that relate well to one another in the formation of text. The capital letters, however, stand out in a spotty manner as the weight of their strokes is disproportionate to that of the lower-case letters.

Apart from the fact, noted above, that Fowler was in a position to pass on the designs for the type to the founder without delay and was able to report on progress within a week (which would suggest a local type foundry), no firm evidence of the foundry involved has been uncovered. Since this type does not appear in any of the type specimen books of the English foundries, and since the foundry of James Marr was the only one operating at the time in Dublin, it is not unreasonable to attribute the punch and foundry work for this fount also to Marr. The foundry of Alexander and Patrick Wilson of 9 Liffey Street had been acquired by Marr in 1845, who moved it to Middle Abbey Street, trading as "James Marr and Co., Irish

Letter Foundry, successors to A. and P. Wilson, type founders and printer's joiners".

An unusual form of this type appeared about 1875 which has resulted in considerable confusion in identifying types in this so-called "modern" category. This fount was identical to the Newman type, with the exception of its lower-case a which was cast at an acute angle. This variation may have resulted simply from an error in casting, for the only difference was in the angle of the a. This odd fount was used perhaps for the first time in *Ereuna or An Investigation of the Elymons of Words and Names, Classical and Scriptual, through the Medium of Celtic,* "by a Celtophile" (Francis Crawford) printed in 1875 at the University Press by Ponsonby and Murphy (see ill. 9.2).

This small pica "odd" fount had an accompanying smaller brevier size which did not contain any irregular features and therefore was identical to the earlier Newman brevier. There is little doubt that these were the two types that baffled Lynam when he wrote: "Two founts of Irish type, a Small Pica and a Brevier, which Sir Charles Reed and Sons made for the Dublin University Press in 1874 and sent over along with the matrices, were not, it seems, available, and, indeed, have never been heard of since, as far as I can discover."[10] Lynam gives no source for this information. Because the Marr foundry, the likely originator of the Newman fount, had ceased to trade in 1864, it is quite possible that the matrices were sent to Charles Reed and Sons who then supplied Dublin University Press with the two founts in question, the small pica size containing the odd angled a.

As has been noted, the Newman type had a profound influence on a number of typefaces produced towards the end of the nineteenth and early twentieth centuries. At this time there was a marked increase in the volume of material being printed in Irish—which in turn led to a greater demand for suitable Irish type. In 1897 the London firm of James Figgins produced a fount modelled directly on the Newman face, and although design credit for this later Figgins type has been attributed to Pádruig Ó Briain, a printer and publisher of Cuffe Street, Dublin, it is so like its source of influence that it can hardly be said to represent a new design at all, the main difference between them being that the ascenders and descenders were shortened in the later version giving the main body of many letters a bolder, more robust appearance (see ills. 9.3 and 9.11).

The Figgins version was used in the *Full Report of the Irish Literary Festival,* printed for the Gaelic League by B. Doyle, in 1897 and it was later used to print *An Claidheamh Soluis,* the weekly paper of the Gaelic League, beginning in March 1899. Apparently impressed with the appearance of *An Claidheamh Soluis,* the readers of *The Gael* in New York sought, through their letters to the editor, a similar typographic innovation for their journal. In reply the editor commented: "The Gaelic pages will be printed from new and clear Irish types just as soon as they can be brought over from

124

GAELIC ON SMALL PICA BODY.

Aʃ an aóóaʃ ʃin, iʃ cóiʃ aguʃ iʃ iomcuóaió óuinne, na hÉiʃeannaig, beiʃ ceanaṁail gʃáóac onóʃac aʃ an óceangain nóúccaiʃ náóúʃca féin, an Ʒaeóealg, noc acá cóm foluigceac cóm múcca ʃin, nac móʃ ná óeacaió ʃí aʃ cuiṁne na nóaoine. A milleán ʃo, iʃ féióiʃ a cuʃ aʃ an aoiʃ ealaóan noc iʃ ugóaʃ óo'n ceangain, óo cuiʃ í fá fóʃóoʃcacc aguʃ cʃuaʃ focal, óá ʃgʃíoóaó i moóaió aguʃ i óʃoclaió óiaṁaʃa óoʃca óocuigʃeanca; aguʃ ní fuilió ʃaoʃ móʃan ó'áʃ nóaoinió uaiʃle, óo óeiʃ a óceanga óúccaiʃ náóúʃca (noc acá foiʃcill fuiʃice onóʃac foglamca

SYNOPSIS.

9.3 The later Figgins type, design adaptation from the Newman type attributed to Pádruig Ó Briain, from the 1899 foreign section added to their specimen of 1895, where it is shown in a full range of text sizes.

LONG PRIMER CELTIC.—3s. per lb.

Leaóaʃ mion-caince i nʒaeóilʃ ⁊ i mbéaʃla.

Óánca, Aṁʃáin iʃ Caoince Seacʃúin Céicinn.

pʃíṁleaóaʃ ʒaeóilʒe le haʒaió na naoióeanán

Aṁʃáin Seaʒáin Clánaiʒ ṁic Óoṁnaill.

Leaóaʃ Caince. Sʒéalaióe feannṁuiʒe. Cʃí Sʒéalca.

£1234567890

9.4 The bold version of the later Figgins Celtic type, from their 1904 specimen.

Dublin, and the general appearance of the magazine will be steadily improved."[11] In the June issue of that year a sample alphabet of the earlier Newman type appeared on page 62, and the February 1900 issue included a facsimile of the poem "Fainne an Lae" set in the later Figgins type with a letter criticizing their Watts-like type: "Everything is beautiful in it but alone the Gaelic type, and that is in the most illegible and ill-formed shape possible."[12] The editor responded:

Anyone can see by looking, and comparing them, that the Gael type is not

Nuair a béió na páióce ʒo léir ar an
ʒclároub aʒac, léiʒ críoca ríor iao.
Fiarruiʒ óer na rcoláirib cao é an c-
acruʒaó a óeineaó ar na roclaib. Má'r óóiʒ
leac ʒur ʒábaó é, óéin roinnc beaʒ míniʒce
ar an riaʒal a óéineabar ór na romplaió.
Acc o'á laiʒeao aimrear a caicrir ar an
ʒcéim reo oe'n ceacc ireaó ir fearr é. Sin é
cúir ʒur cuireaó irceac na nócaí reo acá i
nóeineaó an leabair, i rliʒe a'r ʒo bréaóraó
na mic-léiʒinn iao a léiʒeaṁ nuair a béaó
uain aca cuiʒe, aʒur, ʒo bréaóraióe an

Nuair a béió na páióce ʒo léir ar an
ʒclároub aʒac, léiʒ críoca ríor iao.
Fiarruiʒ óer na rcoláirib cao é an
c-acruʒaó a óeineaó ar na roclaib.
Má'r óóiʒ leac ʒur ʒábaó é, óéin
roinnc beaʒ míniʒce ar an riaʒal a
óéineabar ór na romplaió. Acc o'á
laiʒeao aimrear a caicrir ar an ʒcéim
reo oe'n ceacc ireaó ir fearr é. Sin é
cúir ʒur cuireaó irceac na nócaí reo
acá i nóeinʒeaó an leabair, i rliʒe a'r
ʒo bréaóraó na mic-léiʒinn iao a
léiʒeaṁ nuair a béaó uain aca cuiʒe,
aʒur, ʒo bréaóraióe an leac-uair a
cluiʒ ar fao a caiceaṁ aʒ labairc na
ʒaeóilʒe. Pé rcoláire, óʒ nó aorca, a

9.5 The Monotype Series 24 c.1906 (left), and bold Series 85 (right), in 10 point size.

Is cosṁail ríʒeacc na bflacas le ouine a cuir síol fóʒanca
'n-a cuio cailiṁ ; ac nuair a bí na oaoine 'n-a
ʒcoolaó cáiniʒ an naṁaio aʒus oo cuir sé coʒal i
lár na cruicneaccan, aʒus o'imciʒ sé. Aʒus nuair a
bí an ʒeaṁar aʒ fás, aʒus an coraó aʒ ceacc, oo
conaccas an coʒal leis. Ansan cáiniʒ na seirbísiʒ
cun fir an ciʒe aʒus oubraoar leis : A Ciʒearna,
nác síol fóʒanca a cuiris ao' cuio cailiṁ ? Cá
bfuair sé an coʒal mar sin ? Aʒus oubairc sé leó :
Naṁaio a óein an nío sin. Maic. xiii. 24-29.

9.6 The Monotype Series 24 with adjusted lower-case r and s added c.1913 for Michael O'Rahilly.

ungraceful and certainly is not illegible. The type is new, and the printing is excellent. . . . There is no such thing as ungraceful Irish type. Some may be more artistic than others, but there is none ungraceful, and it's all good. The only fault we have found with our type is that it is too large and occupies too much space for the number of lines of reading matter given. We believe our readers will be pleased to learn that we have ordered a full supply of the latest and most approved Irish type from V. and J. Figgins of London (having vainly tried to procure it in Ireland), and hope to bring out our April number in a new dress of Gaelic type.[13]

Consequently in the April 1900 issue the Figgins type is used, with the editorial comment:

Readers will observe that several of our Gaelic pages are set up in the new Irish type which we have had specially imported for our use. Its late arrival

necessitated our using some of the old type. If the improved appearance of the Gaelic pages makes the Irish matter more attractive to the student, or easier to read, we shall consider ourselves amply repaid for the trouble in obtaining it.[14]

The Irish setting continued in subsequent issues in the later Figgins type and the "Watts-like" type was phased out.

The type appears in the V. and J. Figgins specimen of 1899 and later in the 1904 specimen in a full range of sizes from brevier to great primer together with a range of bold weight sizes (see ill. 9.4). Colm Ó Lochlainn shows a sample of these in his paper, "Irish Script and Type in the Modern World", which he describes as "Body founts and Clarendon (or heavy) types made by R. H. Stevens and Co., London (late Figgins) 1900–1904. Both are rather horrible and the larger they grow the worse they appear

9.7 Michael O'Rahilly's drawings from the revised r and s, and additional characters for Monotype Series 24.

9.8 The Monotype Series 117 type, enlarged to 270% approx.

Plain:-

A B C D E F G H I J K L M N O P Q R S T U V W X Y Z
a b c d e f g h i j k l m n o p q r s t u v w x y z

Italics:-

A B C D E F G H I J K L M N O P Q R S T U V W X Y Z
a b c d e f g h i j k l m n o p q r s t u v w x y z

Seo an cló is ceart do beit agaib.

You can read English in this type.

C'ést parfait pour Français aussi.

9.9 Michael O'Rahilly's drawings for Monotype Series 117, which includes the first designs for an italic Irish type.

We Irish printers do not like them, we do not want to use them, but what can we do?"[15]

Despite this opinion, the Figgins type remained the most popular face during the early years of this century at a time when there was a great amount of printing in Irish. This demand would seem to have influenced other foundries, with the result that a number of typefaces appeared during this period, all modelled so precisely on the Figgins type they can scarcely be said to constitute separate designs. In fact it is difficult to detect any difference at all between the Figgins type and that produced by the Monotype Corporation, as its Series 24. This version was available in a large range of text sizes—6, 8, 10 and 12 point; and in 14, 18, 24, 30 and 36 point in display sizes (see ill. 9.5). Monotype records indicate that Series 24 was prepared in 1906 and acknowledge that they used samples of the Figgins type for reference. A note indicates that the ascenders and descenders were reduced by .004 of an inch.

In 1913 Monotype cast a revised lower-case r and s for the Series 24 type to the specification of Michael O'Rahilly (see ill. 9.6), who had been appointed as editor of *An Claidheamh Soluis* in that year. This revision, together with the use of photograph half-tones and a new mast-heading, gave that journal a significantly different appearance.

O'Rahilly had also prepared a set of additional characters to complete this fount so that non-Irish text could be printed without having to resort

9.10 The Monotype Series 117, above, which was prepared to conform with the existing Series 81, Grotesque Condensed, below.

abcoefshilmnopRstu
a b c o e f s h i l m n o p r r t u

abcoefshilmnopRstu
a b c o e f s h i l m n o p r r t u

abcoefshilmnopRstu
a b c o e f s h i l m n o p R s t u

abcoefshilmnopRstu
a b c o e f s h i l m n o p r r t u

abcoefshilmnopRstu
a b c o e f s h i l m n o p r r t u

abcoefshilmnopR tu
a b c o e f s h i l m n o p r r t u

9.11 The range of modern Irish types enlarged from 10 or 11 point sizes to facilitate comparisons: 1) Newman *c.*1858; 2) later Figgins *c.*1897; 3) Monotype Series 24 *c.*1906, with adjusted lower-case r and s added *c.*1913; 4) Intertype *c.*1913; 5) Linotype *c.*1916; 6) American Type Founders *c.*1916.

Cuipeaḋ an aipce peo i ʒcló pa " ʒClaiḋeaṁ Soluip " cúpla mí ó poin. Cualap ʒup caicin pé le cuiṫ ṫe na ʒaeḋilʒeóipí aʒup naċ mó ná pin é lé cuiṫ eile aca. Ní'l pé i ʒcumap aon ṫuine, ip cuma cé ṫé, aipce ṫo pʒpíoḃaṫ i nʒaeḋilʒ ap ʒnócaiḃ ceápṫaṁla aʒup ap ʒnócaiḃ ealaḋanca ʒan pocail ṫo cumaṫ. Cia ip moice ṫe eicealóipeaċc pé an ʒanppanʒ an ealaḋa ip nuaiḋe pan paoʒal pá lácaip. Ḃí opm pocla a cumaṫ ap éaṫan a céile. Sílim ʒo ḃpéaḋpainn bpíʒ an pʒéil a caḃaipc liom ceapc ʒo leóp ʒan an oipeaṫ pocal úp a cumaṫ ip pinneap, aċc ċuaḋap in éaṫan na hoibpe in aon cupap ċun a capḃáinc ʒo ḃpuil pé i ʒcumap na ceanʒan í lúbaṫ, aʒup i pníoṁ aʒup í a ċapaṫ ċun na pmaoince ip ṫoiṁne aʒup na pocla ceapṫaṁla ip úipe a noċcuʒaṫ innci.

9.12 The Linotype Irish type.

to a different style for those characters not in the normal Irish alphabet. These additional characters are contained in a drawing that he had produced for Monotype, but it would seem that they were never cast (see ill. 9.7).

O'Rahilly also designed a most unusual bold sans-serif-like Irish type which he used in *An Claidheamh Soluis* for sub-headings and for emphasis. This type, also cut by the Monotype Corporation (Series 117) in 1913, applied certain features of roman type to the Irish while attempting to retain an Irish quality. Its capital letters had a consistent height and discarded any suggestion of a lead-in script-like stroke. His initial design drawings show a complete roman fount, together with an italic set of letters which represents the first design for an italic Irish. Unfortunately the italic face was not cut. O'Rahilly's drawings, furthermore, were considerably lighter than the weight of the finished type (see ill. 9.8), and he suggests (as can be seen in ill. 9.9), that this letter was suitable for English and French also.[16] The records of the Monotype Corporation are very thin with regard to the Series 117 type. They do mention, however, that the finished drawings for the special characters were prepared by Monotype from sketches provided by the Dublin printing firm of Cahills, and that these were prepared to match and conform with the existing fount of Series 81, Grotesque Condensed (see ill. 9.10).

As has been noted, in the first decade of the twentieth century a number of types were produced, all of which were so similar to one another and to their Figgins model that they really should be considered as the same design, yet each does contain some individual characteristics which help to identify them (see ill. 9.11). The Linotype fount can perhaps be best identified by

ᴀbcᴅeꝼᵹhilmnopꝝꞅꞇu

abcᴅeꝼᵹhilmnoppꝝꞇu

Cuiꝝ Caeꝝaꝝ a ċuiᴅ lonᵹ aꝝ aiꝝ ċuiᵹ Ḃꝝunᴅiꝝium annꝝin
leiꝝ na ꝼóꝝꝝaí a ꝼáᵹaᴅ ina ᴅiaiᴅ a ċaḃaiꝝꞇ anall. Aċ
na ꞇꝝúꝑaí úᴅ, ꞇꝝaoċꞇa ón ꞇuiꝝꝝe aᵹuꝝ íᴅiꞇe ón iliomaᴅ
naiṁᴅe, iꝝ aṁlaiᴅ a ꝝcaiꝝꞇeaᴅaꝝ aᵹ caꝝaoiᴅ ꝼaoi, le

ᴀbcᴅeꝼᵹhilmnopꝝꞅꞇu

abcᴅeꝼᵹhilmnoppꝝꞇu

Cuiꝝ Caeꝝaꝝ a ċuiᴅ lonᵹ aꝝ aiꝝ ċuiᵹ Ḃꝝunᴅiꝝium annꝝin
leiꝝ na ꝼóꝝꝝaí a ꝼáᵹaᴅ ina ᴅiaiᴅ a ċaḃaiꝝꞇ anall. Aċ
na ꞇꝝúꝑaí úᴅ, ꞇꝝaoċꞇa ón ꞇuiꝝꝝe aᵹuꝝ íᴅiꞇe ón iliomaᴅ
naiṁᴅe, iꝝ aṁlaiᴅ a ꝝcaiꝝꞇeaᴅaꝝ aᵹ caꝝaoiᴅ ꝼaoi, le

9.13 The Intertype
regular and bold
Irish types.

the extremely squat lower bowl to its lower-case g, and its particularly
short descenders in lower-case f, p, r and s (see ill. 9.12). The Intertype
fount can be recognised by the short lead-in ear to the lower-case d (see
ill. 9.13). The Monotype version is most like the Figgins type and is perhaps
identified most readily, at least in its modified form, by the revised lower-
case r and s.

There was in fact another company producing an Irish type to this design
which has generally been overlooked. This omission is quite understandable
in so far as this type, it seems, was not used in Ireland at all. It was pro-
duced by the ATF (American Type Founders) Company of New Jersey in
large quantities; when the demand dwindled they decided to discontinue
it, and according to the manager of ATF "they disposed of the original
engraved matrices"[17](see ill. 9.14). This particular typeface appeared also
on another continent with a large Irish readership, namely, Australia,
where it was used in *An Gaedheal,* published in Sydney for the Gaelic
League by the printing firm of O'Loughlin Bros. More condensed than the
Monotype, Linotype or Intertype versions, this ATF type has a particular
curve to the upper part of the ascender strokes in both the capital and
lower-case letters and has a more pronounced lead-in serif stroke. The
lower-case r is particularly narrow, the d and f are condensed, while the g
has a full, circular lower bowl like the original Newman type, a feature
which had become more squat in the other similar faces; the ear in d is
short like the Intertype version, while the bowl of the p is closed unlike
the other modern faces.

Fleaủ ball Deaṛ5 ó'Doṁnaill.

ḃí feaṛta móṛ a5 ḃall Deaṛ5 uaiṛ aṁáin
a5uṛ ċa Dtiocfaiổ leiṛ ubla fáġailt in áit
aṛ biṫ. Ċuiṛ ṛé feaṛ ai5e Do na ḃṛáiṫṛiḃ i
Cill-ṁic-Cṛénan a5 iaṛṛaiổ ubla oṛṛa. Duḃaiṛt
ṛiaổ leiṛ nac ṛaiḃ ubla aca. Nuaiṛ táinic an
feaṛ aṛ aiṛ D'inniṛ ṛé Do Ḃall-Deaṛ5 naṛ ṫiocf-
faiổ leiṛ na h-ubla fáġailt. "Aṛ ṫu5 ṛiaổ ṛuD aṛ
biṫ le'niṫe Duit" aṛ Ḃall. "Ṫu5," aṛṛ an feaṛ

9.14 The American Type Founders' Irish type.

9.15 The Intertype bold (top) and Monotype Series 85 bold (below), enlarged to 330% approx.

Figgins also produced a bold face which appears in their specimen book of 1904 (see ill. 9.4); despite Lynam's praise for its legibility,[18] it was none-theless a crude and awkward fount, with extremely short descenders rendering many of the forms hard to recognize. This fount also influenced a bold style which accompanied both the Intertype and Monotype versions, the main difference between these being that the Intertype bold is slightly more condensed than the Monotype 85 (see ill. 9.15).

COLUM CILLE TYPE

IN 1921 THE ARTIST VICTOR HAMMER, a native of Vienna, designed a type based on the uncial script of the fifth to seventh centuries. "This calligraphic style, written with a broad quill pen, became his everyday hand writing. By the time he was ready to cut letters in steel . . .he had written the letters of the alphabet so many times and in such a disciplined manner that visualizing each letter on the face of a steel blank was second nature."[1] Of this, Hammer stated: "With this Uncial type I am aiming at a letter form which eventually may fuse roman and black letter, those two national letter forms, into a new unity."[2] Herman Zapf, the renowned type designer, said of Hammer's uncial: "Victor Hammer was, to my knowledge, the first artist to use an uncial letter for a text face."[3] This type, named Hammerschrift (Hammer Unziale), was cut by the punch-maker A. Schuricht of the Klingspor Foundry in 1925. "Working closely with this craftsman, he [Hammer] directed, as best he could, the shaping of his letters by another's hands. When, in the same year, the Klingspor Foundry cast this type . . ., Victor Hammer did not like it."[4] "He never used this face in his own work. The design was bought by the Klingspor house and issued in three sizes. . . .However, it was this face which first brought Hammer's work to the attention of typographers. . . .It has remained a popular face for use with the Gaelic language and indeed Klingspor did provide special sorts for the use of Irish printers."[5]

About this time, Colm Ó Lochlainn, the Gaelic scholar, typographer, and printer, set up his own printing business in Dublin. He later recalled:

> In 1926 when I decided to set up my printing press in Fleet Street, it gave me great joy to find that a large sign board hung outside the premises. This I took down and painted with the sign of the Three Candles which—as Katisha says—has been much admired. . . . 'Three candles that light up every darkness: Truth, Nature and Knowledge' was very suitable as a legend for the sort of book we meant to issue, and so the name of the Candle Press was chosen.[6]

Ó Lochlainn was not an admirer of the popular Irish types available at the time and was particularly outspoken in his criticism of these design departures from the earlier round Petrie types which he so much appreciated. As a typographer and printer, he was aware of the current typographic setting styles, and a strong advocate of the need for a complete range of weights, italics, and small capitals for a Gaelic typeface. He

expressed these sentiments, which he had been formulating since 1925, in an article in the *Irish Book Lover*:

> with present equipment, it is much easier to plan and produce a beautiful book in Roman letter than in Gaelic, and this will remain true until such time as the average Irish Fount, either of type or on the Monotype installation, is extended to comprise such essentials as small capitals, italic, and the usual reference marks, &c. A decent alphabet of initials suitable for fine book work is also badly needed: up to present an artist has had to be called in to design initials when needed, and in most instances the results have been very disappointing.[7] . . . As a printer I revere tradition in all things yet I hold no brief for the present Gaelic type. I consider it one of the worst of the twenty Gaelic typefaces ever used. It is spikey and patchy, it is lacking both in grace and dignity. . . . Here then is the printer's demand. If the Gaelic style of type is to be used at all the founts must be made complete and new faces must be cut—italic, small caps, display faces and the rest.[8]

This announcement prompted a reply from W.I. Burch, the managing director of the Monotype Corporation, who expressed a readiness to take up the above suggestions from Ó Lochlainn. "In the past we have been only too desirous of co-operating with recognised authorities on Gaelic, in order that we could produce a face or faces which would be considered as something better than those which have already existed." He pointed out the difficulties in producing an italic Gaelic and concluded: "However, this question is one in which we are very interested, more especially after reading your articles. I should appreciate very much the opportunity of discussing this matter with you personally if you could spare the time to come over [to London] for this purpose, and bring with you any specimens of ancient printing, or hand written specimens in Gaelic, in faces which you think are preferable to those which we have prepared."[9]

Thus was sown the seed for what was to become the Colum Cille type. The graphic designer, Dara Ó Lochlainn, a son of Colm, points out that "The genesis of this type was a conversation between Stanley Morison and Colm Ó Lochlainn in April 1929."[10] Morison had been appointed as typographical adviser to Monotype in 1922 by Harold Malcom Duncan, the then managing director ("the Corporation didn't hire me, I hired them" was Morison's version). "Burch confirmed Morison in the position of typographical adviser and gave him an office at the Corporation's headquarters in Fetter Lane."[11]

On 1 October 1929 Ó Lochlainn was appointed as part-time director of the department of printing in the Municipal Technical School, Bolton Street, Dublin, and in order to inform himself further in this regard he planned to visit schools on the continent offering similar courses. Morison wrote to Ó Lochlainn on 4 October 1929 congratulating him on his

appointment and suggested that he investigate "the magnificent printing school in Leipzig". He offered to accompany him part of the way and to introduce him to his many "friends in the German print centres".[12] Ó Lochlainn wrote to Morison on 15 July of the following year asking if August would be a good time to visit "the people in Germany". He reminded Morison of his offer "to accompany me to Leipzig and I need not repeat that I would value highly the introductions you would give me to these Continental people. . . . I expect to be free about the 10th August".

In his article, "An Irish Typographical Link with Germany", Ó Lochlainn gives an account of his visit to Germany:[13] "So in the summer of 1927 [i.e. 1930] I left London, armed with letters of introduction from Stanley Morison to Julius Rodenberg of the Deutsche Bucherei in Leipzig, to Rudolf Koch of Offenbach, who was Klingspor's chief type designer and punch cutter, and to other lights of the book and type world in Germany." "On another day", he continues, "we went to meet the artist Walter Tiemann (designer of Tiemann Antiqua), who presided over the Akademie für Kunst und Buchgenerbe, a comprehensive school embracing every kind of technical and process teaching and specialising in art training for book design. There a year later [1931] I brought my disciple Karl Uhlemann—half German already—and left him for a year under Dr Tiemann. The next summer I collected him from his father's people in Marburg on the Lahn; and he returned to work with me at the Three Candles." The visit in 1930 to Germany was most eventful, Ó Lochlainn records: "My voyage of exploration took me to Antwerp (Plantin Museum), Leipzig, Frankfurt, Offenbach and Mainz . . . and so began my friendship with Rodenberg, Hartmann, Jost and Konrad Bauer and, most fruitful of all, with Rudolf Koch and his son Paul which lasted until they died."[14]

In a letter to Ó Lochlainn of 16 September 1930, Morison says: "I am very glad that you have happy recollections of the day you spent in London. I am only too happy to have shared it with you." And with a remark that would suggest that discussion had taken place regarding the production of a Gaelic type he goes on: "As to the Gaelic business, I feel a little more disposed to occupy my mind with the question as a result of seeing the *An Fiolar*" (see ill. 10.1). Colm had sent Morison a copy of *An Fiolar,* the annual journal of St Joseph's College, Roscrea, in which the Irish sections were printed using the Monotype Series 24 Gaelic, by the Three Candles Press. In this journal extensive use was made of engraved blocks to print title headings and larger text, handwritten in a round style of letter.

Ó Lochlainn had, at this time, the idea of the development of a Gaelic type progressing on two fronts, one as we have seen with Morison of the Monotype Corporation, the other was with the Klingspor type foundry in Offenbach. In September 1930, seemingly as a result of queries he made

Aɡ ɡabáil buiðeaċais
le ɡaċ éinne a ṫuɡ cabair aɡus
conɡnaṁ ċun an leabar so ðo ċur
i ɡcionn a ċéile.
Aɡ sɡríbneóiriḃ, óɡ aɡus sean, aɡ
luċt pictiúr aɡus ornáið (ɡo mór-
mór liam mac ɡiolla ḃríɡðe aɡus
Miċeál Ó ḃriain) tá buiðeaċas na
n-eaɡartóir aɡus buiðeaċas
an ċlóðóra tuillte.
ɡo ðtuɡaið ðia
luaċ ár saoṫair
ðúinn uile.

10.1 A sample letterpress block print from *An Fiolar*, 1930 showing use of a round script which helped convince Stanley Morison of the need for a type based on this style of lettering.

during his visit to Germany, he received a letter from Klingspor: "Dr Rodenberg from Leipzig tells us that you are interested in our 'Hupp Unziale' as well as in our 'Hammer Unziale', specimen books of which types we are sending you today under separate cover."[15]

There followed a lengthy gap in any correspondence relating to Irish type. However, in 1932 an article by Ó Lochlainn appeared in the *Gutenberg Jarbuch* entitled "Irish Script and Type in the Modern World", which in part reflects his earlier article in the *Irish Book Lover*, both of which have been referred to above. In the 1932 article he says: "To summarise the present position of Irish Printing from the technical side I quote from an article contributed two years ago to 'The Irish Book Lover' May–June

1928 and July-Dec 1928" which would indicate that the *Gutenberg Jarbuch* article was prepared in late 1930/early 1931 (the date is not particularly significant, except that it does help to establish the progress in his planning of the Irish type with Klingspor). In the article Ó Lochlainn says: "Already one German type designer Victor Hammer has found in the Irish Uncial the inspiration for a very beautiful ornamental type 'Hammerschrift' which has been cut by Gebr. Klingspor of Offenbach and I submit that in Irish handwriting from the year 800 to the present day there is an unlimited fount of inspiration for the design of types for Advertising Display, Ornamental bookwork and Poster work."[16]

Victor Hammer wrote to Ó Lochlainn on 15 July 1932 stating that he had heard about his article in the *Gutenberg Jarbuch* and mentioning his own study of Irish manuscripts and the influence they had on his type. On 29 July 1932 Ó Lochlainn again received a letter from Hammer acknowledging receipt of a copy of Ó Lochlainn's article and stating that he would be in England during September and October. He enclosed a prospectus of his Samson Uncial type (an improved development of the Hammerschrift type), and went on: "I would be delighted to cut, either myself or with my pupil Paul Koch—Rudolf Koch's son—an entire Irish type-face. I started my studies with the Book of Kells, I tried to use some Irish forms—the t above shows it to you." Hammer included a sample print of the letter t prepared in the Irish style, a character not in fact used in his typeface, and explained: "the needs for the German and English are so clearly and inevitably circumscribed that it was useless to try, nevertheless I couldn't help to preserve the ductus of the Irish manuscripts also in my typefaces."

At this time Ó Lochlainn wished to adapt Hammerschrift for use in Gaelic and had approached the Klingspor foundry, the owners of this face, to that end. He received a reply from Klingspor on 6 October 1932 expressing an interest in "selling the Hammer type in Ireland. . . . For this reason we are ready on principal [*sic*] to manufacture the required Irish figures." Some financial aspects of this arrangement were mentioned and the letter concluded: "At any rate we are awaiting your opinion with interest. Meanwhile we shall prepare the producing of the special types, copies of which we shall send you before casting for your examination." Hammer came to London in mid-October 1932 and Ó Lochlainn visited him there. He later recalled: "Dr Klingspor . . . was much interested in my proposed extension of Hammerschrift to fit it for printing Modern Irish—especially display matter, certificates and diplomas, so I redesigned A,B,D,G and T in proper Irish scribal form, gave all five vowels an acute accent, and aspirated (dotted) B,C,D,E,G,M,P,S,T. I crossed to London and spent a night with Hammer at the Austrian Embassy, where we considered and approved my innovations. Rudolf Koch, or perhaps Paul, cut the punches, and I called the type Baoithín: for Colm Cille's last written words were 'Reliqua scribat

Baitenus'. Let Baoithín (his disciple at Iona), write the rest, just as I had designed 'the rest' for Victor Hammer"[17] (see ill. 10.2 and 10.3).

In 1936 Ó Lochlainn gave a similar account of this effort, with some confusion as to the number of letters he had redesigned: "Already one German type designer, Victor Hammer, has found in the Irish Uncial the inspiration for a very beautiful ornamental type 'Hammerschrift' which has been cut by Gebr. Klingspor of Offenbach. For this type I recently designed six special letters and am using it for announcements of an inscriptional nature, for chapter-headings and for cards and calendars. Admittedly it is hardly a type for book-work but its uses are many, and Irish printers would be well advised to possess themselves of a small fount of it. It is available in three sizes, 18, 24 and 30 point."[18]

In a letter dated 31 October 1932, Morison expressed sorrow at having missed Ó Lochlainn while he was in London; but this may have been just as well for it is not clear to what extent Ó Lochlainn kept him informed with regard to his dealings with Hammer. Ó Lochlainn, it would appear, discussed the possibility of himself cutting the punches of a text size with Hammer. This is evident from a letter to Ó Lochlainn from Morison dated 23 November 1932: "Victor Hammer came to see me last week [after his meeting with Ó Lochlainn], and I was rather taken with his universal

10.2 Hammer Uncial type (Hammerschrift), c.1925.

10.3 The Baoithín type, with redesigned A, B, D, G and T, and aspirated characters added c.1932.

benevolence, but I did not care to argue with him on the first occasion of meeting. To my mind, the suggestion that you should cut the punches argues a misunderstanding of the position. Hammer appears to me to inhabit some mental monastery in which a worship of beauty and culture and the like is carried on in an atmosphere steaming with aesthetic complacency. I hope this does not sound uncharitable."

10.4 Karl Uhlemann's first drawings for the Colum Cille type, dated December 1932, reduced to 54% approx.

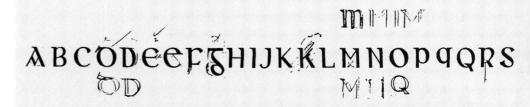

10.5 Monotype designs based on Uhlemann's drawings for the Colum-Cille type, reduced to 45% approx. These may have been prepared by Eric Gill, for Morison had mentioned the possibility of getting "Gill to work over the designs".

Indeed there may have been an element of playing one off against the other on Ó Lochlainn's part, for he had already discussed in detail the production of text sizes with Morison, regarding which certain financial difficulties had been identified.

Earlier in this year, on 8 April, Morison wrote a note to Ó Lochlainn in which he playfully uses a minuscule Irish style of writing and followed this up with a letter on the same day urging him to work on a Gaelic alphabet: "If you will design a humanistic Gaelic, I will get it cut. The new political line makes this a very opportune moment. If your people would only look at Gaelic from a calligraphical point of view, instead of from a purely archaeological point of view, they would realise the enormous advantage in taking up my suggestions." In a letter of 28 April 1932, Morison makes an observation which as we have seen was put forward by Ó Lochlainn in his 1928 article in the *Irish Book Lover*: "In my judgement, there can be no sort of future for Gaelic or anything else which does not give capitals, lower-case, roman, italic and small capitals." He makes this point again in a letter of 12 June 1932 and continues: "Will you undertake to design a lower-case of Gaelic which shall go with the Gill Sans capitals used on the Customs declaration? If you will, I will get Gill to work over the designs and you will then have the first of all sensible alphabets for displayed Gaelic. Is the time ripe for the bringing out of this alphabet with an introduction justifying the idea and attempting to propagate it."

Ó Lochlainn seems to have applied himself to these urgings, for in a letter to Morison on 26 July 1932 he says: "After much delay I am acknowledging your little book about the Hebrew Type [sent on 28 April 1932] and your recommendations. I have been trying to see what can be done to make Irish type follow these lines but so far have nothing to show except rough pencil sketches. . . . I will be going to Germany the end of this week and will probably see Rodenberg and some of the others also but I am not going to work very hard while I am there."

It was on his return from Germany that he brought Karl Uhlemann back to Dublin. Uhlemann had originally come to work for Colm Ó Lochlainn in 1929–30. His art teacher at Synge Street Christian Brothers School had advised him in his pursuit of a career in art, a subject in which he excelled, to seek employment at Gill's religious providers, a firm which designed some of its own stock. Uhlemann describes how, having set off for Gill's with his portfolio of drawings, he was attracted by a display of printed work at the Sign of the Three Candles Press as he passed the premises in Fleet Street and went in on speculation, seeking a job. He was interviewed by Ó Lochlainn and engaged as a junior in the art section directly.[19] On his return from Germany in 1932 it would seem that Ó Lochlainn had him work on drawing up the alphabet that he had been so involved in himself.

Uhlemann still has his original drawing of the capital letters which is dated 21 December 1932 (see ill. 10.4). It is interesting to recall Morison's offer: "I will get Gill to work over the designs", for the Monotype archives contain an undated set of drawings which include later alterations pasted on, obviously based on Uhlemann's letters and from which the first set of characters were cut (see ill. 10.5). It was some time later that evidence of this work emerged, for on 8 September 1933 Morison wrote to Ó Lochlainn: "The alphabet looks good to me. I am not sufficiently up in the palaeo-graphy of the thing to be absolutely sure that your serif treatment is thoroughly unobjectionable." After some comment on various individual characters he continued: "However, it is such an enormous gain to get a set of Capitals I really ought not to do any more than congratulate you on the design . . . Do you think that we could possibly interest the Welsh in this alphabet? I imagine not. Yet, surely if there is any sense in using a special alphabet for Ireland it ought to suit the Bretons, the Scottish Gaels and the others." Later in a letter of 18 September 1933, Morison states: "The Sans Serif GAELIC appears to me to be very satisfactory. I should say myself that the lower-case n is too narrow. We are making a few sorts of the New Gaelic in 14 point. They will be ready, I hope, by the time you arrive." On 30 September 1933, he wrote again: "I think you should be very pleased with the trial characters of your GAELIC as shown on the accompanying proof. I should like the foot of the Capital B to be opened out a little more, but I have no other criticism to make. The trial characters seem to me to promise a really fine fount" (see ill.10.6). On 30 October 1933, Morison added further approval: "The accompanying new proof, I think, does go still further modernising the alphabet, and I cordially approve" (see ill. 10.7).

There followed a number of letters from Morison urging some response from Ó Lochlainn: "If there is any News about the Gaelic I should be interested. If it is abuse, rather than news, I shall still be interested."[20] Ó Lochlainn was reluctant to rush into approving the sample prints. "Gener-ally speaking", he wrote, "they are quite satisfactory." He suggested a few changes,[21] and finally on 10 January 1934 he wrote: "I certainly think trial number two sufficiently good to warrant the completion of the font, and I would be glad indeed to know that you are proceeding." Morison ack-nowledged this approval and confirmed that he was indeed proceeding[22] and on 16 March 1934 he wrote: "I am happy . . . to send you proofs of the new Gaelic, which, as a design, seems to me to be most attractive [see ill. 10.8]. I hope you and yours will look upon it favourably, for whatever may be said against it by the orthodox, Series 121 [the Monotype reference number for the type] is surely a much more reasonable pair of alphabets than has ever been produced for the benefit of Irish printers. It is a typographical, and not a calligraphical industry we are working in and for.

Trial No. ⅄ A 26-9-33

MONOTYPE

Gaelic (O'Loughlin) Series No. 121—14 point 2x2
 14 Set Composition Line .1543

Amirr ʒamir ram marr Baʒ aʒim ir mam am
mammir Dirr ʒimmir mimir Eiʒr ʒirrim ramʒ
Cammiʒr am riram irram Bamir ʒirram ʒirr
Amirr ʒamir ram marr Baʒ aʒim ir mam am
mammir Dirr ʒimmir mimir Eiʒr ʒirrim ramʒ
Cammiʒr am riram irram Bamir ʒirram ʒirr
Amirr ʒamir ram marr Baʒ aʒim ir mam am
mammir Dirr ʒimmir mimir Eiʒr ʒirrim ramʒ
Cammiʒr am riram irram Bamir ʒirram ʒirr
ABDEF aʒimr

10.6 Monotype trial A for the Colum Cille type, 26 September 1933.

10.7 Monotype trial B for the Colum Cille type, 24 October 1933.

Trial No. ʒ B 24-10-33

MONOTYPE

Gaelic (O'Loughlin) Series No. 121—14 point 2x2
 14 Set Composition Line .1543

Lower-case redesigned

Amirr ʒamir ram marr Baʒ arim ir mam am
mammir Dirr ʒimmir mimir Eiʒr ʒirrim ramʒ
Cammiʒr am riram irram Bamir ʒirram ʒirr
Amirr ʒamir ram marr Baʒ arim ir mam am
mammir Dirr ʒ immirmimir Eiʒr ʒirrim ramʒ
Cammiʒr am riram irram Bamir ʒirram ʒirr
Amirr ʒamir ram marr Baʒ arim ir mam am
mammir Dirr ʒimmir mimir Eiʒr ʒirrim ramʒ
Cammiʒr am riram irram Bamir ʒirram ʒirr
Amirr ʒamir ram marr Baʒ arim ir mam am
ABDEF aʒimr

Trial No. 1 13-3-34
 MONOTYPE

Gaelic Series No. 121—14 point
 14 Set Composition .2x.2 Line .1543

Seo cuṁ a céile iaᴅ aguṡ an beiṅc ag ṡaṅúgaᴅ na
n-uan, Domnall ag iaṅṅaiᴅ iaᴅ ᴅo ḃaiṅc ᴅe aguṡ
Seáġan na leogṡaᴅ leiṡ iaᴅ. Inṡ an cṡaṅúġaᴅ ᴅóiḃ iṡ
gaiṅiᴅ gun cuaᴅaṅ i ṡgóṅnacaiḃ a'céile, aguṡ im ḃóṡa
pḃlanncaᴅaṅ a céile go ceiċ leiṡ na ᴅóiṅne. Iṡ gaiṅiᴅ
go ṅaiḃ locáin ṡola aiṅ ṡuaiᴅ an bocaiṅ. Ní ṅaiḃ
ᴅuine i gcúṅam na n-uan iṡ cuiṅeaᴅaṅ an céim ṡuaṡ
ᴅioḃ. Ġaiḃ ṡeaṅ anuaṡ ó'n muileann aguṡ bṅaiċlín
lán ᴅe ṁin coiṅce aige an ᴅṅom capaill. Do cuaiᴅ ṡé
eacoṅṅa iṡ coṡam ṡé aṅ a céile iaᴅ. Buail ṡeaṅ cuige
cṅeaṅna iṡ ᴅo ṡiaṡṅaig ṡé ᴅe caᴅ é ṡác na bṅuiġne, iṡ
níoṅ ᴅein ṡeaṅ ancapaill aon blúiṅe aṁáin acc ceacċ
aṅ an mbṅaiċlín aguṡ i ṡgaoileaᴅ iṡ gaċ uile ṗioc
ṅiaṁ ᴅ'n ṁin-coiṅce ᴅo leiginc leiṡ an abainn ᴅe
ᴅṅuim an ᴅṅoiċiᴅ. Bain ṡe cúpla cṅoca aṡ an mbṅaiċ-
lín, cuṁ ná ṡanṡaᴅ púinn ᴅe'n ṁin coiṅce uiṅce. Bí
mo ṡiġeaᴅóiṅ ag ṡeacainc aṡ an obaiṅ go léiṅ, iṡ níoṅ
coṅṅuig ṡe aṡ an áiċ go ṅaiḃ ṡé 'na ṡeaṡaṁ ain ṡeaᴅ
na haimṡiṅe.
 "A ḃṡeiceann cú an bṅaiċlín ṡin ?" aṅṡa ṡeaṅ an
capaill.

 MONOCYPE

 ABCDEꝠSHILMNOPRSCU ƐEFGJKQVWXYZ
 ÁḂĊḊÉꝠṠÍṀÓṖṠĊÚ
 abcᴅeꝠshilmnopṅṡcu djkqvwxyz
 áḃċᴅéꝠṡṁóṗṡċú
 £1234567890 .,;:-'"!?–()┐—

10.8 Monotype
trial no. 1 for the
Colum Cille type,
13 March 1934.
Some text has been
deleted from the
sample for purpose
of fit.

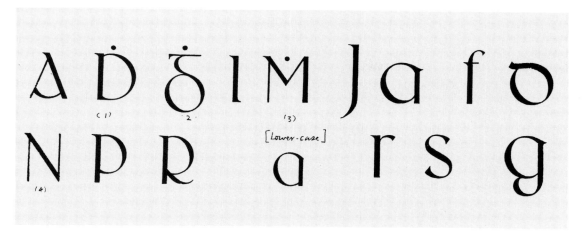

10.9 Revised drawings to trial no. 1, dated 30 July 1934, reduced to 45% approx.

Please let me know what you think of the design." Again on 18 May 1934 he had to exhort Ó Lochlainn to comment on the type: "If you can send me a report on the Gaelic I shall welcome it. The works are inclined to fidget a little without an approving or disapproving verdict."

The cause for Ó Lochlainn's delay was that he was having alterations made to many of the letters. He was clearly unhappy with their appearance, and on 30 July 1934 he wrote: "At last I have the revised letters to send you" (see ill. 10.9). He enclosed new sketches for a, D, G, I, M, N, P, and R, and states: "The cap 'A' which appears on this I do not think we need bother about. My draughtsman [Uhlemann] heard some people criticising our angular 'A' but I think I should stand firm for it as it certainly gives us a definite distinction between caps. and lower-case, and this is what we want if ever small-caps. are to be made." Morison acknowledged receipt of these submissions, and demonstrated how accustomed he was to this form of critical comment: "Very many thanks. You cannot tell how many times I have wondered whether you disliked everything in the fount. I am very relieved and pleased that the revisions are so few. I do not doubt that you will have other small corrections to make later." Morison goes on to give a detailed comment on the proposed alterations and makes some further suggestions himself, particularly regarding the use and non-use of serifs; he concludes: "Many thanks for letting me see the proof of the revised Hammerschrift. This looks to me to be very successful."[23] Ó Lochlainn in his letter of 2 August 1934 thanks Morison for his very reasonable attitude to the changes, and comments that he was attempting to retain the more traditional scribal quality in the lower-case letters and a more disciplined line in the capital letters. These he was quite satisfied he had achieved. On 3 December 1934 he writes: "I am keeping the proofs you sent me and the photo prints also. I find the type improving with reduction, but as you say the photo is rather thick [see ill. 10.10]. I may as

Trial No. 2 20-8-34

MONOTYPE

Gaelic Series No. 121—14 point

14 Set Composition .2x.2 Line .1543

Redesigned D ᵹ M N Ḋ ᵹ̇ Ṁ a j á Added í No. 454

Seo ċuṁ a céile iaḃ aguſ an beinc aᵹ ṛaṗuᵹaḃ na n-uan, Ḋoṁnall aᵹ iaṛṛaiḃ iaḃ ḃo ḃainc ḃe aᵹua Seáᵹan na leoᵹ̇aḃ leiṛ iaḃ. Inṛ an cṛaṗuᵹaḃ ḋóiḃ iṛ ᵹaiṛiḃ ᵹun ċuaḋaṛ i ṛᵹóṛnaċaiḃ a'ċéile, aguṛ im ḃóṛa ᵹlanncaḃaṛ a céile ᵹo ceiċ leiṛ na ḃóiṛne. Iṛ ᵹaiṛiḃ ᵹo ṛaiḃ loċain ṛola aiṛ ṛuaiḃ an ḃoċaiṛ. Ní ṛaiḃ ḃuine i ᵹcúṛam na n-uan iṛ ċuiṛeaḃaṛ an ċéim ṛuaṛ ḃioḃ. Ᵹ̇aiḃ ṛean anuaṛ ó'n muileann aᵹuṛ ḃṛaiclín lán ḃe ṁin ċoiṛce aiᵹe aṛ ḃṛom capaill. Do ċuaiḃ ṛé eacoṛṛa iṛ ċoṛam ṛé aṛ a ċéile iaḃ. Ḃuail ṛeaṛ ċuiᵹe cṛeaṛna iṛ ḃo ṛiaṛṛaiᵹ ṛé ḃe caḃ é ṛáċ na ḃṛuiᵹ̇ne, iṛ níoṛ ḃein ṛeaṛ anċapaill aon ḃlúiṛe aṁáin acc ceaċc aṛ an mḃṛaiclín aᵹuṛ i ṛᵹaoileaḃ iṛ ᵹaċ uile ṗioc ṛiaṁ ḃ'n ṁin-ċoiṛce ḃo lieᵹinc leiṛ an aḃainn ḃe ḃṛuim an ḃṛoiċiḃ. Bain ṛe cúṗla cṛoċa aṛ an mḃṛaiclín, ċuṁ ná ṛanṛaḃ púinn ḃe'n ṁin ċoiṛce uiṛce. Ḃí mo Ṫiᵹeaḃóiṛ aᵹ ṛéaċainc aṛ an obaiṛ ᵹo léiṛ, iṛ níoṛ ċoṛṛuiᵹ ṛe aṛ an áic ᵹo ṛaiḃ ṛé 'na ṛeaṛaṁ aiṛ ṛeaḃ na haimṛiṛe.

"A ḃḞeiceann cú an ḃṛaiclín ṛin ?" aṗṛa ṛeaṛ an ċapaill.

MONOTYPE
ABCDEFᵹHILMNOPRSCU EEFGJKQVWXYZ
ÁḂĊḊÉḞᵹ̇ÍMÓṖṠĊÚ
abcḃeḟᵹhilmnopṛṛcu dijkqvwxyz
áḃċḋéḟᵹ̇íṁóṗṛ̇cú
£1234567890 .,:;-"!?–()₇—

10.10 Monotype trial no. 2 for Colum Cille, 20 August 1934. Some text has been deleted from the sample for purpose of fit.

well order now three sizes, 14, 12 and 10. I do not know what arrangements we should make for this or do I get my founts for nothing on account of initiating the design."

From 3 January to 4 February 1935 several letters were sent by Morison about the terms between Ó Lochlainn and Monotype regarding the production costs of the project. Initially he suggested, since 20 sets of matrices would need to be sold before showing a profit, that Ó Lochlainn should himself be obliged to purchase his matrices and that he receive a royalty payment for sets sold in excess of an agreed number and that there should be no fee paid for the designs. This arrangement was adjusted as follows: that all rights in the design be transferred to Monotype in return for matrices for three sizes of the face with the required equipment. Ó Lochlainn agreed to this, naming 12 point, 10 point, and 8 point as the sizes required (14 point being the only size on which any work had been done at that stage). He further suggested that "italics and small caps should be considered" and continued:

> I do of course understand that the expense to your company is very consider-able, and my mind was at no time running on the provision of a cash payment to myself. My anxiety is that the font should be as perfect as possible so that yourselves will not suffer through adverse criticism. There is a general feeling that a variety of type would be desirable, and I am glad that my efforts coupled with yours, have brought the type to such an advanced stage that now only some minor changes are required. I wish that the type should be called COLUM CILLE as he is, par excellence, the patron of Irish scribes.[24]

Following this instruction the Monotype records include an entry dated 20 February 1935: "To be known in future as Colum Cille."

Morison may have become somewhat disenchanted with the project about this time, for he frequently referred to the financial risk involved to Monotype and, on occasion, it takes great persuasion on the part of Ó Lochlainn to effect changes called for. In his letter of 20 March 1935 he is quite forceful: "The re-designed cap B seems quite satisfactory but the new D [d] is wrong entirely and I do not know where you got it as I referred you to the Rudolf Koch Memorial Inscription for my own D in order that you would see exactly how the thick stroke proceeds across the whole top of the letter. Whatever else is done or not done this D must be cut right before we proceed any further." He also proposed design alterations to capitals A—angular form too much like Greek, one with a curved base line submitted; E—upturned tongue replaced by a straight stroke; F—medial stroke raised higher; G—smaller lower bowl required (drawing submitted); he approved the widening of capital B, and requested an overall strengthening of the horizontal strokes together with a strengthening of the thin strokes throughout.

On 5 February 1935, H. G. Tempest of the Dundalgan Press, Dundalk, wrote to Morison: "I was very much surprised to see in the recent Bulletin a new Gaelic type. Credit is due to Mr Colm Ó Lochlainn for urging this on your company and directing the design. But surely it would have been useful, if not usual, to have consulted other Irish printers who might be expected to use the face. There are some of us who take an artistic and practical interest in type form. As a matter of fact I was in correspondence with the company 10 or 15 years ago about a new Gaelic face of a very similar nature based on the same original fount and hand written MS. form. But I should then have had to pay for the fount myself, which put it beyond me."[25] To which Morison replied on 6 February 1935: "We are grateful for your interest in the Gaelic", and continued by explaining why he did not seek the advice of printers regarding the type: "This, however, is not to say that we do not respect informed criticism. I would indeed be very pleased if you would let me know what you think of the complete fount as shewn in the accompanying trial." Tempest had in fact written to Monotype as early as 19 November 1926 enquiring as to "your lowest price for making me a complete set of punches and matrices in 12 point from a face I would supply you impressions of. They are Irish letters. There are 41 characters in a font I see. Of these 10 are accented forms of other letters and 18 are dotted forms. I would want you to undertake not to supply any other printer with similar matrices." Monotype replied on 22 November explaining that they would need to see the drawings of the characters required; "providing . . . they do not present any great difficulty, we could undertake the manufacture of 41 of these characters at the price of £50. 0. 0."

Morison forwarded Tempest's letter of 5 February 1935 to Ó Lochlainn on the following day, commenting on Tempest's remarks: "There is no advantage in extending the committee system to the consideration of type designs, although I don't doubt that Irish printers are more intelligent than English ones." Ó Lochlainn, in turn, wrote to Tempest on 13 February 1935: "I am glad to find that there is somebody interested in this besides myself and the few scholars whose advice I have had." He goes on to explain some of the design considerations in his type and concludes: "Morison tells me that he has sent you a proof of the complete font. Perhaps you would let me have your further remarks." Tempest wrote to Morison on 15 February 1935: "I am thinking over the face now and will write to him [Ó Lochlainn] and to you shortly. I should like to say straight away that taken as a whole on the printed page it is very satisfactory and as a whole a vast improvement on any of its forerunners, even on the Irish Archaeological Society's 1841 type, beautiful as that is. This is mainly because of its greater set and general roundness." On the same day, Tempest wrote also to Ó Lochlainn expressing his interest in the new Irish type, mentioning that he had attempted to get a similar face cut by Monotype some years ago. Like

10.11 Drawings showing some suggestions by H.G. Tempest for the Colum Cille type, dated 22 Februrary 1935.

Ó Lochlainn, Tempest had little regard for the popular Irish type of the time: "I never liked the present Figgins face. It is too thin in line, too spiky and really wearying to the eyesight. My choice, like your own, was towards the beautiful round shapes . . . The Irish Archaeological Society's face was the nearest to what I had in mind. . . . I am thinking over the fount as it now is, and will write to you shortly. I hope you won't let them rush the face out. It is so great an opportunity that we must get the nicest face we can."

True to his word, Tempest followed up on 22 February 1935 with a most detailed set of criticisms and suggestions regarding each letter of the new type. He enclosed a sheet of hand-lettered forms for consideration, with the note: "These are only very rough indications." (see ill. 10.11).

Trial No. 3 21-2-35

MONOTYPE

Colum Cille Series No. 121—14 point

14 Set Composition .2x.2 Line .1543

Redesigned B Ḃ ᵭ ᵭ

Seo cuṁ a céile iad aguṙ an beiṅc aꞃ ꞃaꞃuᵹaᵭ na n-uan, Ḋoṁnall aᵹ iaꞃꞃaiᵭ iad do ḃaiṅc de aᵹua Seáᵹan na leoᵹꞃaᵭ leiꞃ iad. Iꞃ an cꞃaꞃúᵹaᵭ ᵭóiḃ iꞃ ᵹaiꞃiᵭ ᵹuꞃ cuadaꞃ i ꞃᵹóꞃnacaiḃ a'céile, aᵹuꞃ im ḃóꞃa ꞃlanncadaꞃ a céile ᵹo ceiṙ leiꞃ na ᵭᵭuine. Iꞃ ᵹaiꞃiᵭ ᵹo ꞃaiḃ locáin ꞃola aiꞃ ꞃuaiᵭ an ḃócaiꞃ. Ní ꞃaiḃ duine i ᵹcúꞃam na n-uan iꞃ cuiꞃeadaꞃ an céim ꞃuaꞃ díoḃ. Ḃaiḃ ꞃean anuaꞃ ó'n muileann aᵹuꞃ ḃꞃaicᵭlín lán de ṁin coiꞃce aiᵹe aꞃ ᵭꞃom caꞃaill. Do cuaiᵭ ꞃé eacoꞃꞃa iꞃ coꞃam ꞃé aꞃ a céile iad. Ḃuail ꞃean cuiᵹe cꞃeaꞃna iꞃ do ꞃiaꞃꞃaiᵹ ꞃé de cad é ꞃáṙ na ḃꞃuiᵹne, iꞃ níoꞃ ᵭein ꞃean ancaꞃaill aon ḃlúiꞃe aṁáin acṙ ceaṙṙ aꞃ an mḃꞃaicᵭlín aᵹuꞃ i ꞃᵹaoileaᵭ iꞃ ᵹac uile ꞃioc ꞃiaṁ ᵭ'n ṁin-coiꞃce do lieᵹiṅc leiꞃ an abainn de ᵭꞃuim an ᵭꞃoicᵭiᵭ. Bain ꞃe cúꞃla cꞃoṙa aꞃ an mḃꞃaicᵭlin, cuṁ ná ꞃanꞃaᵭ púinn de'n ṁin coiꞃce uiꞃce. Ḃí mo Ḟiᵹeaᵭóiꞃ aᵹ ꞃéacaiṅc aꞃ an obaiꞃ ᵹo léiꞃ, iꞃ níoꞃ coꞃꞃuiᵹ ꞃe aꞃ an áiṙ ᵹo ꞃaiḃ ꞃé 'na ꞃeaꞃaṁ aiꞃ ꞃeaᵭ na haimꞃiꞃe.

"A ḃꞃeiceann cú an ḃꞃaicᵭlin ꞃin?" aꞃꞃa ꞃean an caꞃaill.

MONOTYPE
ABCDEꝼᵹHILMNOPꞂSCU EEFGJKQVWXYZ
ÁḂĊḊÉḞᵹÍṀÓṖṠṪÚ
abcᵭeꝼᵹhilmnoꞃꞃꞃcu dijkqvwxyz
áḃċᵭéḟᵹíṁóṗꞃṫú
£1234567890 .,:;-''!?–()ꞃ—

10.12 Monotype trial no. 3 for Colum Cille, 21 February 1935. Some text has been deleted from the sample for purpose of fit.

Trial No. 5 3-5-35

MONOTYPE

Colum Cille Series No. 121—14 point
 14 Set Composition .2x.2 Line .1543

Alternative No. 829 Ꝏ & No. 324 ᵹ Added

Seo cuṁ a céile iad aguſ an beinc aᵹuſ an ᵹapuᵹaḋ na
n-uan, Doṁnall aᵹ iappaiḋ iad do baint de aᵹua
Seáᵹan na leoᵹfaḋ leiſ iad. Inſ an tpapúᵹaḋ ḋóiḃ iſ
ᵹaipid ᵹup cuadap i pᵹópnacaiḃ a'céile, aᵹuſ im ḃópa
planncadap a céile ᵹo teic leiſ na doinne. Iſ ᵹaipid
ᵹo paiḃ locáin fola aip fuaiḋ an ḃócaip. Ní paiḃ
duine i ᵹcúpam na n-uan iſ cuipeadap an céim fuaſ
díoḃ. Ḋaiḃ fean anuaſ ó'n muileann aᵹuſ bpaiclín
lán de ṁin coince aiᵹe an ḋpom capaill. Do cuaid ſé
eatoppa iſ copam ſé ap a céile iad. Ḃuail fean cuiᵹe
tpeapna iſ do fiafpaiᵹ ſé de cad é fác na ḃpuiᵹne, iſ
niop déin fean ancapaill aon blúipe aṁáin act teact
ap an mbpaiclín aᵹuſ i pᵹaoileaḋ iſ ᵹac uile pioc
piaṁ ó'n ṁin-coince do lieᵹint leiſ an abainn de
ḋpuim an dpoicid. Bain ſe cúpla cpoca aſ an mbpaic-
lin, cuṁ ná fanfaḋ púinn de'n ṁin coince uipce. Ḃí
mo Ḟiᵹeadóip aᵹ féacaint aſ an obaip ᵹo léip, iſ niop
coppuiᵹ ſe aſ an áic ᵹo paiḃ ſé 'na feapaṁ ain feaḋ
na haimpine.
 "Ꝏ ḃḞeiceann tú an ḃpaiclin ſin ?" appa fean an
capaill.

MONOTYPE
ABCDEᵹHILMNOPRSCU EFGJKQVWXYZ Ꝏᵹ
ÁḂĊḊÉḞᵹÍMÓṖṠĊÚ
abcdefᵹhilmnopppcu dijkqvwxyz
áḃċḋéḟᵹímóṗṙċú
.,:;-"'!?–()ꝗ—

On the same day Tempest also wrote a detailed letter of "appreciation and criticism" of the new Gaelic type to Morison, who pointed out in his reply of 25 February 1935 that "there is no need for a new Gaelic based upon MSS., but what is required, if anything, is a Gaelic which shall do all the work at present performed by what is called Roman. From my point of view, Gaelic is a Roman in a state of arrested development." Morison continued by defending this non-calligraphic type and concluded: "I have said enough to indicate that the new Gaelic is regarded by us here as a commercial as well as a book type." Morison passed these, in his words, "excellent criticisms which deserve consideration" on to Ó Lochlainn: "I am pleased on the whole with Mr Tempest's criticisms. He is very good-tempered about it, particularly as it seems years ago he suggested a new Gaelic—unfortunately without receiving any encouragement from us."[26] On 28 February 1935 Morison wrote to Ó Lochlainn: "I have been spending a good deal of time off and on during the last few days in looking at all the sorts, lower-case and capitals, in conjunction with Mr Tempest's recent letter. I do not find myself very much in agreement. Some of the things that he asks for will be better seen in the italic. . . . One point Tempest makes with which I agree is that the numerals do not sort with the fount except in colour. I am sending another trial shewing of the new 'B' and 'd'. You will see that we have officially adopted the name 'Colum Cille' " (see ill. 10.12). On 7 March 1935, Morison wrote to Tempest: "We find ourselves in agreement with much of your criticism." He assured him that many of his suggested improvements were being put into effect, some of which were already under way prior to Tempest's comments. He explained that "it will be possible to meet some of your criticisms of the lower-case in the italic. . . . For my own part, I would add that I desire to see all trace of pen-work removed from these alphabets, but I realise that this end cannot be achieved for a very long time. Therefore the Gaelic at present under discussion is an interim solution." Ó Lochlainn reported to Morison on 20 March 1935: "[Tempest] criticises almost every letter but almost all his criticisms seem to be from a calligraphic rather than from a typographic stand point and the pen-made letters that he sent are of very little interest. Indeed I could improve on them very much with my own pen. I am writing to him to tell him that my task has not been to devise a scribal-looking letter but a Gaelic-looking type. All my difficulties have arisen from the undisciplined sense of freedom which the scribes, being Irishmen, allowed to influence their penmanship."

Ó Lochlainn replied to Tempest in detail on 20 March 1935, considering each letter commented on by Tempest. He concluded: "Generally speaking I hope I have not dealt too cavalierly with your very helpful suggestions but I feel that to some extent we are at cross purposes for I have been trying to convert the unruly and undisciplined Irish scribal alphabet into a

regular soldierly typographic font retaining a little of the particular charm of scribal lettering but divesting it of its over-emphasised peculiarities." Ó Lochlainn enclosed a copy of his *Gutenberg Jahrbuch* article and continued: "I really think that in this type we will come nearer to the form which 16th and 17th century type-cutters would have given to the Irish script if they had not been tramelled by the personal idiosyncracies of Irish scribes standing at their elbows. The contemporary scribes of either Latin, French, German, or Italian were not so exacting in their demands and so the type-founders or punch-cutters were given a free hand and contributed in no little way to the development on strict lines, of various beautiful designs both of Black-letter and Roman. But no punch-cutter, however enthusiastic, attempted to bring into Gothic Black-letter all the freedom of invention of the Gothic scribes of his time. I have been over twenty years reading and transcribing from MSS. of almost all periods from the Book of Armagh to the mid 19th century. . . . I have been ten years thinking about this type and three years actually working on it. You must then bear with me if I defend my progeny perhaps a little too stoutly."

Showing a sensitivity for both the modern and traditional views of Irish type, Tempest in his reply to this rebuff from Ó Lochlainn, on 23 March 1935, wrote: "It would be too much to expect that everyone should agree on the form of the new Gaelic type. It is such an important event to have such thing cut at all, that it is a great privilege to be able to express one's opinion and influence it in any way. . . . Mr Morison confesses that he considers Gaelic an 'arrested' roman and aims to persuade it gradually to become roman. To this I entirely dissent. I see no reason at all why we should all be mangled into one uniformity however good. Hence my plea is to retain all the good and beautiful points of—not 16th and 17th century writing—but the Book of Kells period, where they definitely need not be discarded either for ease of modern comprehension or technical reasons. . . . Please understand that in spite of my comments and remarks, I like your progeny as a whole immensely, and consider it far and away better than any former fount especially in the lower-case. I only wish I had known earlier that you were engaged on the work. Certainly I will have another friendly round with you at any time."

Apparently impressed with some of Tempest's comments, Morison at this time urged Ó Lochlainn to start on an italic: "I do not know when you intend us to get to work on the italic, but it would not be a bad idea if we began right away. On this point, I think some of Mr Tempest's suggestions might be considered since many of them originate in a desire to see closer approximation to MS. sources."[27] On 26 March 1935, Morison, in a lengthy letter to Tempest, again argued for the preference of the engraver's skills over the calligrapher's in type design: "I think it not only an error, but a vain error, to attempt, for instance, to force modern Irish

printing back into the state of arrested development which the Gaelic of our 'Monotype' series 24 symbolises." He continued: "I think, on the whole, it will be well to complete the fount as soon as possible in accordance with Mr Ó Lochlainn's design, corrected by you at certain points." Furthermore he made a particularly interesting offer to Tempest, apparently without having sought the approval of Ó Lochlainn: "later we might make a few sorts to your design which would be more traditional, though in harmony with the rest of the fount. These could be alternative characters and could be ordered in accordance with the preferences of the trade."

In an effort to get some more widespread comment on the appearance of the type, at Ó Lochlainn's request Monotype set a trial four pages for the *Gaelic Journal*, which Ó Lochlainn acknowledged on 13 November: "It is only next week that we are publishing the Gaelic Journal for which you set four pages. I will probably make more comments when this has been issued." Morison replied: "I will employ all these [corrections] with those that you send me after the forth-coming number of the Gaelic Journal. We ought then to be in a position to make a final trial."[28] Later Morison expressed his satisfaction: "The Colum Cille as printed in the *Index to the Gaelic Journal* seems to me to be very attractive" and, with a thought for the promotion of the type, he continued: "I very much hope that, when you have a few expressions of opinion, good, bad or indifferent, you will employ us to set up a little specimen in which these can be quoted, or, rather, let us employ you to set it up."[29]

Ó Lochlainn used this trial setting to canvas opinion. Paul Grosjean, SJ, of Brussels, in a letter of 12 January 1936, commented: "Now concerning your Colum Cille type, since you invite criticism from those who may have ideas about it. First of all congratulations for your boldness in venturing upon such work. I am rather diffident in facing such authorities as Stanley Morison and yourself, but I am (so far as I can say) one of the most particular amateurs of fine type, with some experience, as you remember, of early printing and Gaelic palaeography. I am not entirely satisfied with your Colum Cille as it stands. . . . As to the separate letters the one I dislike most (and I must say I hate it fiercely), is capital A: it is quite unhistorical, against the very evolution of the letter. . . . As a whole I like the l.c. series better than the capitals. . . . I should be delighted to see some of the earlier designs for the type, and to have some idea of the improvements you are thinking of. I am really interested in this, as you perceive. And very sorry that I should live so far from Dublin." Ó Lochlainn had requested changes to capital A on 20 March 1935: "Cap A the angular form has been objected to by two or three people. The alternative design I sent is a nearer approach to the normal form already in use" (see ill. 10.13).

Ó Lochlainn contributed an article to *Progress in Irish Printing*, issued by Alex Thom in 1936, entitled "Gaelic Script and Modern Type" in which

he gave a brief account of the development of Irish type design and mentioned his Colum Cille as "now nearing completion". He went on:

> This is an attempt to combine the inspiration of scribal forms with the formal elements of printing type design. An entire elimination of non-essential scribal motifs has resulted in a severe yet attractive face which composes in a soldierly line, legible and clear and free from angularity, even in tone colour without the monotony of some modern sans-serifs. Through the kind offices of my friend Stanley Morison, I was given every opportunity of dropping and changing until at last my dream-type has become a reality. The elements used are simple. No serif is allowed except a small "lead-in" from the left. Lower case "l" is the first element and from this and the second—the l.c. "o"—all such letters as a, b, d, p, g, etc. are formed. The "o" again gives, in combination with a horizontal line, the "t" and "g", those two unruly letters which seem to resist all efforts at formulization. The capitals have been brought all to line and definitely Roman forms have here and there been used, historically and scribally defendable, and exceedingly clear and useful, in view of the intention to develop small capitals and italics at a later stage. All the additional letters not needed for Irish are also included, as well as the normal forms of d, g, t, s, r, thus rendering the type usable for display work in any language.[30]

Dara Ó Lochlainn describes the Colum Cille type in a similar fashion:

> This began as an attempt to improve on Petrie's 1840 type. Soon it developed into the fashioning of an alphabet from two or three elements: (1) a vertical with a slight lead in from the left-hand side as if a sculptor or engraver were striking with a chisel or V-pointed graver. (2) A letter "O" with an oblique stress of about 30 degrees from N.W. to S.E. From these two elements practically all letters except T, G and S were made. T and G required a straight top line and G and S needed a sinuous curve with the lower lobe of G falling below the base line. For some letters alternative forms were cut, and finally a cursive or sloping version to serve as an "italic" was contrived.[31]

Ó Lochlainn used the 14 point size from a supply of foundry type (he had not yet received any matrices), for the setting of invitations and various small jobbing print requirements in Irish, but unfortunately this new type did not find favour immediately with printers in Ireland. Morison noted this in his letter to Ó Lochlainn on 7 December 1938: "We are sorry to have to report that no enquiries for matrices of this design have followed its use in your publications, and we have not, therefore, found it necessary to put in hand any further sizes. Notwithstanding, we are prepared to cut a 12 point, a 10 point, or an 8 point if you will order any of these sizes; and we think we could promise you delivery within five or six weeks of the receipt of your order."

As may be evident, the correspondence between Ó Lochlainn and Morison often drew on the personal friendship that had developed

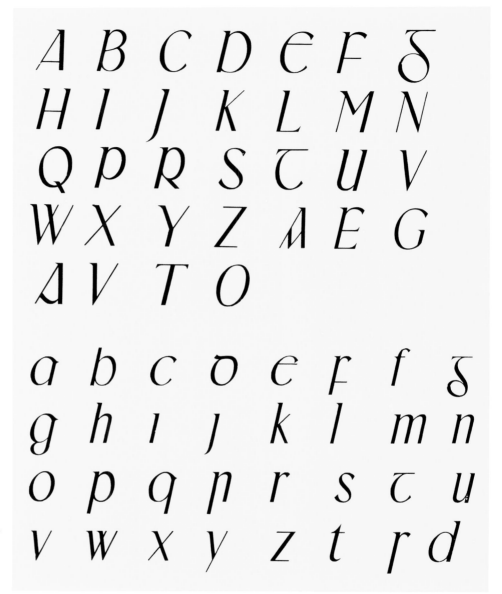

10.14 Drawings for the italic version of Colum Cille, dated 20 January, 1939, reduced to 30% approx.

between them; hence it is sometimes difficult to appreciate the full objective measure of their comment. In this vein, Ó Lochlainn castigated him in a letter of 6 January 1939 for an omission in a lecture by Morison: "I am very much annoyed by your British Association pamphlet in as much as you do not refer to Ireland. Is it a result of the American Declaration of 1776 or the more recent economic war with Ireland that has given all your English necks a twist eastward instead of westward?" He

continued, referring to the influence for the design of his type mentioned in the pamphlet: "Two very important volumes were published after George Petrie's—both edited by Margaret Stokes—by the Society of Antiquaries of Ireland. Most of the inscriptions are from stone, but some of them are from the metal work of book-shrines, chalices, etc. and as one of them is the alphabet which George Petrie, and after him Colm Ó Lochlainn, used as a basis for modern Irish type, they should not be beneath your notice." He continued: "Now to cease my vain and futile attempts at humour. I want to tell you that I wish you to proceed at once with the cutting of the 10 point Colum Cille." Morison replied on 9 January 1939: "You are quite right to object to my having excluded Ireland from the appendix to my lecture. I wish you would write a note ad perpetuam rei memoriam attacking the pamphlet containing the lecture. . . . We will proceed at once with the cutting of the 10 point Colum Cille if you will send an order for it. You are at present our only customer, and I cannot tell you how we prize you. If you send in the order at once the fount of 10 point shall be completed within six weeks at the most." On 23 January 1939 Ó Lochlainn wrote: "Herewith a definite order for the 10 point to be executed as soon as possible." On one attached sheet he submitted a number of redesigns and alterations, and commented regarding a second enclosure: "The other sheet contains the first italic alphabet ever planned for Irish [see ill. 10.14], at which let Nations tremble!" (a remark which ignores O'Rahilly's earlier design for an italic). He continues: "I would like you to study this very carefully and let me have your remarks. I myself am well satisfied with it—indeed I think it will look even nicer than Roman as it retains the inscriptional character and only follows scribal tradition in its slope." He then reminded Morison that "Now the only thing that is wanting is an alphabet of small caps."

The artist responsible for preparing these drawings has not been identified. Karl Uhlemann states that he had no involvement in the italic and that it has a noticeably different appearance to that of the upright. On 25 January Morison wrote: "As for the italic, I have first of all to acknowledge receipt of your drawings, and congratulate you on the effort. The only criticism I have to make concerns the lower-case 'g', the form of which appears to me to be a very difficult affair for a stone carver. On the whole, however, I think that the lower-case is satisfactory. You notice no doubt that the letters 'n', 'u' and 'h' are very narrow sorts compared with 'a', 'd' and 'e'. I fancy in 10 point they will look very narrow indeed. In fact you have altered the proportions from the roman very materially indeed." On 6 February Morison sent a photographic print of the italic drawings reduced to 10 point, from which the relative lightness and narrowness of some of the sorts is quite evident (see ill. 10.15). For this Ó Lochlainn thanked

10.15 Photographic reduction for the 10 point italic sent by Morison, 6 February 1939.

Trial No. 2 14-6-39
"MONOTYPE"

Colum Cille Series No. 121—10 point
 10 Set Composition Line .1334
Keybar Frames 3777, 3778 London Order E1433 & E1438

Seo cum a céile iad agur an beirt ag rápugad na
n-uan, Domnall ag iarraid iad do baint de agur
Seágan ná leogfad leir iad. Inr an trápugad dóib ir
gairid gur cuadar i rgópnacaib a céile, agur im bora
planncadar a céile go teit leir na dóirne. Ir gairid
go raib locáin fola air fuaid an bótair. Ní raib
duine i gcúpam na n-uan ir cuireadar an céim fuar
díob. Ġaib fear anuar ó'n *muileann* agur braitlín
lán de min coince aige ap ópom capaill. Do cuaid ré
eatorra ir corain ré ar a céile iad. Buail fear cuige
trearna ir do fiarpaig ré de cad é fát na bruitne, ir
níor dein fear an capaill aon blúire amáin act teact
ap an mbraitlín agur í rgaoilead ir gac uile pioc
riam de'n min coince do leigint leir an abann de
óruim an droicid. Bain ré cúpla cnota ar an mbrai-t
lin, cum ná fanfad puinn de'n min coince uirte. Bí
mo *fiġeadóir* ag féacaint ar an obair go léir, ir níor
corruig ré ar an áit go raib ré 'na fearam air fead
na haimrire.

"Δ' Bfeiceann tú an braitlín rin ?" arra fear an
capaill.

"*Cím go dian mait*," *apr an fear eile.*

"*Níor bfiú a bfuil de min coince ap an mbraitlín
rin an cár ó túir deire. Dá mbéad ciall aca, níor ġábad
dóib a leitéid do beit amlaid*," arra fear an capaill.

ΔBCDEFＧHILMNOPRSCU ΔTGJKQVWXYZ
ÁBĊDÉḞＧÍṀÓṖṠĊŪ ÁΔÁ
abcdefghilmnopprcu dfgijkqrstvwxyz
ábċdéḟġíṁóṗṙċú
ΔBCDEFＧHILMNOPRSCU ΔTGJKQVWXYZ
ÁBĊDÉḞＧÍṀÓṖṠĊŪ Áſj
abcdefgilmnopprcu dfgijkqrstvwxyz
ábċdéḟġíṁóṗṙċú
£1234567890 .,:;-!?"'-()ꝛ—

10.16 Monotype
trial no. 2 for the
10 point regular
and italic,
14 June 1939.

158

SYNOPSIS IN 10 POINT

ABCDEFSHILMNODRSCU ÁBĊDÉḞĠÍṀÓṖŚŪ
abcoefshijlmnoppṛcu ábċóéḟġíṁóṗṛċú
ABCDEFSHILMNODRSCU *ÁBĊDÉḞĠÍṀÓṖŚŪ*
abcoefshijlmnoppṛcu *ábċóéḟġíṁóṗṛċú*
1234567890 .,:;-!?''()-£⁊—

ADDITIONAL CHARACTERS

Ä 1001 Á̈ 1000 A 1132 Á 1133 G 296 J 210 K 193 Q 163 T 471 V 182 W 140 X 94 Y 199 Z 268 d 296 f 301 g 436 i 454

k 194 q 164 г 385 S 633 t 472 v 183 w 141 x 95 y 200 z 269 A 1134 Á 1135 G 440 J 209 K 265 Q 218 T 473 V 256 W 197

X 149 Y 311 Z 376 d 446 f 303 g 441 i 664 k 266 q 219 г 386 S 634 t 474 v 257 w 198 x 150 y 312 z 377 ſ 442 j̇ 443

8 PT. (8D) 8½ SET U.A. 407 LINE M·1270

Nuaip a béiȯ na páiȯce ȝo léip ap an ȝclápȯub aȝac, léiȝ cpíoca píop iaȯ. Fiaɼpuiȝ ȯep na ɼcoláipíb caȯ é an c-acpuȝaȯ a ȯeineaȯ ap na ɼoclaib. Má'p ȯóiȝ leac ȝup ȝábaȯ é, ȯein poinnc beaȝ míniȝce ap an piaȝal a ȯéineaban óp na ɼomplaib. Ácc ȯ'á laiȝeaȯ aimpeap a caicɼip ap an ȝcéim peo ȯe'n céacc ipeaȯ iɼ peapp é. *Nuaip a béiȯ na páiȯce ȝo léip ap an ȝclápȯub aȝac, léiȝ cpíoca píop iaȯ. Fiaɼpuiȝ ȯep na ɼcoláipíb caȯ é an c-acpuȝaȯ a ȯeineaȯ ap na ɼoclaib. Má'p ȯóiȝ leac ȝup ȝábaȯ é, ȯein poinnc beaȝ míniȝce ap an piaȝal a ȯéineaban óp na ɼomplaib.*
ABCDEFSHILMNODRSCU *ABCDEFSHILMNODRSCU* AB

10 PT. (10D) 10 SET U.A. 407 LINE M·1334

Nuaip a béiȯ na páiȯce ȝo léip ap an ȝclápȯub aȝac, léiȝ cpíoca píop iaȯ. Fiaɼpuiȝ ȯep na ɼcoláipíb caȯ é an c-acpuȝaȯ a ȯeineaȯ ap na ɼoclaib. Má'p ȯóiȝ leac ȝup ȝábaȯ é, ȯein poinnc beaȝ míniȝce ap an piaȝal a ȯéineaban óp na ɼomplaib. Ácc ȯ'á laiȝeaȯ aimpeap a *Nuaip a béiȯ na páiȯce ȝo léip ap an ȝclápȯub aȝac, léiȝ cpíoca píop iaȯ. Fiaɼpuiȝ ȯep na ɼcoláipíb caȯ é an c-acpuȝaȯ a ȯeineaȯ ap na ɼoclaib. Má'p ȯóiȝ leac ȝup ȝábaȯ é, ȯein poinnc beaȝ míniȝce ap an*
ABCDEFSHILMNODRSCU *ABCDEFSHILMNOD*

12 PT. (12D) 12 SET U.A. 407 LINE M·1400

Nuaip a béiȯ na páiȯce ȝo léip ap an ȝclápȯub aȝac, léiȝ cpíoca píop iaȯ. Fiaɼpuiȝ ȯep na ɼcoláipíb caȯ é an c-acpuȝaȯ a ȯeineaȯ ap na ɼoclaib. Má'p ȯóiȝ leac ȝup ȝábaȯ é, ȯein *Nuaip a béiȯ na páiȯce ȝo léip ap an ȝclápȯub aȝac, léiȝ cpíoca píop iaȯ. Fiaɼpuiȝ ȯep na ɼcoláipíb caȯ é*
ABCDEFSHILMNODRSCU *ABCDEFSHILMNODR*

14 PT. (14D) 14 SET U.A. 147 LINE M·1543

Nuaip a béiȯ na páiȯce ȝo léip ap an ȝclápȯub aȝac, léiȝ cpíoca píop iaȯ. Fiaɼpuiȝ ȯep na ɼcoláipíb caȯ é an c-acpuȝaȯ a ȯeineaȯ ap na ɼoclaib. Má'p ȯóiȝ leac ȝup ȝábaȯ é, ȯein poinnc beaȝ míniȝce ap an piaȝal a ȯéineaban óp na ɼomplaib. Ácc ȯ'á laiȝeaȯ aimpeap a caicɼip
ABCDEFSHILMNODRSCU ABCDEFSHI

Morison and asked: "Do you think the general line of this too thin? and would it be strengthened in cutting? . . . Many thanks for the interest you are taking in this. You do not know what balm it is to the soul of the neglected Type designer whose obsession is Gaelic!"[32] On 26 April 1939, he asked for an early delivery of the necessary matrix case for the 10 point "as I am closing in on the big MacNeill book" (see ill. 10.16). In the same letter he further pushes to realize his initial goal of a complete range to this type: "By the way, some of those who are interested in the type have been asking me about a black to work with it. Will it be necessary for us to make new drawings or will your artist work out a heavy version of the alphabet?"

He was still pursuing this matter over three years later when he wrote

10.17 Monotype specimen sheet showing the complete range of Colum Cille Series 121, 1972.

ABCDEFGHIJKLMNOPQRSTTUVW
XYZabcdefghijklmnopqrstuvwxyz
1234567890;)(&?!!£$¢

10.18 Modified Colmcille prepared by Dara Ó Lochlainn for an instant transfer lettering system.

on 30 September 1942: "I suppose this is a bad time to be talking about extending the range of COLUM CILLE, but we do need badly the 14 point which was never completed. If you think anything can be done I will mark on the 12 point sheet all the sorts which we require. If that were once finished we could proceed with an 8 point which could be set either solid or on 10 point." Morison replied: "This is a bad time to talk about extending the range of Colum Cille. Look into the characters that you really want and let me know. I do not make any promises but I will do what I can."[33]

After receiving a copy of *Féil-Sgríbhinn Eóin Mhic Néill*, which had been printed at the Three Candles Press, Morison was moved to comment: "I am very greatly impressed by the contents, and by the typographical presentation. . . . As to the Ó Lochlainn Gaelic, complete with italics, I express myself as being thoroughly pleased. This is the first occasion on which I have seen the stuff in actual application; as shown, say, in Thomas O'Rahilly's article, the italic is very well deployed."[34] In 1945 Monotype promoted the Colum Cille type in a leaflet stating: "This incomparable Gaelic type, 'Monotype' Colum Cille, is available in two sizes (14 point and 10 point). Further sizes can be cut to order. Serene dignity and classic beauty set 'Monotype' Colum Cille, the type that you are reading here, head and shoulders above any other Gaelic design. This face is available only for 'Monotype' type composing and casting machines. It has all the necessary 'sorts' for printing English, French and Irish, and for the first time in history it has a companion 'italic'."

Ó Lochlainn put his new type to good use and with it produced a range of books remarkable for their typographic excellence. Among the titles to first use the 10 point was an attractive small book, *Cúpla Laoi as Edda* by Pádraig de Brún. On the reverse of its title page is printed the statement: "Columcille is ainm don chló so. An chuallacht Monotype a ghearr é ó litreacha a tharraing Colm Ó Lochlainn."[35] (The type-face is Columcille. It was cut by the Monotype Corporation from letters supplied by Colm Ó Lochlainn.) Regretfully, the Colum Cille type did not prove to be very

popular, the Three Candles Press being the only printing house offering this face.

The preference among printers for the more angular minuscule-based alphabet which Ó Lochlainn so disliked, together with the ongoing lobbying for the use of the roman character for the printing of Irish, tended to polarize opinion, with some supporting the roman character for printing Irish, and others the more traditional Irish character; this left little room in between for this Irish type with roman characteristics. Seán Jennett later commented: "This handsome type was designed by the Dublin printer and typographer Colm Ó Lochlainn and was cut by the Monotype Corporation Ltd in 1936. Because he is a printer, Mr Ó Lochlainn understands that a type is not a version of calligraphy, and he has produced an eminently prin-terly character, based on the Petrie designs. It has unfortunately not proved popular; perhaps because it has too many affiliations with roman—the capitals L M N, for example. This is the only Irish type with the rest of the roman alphabet designed to match, and certainly the only one with an italic."[36]

Jennett's article prompted Karl Uhlemann, who as we have seen was in-volved in producing the original drawings for the type, to seek clarification from Ó Lochlainn regarding the authorship of the designs. He asked Ó Lochlainn to acknowledge his (Uhlemann's) leading role in the design and to disassociate himself from the statement made by Jennett that attributed the design to Ó Lochlainn. Ó Lochlainn replied to Uhlemann: "That article in The British Printer was not inspired by me, although considerable use was made of things I had written elsewhere. All I did was to send, when requested by the Editor, a few samples of *Colum Cille*, and *Baoithín*. I have

10.19 Monotype trial-proof for a bold version of the 14 point size of Columcille, 5 October 1988.

Fount 12A1 Size 14pt.

HO aeꝼ⁊hınopꞇy,

HaH HeH HꝼH H⁊H HhH HıH HnH HoH HpH HꞇH HyH
OaO OeO OꝼO O⁊O OhO OıO OnO OoO OpO OꞇO OyO

One Honey, One aꞇ ꞇhe hoꞇꞇon ıeꝼꞇ hany⁊ın anonıh he oꝼ a pa⁊e ꞇhan aꞇ ꞇhe ꞇop, oꞇheıye ꞇhe ꞇype hae ꞇhe appeyanoe oꝼ ꝼaıhın⁊ ꞇon oꝼ ꞇhe pa⁊e, Heh nıne an⁊ına ahonıh he ıea ꞇhan ꞇhe onꞇey an⁊ına, oꝼ a honhıe ꞇeyꞇ, pa⁊e openın⁊ aꞇyıhea ꞇheeye ꞇo an enꞇıꞇy, noꞇ oꝼ aın⁊ıe pa⁊e

never met the strangely named Mr Jennett—I hope he is not an ass as his name would seem to indicate."[37] It is interesting to note that Uhlemann insists that when preparing the drawings for the Colum Cille type he was quite unaware of the Petrie type which shares so many of its characteristics, but was inspired solely by his studies of the Book of Kells. Regarding this influence Alf MacLochlainn, in an introduction to a reprint of Lynam's seminal article, says: "We refer to Colm Cille Gaelic, designed by Colm Ó Lochlainn and cut by the Monotype Corporation in 8, 10, 12 and 14 point sizes, with an associated Baoithín type for titling developed by Colm Ó Lochlainn in collaboration with Victor Hammer. The relationship of this type to those which Lynam has called the Archaeological Society types is readily discernible."[38]

In a 1959 review of Sir Cyril Burt's *A Psychological Study of Typography*, Ó Lochlainn praised the introduction by Stanley Morison, and more generally his on-going work in typographic design, with a sad note regarding his own efforts: "His [Morison's] success is apparent to all; and I salute him as the best living type designer. This from one who tried and failed!"[39]

Under new management of the Three Candles Press in the late 1960s there continued to be a small demand for this type. However, as the press began to phase out its letterpress department from about 1974, John McManus of John Augustine Printers purchased some of the hot metal stock, which he states included the Colum Cille material. Consequently he took charge of the matrix case and the associated equipment and set these up at the Athlone premises of John Augustine Print Ltd in 1982, where it is presently available in the 10 point size. In addition it is in the process of being adapted for use on the Merganthaler photo-typesetting system by McManus, who hopes to provide it in a range of sizes.

In the early 1980's, Dara Ó Lochlainn adjusted the alphabet for use in an instant dry transfer lettering system in a 28 point size, of which he remarked: "A while ago we thought we had all the typefaces man would ever need; all there was to do was to enlarge the old proofs, clean up the edges and Bingo!—we had a new and improved photosetting fount. I found out this is not so when trying to render a display fount for the Colmcille typeface designed in the 30s by my father Colm, with Stanley Morison at the Monotype end. All kinds of horrors and distortions occurred and it took three months on and off to redraw and embolden the face before it was fit for use. Even now the discerning eye will find when using the Colmcille Modern . . . that my 'O' looks as though it hadn't eaten for a while! [see ill. 10.18]. I am currently in the process of trying to make the italic acceptable for display."[40] More recently he completed the drawings for a bold version for Monotype, who are considering the reissuing of this face in an extended range of weights (see ill. 10.19).

THE ROMAN v. THE IRISH CHARACTER

THE FIRST RECORDED book printed in Gaelic used roman type. This book by John Knox and translated by John Carswell, entitled *Foirm na Nurrnuidheadh* (Forms of Prayer), was printed in Edinburgh by Robert Lekprevik, and is dated 24 April 1567 (see ill. 11.1). Knox refers in his preface to "one great disadvantage which we the Gaeil of Scotland and *Ireland* labour under beyond the rest of the world, that our Gaelic language has never been *printed*, as the language of every race of men has been; and we labour under a disadvantage which is still greater than every other, that we have not the Holy Bible printed in Gaelic, as it has been printed in Latin and in English, and in every other language." Unlike in Ireland, roman type was to continue as the popular and predominant form for printing Gaelic in Scotland.

Theobald Stapleton, one of the earliest supporters of the use of roman type for Irish, issued his *Catechismus, seu Doctrina Christiana*, at Brussels in 1639 in roman type, stating in the preface that he chose to have it printed in roman (it is printed in parallel columns, Latin and Irish, the Irish in italic) so that it would be more easily read and understood (see ill. 11.2). Indeed, this would seem to have been so important to him that he mentions on the title page that the roman character is being used to facilitate the reading of the Irish. Stapleton was also an early exponent of simplified spelling and a most outspoken critic of many of the native writers. He told them in his preface: "it is right and very fitting for us Irishmen to esteem, love and honour our own natural native language, Irish, which is so concealed and so suppressed that it has almost passed out of people's minds; the blame for this can be put on the poets who are authorities on the language, who have put it under great darkness and difficulty of words, writing it in contractions and mysterious words which are obscure and difficult to understand; and many of our nobles are not free [from blame] who bring their natural native tongue (which is efficient, complete, dignified, cultured and acute in itself) into contempt and disregard, and who spend their time developing and learning other foreign tongues."

The next occasion in which roman type was used for Irish was in 1690 when *An Biobla Naomhtha*, edited by Robert Kirke, was printed by Robert Everingham, the London printer who was the first one to use the Moxon

fandaigh .ı. donathair mhor mhiribh-
aileach ,& don mhac mhaifeach mhor
chumachtach, agas don fpirad naomh
nó oirrdheirc, is cóir gach vile onoir
& galoir agas bhuidheachas do thab-
hautt tré bhioth fiór.

(₊*₊)

DO CHVM
GACH VILE CHRISDV-
idhe ar feadh an domhain go himlan &
go haimidhe dfearaibh Al an & Eire-
and, don mheid dibh ler bhail briathra-
difle Dé do ghaohail chuca na geroid-
headnaibh & na nindtndibh, ata Eóin
Carfuel acur abheandachta agas
aguidhe an fpirad naomh dho
ibh odhia athar trid.
IOSA CRISD
ARDTIGH-
EARNA.
(₊✝₊)
B. 2.

11.1 Page from
*Foirm na
Nurmuidheadh*
(Forms of Prayer),
1567.

Irish type. This edition was intended largely for use in Scotland and as such
was more acceptable in that form.

John Richardson, author of *A Proposal for the Conversion of the Popish Natives
of Ireland to the Established Religion*, printed in 1712, gave great importance
to the use of the Irish character in print. In that work he argued for the
special Irish character and suggested that the use of the aspirant dot instead
of h resulted in a space saving of approximately 10%; that the language was
easier to learn in the Irish character; and that the Irish character was preferred
by the best authorities on the matter. He went on: "There is one argument
still remaining, which will go very far, and have great weight with any
one, that seriously considers of the most effectual method of converting

11.2 Page from
Theobald
Stapleton's
Catechism, 1639.

TRACTATVS III.
SECVNDI LIBRI
DOCT. CHRIST.

In quo tractatur de Praeceptis legis divina & Ecclesia, & operibus misericordia.

CAP. I.

De Praeceptis decalogi.

MAGISTER.

1. COgnitis Symbolo Apostolico, articulis Fdei, oratione Dominicâ, & salutatione Angelicâ, decem Dei Praecepta, seu Decalogum, modò explica: quia haec est tertia pars principalis, vt in libro primo huius doctrinae dixisti?

D. In primis, scire oportet decem Praecepta divinae legis, ac Ecclesiae, & opera misericordiae: quia Fides & Spes sine charitate, & observantiâ legis divinae, ad salutem non sufficiunt.

2. M. Quid sibi vult hoc, cùm tot leges in mundo & in Ecclesiâ sint, & tot Praecepta: quod lex nostra decem Praecepta complectens, caeteris omnibus legibus anteponatur?

D. Multae rationes adduci possunt ad legis huius excellentiam commonstrandam. Primò quidem, quia haec lex à Deo primitus facta est, & ab eomet initio quidem in cordibus hominum descripta, deinde verò in duabus marmoreis tabulis incisa. Secundò, quia antiquissima est legum omnium, & veluti reliquarum origo ac fons. Tertiò, quia haec lex est generalissima legum om-

AN III. TRACHT
DON II. LEABHAR
DHON THEAG. CHRIOST.

Na ttrachtar ar Aitheanthaibh dlige Dé & na Heagluise, & ar oibreachuibh na trocaire.

AN I. CAIB.

Ar Aitheantuibh Dé.

MAGHISTIR.

1. OAta fios chrée na Neapostal, artec guil an chreidimh, vrnuighthe an Ttighearna, failthe an Aingil, & vrnuighthe ele go lionmhor agad, as sonnamhar lium à nois go minightha deith Naitheanta dlige Dé: or á se so an treas tracht prinsipaltha don Teagasc Chrioscuighe, mar a reamhradhais san chead leabhar?

D. As fior nach folair (dona cead nithibh) eclas do bheith ar Aitheantuibh dligh Dé, a chuig Aitheantaibh na Heagluise, & ar oibreachaibh na Trocaire: or ni leor creideamh, & dochus chum ar slanuighthe, gan cartheracht, & comhaill dlige Dé.

2. M. Cred an fath, faccurthar ar ndlighe .I. na deith Naitheanta roimh an vile dlighe, & à liacht dlighe & racht san Saoghal & san Eagluis na niagmuii?

D. As iomdha résun as fedir do thabhairt ar vosleacht, & ar mhaith an dlighe so, & ar tosach do bhrigh gur ab é Dia do scribh ia ecroidhthibh na ndaoine, ina dheaigh sin fós an da clár chloithe marmail. An dara cúis, ar son gur ab é as sine dhon vile dlighe, & gur ab é as preamh, & as tobar dhaibh. An treas adhbhar do bhrigh nach fuil dligh ar bith as coitchinne, & as genaraltha na nium.

For though I be free from all men, yet have I made my self a servant unto all, that I might gain the more.

And unto the Jewes, I became as a Jew, that I might gain the Jewes; to them that are under the law, as under the law, that I might gain them that are under the law;. 1 Cor. 9. 19. 20.

Ⱥ dhé bhi do bhriathar ro dhionchabharthach dhamh
Ⱥ dé bi do briacar ro dionċabarcaċ dam.

A Specimen of Irish in the English Character.

Ar a nadhbharsin a dubhradar a bhraithreacha-sin ris; Fag so, agus imthigh go tir Iudaighe, do chum go bhfaicfidis do dhelciobail fos na hoibreacha do ni thu.

Oir ni dheunann neach ar bith ein ni a bhfolach, agus, iarrus e fein do bheith oirdheirc: ma ni tu iad so, foilligh thu fein fos ann. *Eo.* 7. 3, 4.

11.3 Examples of text using the Moxon Irish type to print English (top), Irish using the h and dot for aspiration (middle), and Irish set with roman type from Richardson's *Proposal*, 1712.

men to the truth; and that is, that the *Irish* character is more acceptable to the *Irish* nation, than any other. It hath been used by that people for many ages, they are therefore very fond of it, and like books written in it, much better than in any other letter."[1] In support of his argument Richardson provided examples of English printed in the Irish character; Irish in the Irish character (Moxon type) using both the aspirant dot and the h following the consonant; and Irish printed in roman type (in his words, "A specimen of Irish in the English character": see ill. 11.3).

Ten years later, in 1722, another interesting book in this connexion was printed in Belfast by James Blow—*The Church Catechism in Irish*, compiled by Francis Hutchinson, bishop of Down and Connor. In it Hutchinson made an equally outspoken argument *against* the use of the Irish character: there are too few letters in the Irish alphabet; those that are included are awkward and strange; the addition of needless letters leads to intolerably long words, with many then being shortened again by replacing the more useful letters with confusing abbreviations. This complexity, he suggested, was intended to confuse: "But the worse and less intelligible the language

of those times was, the better it answer'd the ends of those who were masters of it. For the Pope's design was to keep Ireland a SACRED, as he call'd it, that is a separate people to himself, and the popish priests kept the laity in subjection to 'em, by means of their ignorance; and by the obscurity of their language, they did it effectually." Possibly referring to Richardson's comment of ten years earlier, he went on: "But it is said by some, that the natives are fond of their old character, and therefore we must keep it, that

11.4 The Raghlin alphabet with sample setting, from Hutchinson's *The Church Catechism in Irish*, 1722.

The *Raghlin Alphabet.*

ABCDEFGGHIKLMNOPQRSTUVWXYZÆ.
ABCDFEGGHIKLMNOPQRSTUVUWXYZÆ.
Roman *Italick*

a	*a*	A
b	*b*	bee
c	*c*	che as in *Charity,* *Chalice,* *Charles,*
d	*d*	dee *Richard,* *Archbishop,* *such,* *which,*
e	*e*	e approach.
f	*f*	eff
g	*g*	ghee
g	*j*	jee
h	*h*	atch
i	*i*	i
k	*k*	insted of *c* hard, as *Aker,* *Kaptain,*
l	*l*	ell *Kandle.*
m	*m*	em
n	*n*	enn
o	*o*	o
p	*p*	pee
q	*q*	qu
r	*r*	ar
ſ	*ſ*	eſs
s	*ſ*	eſe
t	*t*	tee
u	*u*	u
v	*v*	*V,* y or *Vaw.*
w		w kalled *wi,* as, *Wi,* a, s, *Was, Wi,* &c.
x	*x*	eks
y	*y*	i long
y	*y*	kalled *yi,* yɪ, o, u, you, yi, o, k, e,
z	*z*	ezzard or zod or ſ ſoft. (yoke.

Keſt. Kred do rinnedar do yeea a'are agus de yeea-vaare an tan ſhin ar do kons?

Fre. Do yalladar agus do vodidar tree neehe an Mainim. Akedor, Go nultfin don Diaval agus da Oibreheev oole, do Foimp agus do Yeevanis an droch-healſe agus do gagh oole Anvianeev pekkah a na kolla.: An dara huair, Go kredfinn gah oole Artikle don Chredeev Chreeſdee: Agus a tres Uair,

Fer

we may please them. But I wish, that they who make this objection, wou'd show, how it appears, that the natives, have really any fondness for it. There is not one in twenty thousand of 'em that can read it, or knows any thing of it. There is not one popish school in all Ireland that teaches it. Where then lies this fondness?"

Hutchinson made a particularly noteworthy proposal which he outlined as follows:

> First. Instead of calling a Ailim, b Beith, c Koll, d Duir, e Eadha, and f Fearn etc. we call them plainly, a, bee, c, dee, e, ef, etc. But this is no real change, but only pulling of a silly distinction where there is no difference. Then 2dly, as the old character is nothing but the Anglo-Saxonic, that is, our own and theirs both, about a 11 hundred years since, before time and printing had given it a smoother and better turn: we have taken them as they are now improved, without being at the trouble and charge of making new types to carry us back to the old figures which are worse. Then 3dly, as those old times and this old character wanted 8 letters, which time and experience have taught us to use: we have added all eight at once. . . . Then 4thly, as by taking the sounds by the ear, and adjusting their spelling with care and regularity, we have cast out an intolerable number of quiescents; we have taken away the occasion of as many abbreviations. . . . The alphabet that we have made use of, is this that follows, which we will take leave to kall the Raghlin Alphabet [named after the fact that Hutchinson had begun a mission on Rathlin Island as a base for evangelisation of the mainland].

Hutchinson presents his Raghlin Alphabet (see ill. 11.4) in roman and italic letters with a few modifications as follows: a second G is added to both capital and lower-case sets, using in addition the italic G with the roman alphabet and the roman G with the italic alphabet in the upper-case, and by adding the italic g to the roman, and the italic j for g to the italic alphabet in the lower-case, together with an additional y added to the roman and italic lower-case. With regard to the second g's Hutchinson explains: "Again, as two g's, g hard and gee soft, are mentioned in the Alphabet, for g soft we intend to have put i consonant, or an italic g, or only g with the tail reverted: but in the English we found it hardly twice, and in the Irish I am not sure whether the sound is found: And therefore we made little use of it, but yet let it stand in the alphabet, that others who come after may consider it, and use or leave it as they find best." The J is removed from the capital and lower-case alphabets which otherwise remain as the full conventional roman alphabet. Hutchinson explains the purpose of the Raghlin experiment alphabet: "If that benefit reaches only to that Island Raghlin, which it is prepared for, it will be richly worth all the pains we have taken; but if it shou'd prove a step, which the charity schools shou'd carry on, to the converting any considerable number of Natives

Fioṛaiẓhim ʒo maiṫ ḋaḃṛaḋh moṗán ḋo ḋhuinibh ʒuṗ aṛ ni buḋh iomchumhaiḋhe, ḋo ṫaḃḃaiṛṫ chunṫaṛ aṗ an ṫṫeanʒa *Ghaoidheilg* ṛa leiṫh, aṗ an *Breaṫnach* ṛa leiṫh ; aʒuṛ aṗ an *Gceirneach* ⁊ an *Harṁ-buireach* ṛa leiṫh maṗ an cceaḋna. Aḋmhuiʒhim ʒuṗ bhiḋhiṛi ann ṛin, iṛle a lúach ṛa ʒach én ṫíṗ ; achḋ ni a bhṛoʒuṛ chomhṫaṗbhach ḋhon *Sgolairiḃh* aʒuṛ ḋhon *Chriteachuibh* ; ḋo chionn ʒabhuiḋ ṛiaḋ eoluṛ aṛ ṛoileiṗḋhe a moṗán ḋṛoclaibh ṛéin (aʒ leiʒheoṗachḋ ṛeanlaimhṛʒṗibhṫe ʒo haiṗiʒhe) o chial-luʒhaḋh leiṫhiḋ bṗeiṫiṗi ameaṛʒ na chineaḋh coimhneaṛaḋha. Do ṗaiḃh ṛóṛ ni eile ḋha mheaṛuʒhaḋh an ṛin : aoḋhon ʒuṗ ceainneochṫaṗ (ṛa ni aṛ luʒhaiḋhe) leaṫhchuiḋ ḋon *Chlodhughadh* leiṛ na *Shag-fnachuibh* aʒuṛ eachḋṛanachuibh ṫaiṗleaṗacha, leaṗab ionann ṛonn no míon cuiṗealṫa ṗiṛ ʒach neach ṫeanʒa, aʒuṛ uime ṛin bioḋh ionḋhuil aca ʒuṗ chomhchloiḋhṫeaṗ iaḋ ṛa ṗe cheile.

Aʒuṛ anoiṛ nioṗi míon leam ḋo chuṗi bacail buḋh ṫuile oṗuibh ; achḋ aṗi an aḋhbhaṗ ʒuṗ chiʒhṫeaṗ ṛóṛ ṗiachḋanach ní éiʒen ḋo labhaiṗṫ ṗiṛ an luchḋ maʒamhail leaṗab ionʒaiṗeamhuil an ṫeanʒa *Breaṫnach* ⁊ an *Ghaoidheilg* aʒuṛ noch ḋamnaiʒhiḋ uime ṛin ṛhaoṫaṗi na nḋṗuinʒ ḋhiṫchilliḋ ḋha conʒbhail ṛúaṛ maṗi obaiṗi mioṫaṗbhach aʒuṛ ḋiamhaoineach.

Ni bhuil ḋúalach aṗi aonḋhuine cṗionna aʒuṛ eolach aiṗe aṗi biṫ ḋo ṫhabhaiṗṫ ḋhon *Bhriuninṫleach-daiẓhiḃh* ceaḋna ; oiṗi aṛ e o haincoluṛ no (ṛa ni aṛ luʒhaiḋe) o eaṛbhaḋh ṫeaʒaṛʒ buḋh ṛeaṗṗ, ṫhiʒhiḋ a ṛʒiʒeaiḋhiʒh uile. Aʒuṛ aṛ eioiṗi liom ḋheaṗbhaḋh lem ṫheaṛṫaʒhaḋh ṛe.in (iṛ ʒan amhaṗuṛ aṫa an ni ceaḋna aṗi na chṗuṫhaʒhaḋh aʒ moṗán ḋhoiḃhiṛi) ʒuṗ ʒibheaḋh aṫa ḋaoine iomaḋamhail aʒ labhaiṗṫ maṗi ṛin ; ni bhṛuil amhain cheana míon ṛhonnmhaṗi leiṛ an ḋhṗionʒ aṫa ṗo ṫheaʒaiṗʒṫhe ⁊ ʒhnaṫha-ṛach ḋhon chineaḋh na *Shagfanuigh* aṗi ṫṫeanʒaiḋhe aʒuṛ aṗi leabhṗa laimhṛʒṗiobhṫha chum coimhéaḋaḋh, achḋ aṫaiḋ umoṗṗio ʒo ʒheineaṛalṫa, na Paṫṗiunuiʒh aṛ mo ṛhialmhuṗi ḋhon ṛhoʒhlaim, ⁊ ḋobeiḋiṗi ḋhon ṫhuiʒṛeanachḋ aṛ mó ṛhaiṗiṛeanʒ, ṛan uile ʒhne ḋealabhuiʒh (ceachṫaṗi ṗe cheile) ⁊ ḋaiṫhneaḋhuiʒh ṛa nuile *Eoraip*. Ni bhṛuil ṗeaṛun aṗi bioṫ aʒumṛa chum bheiṫh eaʒcomhṫhṗiom ṛa ní ṛin ; ḋo chionn nach aṫaim ṛéin *Sagfanach* achḋ *Sinbhreaṫknach* aʒuṛ ṛóṛ (ḋo ṗeiṗi aṗi Sheanchuṛ Bṗeaṫhnuiʒh) eiṗiʒṫhe amach ʒo haṫṗiamhail o Hélioḋoṗi leaṫhanuin ṁhac Mheiṗichiaḋ, ṁhic Guṗiʒhuiṛṫ, ṁhic Ceneu, ṁhic Coel

throu' the whole kingdom, how important wou'd be the advantage then?"[2] The experiment would not seem to have met with much success, for it does not appear to have been put to any significant further use.

In the interest of making the comparison between the views of Richardson and Hutchinson, an important work in this regard has been overlooked namely Edward Lhuyd's *Archaeologia Britannica*. In this book, printed at the Oxford University Press in 1707, Lhuyd included "A brief Introduction to the Irish or ancient Scotish Language" taken mainly from Francis Molloy's *Grammatica Latino-Hibernica*, together with an "Irish-English Dictionary" in which he used the Anglo-Saxon character for printing the Irish text (see ill. 11.5).

Although he was aware of the existence of Moxon's type, Lhuyd did not use it, either through difficulty in obtaining it or by choice, for commenting on the inclusion of abbreviations in Irish he stated: "These abbreviations are in some measure still continued, . . . there are also some few of them cast amongst the Irish letters at Mr Everingham's press in London; and at the Irish press in Louvain."[3] He explained his choice of type, to some extent, in his general preface: "Having written a preface before the *Irish Dictionary*, there remains little more to be said of that part,

11.5 Sample of Anglo-Saxon type to print Irish, from Lhuyd's *Archaeologia Britannica*, 1707.

but the informing such as are altogether strangers to the language, that 'tis not any difficulty of its pronunciation that makes it appear so singular, but our not having at the press, those auxiliary or pointed letters they use in writing."

Lhuyd gives some interesting advice to those wishing to print Irish where no such special Irish types were available: "Another cause of dislike that strangers have to the *Irish*, is to find the auxiliary h made use of so often; . . . now this disagreeableness and inconvenience might, in my opinion, be remov'd by omitting after the example of others those super-fluous letters, and by printing the words exactly (as the *French* begin to do now) after the manner we speak them, which may easily be done by making use of an alphabet, made up of *Latin and Irish* characters."

This proposed alphabet uses the Irish d, g, and t: "And as there are without doubt but few printing-houses where these characters d[h], g[h], and t[h] are to be found; it will therefore be convenient to use in their place *Greek* characters, ∂, γ and θ [delta, gamma, and theta], and likewise, if there be occasion for a farther distinction, the *Greek* letters λ [lambda] for ll, ß and μ [beta and mu] for bh and mh . . .". A bewildered-sounding Lhuyd explains: "all I design by it is the expediency of making use of such an alphabet in printing the *Irish* language in such places where there are few or no *Irish-men*." He prints a sample of the Creed in this proposed alphabet, which uses roman, Irish (Anglo-Saxon), Greek and upside down Anglo-Saxon g for ng (see ill. 11.6). While the genuine intent of Lhuyd to come to terms with the idiosyncrasies of printing in Irish cannot be doubted, his proposal was too complex compared with the other methods common at the time. John O'Donovan, unimpressed with Lhuyd's effort, commented: "From the preface to his Dictionary, written in Irish, it appears that this great philologer knew almost nothing of the idioms of the Irish language, for he uses the English collocation in most of his sentences, which gives his Irish composition a strange, if not ridiculous, appearance."[4]

It is of interest that Bishop William Nicholson, for his translation into English of Lhuyd's Irish preface, had not the means of printing the Irish characters for Lhuyd's proposed alphabet, and noted that "the Letters mark'd thus \star should be in *Irish* characters, but none such are in the king-dom". This translation was printed by Aaron Rhames in Skinner Row, Dublin, in 1724.[5]

The Anglo-Saxon characters used in the printing of Lhuyd's work are the small pica Saxon which appeared in the Oxford University specimen of 1706, the special sorts of which were evidently cut by De Walpergen to work with the existing small pica roman (see ill. 11.7). A sample of the Anglo-Saxon sorts are given in Hart's account of typography at Oxford University Press where he states "Small Pica Saxon. No punches exist at this date [1899], but 17 matrices have been identified, and from them types

A, *a Angl.* v,*aw Angl.* b,*b* ; x,*ch* ; d,*d* ; ᴆ,*dh* ; e,*e* ; f,*f* ; g,*g* ; ᵹ,*gh* ; Ꙍ,*ng* ; i,*ee* ; *Angl.* k,*k* ; l,*l* ; m,*m* ; n,*n* ; o,*o* ; p,*p* ; r,*r* ; s, no ſ, ʃb *Angl.* t,*t* ; ꞇ, *th* ; u,*oo Angl.* v,*v* ; y, *i Angl.* in *Third, bird,* &c. no *ao* Ghaoıᴆheılᵹ.

"Kreidim a'n 'Ia aꞇair na'n uile xuvaxd, Kruꞇaiteoir neive & talvan : Agus an Ioſa Kríſt a éunvakſan
"an ðiarnaine, nox do gavaᴆ ón Spirad nẏv ; rugaᴆ le *Muire* oiᵹ, ᴆo 'ulaᎦ an fáis fa FuiᎦk Filáid, ᴆo
" kroxaᴆ, ᴆo keuſaᴆ, Fúair bás & do haᴆlaikeaᴆ, do xuaiᴆ ſios go hifrean, do eirᵹiᴆ o vís a gionn an treas la,
" do xuaiᴆ ſúas ar neav, agus atá anoiſ na huiᴆe ar deis De, Aꞇair na nuile xuvaxd : aſ ſin ꞇiocfas ᴆo vreiꞇ
" vreiꞇe ar veoᵹhaiv agus ar varvaiv. Kreidim an ſa Spirad nẏv, a'n Eagl�84is nẏvꞇa xovxodxionn, ku-
" man na nẏv, maiꞇeamh na beakꞇaᴆ, eiſeirᵹe xodla na marv, agus an veiꞇa varꞇanax. *Amen.*

Fæᴆeꞃ uꞃe þu þe eaꞃꞇ on heoꝼenum. Sı þın nama ᵹehalᵹoᴆ . To-
becume þın ꞃıce. Gepuꞃᴆe þın ꝼılla on eoꞃþan. ſpa ſpa on heoꝼenum.

Ð ᴆ þ ᴆ ꝼ ᵹ ı ꞃ ſ ꞇ ᴆ þ p ẏ ꞁ þ ꞃ ꝼ

11.6 Lhuyd's proposed Irish alphabet, with sample setting, 1707.

11.7 The small pica Anglo-Saxon fount of the University of Oxford specimen, 1706, used for Lhuyd's Irish, from Hart's *Typograhy at the University Press,* 1900.

for the Saxon characters have been cast afresh to reproduce the above examples. The ı was obtained by casting from the matrix for the i and removing the dot."[6] The fount is that used in Thomas Benson's *Vocabularium Anglo-Saxonicum* (Oxford, 1701). An examination of the letters d, g, t, and f identifies this face as different from the other Anglo-Saxons at Oxford at the time.

A particularly popular devotional book of this period was *Sixteen Irish Sermons* by James O'Gallagher, printed in Dublin in 1736. Both roman and italic type were used for the Irish text (see ill. 11.8), regarding which O'Gallagher explained on the title page that the book was set "In English characters; as being the more familiar to the generality of our Irish clergy"; and in his preface he says: "If my brethren will admire, why Irish sermons should come clothed in English dress, which seems not to suit so well the Irish language, one reason is, that our printers have no Irish types: and another, that our mother language, sharing so far the fate of her professors, is so far abandoned, and is so great a stranger in her native soil, that scarce one in ten is acquainted with her characters. Lest any, then, should be discouraged from making use of this little work, by being strangers to its very elements, I have made choice of letters, which are obvious to all; and in spelling, kept nearer to the present manner of speaking, than to the true and ancient orthography."

Walter Harris, in his revised and improved edition of *The Whole Works of Sir James Ware concerning Ireland* (1745), used what would appear to be an

odd compilation of Anglo-Saxon, Irish and made-up sorts to illustrate the Irish alphabet (see ill. 11.9) as "Flaherty hath copied it out of the Book of Lecane; to which I have added the form of each of the Irish letters in the proper character. . . . The Irish had the use of the *Greek* letters in common with the *Britains*, nor is it unlikely that the *Greek* letters might in time have degenerated into what we call the *Irish* or *Saxon* characters, which will be illustrated by comparing some of them together, especially the form of the ancient *Greek* characters."[7] Harris offers another sample of the Irish alphabet which differs from his earlier one, with the possible exception of the b, d, E, m, and t (see ill. 11.10). Where these curious sets

86 *On the danger*

A

S E R M O N,

On the danger of delaying of Pe-
nance.

Ego vado & quæretis me, & in peccato veſtro
moriemini. *Jo.* 8. ver. 21.

Imeochuidh Miſe, agus beidh ſibh dom iarruidh,
agus gheabuidh ſibh Bas an bhur bpeacuidh.
Briathra Chrioſd ag Eoin, anſa 8. *C*ab. v. 21.

A Ta Crioſd ag bagairt a niu go nimeochuidh
ſe uain; go dturſaidh ſe Cul a Chinn duinn:
Agus ni he ſin a mhain, acht go dturſaidh ſe cead
ſgartuidh agus garrtha dhuinn, ag iarruidh ar fil-
leamh, agus nach dtugann ſe binn no aird orainn.
Quæretis me, & non invenietis. Jo. 7. *Agus*
mur bharr druighill air ar Miſhortun, go leigſe
ſe dhuinn Bas dſaghail an ar bpeacuidh. *Et in*

1.	B. ḃ.	Beith,	*A Birch-tree.*
2.	L. ʟ.	Luis,	*A Quicken-tree.*
3.	F. Ḟ f.	Fearn,	*An Alder.*
4.	S. ſ.	Sail,	*A Willow.*
5.	N. ɴ n.	Nion,	*An Aſh-tree.*
6.	H. ħ.	Uath,	*A White-thorn.*
7.	D. δ.	Duir,	*An Oak.*
8.	T. ⁊.	Tinne,	{ Not expounded. Perhaps the *Tinu* of *Pliny,* A ſort of *Bay-tree.*
9.	C. c.	Coll,	*An Hazle-tree.*
10.	Q. ꝗ.	Queirt,	*An Apple-tree.*
11.	M. m.	Muin,	*A Vine.*
12.	G. ʒ.	Gort,	*Ivy.*
13.	Ng, ɴ.	Ngedal,	*A Reed.*
14.	P. p.	Pethpoc,	Not expounded.
15.	Z. z.	Ztraif,	*A Black-thorn.*
16.	R. ꞃ.	Ruis,	*An Elder-tree.*
17.	A. ɑ.	Ailm,	*The Fir-tree.*
18.	O. o.	Onn,	*Broom* or *Furze.*
19.	U. u ɣ.	Ur,	*Heath.*
20.	E. ᴇe.	Eadhadh,	*An Aſpen-tree.*
21.	I. ʝ.	Idho,	*The Ewe-tree.*
22.	EA. ᴇa.	Ebhadh,	*An Aſpen-Tree.*
23.	Oi. Oi.	Oir,	*The Spine-tree.*
24.	Y. ui.	Uillean	*The Honey-ſuckle.*
25.	Jo. ʝo.	Iphin,	*The Goosberry-tree.*
26.	X. ɑᴇ.	Amhancoll.	Not expounded.

11.9 The Irish alphabet from Harris's edition of *Ware's Works,* 1745 compiled from Anglo-Saxon, and Irish sorts.

11.10 An example of the Greek and Irish alphabets from Harris's edition of *Ware's Works,* 1745.

of letters came from is not recorded; they do not appear to have ever been used for setting text, and may have been compiled from odd sources and especially made up sorts just for the purpose of the illustration, for later in his account concerning the use of abbreviations in Irish, Harris states: "I shall give them in the *Roman* Character, there being no *Irish* types, or abbreviations in this kingdom."[8]

Later in the century, however, it would seem that Irish type was available in Ireland, for Edward Rowe Mores, writing in 1778, points out that Moxon's Irish was "the only type of that language we ever saw. . . . The punches and matrices have ever since continued in England. The Irish themselves have no letter of this face, but are supplied with it by us from England."[9]

The printing of Irish, particularly in the Irish character, was opposed

Greek.	Iriſh.

173

by officialdom, as it was seen to foster nationalism, and thereby serve the enemies of the Crown. This posed a dilemma for some of those promoting the doctrine of the Reformed Church, for they recognised the value of communicating in Irish and yet supported the suppression of the nationalism associated both with the language and with the Roman Catholics they sought to influence. Christopher Anderson, writing in 1828, described this reluctance to allow the use of the Irish character: "About the beginning of this [18th] century, an expedient presented itself, then no doubt deemed a happy one—which was, that if this Irish language was to be tolerated at all in the British dominions through the medium of books, it must only be by using the English or Roman *letter*. The jealousy which had reigned for centuries over the language, now settled itself, as a last resort, upon the appropriate character which belonged to it. . . . The entire abolition of the language was about to become the prevalent and favourite idea, as it continued to be during the whole of the eighteenth century."[10] He suggested that with the death of Richardson and other advocates of the use of Irish in the printing of Protestant doctrines, there was no pressure to use Irish in print at official levels, which contributed to its decline during the eighteenth century.

Another curious alphabet example, prepared it would seem as a relief block, was used to illustrate the Irish character in *An Analysis of the Gaelic Language* by William Shaw in 1778 (see ill. 11.11)[11]. Talbot Baines Rees recorded this alphabet in a small note book dated 1887, in which he kept an account of his observations on various Irish printing types.[12] In it he lists a "Shaw Irish Type", but later he apparently ceased to consider it as a legitimate printing type, for he makes no further mention of it as a typeface. Shaw says in his introduction: "Being the first that has offered the public a grammatical account of the [Scots] Galic, it was recommended by several persons to frame a new alphabet, consisting of letters or combinations, to express all the sounds in the language, without any mute letter. This is impracticable; but though it could be effected, it would only render the etymology more perplexing. . . . Unlike the Irish, the Scots Galic delights to pronounce every letter, and is not bristled over with so many useless and quiescent consonants."

In 1786, John O'Brien, bishop of Cloyne and Ross, published his *Irish-English Dictionary* in Paris. In his preface, he states that "the work has been published with a view not only to preserve for the natives of Ireland, but also to recommend to the notice of those in other countries, a language which is asserted by very learned foreigners to be the most ancient and best-preserved dialect of the Celtic tongue of the Gauls and Celtiberians." He goes on: "it is fit to inform the reader, that as the *Irish* characters are not known to strangers, and even far from being generally understood by the natives of Ireland, whereof but very few apply themselves to the reading

Ⅎⅎ, bb, Cc, δδ, ee. Ff, ʓʓ, 11, ℓℓ, ꝏm, Nɳ, Oo,
Pp, Rɲ, Sɾ, ℃ɕ, Uuɲ, ɧɧ.

11.11 Sample Irish alphabet from William Shaw's *Analysis of the Gaelic Language*, 1778.

Ar nathair atá ar neamb, naomhthar hainm:
tigeadh do rioghachd, deúntar do thoil ar an
ttalâmh, mar do nithear ar neamb; ar narán
laéathamhail tabhair dhúinn a niu; agus ma-
ith dhúinn ar bhfiacha, mar mhaithm ìdne dar
bhféitheamnuibh féin: agus na léig sinn a ca
thughadh, achd sáor inn ò olc: oir is leachd

11.12 Irish set in roman type from Fry's *Pantographia*, 1799.

of Irish books or manuscripts, it hath been judged more expedient and of more general use to print this Dictionary in the *Roman* and *Italic* types."

Edmund Fry, in his *Pantographia* of 1799, showed the Moxon Irish type on page 166, and on page 168 he included a sample of Irish set in roman type containing a number of unexplained vowel accents and h in place of the aspiration dot (see ill. 11.12).

The first roman type specifically prepared through adjustment for use in Irish seems to have been that used to print William Neilson's *Introduction to the Irish Language* in 1808, where it appears with the Parker Irish type (see ill. 11.13). Anderson described this development as follows: "it is evident that . . . putting a dot (˙) over a letter, as ġ, will be preferable to annexing h, in order to express the power arising from the combination, whether the character employed be Irish or Roman; of this Dr Neilson has been so convinced, that he has used the dot, even though he employs the Roman character; a further advantage is, that less room is occupied by the word, a benefit which affects not merely the size of the book, but also the ease with which the meaning of the word thus presented in a condensed form to the eye, will be understood."[13]

Basically two systems could be used to achieve this effect. Firstly, the top portion of the shoulder of the metal of each effected letter could be removed, making room for the insertion, at the composing stage, of a similarly adjusted full stop point. This procedure involved an extremely

> " A daoine uaisle," arsa an ta'tair Brian, "na daor-
> aiḋ me, go gcluine siḃ deireaḋ an sgèil. Cuiŕtear
> an Seóiġeaċ ċum a ṁionna."
>
> Do ṁionnaiġ an Seoiġeaċ gur pòsaḋ è fa ḋo—go
> ḃfuair se an ċead ḃean aig baile Ghoirt—go raiḃ si
> bliaḋain aige, laiṁ le ċnoc Maġa—gur imṫiġ si uaḋ
> as sin—naċ raiḃ fios aige cia leis—bi se fèin fan
> ḃaile—ni faca se ag imṫeaċt i—ni raiḃ si fallain, an-
> ḋiaiġ cloinne breiṫ—fuar se an dara ḃean san àit
> sin—saoil se gur eug an ċead ḃean—saoil an sa-
> gart è—ḋ'eug an dara ḃean.
>
> " Anois, a ḋaoine uaisle," arsa an ta'tair Brian,
> " so litir a fuar mise, faoi laiṁ saġairt paraiste an
> tSeoiġiġ, a ḋearbuiġeas gur eug a ċead ḃean—go
> ḃfaca se fèin marḃ i—'s go raiḃ se ag a torraṁ—
> gur pòs se an Seóiġeaċ, na ḋiaiġ sin, le cailin eile
> san àit;—'s gur eug sise fòs o ṡoin. Feuċaiḋ anois,
> go rinne me mo ḋitċioll an firinne faġail amaċ."

11.13 Neilson's aspirated roman type from his *Grammar*, 1808.

tedious setting operation, and would, more than likely, have resulted in an inconsistent placement of the aspiration dot. Secondly, and more likely the case in the Neilson type, the original punches of roman sorts could be adjusted with that for the dot being combined with that of the appropriate letter, and a matrix formed from a single strike. This was done in such a way that the dot could be removed or added to the punch as required. It was usually not possible to add the dot to the capital letters without creating the need for additional interlinear spacing. Neilson's type made use of the dot on the lower-case letters only, the distance of the dot varying up and down from one letter to the next and from the retained dot over the i, resulting in an unsightly, uneven line of dots. Furthermore, the placement of the dot to the side of those letters with ascenders has a particularly awkward appearance, while the weight of the dots is uneven, with that used over the t being almost indiscernible.

Mention should also be made of the so-called Barlow Irish type, already described in the section attributed to that style (see page 75). This fount made extensive initial use of roman letters mixed with the Irish, in an attempt to provide a form more acceptable to non-native readers, whilst also employing an extended range of unusual and complex marks of aspiration (see ill. 6.2).

About the beginning of the nineteenth century, the appropriate letter-

form for printing Irish acquired new importance. The newly formed Hibernian Bible Society, together with the British and Foreign Bible Society, wished to reach the widest possible readership among the Irish-speaking natives. Sub-committees of the Hibernian Bible Society were set-up in 1814 and again in 1823 to consider and report upon the question of printing an edition of the Bible, in the Irish language and character.[14]

The later sub-committee considered a number of proposals and reported this submission by the archbishop of Tuam: "We are convinced that the Irish character affords facilities for the expression in print, or writing, of the Irish language, which the English character does not; and from its nationality meets the prejudices, and gratifies the feelings of the people. That, therefore, for the purpose of being enabled to put the Scriptures into the hands of the population, in the most useful and most acceptable way, we earnestly solicit, without delay, an edition of the Irish Scriptures, in the Irish character."[15] The committee conducted an opinion poll among clergymen and gentlemen from all (in their opinion) relevant parts of the country; The first question was: "What opinion, grounded on your experience, are you inclined to form on the expediency of the measure? [the printing of the Bible in Irish in the Irish character] and, if you know of any particular facts to sanction that opinion, please to state them."[16] While most of the respondents enthusiastically supported the need for the availability of the Bible in Irish, some neglected to comment on the question of the suitability of the Irish character. Those who did were quite clear in their preference: the Revd Peter Roe, rector of Dungarvan, replied: "I observe in the people an attachment both to the Irish language and character." The earl of Roden wrote: "It is highly important to give the people the Irish Bible in the Irish character; many value the Testament in that character and delight in it, when they would read no other; and, as there are very few if any books published in the Irish language, having the Bible in it appears to me the best way of getting that blessed book read by them." The Revd Mr Daly submitted that "My cousin, James Daly, the Warden of Galway, stated to me the preference of the people, taught to read both Irish and English in the jail, towards the Irish language; and so strongly towards the Irish character, that when, from being without a supply of them, he has given a Testament in the Roman character, he has been obliged to promise to exchange it; and has frequently been called upon to do so after a long interval." To this might be added the opinion of Lord Teignmouth published in the second number of the *Quarterly Extracts* of the Irish Society: "There is one argument in favour of publishing the Scriptures in the Irish language and character, which to me was conclusive, viz. that if amidst the population of Ireland, there are only twenty or only ten thousand Irish who will read the Scriptures in their native dialect and character, and not in any other, they ought to have it."

The committee commented: "we have before us evidence to demonstrate, that in some places the Roman letter has been looked upon with the same suspicion as the authorised version; and it will not surely be doubted, that the Irish character will serve at least to add to the recommendation of the Irish Scriptures, and never to the contrary." They went on to point out that the use of the h for aspiration in the roman type resulted in a 10% increase in space required. The committee's view was that "Again, the printing Irish in Roman letters is precisely similar to doing the same with books in the Greek or Hebrew languages, and is only to be defended on one supposition, which is however mistaken, that learning Irish, in the native character, increases the difficulty of a transition towards the reading of the English; but, in fact, we find that this is quite the reverse" [there followed a sample line of the lower-case alphabet using the Fry Irish type with the roman letter below]. "We see, by the inspection of these, that he who is acquainted with the Irish letter has, in passing to the English character, only to learn the new letters j v x y z (which he must do at all events) and the difference between the letters f g r s and t, in the two alphabets, which can obviously be accomplished in a day; while, if he be first taught to read the Irish in the Roman letter, his business in passing to the English will be to unlearn what he has been taught of the powers of h, in combination with b c d f p s and t."

The report continued: "we feel confident, that if the Irish Bible be printed in the Roman character, it will entirely fail of its object, and of acquiring that extended circulation which the popularity of the native character will ensure it. We conclude this point with an allusion to two facts; the one, which we have mentioned before, is, that Irish Bibles in the Roman character are now said to be lying uncalled for in the depository of the British and Foreign Bible Society; the other is, that the unanimous testimony of the experience of the Irish Society is in favour of the native letter—so convinced are they of its importance that they confine themselves entirely to it, and have never sought for Bibles in the Roman character; while, such has been the demand for the New Testaments in the Irish character, that they have never been able fully to supply it."[17]

Following from these considerations it is recorded in the minutes of the report: "Resolved—that arrangements be entered into for the purpose of printing a pocket edition of the whole Scriptures in the Irish language and character; the work to be undertaken as soon as the funds of the Society will permit."[18] The Bible was completed in 1827 and its publication announced in the Report of the society of that year: "The Irish Bible in the vernacular character, *so anxiously looked for*, has at length been completed."[19]

Another roman typeface adjusted in a similar fashion to the earlier Neilson type was used by John Mullany, a printer at 11 Capel Street, Dublin, to print *The Christian's Friend*, a prayer book compiled by Jonathan

GNÍOṀ CREIDIṀ.

A Dé, creidim go diongḃálta, gur b'aon Dia aṁáin tú, crutuiġ-tóir, agus árdtiarna neiṁe ⁊ talṁan; go ḃ-fuil do ṁórdaċt agus do ṁaiteas dóċoimseaċ. Creidim go diongḃálta go ḃ-fuil ioñadsa, an t-aon Dia aṁáin, trí pearsana go h-eidirdealliġte, agus coṁionan añ gaċ uile nid, an t-Atair, agus an Mac, agus an Spiorad Naoṁ. Creidim go diongḃálta gur ġlac Íosa Críosd Dia an Mac, colañ daona, gur gabaḋ ón Spiorad Naoṁ é, gur rugaḋ é ón Maigdean Muire, gur fulaing sé páis, agus go ḃ-fuair bás air an g-crois, ċum siñe d'ḟuasguilt, agus do ṡáḃáil; gur aiséiriġ sé an treas lá ó ṁarḃiḃ, go n-deacaid sé suas air neaṁ, go d-tiocfaiġ a n-deireaḋ an t-saoġail, ċum breiteaṁnais do taḃairt air an g-cine daona; go d-tabarfaid sé aoiḃneas síorruiġ mar luaċ saotair do na deaġdaoiniḃ, agus go d-teilgfid sé na droċ-daoine go pianta síorruiġe ifriñ. Creidim so, agus gaċ nid eile do ċraoḃsgaoilas an naoṁ Eaglais Catoilice Rómánaċ dúiñ, de-ḃríġ gur tusa, A Dé, an fíriñe dó-ṁeallta d'ḟoillsiġ iad, agus d'or-duiġ dúiñ éisteaċt leis an Eagluis, ó sí bun, agus piléur na fíriñe í. Añsa g-creideaṁ so tá rún seasa-maċ agam le cungnaṁ do naoṁ-

11.14 Furlong aspirated roman type from *A Christian Friend*, 1842.

Furlong, a Catholic priest, in 1842 (see ill. 11.14). This prayer book was mentioned by Colin Chisholm of Inverness, in a letter to the *Gaelic Journal* in 1882, in which he stated a preference for "the plain, round Roman type" over the "angular Irish type". He pointed out that "the Irish letter seems to me more distressing to the eyesight, especially in small print" and, in support of the roman type, stated that over the period of 41 years of his residing in England most of his "Irish gentlemen acquaintances" were in favour of the roman type. The late Revd Jonathan Furlong, a Catholic priest, was one of the gentlemen alluded to. Chisholm referred to how in 1842 he published in Dublin "a small Gaelic prayer book 32mo, of 248 pages wholly in Roman Print. . . . I was present when the reverend author stated that he used the Roman type in obedience to the wishes of the majority of his subscribers." In conclusion, he wrote: "Let us all acknowledge our indebtedness to the old black-letter, but let us bear in mind that the Roman letter is the most handy business letter, and used in most of the civilized parts of the world."[20]

This type goes further than the Neilson in accommodating the particular requirements of Irish in so far as the capital letters, in addition to the lower-case, had aspirated consonants. A close examination of this feature reveals that the dot, while consistently fixed on the lower-case letters, moved from left to right on certain capital letters, which suggests that it

was introduced during the type setting process over the relevant capital letters, while the lower-case accented letters were cast from adjusted matrices, as described in the account of the Neilson type.

The Furlong type appears in three sizes with the aspirated capital and lower-case letters. Furlong would seem to have given much consideration to the matter of the most suitable type for in 1839 he produced a catechism, *Aithghearughadh an Teagaisg Críosdaighe Geinearalte*, in which he used the Fry Irish type throughout, although mixed in with the capitals are the roman upper-case letters, G, U, N, and M, with the G appearing with the aspirated dot where required. This book was printed by T. Coldwell, of 50 Capel Street. In the same year he brought out an 18-page Irish Primer stereotyped and printed also by Coldwell, in which he again used the Fry type. Three years later, in 1842, a second edition of this primer was printed for him, this time by the above-mentioned John Mullany, not as a reprint as would perhaps have been more expedient, but using the roman aspirated type. In a note to the reader Furlong explained this choice: "To those who speak the Irish, and can read English, this little elementary Treatise on the Irish language will be found of the greatest use, to facilitate the reading of that idiom. Since the publication of the first edition of it, experience has proved that the chief difficulty is, to persuade persons that the reading of the Irish is *so easy as it really is*. Surely nothing can be acquired without *some* trouble; and if the trouble which, with the aid of this Primer, is required for reading the Irish be considered in the ratio of effect, it may be a matter of some difficulty to point out any other acquirement so easily obtained, so interesting, and so useful, as that of the reading of our Native Dialect; which *in the short space of one hour*, hundreds have accomplished since the publication of the first edition of this Primer. This second edition contains the same matter as the First, but the arrangement is somewhat altered, in order to render it more suitable to the capacity of even a child."[21]

The second edition of this Primer is often found bound into the back of another work by Furlong, also printed in 1842, *Compánach an Chríosdaigh*, which also uses the roman aspirated type. This work was printed by E. Eginton, 36 L. Ormond Quay, which suggests that Mullany was not the only printer to carry founts of this unusual type.

The entry in the Trinity College accessions catalogue lists Furlong's *Compánach an Chríosdaigh*, 1842, in accented roman type with capital aspiration (see ill. 11.15). This two-line entry uses the aspirate dot placed at the typesetting stage, for its position varies in relation to the lower-case b and g, and it retains the dot on the lower-case i. It uses a roman type which appears in other entries for the setting of English. It is not unreasonable, therefore, to assume that this was simply an attempt on the part of the university printer to render this brief entry in a style similar to that in which the main text of the book was printed.

GRAMMAR, Irish [107,934—1907
FURLONG (Jonathan).—Companaċ an Ċriosdaiġ, no tiomsuġ d' urnaiġib
 craibteaċa, &c. [followed by The Irish primer, 2nd ed.]
 Dubl., Lond. & New York, 1842. 141 × 99. [2 pts. in 1 vol.] 26. y. 81.

AN ĊEUD ṖUNC:

An uair a ṫig bain-riġan air biṫ go nuaḋ ċum riġaċta
no ċum caṫraċ, biḋ spéis agus dúil aig an uile ḋuine śi a
feicsint; teid an t-uasal agus an t-ísiol, an lag agus an
laidir, an boċt agus an saiḋbir, 'nna áracais agus 'g a
fáiltuġaḋ; ní biḋeann niḋ air biṫ le feicsint aċt féastaiḋ 'g
a g-caiteaḋ; fíonta 'g a n-dórtaḋ, gunnaiḋ móra 'g a
sgaoileaḋ; cruit agus orgáin 'g a seinm; brontanais mór-
luaiċ 'g a b-pronnaḋ do 'n bain-ṗrionsa, ann aon focal
an uile cineál solomainn agus subailce gnitear le linn
Ṗrionsa no bain-ṗrionsa ṫeaċt a ġlacaḋ seilḃ air an
g-coróin.

11.15 Irish setting in aspirated roman type from the accessions catalogue entry for Furlong's *Companach an Chriosdaigh*, Trinity College, Dublin.

11.16 Canon Bourke's Romano-Keltic type from his edition of O'Gallagher's *Sermons*, 1877.

While neither the Neilson or the Furlong adjusted roman type found much favour amongst printers of Irish, this did not deter Canon Ulick J. Bourke from embarking on a similar experiment some years later (see ill. 11.16). Canon Bourke held some very particular opinions regarding the proper letter-form for printing Irish. One of his early works, *The College Irish Grammar*, 1856, includes as a frontispiece an example of Irish chirography or handwriting (see ill. 11.17).

In his account of the writing of Irish he states: "To write Greek in the characters of any foreign language is to destroy half its worth. . . . Greece has never really suffered the disgrace of having her national language thus paraded in alien costume. *Ireland has. Her* written language has been tortured into a thousand ignoble shapes, which have made it appear to the eyes of some the pencilled jargon of slaves; . . . the Irish language has been unmercifully mangled in endeavouring to make it look neat in its foreign anti-national dress. English letters and English accent, however grand they may appear to some, are, to say the least, quite *unceltic*, and therefore most unfit to display the natural grace and energy of the Irish language. Hence no Irishman ought to write his native tongue in any other than in Irish or Celtic characters."[22] Canon Bourke used the Fry Irish type for this grammar,

11.17 Sample of handwriting shown in Canon Bourke's *Irish Grammar*, 1856.

as also for his *Easy Lessons or Self Instruction in Irish*, printed in 1860. Later, in 1868, for *The Bull Ineffabilis of Pius IX* edited by Canon Bourke, and printed by John Mullany, the Fry Irish type was again used.

Over the next seven years, however, Canon Bourke had reason to change his mind regarding the appropriate letter for printing Irish, for in his major work *The Aryan Origin of the Gaelic Race and Language* he used a new adjusted roman type which he called Romano-Keltic. In this book he asked: "What is the origin of that *letter* or *character*, which at present is

usually called old Irish character?"[23] By a process of simple elimination he deduced that "it is Roman; and, as a historic fact, proved by numberless manuscripts, it is Roman. Therefore, it is a misnomer to call these letters in printed Irish books and manuscripts *old Irish character*, whereas, in real truth, they are old Roman characters. . . . Is there any portion of the so-called Irish character to which Ireland can lay claim?" he asked, suggesting as a solution "the (˙) dot, or diacritical mark alone which points out to the eye the phonetic fact, that a change has taken place in the sound of the radical consonant. That portion of the character, and that alone, is Irish. . . . The present writer then suggests, and he has himself adopted the plan, to make use, like most of the peoples of Europe, of modern Roman character, retaining, the while, the dot over the letter to note to the eye the change of the sound which the affected consonant represents. Thus the new letter is Roman, while it is Irish. Hence he has styled it Romano-Keltic. He has matrices of this form moulded in London, and two founts of Romano-Keltic struck off. It is in type of that mould the Irish Gaelic in these pages has been printed."

Two years later in his introduction to the vocabulary appendix to his edition of *Sermons in Irish-Gaelic*, Canon Bourke explained: "The modern letter in use amongst us, such as I am penning, can be employed, merely super-imposing the dot or diacritical point on the letter to be aspirated. When I wrote the 'College Irish Grammar' I was under the impression, from all I had then heard and known, that the form of the letter called the 'old Irish character' belonged actually to the Irish race, as special to their written speech, just as Greek letters are special for the language of the Hellenic race. A wider range of reading and greater experience proved beyond all doubt that the 'old Irish character', as such, was old 'Roman' the parent of the Anglo-Saxon, and the German, and like them borrowed from the Romans."[24] He went on: "It is only fair to come to the conclusion that, as the 'old Irish character' is really Roman and the modern so-called 'English letter' is Roman also; therefore, we, to be up to the age, ought, like men of sense, to adopt that letter which is the best, the most pleasing to the eye, the readiest in writing, and that which from practice is to our own hand ready and easy. To supply the required 'dot' or diacritical point in a smooth modern Roman letter is as easy as to supply it on the angular or squared letter known as the 'old Irish character'."

A number of letters to the editor of the *Gaelic Journal* about this time (early 1883) commented on the general subject. T. Flannery, for example, offered the following points in support of the use of roman letters: "The first and principal, then, is that it would make the printing of Irish obviously easier and cheaper; as easy to print it in Cork, Galway, Derry, Athlone, Kilkenny, or any other part of Ireland as it is done in Dublin: and not merely in Ireland, but in any part of Europe, America, or Australia. . . . The

second reason why I consider the Latin characters preferable for practical work in Irish is that foreign languages could be easily and conveniently used without giving a strange and grotesque appearance to the Irish text in which the[y] occur. . . . A third advantage the employment of the ordinary character gives is the command of italics, the want of which is often felt in writing the Irish character."[25]

On the other hand, "Clann Conchobhair" argued for the retention of the Irish letters: "the Irish language has been in possession of the characters it still uses from, at least, the fifth century uninterruptedly up to the present;" he disputed that the Irish character was harder to learn than the roman: "the eye, when once accustomed to the Irish letters, reads the language in them with greater ease than in the Roman character;" answering criticism that angular letters distress the eyesight he stated that "there are several varieties of Irish type, the best being quite as round as the Roman, and every bit as distinct." The roman type was generally used "almost in every case because the printers had no founts of Irish type at their disposal". In the case of Canon Burke's edition of Gallagher's *Sermons*, he argued, the Roman letters were the result of a temporary crochet of that dignitary, which I believe he has since, on more mature consideration, abandoned. "He [Bourke] had (at considerable expense) to get a special fount cast for his purpose, and the attempt to put dots over the t's, d's, and b's, gave these letters a most awkward appearance." Moreover, "the best Irish type is not only clear and distinct, but is artistically beautiful, which is more than can be said of ordinary Roman type" and "the use of Irish type makes the language easier to read, because it admits of the accents and aspiration marks necessary in its orthography."[26]

The various, well-intentioned, views of those interested in the Irish language during this period of decline in its spoken use, led to a polarisation, with very little give on either side. In attempting to provide a compromise solution, the dilemma was addressed by the Revd Edmund Hogan: "As to Irish type, 1) it is beautiful to look at, though like the German and Greek it is more trying to the sight than the Roman; 2), its d, f, and t bear the dots with more grace than does the Roman; 3), it is our own Irish character, and should be as patriotically preserved as are the German and Greek; 4), a people so conservative as the Irish ought to cling to their characters at all costs."[27] And yet, Hogan suggested, the Irish type might best be used for the publications of learned societies where "they have plenty of money and their writers have plenty of time. . . . I deem it useful and patriotic not to employ Irish letters in elementary books" since Irish letters are "old Roman, which Rome, and the world, except Ireland, have discarded for the improved modern Roman. . . . They are the type which Queen Elizabeth was the first to get cast" and thereby "struck at the Irish language and literature a blow under which it has reeled for three

ní rugabar orm ; rugadar ar a chosaib-sion.	ye laid no hold on me; they held him by the feet *m.* 26, 28.
beirid air agus tabraid líb ; cionnas do beuraidís a b-feill air-sion ; rugadar na hógánaig air.	take and lead him away ; how they might take him by craft ; the young men laid hold of him. *mk.* 14, 15, 14.
ar m-breith do Pheadar air do thionnsgain achmusán do thabairt dó.	Peter took and began to rebuke him, *mk.* 8.
rugadar na sgológa orra, agus do gabadar ar fear díob agus do gabadar do chlochaib ar fear eile.	the husbandmen took them, and beat one and stoned another, *m.* 21.
ag sínead a láime ar an m-ball d'Iosa, rug sé air.	Jesus immediately stretched forth his hand and caught him, *mk.* 14.
ann sin rug Diarmaid ar Ghráinne	then Diarmaid caught Gráinne *dg.* 146.
do breith ar dreangcuid.	to catch a flea. *b.* 221.
má beirthear é aiseocaid sé seacht n-oirid.	if he be caught, he shall restore sevenfold, *pr.* 6.
ar m-breith ar leanb dó do chuir sé ann a lár é.	he took a child and set him in the midst of them. *mk.* 9.
beirim ort, *Lucerna Fidel.* 338	I hold you, I have you.
do breith air a m-bréig folluis.	to take him in a flat lie. *b.* 220.
do rugad orm go cealgach.	I brought my hogs to a fine market. *b.* 216.

11.18 Irish aspirated roman type from Hogan's *Irish Phrase Book*, 1891.

centuries". Writing in Irish letters was more time-consuming and thereby more expensive to set, he argued; mistakes were more likely to occur in Irish type; Irish founts were not "supplemented by italics or their equivalent". Pupils required more time learning to write the Irish character, and "as a rule, the writing was so wretched as almost to deter a person from reading it". Many "are deterred from reading Irish books by the strange look of the letters" and "since I feel that for these reasons Irish type is not as good as the modern Roman, I do not employ it, as I would not use an old Roman or Irish plough, or go in a boat, like St Brendan's, from Kingstown to Holyhead, or in a 'chariot' like Cuchulaind's from Dublin to Cork; or give up coal, gas and electric light for turf, rush lights and candles."

Hogan used an aspirated roman type which attempts, through compromise, to please those favouring the retention of the dot with roman, and those preferring the use of the h (see ill. 11.18): "In books the nine aspirated consonants are marked with dots, or with h's (as in O'Brien's Dictionary); so that the pages are crowded with dots or h's. By printing ph, ch and th, as they are written in old Irish, I diminish the dots by one-

185

third or more and lessen the proverbial danger of omitting the dots; by dotting the other six letters I diminish the h's by about one-third. I propose this compromise to the partisans of both methods of aspiration."[28] This experiment, also, would seem to have failed, for rather than please all it seems to have found favour with none, although it must be said that the roman used was rather a neat type and the overall colour on the page is even. This experimental work was printed by A. Thom & Co. Ltd.

Despite the many arguments for the roman letter, the major publishers of Irish, namely the Society for the Preservation of the Irish Language, the Gaelic Union, and later the Gaelic League, all favoured the Irish character. It should be noted, however, that the policy of the editor of the *Gaelic Journal* was that "our contributors are free to use their own judgement as to the characters in which they write."[29] The debate continued. Standish O'Grady made an interesting comment about the choice of roman type for the initial volume of his *Silva Gadelica*: "Nor must I omit hearty tribute to the good-will and intelligent interest manifested by all concerned in the material production of this book: the Irish was printed as readily and as correctly as the English, and throughout there has not been a hitch. This leads me to briefly account for non-use of Irish type: the reason is a business one simply; it was commercially impossible. The old character is the best for texts such as I have printed, in which aspirations abound; scientifically, it is not suitable for the oldest texts: for them italics are essential, and in Irish type you have them not."[30] In a footnote, O'Grady explained: "Many inconsequent utterances there have been about the difficulties of its use, and the impossibility of attaining to accuracy; but what about setting up and correcting Arabic, Hebrew, Sanskrit, and mathematical work? I take it on myself to say that, were the demand by a miracle to become such as would warrant the purchase of an Irish fount, not a murmur would be heard in the office of [his printers] Messrs Green and Son."

In his inaugural address to the Society for the Simplification of the Spelling of Irish in 1910, Osborn Bergin strongly recommended the use of roman type for printing Irish: "Once you admit that the use of the ordinary international form of the Roman alphabet will not turn Irish into English, any more than it will turn Irish into French, the way becomes clear for considering some of the advantages of the course we recommend."[31] He outlined his account of the disadvantages of the Irish character: "the modern form of the Roman alphabet is in possession; no publisher finds it worth his while to lay in a large stock of 'Gaelic' type of various shapes and sizes, and no type-founder can be expected to experiment in new founts." "How many newspaper offices in Ireland", he asked, "can afford double sets of linotypes?" and "Can you imagine any firm going to the expense of double sets of typewriters, and cutting itself off from the telegraph system of the world?" Moreover, "As for using the Medieval alphabet in scientific work,

I need only say that, in dealing with my own subject—the scientific study of the earlier forms of the language itself and the literature produced in it—the Roman alphabet is the only one in use I hold it to be educationally unsound to teach children to read or write in two different alphabets, or two different forms of the same alphabet at the same time." He continues with some observations that reflect the concern of many of his fellow advocates of the roman letter: "It is a question of type. On the one hand, the capitals and lower-case letters are too much alike, and too much space is wasted in order to leave room for aspiration marks in case they should be wanted. On the other, you have, as I have said, the fruit of centuries of experiment in many lands in the direction of clearness and convenience, with all manner of special types —italic, clarendon, egyptian, and so on—to draw on when necessary."

Brian Ó Cuív points out that on the setting up of the Irish State in 1922 "there was a tendency from the outset to use Roman type in official documents and especially in the work of the Oireachtas [Parliament]. Indeed Roman type had been used to some extent in the official printed reports and documents of the first Dáil Éireann in the period 1919-1921 and, one might add, for the Irish words and names in the printed proclamation of Poblacht na hÉireann in 1916.[32] However, there was no definite rule requiring its use in all the government services after 1922 and official policy vacillated, especially in the Department of Education where a change of government was sufficient to bring about the abandonment of a plan for an ordered change-over in the schools from Gaelic to Roman type. In the last two decades there has been a more realistic approach to the problem and there now seems to be general agreement in publishing and educational circles that it would be to the advantage of the Irish language that Gaelic type should be laid aside to take its place with *Ogam* as something belonging to another era, or, at most, should be used in inscriptions and the like where its antiquarian and decorative features can have appeal on aesthetic and sentimental grounds."[33] He also notes that despite the popularity of the roman type in the years following 1922 in official publications, when the new Irish Constitution of 1937 was issued it was printed in Irish type.

In the context of adopting a system of simplified spelling for his dictionary of 1935, Lambert McKenna referred to this uncertainty: "The question as to whether Roman or Irish letters should be used in writing Irish is a debatable one, strong reasons and weighty authorities being available on both sides. In the earlier stages of our work we used Roman letters, being instructed so to do. . . . When, subsequently, we had received instructions to adopt the Irish letters, the reasons for any simplified system of spelling seemed less urgent."[34] He mentioned that "The idea of compiling a Dictionary of this kind came from the last Government and especially from Mr Blythe, the then Minister of Finance."

Mícheál Ó Murchú, in an interesting appeal in his article "A Plea for Modern Rational Irish", pointed out that "The Roman script will soon be forced into our schools. But what nation that can count would tolerate a language inspissated with h's? We must get rid of double letters. This can be done by using the Roman script but inserting dots as usual. The method only goes half way, perhaps, and we ought to have no botching at this stage. By getting rid of initial aspiration whole legions of h's will disappear."[35]

In 1925 Séamus Ó Searcaigh had his book *Foghraidheacht Ghaedhilge an Tuaiscirt*, printed in Germany in a typeface which contains a number of characters similar to the Irish (see ill. 11.19). The capital letters, with the exception of G and H, are roman, while the lower-case letters have a more calligraphic quality not unlike some of the Irish alphabets. In his foreword, Ó Searcaigh mentions his indebtedness to his colleagues at Coláiste Chloich Cheannfhaolaidh, for contributing to the expenses involved in acquiring the special type necessary for his book. This comment may, however, refer to the unusual sorts required to express the phonetic detail of his research, which in fact used a roman type for the main text rather than the Irish-like type. A note stamped on the title page of many copies of this book indicates that "The type for this book was set in Germany for the author."

It is likely, however, that this was simply an existing fount of Anglo-Saxon characters used because of its similarity to Irish type. It was not unusual, during the early part of the twentieth century, on the infrequent occasions in which printing in Irish was required on the Continent, for such characters to be used, as is also evident in *Notices sur les Caractères Étrangers* by Charles Fossey printed in Paris in 1927 (see ill. 11.20). It should be noted that in the examples from both the Ó Searcaigh and the Fossey works, the aspirate dot appears inconsistently placed, indicating that this form of aspiration was not designed as a feature of either fount, but was introduced, instead, at the typesetting stage, further supporting the fact that these were Anglo-Saxon and not truly Irish founts.

The limited range of styles available in the Irish typefaces led Seán Jennett to observe in 1958: "It is problems of this sort that are helping to drive much Gaelic printing into the framework of roman characters. A great deal of Gaelic is already printed in roman, and no doubt more will be eventually." He proposed that some attempt should be made to extend the existing Irish founts to include italic and small capital letters and that new Irish types be designed, but he concluded, more pragmatically, "This is a pipe dream and not likely to be realised. The alternative is much more simple and practical. It is no less than to abandon the Irish letter. Though I love it, I cannot in reason argue that it has a place in modern society. It can never now achieve anything like the variety of design and expression

(ð) An Ṗaıdıɼ.

Aɼ n-aċaıɼ aτā aɼ neaṁ, ʒo naoṁτaɼ τ'aınm; [ʒo] ðτıʒe ðo ɼīoġaċτ; maɼ nðéanταɼ ðo ċoıl aɼ an ταlaṁ maɼ nīτeaɼ aɼ neaṁ. Aɼ n-aɼāl (aɼān) laeċaṁaıl, ταbaıɼ ðúınn ınðıu; maıτ ðúınn aɼ bḟıaċ' le maɼ maıτ ðúınn. Nā léıʒ ðúınn τuıτım ı ʒcaτuıʒτe, aċ ɼaoɼ ɼınn ó ʒaċ olc 'noıɼ aʒuɼ aɼ uaıɼ aɼ mbāıɼ. Amen.

11.19 Anglo-Saxon type used for Irish in S. O'Searcaigh's *Foghraidheacht Gaedhilge an Tuaiscirt*, 1925.

11.20 Anglo-Saxon type used for Irish in *Notices sur les Caractères Etrangers*, 1927.

TEXTE IRLANDAIS.

Tɼáċ ɼá ɼaıbe Conċubaɼ mac Faċτna Faċaıġ áıɼð-ɼíġ Ulað a meıɼτne ⁊ a móıɼ-
Tráth fá raibhe Conchubhar mac Fachtna Fathaigh áird-rígh Uladh a meirtne ⁊ a móir-

cheaɼ ɼé ɼae ċıan ⁊ ɼé haımɼıɼ ɼaða, ⁊ níoɼ ċoðaıl ⁊ níoɼ τoṁuıl bıað ɼıɼ an ɼae ɼın,
cheas ré rae chian ⁊ ré haimsir fhada, ⁊ níor chodail ⁊ níor thomhuil bíadh ris an rae sin,

⁊ níoɼ luıð τoıl ıoná ınnτın leıɼ, ⁊ ní ðeaɼɼna ʒean ġáıɼe ıoná ɼoɼbɼaoılτe ɼé mnaoı ná
⁊ níor luidh toil ioná inntin leis, ⁊ ní dhearrna gean gháire ioná forbhsaoilte ré mnaoi ná

ɼé ɼeaɼ ð'ɼeaɼaıb Ulað ɼé h-uċτ na h-aımɼıɼe ɼın. Aʒaɼ bað h-ımɼníoṁ móɼ le h-Ullταıb
ré fear d'fhearaibh Uladh ré h-ucht na h-aimsire sin. Agas badh h-imshníomh mór le h-Ulltaibh

uıle an ní ɼın. Aʒaɼ ðo ɼáðɼað ɼé Caτɼað caoṁðɼaoı a ɼáð ɼé Conċubaɼ ʒan beıċ ıɼan
uile an ní sin. Agas do rádhsad ré Cathfadh caomhdhraoi a rádh ré Conchubar gan bheith isan

meıɼτne ıoná ɼan míolaoċaɼ ɼoın ınna ɼaıbe, ⁊ ðo ċan Caτɼað ɼın ɼıɼ. Fɼeaʒɼaɼ
meirtne ioná san míolaochas soin inna raibhe, ⁊ do chan Cathfadh sin ris. Freagras

Conċubaɼ ðó ⁊ ıɼ eað aðubaıɼτ: A mo ṗopa, a Caτɼaıð, aɼɼé, ıɼ móɼ aðbaɼ ⁊ ðaṁna
Conchubhar dhó ⁊ is eadh adubhairt: A mo phopa, a Chathfaidh, arsé, is mór adhbhar ⁊ damhna

aʒamɼa, óıɼ ðo ɼuaċταðaɼ ceıτɼe hollċóıʒıð Éıɼıonn, ⁊ ðo ṁúɼɼað mo ðaınʒın ⁊ mo
agamsa, óir do ruachtadar ceithre hollchóigidh Éirionn, ⁊ do mhúrsad mo dhaingin ⁊ mo

that modern conditions demand, and its use only serves to keep the printing of Gaelic out of the mainstream of European and American typographical progress."[36] He proposed that existing roman be adjusted to include aspiration and accents, very much in the style of those adjusted roman types that have already been examined: "This would be a comparatively simple matter for the typefounder and the composing machine companies. If this could be done, all the typographical treasure of the roman letter would be made available to the typographer in Gaelic."

Perhaps influenced by the above article, William Britton of the Leinster Leader Ltd in the early 1960s addressed himself to this problem. He explains in a printed statement: "A method was then sought by which Roman types could be availed of without making reading more difficult or inter-fering with the general character of the typeface in use. . . . At the outset it was decided to endeavour to achieve these aims without any major alteration to the design of the basic Roman typeface. After many experi-ments a type fount incorporating most of the desired characteristics evolved. This type retains two of the letter forms of the Gaelic face which are designed to harmonise with the Roman letters and it is felt that they impart a distinctive appearance to the text without interfering with legi-bility."[37] To achieve this result Britton discussed his project with the eminent typographer and publisher Liam Miller, who had a keen interest in this matter. A solution was arrived at which involved the use of the Monotype Times Roman with adjusted characters for lower-case t and f. Miller produced rough drawings for these letters and both he and Britton gave considerable thought to the positioning of the aspirant dots which were to be incorporated into the face to avoid the repetitive use of the h. Finished drawings prepared by Britton in 1963 show the new characters and the proposed position of the dots (see ill. 11.21).

A note to this drawing indicates that "Times Roman was chosen as basic fount. Letter t to be cast for τ, dots to be ¾ width of thick strokes and their own thickness in distance from top of letter. To ensure a uniform line of dots drop f to line and change serif to kern, shorten this to avoid overhang. If serif were retained letter would have a squat appearance. If it is decided to retain dot over the letter i it will be necessary to have letter re-cast with aligning dot."[38] A sample setting shows the use of dots in this fashion together with the re-cast t (see ill. 11.22).

It is interesting that the normal Times Roman f was used in this sample; as Britton remarks: "The sample from Luke's Gospel . . . was set with an ascending f as I was awaiting delivery of the lower case x height f from Monotype at the time."[39] Rather than use a lowered f with kern in place of serif as suggested on the drawing it was decided to redraw this character also in the Irish style. Britton further explains his efforts in a letter to Pádraig Ó Mathúna: "I approached the (h) problem in Irish from a purely

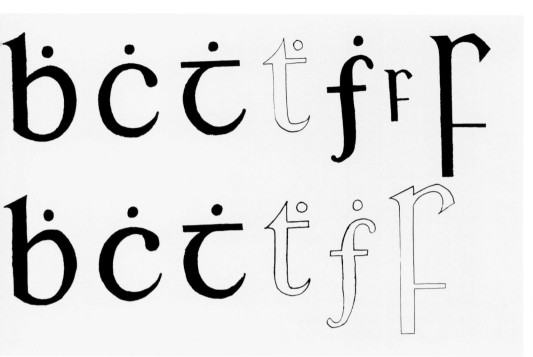

11.21 Drawings prepared by William Britton for his adjustments to Monotype Times Roman Gaelic.

11.22 Samples of Irish set with Times Roman, using the normal fount with h aspiration (above), and using the new lower-case t with dot aspiration (below), with the comment: "New setting note saving of space".

²¹Bhí an pobal ag feitheamh le Zacháirias agus dob ionadh leo é bheith ag déanamh moille sa tsanctóir. ²²Ach ar theacht amach dó, ní fhéadfadh sé labhairt leo, agus bhí a fhios acu go raibh fís feicthe sa tsanctóir aige. Agus bhí sé ag sméideadh orthu, agus d'fhan balbh.

²³ Nuair a bhí laethe a sheirbhíse críochnaithe, chuaigh sé abhaile. ²⁴Agus ina dhiaidh sin, ghabh a bhean, Eiliosaibeit, gin, agus d'fholaigh í féin ar feadh cúig mí, ²⁵ag rá: 'Is mar seo a rinne an Tiarna liom é sna laethe inar dhearc sé orm chun m'aithis i measc daoine do thógáil díom'.

²¹Bhí an pobal ag feiteam le Zacháirias agus dob ionad leo é beit ag déanam moille sa tsanctóir. ²²Ac ar teact amac dó, ní féadfad sé labairc leo, agus bí a fios acu go raib fís feicte sa tsanctóir aige. Agus bí sé ag sméidead ortu, agus d'fan balb.

²³Nuair a bí laete a seirbíse críocnaite, cuaig sé abhaile. ²⁴Agus ina diaid sin, gab a bean, Eiliosaibeit, gin, agus d'folaig í féin ar fead cúig mí, ²⁵ag rá: 'Is mar seo a rinne an Tiarna liom é sna laete inar dearc sé orm cun m'aitis i measc daoine do tógáil díom'.

Dṛán mé balḃ, gan caoi agam an ċeisc a ṛreag-
airc. Annsan, ċonnac an duine marḃ—má's marḃ
aḃí sé nó suaiċe go smior le cuirse na biocáille—ag
iaraí é ṛéin a ṡocrú ar a ṡuíocán cloiċe, an dá spág
á ṡaċad i dcreo na ceine, agus a sceadamán a
réiċeaċ ċun seanċais. Tháinic an glóirín déireóil arís
uaiḋ, agus is beag nar cailleaḋ le nearc scanarca mé.
"Ni ṛios crec ṛa a cucad in Capicin ar in ṛer
monbuide cneisgel becnercaig gur ba loc ocus aicreb
ocus buanbaile do in cec bec aolban in escal in
glenna. Fa gnac ris in bliaḋain do caicem .i. o
ḃellcane so samain for in draplas in nAlpain ocus o
samain co bellcine for in draplas in Erind. Feaċc
n-aen . . .".

typographical angle, taking into account, however, the historical develop-
ment in reproducing the language. The (h) came into general use with the
development of the Linotype machine when printers were confined to
two founts of Gaelic type 8pt and 10pt and had no display faces on the
machine. Mechanical setting is about five times as fast as type assembled
from the case and printers took the easy way out. In fact nobody came
forward to direct the printers and a policy of drift ensued which was most
regrettable. . . . One of the difficulties facing a typographer was the
aesthetic effect of placing dots over letters which were not designed for
this purpose. Also for easy reading all dots would need to be on the same
visual line, Secondly the dots on a number of lines of caps printed con-
secutively would not be typographically pleasing. As you are aware the
letters (t) and (f) are not in alignment with the x height and needed to be
re-designed to conform to the roman fount and to carry the dot at the
same visual level as the other letters."[40]

Although decisions had already been made to use the ordinary roman
character for Irish, to the disappointment of the advocates of the Irish
letter, Britton's proposal went some way towards easing this disappoint-
ment while adhering in principle to that decision, with a particularly
effective result. Miller explained in a publisher's note to the only book to
use this type that "within the language movement itself, there are two
major schools of thought about the printing of the language, one adhering
to the so-called tradition of *Cló Gaelach* and the other to *Cló Rómhánach*,
or the use of the ordinary printer's repertoire of so-called 'Roman'
typefaces with the addition of vowel accents and the use of lower-case 'h'
to indicate aspirated consonants. There is right on both sides, for the

lowercase 'Roman' alphabet of everyday print derives directly from the Irish half uncial of our historic manuscripts and is, in typographical terms, a practical expression of that alphabet."[41]

The matrices were produced by Monotype and the type cast by the Leinster Leader was used in the Dolmen's edition of An Béal Bocht in 1964. *The Sunday Independent* announced this "New face for Gaelic type" in its report: "A new Gaelic typeface in which two characters—t and f— have been specially cut in Gaelic style is used in the printing of '*An Beal Bocht*' by Myles na gCopaleen. The use of 'h' to indicate aspirated consonants is dispensed with. Mr W. Britton, Leinster Leader Ltd, Naas, and the Monotype Corporation have co-operated in the production of the type, which may revolutionise Gaelic printing" (see plate 11.23).[42]

The matrices still exist at the Leinster Leader, and although setting in metal has been virtually replaced there by more contemporary methods, this type is still available. The lower-case i was not initially re-cast to align its dot with the other aspirant dots, and those on b and d were placed higher than those on the other consonants. It should be recorded that Wm. Britton, who was the primary instigator of this typographical experiment, intended that should this development prove popular, it could be applied to any roman face as required. This type was and still is available in 8 point and 10 point sizes in roman, italic and bold. Apart from being used in a few pamphlets the only major use to which it was put was in the above-mentioned *An Béal Bocht*.

NOTES

INTRODUCTION

1 *A Grammar* (Dublin, 1845), p. xxxi.

CHAPTER 1

1 Matthew Parker, Letter to Sir William Cecil, 13 December 1572, British Library, MS. Lansd. 15, no. 50.

2 Talbot B. Reed, *A History of the Old English Letter Foundries* (London, 1887), p. 95.

3 C. H. Garrett, *The Marian Exiles* (London, 1938), p. 142.

4 Asser Menevensis, *Ælfredi Res Gestae* (1574), preface.

5 John Strype, *The Life and Acts of Matthew Parker*, Book 4, Sect. 2 (London, 1711), p. 536.

6 Ibid., p. 535.

7 John T. Gilbert, "Queen Elizabeth's Primer of the Irish Language", *Facsimiles of National Manuscripts of Ireland*, part IV, no. 1 (London 1882), item XXII.

8 C. McNeill, "Fitzwilliam MSS. at Milton", *Analecta Hibernica*, no. 4 (October 1932), p. 300.

9 *Calendar of State Papers, Ireland, 1509-73* (London, 1860), p. 356.

10 C. McNeill, loc. cit.; see Public Records Office, London, Enrolled Accounts, Audit Office AO1/284 (1072).

11 Sir James Ware, *The Annals of the Affairs of Ireland* (Dublin, 1705), p. 15.

12 This handwriting has been identified as that of one of Parker's secretaries according to E. R. McC. Dix in his "The First Publication Printed in Irish", *Irisleabhar na Gaedhilge*, vol. 9, no. 103 (January 1899), p. 306, while, according to Bruce Dickins in his "The Irish Broadside of 1571", *Transactions of the Cambridge Bib. Soc.*, vol. 1 (1949-53), p. 48, it is "pretty certainly that of the Archbishop's son John".

13 E. R. McC. Dix, "William Kearney, the Second Earliest Known Printer in Dublin", *Proceedings of the Royal Irish Academy*, vol. 28, sect. C (16 July 1910), p. 157.

14 Liam Miller, "Author and Artist", *Books Ireland* (April 1985), p. 47.

15 Dickins, art. cit., p. 48.

16 Henry Bradshaw, "Printing in the Irish Character" [Letters to Talbot B. Reed], *Bibliographical Register*, vol. 1, no. 1 (London, 1905), p. 9.

17 J. R. Dasent, ed., "20-21 August 1587, Letter from the Council to the Lord Deputy and Council of Ireland", *Acts of the Privy Council of England*, vol. XV, new series (London, 1897), p. 201.

18 W. W. Greg and E. Boswell, eds., *Records of the Court of the Stationers' Company, 1576-1602* (London, 1930), p. 40.

19 Acts of the Privy Council, 17 October 1591, vol. XXII (London, 1901), p. 26.

20 Letter undated [1592-3?], Trinity College MS. MUN/P/1.14. See Dix, *The Earliest Dublin Printing* (Dublin, 1901), p. 26.

21 Letter to the Privy Council, 18 May 1595, *Calendar of State Papers, Ireland, Elizabeth 1592-1596*, p. 317.

22 Ibid., Letter from Sir Geff Fenton to Burghley, 24 June 1595, p. 332, ibid.

23 Dix, *The Earliest Dublin Printing,* op. cit., p. 24.

24 Proposed terms between Trinity College, Dublin and William Kearney, 18 March 1596, Trinity College Dublin Library, MSS. MUN/P/1.25.

25 T.C. Kirkpatrick, *Notes on the Printers in Dublin during the 17th century* (Dublin, 1929), p. 5.

26 *Calendar of State Papers, Ireland*, 28 March 1595, Archbishop Loftus letter to Burghley, p. 308.

27 Proclamation against Hugh Neale, 1600, dated 22 November.

28 *Calendar of State Papers, Ireland*, 30 September 1600, p. 450.

29 *Tiomna Nuadh*, trans. Uilliam Ó Domhnuill, 1602, dedication.

30 *Calendar of State Papers, Ireland, 1608-1610,* p. 75.

31 E.R. McC. Dix, "The Law as to Printing

in Ireland", *Irish Book Lover*, vol. XXII, (September – October 1934), p. 111.

32 William A. Jackson, ed., *Record of the Court of the Stationers Company, 1602-1640*, (London, 1957), p. 359.

33 *Calendar of State Papers, Ireland, 1615-25*, Lord Deputy to Attorney General, 6 May 1618, p.192.

34 E. R. McC. Dix, "A Dublin Almanack of 1612", *Proc. R.I.A.*, vol. XXX, section C, plate 37 (1912), p. 330.

35 Richard Parr, *The Life of . . . James Usher*, part 2 (London, 1686), p. 64.

36 Jackson, *Stationers Company*, op. cit. p. 123.

37 Dickins, art. cit., p. 54.

38 Chancery Proceedings, Mitford, 124/105, Bill of complaint lodged in chancery by Walter Leake, 30 June 1653.

39 Henry R. Plomer, "On the Latin and Irish Stocks of the Company of Stationers", *The Library*, series 2, no. 8 (1907), p. 295.

40 Ibid.

41 Letter dated 19 November 1886, from Talbot B. Reed, Fann Street Letter Foundry, London, to R. Martineau of the British Museum, attached to the British Library copy of *The Christian Doctrine* (1652).

42 Letter dated 20 December 1886, from R. Martineau to T.B. Reed, Reed MS. Collection, St Bride's Library.

43 Dickins, art. cit., p. 59.

44 Dix, "Earliest Dublin Printers and the Company of Stationers of London", *Transactions of the Bibliographical Society*, vol.VII (London, 1904), p. 78.

45 Kirkpatrick, op. cit., p. 15.

46 Thomas Birch, ed., *The Works of the Hon. Robert Boyle*, I (London, 1772), p. clxxii.

CHAPTER 2

1 Brendan Jennings, *Michael O'Cleirigh and his Associates* (Dublin, 1936), p. 20, citing Letter of Philip to the Archduke Albert, San Lorenzo, 21 September 1606, in Archives of the Franciscans, Dublin.

2 *Fourth Report of the Royal Commission on Historical Manuscripts*, Part 1, Appendix (London, 1874), p. 602.

3 Patrick Conlan OFM, *Saint Anthony's College of the Franciscans, Louvain* (Dublin, 1977), p.18

4 Ibid.

5 Letter from O'Hussey to Robert Nugent, State Papers, Ireland, Public Records Office, London, vol. CCXVII, 55, p. 311, item 529.

6 Luke Wadding, *Scriptores Ordinis Minorum* (Rome, 1650).

7 Brendan Jennings, ed., *Louvain Papers 1606-1827* (Dublin, 1968), p. 38.

8 Ibid., p. 40.

9 Francis Matthews, "Brevis Synopsis Provinciae Hiberniae Fratrum Minorum", *Analecta Hibernica*, no.6 (1934), p. 161.

10 A. B. Hinds, ed., *Report of the MSS. of the Marquess of Downshire*, IV, Historical MSS. Commission (London, 1940), p. 443.

11 Ibid., p. 454.

12 Colm Ó Lochlainn, "The Louvain Irish Type", *Irish Book Lover*, vol. XX (September–October 1932), p. 103.

13 Bonaventure O'Hussey, *An Teagasg Criosdaidhe* (Antwerp, 1611), last page.

14 Henry Bradshaw, "Printing in the Irish Character" [Letters to Talbot Baines Reed], *Bibliographical Register*, vol. 1, no. 1 (London, 1905), p.11.

15 B. Jennings, ed., *Wadding Papers 1614-38* (Dublin, 1953), p. 270.

16 Leon Voet, *The Golden Compasses*, II (Amsterdam, 1972), p. 109.

17 Stadsarchieven van Antwerpen, Certificatie Boek 59 (1598), p. 247v. (City of Antwerp Public Records Office). The John Scudamore of Home-lacy, referred to as co-guarantor in this letter of recommendation would appear to be of the renowned family of Scudamore. According to Matthew Gibson in his book *A View of the Ancient and Present State of the Churches of Door, Home-lacy and Hempsted . . . with Memoirs of the Ancient Family of John, Lord Viscount Scudamore* (London, 1727), pp. 60-63, Sir John Scudamore had attained the position of high sheriff of Hereford in 1581, and as gentleman usher to Queen Elizabeth was highly regarded by the monarch.

18 De Burbure, Historische Nota's, PK2920, 1,29 (City of Antwerp, PRO).

19 Voet, *Golden Compasses*, II, p. 354, fn. 355 (Plantin Moretus Arch. 780).

20 Plantin Moretus Arch. 118, p. 575.

21 Jennings, *Louvain Papers*, op. cit., p.19.

22 *Exhibitio Consolatoria Tabulae Emblematicae Serenissimae Principi Isabellae* (Douai, 1622), p. 31.

23 *Fourth Report*, op. cit., Part 1, Appendix (1874), p. 603.

24 B. Jennings, "Irish Names in the Malines Ordination Registers 1602-1794", *Irish Ecclesiastical Record*, 5th series, vol. 77 (1952), p. 202.

25 *Calendar of State Papers, Ireland, 1606-8*, Item 736, dated May 1608. SP. Ireland, vol. 224, 113A.

26 *Report on Franciscan Manuscripts*, Historical MSS. Commission (Dublin, 1906), p. 4.

27 Ibid., p. 16, Letter from Strong to Wadding, 20 November 1629.

28 William Carrigan, *The History and Antiquities of the Diocese of Ossory*, I (Dublin, 1905), p. 73, and IV, p. 94.

29 Harry Carter, "Plantin's Types and their Makers", *De Gulden Passer* (Antwerp, 1956), p. 129.

30 John A. Lane, from a sound tape recording by him of Carter's lecture.

31 Canice Mooney, "St Anthony's College, Louvain", *Donegal Annual*, vol. VIII (1969), p. 33.

32 F.C. [Florence Conry (Flaithri Ó Maolchonaire)], *Sgáthán an Chrábhaidh*, Thomas F. O'Rahilly, ed., (1941), p. xliv.

33 Letter from Frater Ant. to Fr Brandon Ó Connor, 23 October 1638, Franciscan Library MS. A30.4.

34 Jennings, *M. O'Cleirigh*, op cit., p. 176. See also Jennings, *Louvain Papers*, op. cit., p. 144.

35 John Colgan, *Acta Sanctorum Hiberniae*, 1645, facsimile reprint, B. Jennings, ed., Irish MS. Commission (1948), introduction.

36 Bradshaw, "Letters to Reed", *Bib. Register,* op. cit. (1905), p. 13.

37 "Letter from Fr Sheerin to Fr Harold, 4 Nov. 1671", *Louvain Papers*, op. cit., p. 232.

CHAPTER 3

1 Bartholomew Egan, OFM, "Notes on Propaganda Fide Printing-Press and Correspondence concerning Francis Molloy, OFM", *Collectanea Hibernica*, vol. II (1959), p. 115.

2 Ibid. (Egan quotes from Archives Propaganda, Acta, 13 (1638-39), f.90rv).

3 Ibid., p. 117; Egan quotes from Archives Propaganda, Scritture riferite nelle congregazioni generali, 448, ff. 58r, 59v.

4 Ibid., p. 119, Archives Propaganda, Scrit. rif. cong. gen. 459, ff. 72r, 73v.

5 Ibid., Scrit. rif. cong. gen. 462, ff. 31r, 32v.

6 *Caractères de l'Imprimerie de M. Pierres* (Paris, 1785), p. 59. It should be noted that the Bibliotheque Nationale, Paris, copy of this specimen book has all of its 310 pages of samples pasted in.

7 Willi Henkel, "The Polyglot Printing Office", *Sacrae Congregationis de Propaganda Fide Memoria Rerum 1622-1972*, II (Rome, 1973), p. 306, fn. 49 (SC Stamperia Misc., vol. 1, f. 105r, 114r-114v).

8 Ibid., p. 306, fn. 50. A copy of the letter is in SC Stamperia Misc., vol. 1, f. 105r, 115r. A list of the letters is to be found in f.110r, and in SC Stamperia, vol. 4, f.453r - M. Galeotti, Della Tipografia Poligotta 22-23.

9 J. J. Marcel, *Alphabet Irlandais* (Paris, 1804) pp. 28-30.

10 Ibid., pp. 32-6.

11 E.W. Lynam, "The Irish Character in Print, 1571–1923, *The Library*, series 4, vol. IV (Oxford, 1924), p. 299.

12 Colm Ó Lochlainn, "Gaelic Script and Modern Type", *Progress in Irish Printing* (Dublin, 1936), p. 75.

13 Henkel, art. cit., p. 307.

14 Ibid., p. 315, fn.

15 D. Agostino Corbanese SDB, letter to the author, 16 May 1988.

16 Kenneth A. Lohf, ed., *The History of Printing from its Beginning to 1930: Subject Catalogue of American Type Founders*, vol. 4 (New York, 1980), p. 2359.

17 Henkel, art. cit., p. 311.

18 Samuel Bagster & Sons, eds., *The Bible of Every Land* (London, 1851), p. 1.

19 Letter from Anton Durstmuller to the author, 14 March 1986.

CHAPTER 4

1 E. S. Shuckburgh, ed., *Two Biographies of William Bedell* (Cambridge, 1902), p. 135. See also Henry Monck Mason, *The Life of William Bedell* (London, 1843), p. 287, and his *Memoir of the Irish Version of the Bible* (Dublin, 1854), p. 24.

2 R. E. W. Maddison, "Robert Boyle and his Irish Bible", *Bulletin of the John Rylands Library*, no. 1 (1958), p. 82.

3 Andrew Sall, *A Sermon Preached at Christ's Church, July 1674* (Dublin, 1675), title page.

4 Letter from Jones to Boyle, 4 August 1680, in Thomas Birch, ed., *The Works of the Honourable Robert Boyle*, I (London, 1772), p. clxxii.

5 Letter from Boyle to Jones, 27 September 1681, in *Works of Boyle*, I, p. clxxx.

6 Letter from Boyle to Marsh, 17 January 1681, in Mason, *Life of Bedell*, p. 301.

7 Letter from Boyle to Kirkwood, 5 March 1687, in *Works of Boyle*, I, appendix, p. cxcviii.

8 *Tiomna Nuadh*, trans. Uilliam Ó Domhnuill (London,1681), preface.

9 Letter from Sall to Boyle, 17 December 1678, in *Works of Boyle*, VI, p. 592.

10 Joseph Moxon, *Mechanick Exercises*, rev. edn., eds. Herbert Davis and Harry Carter (London, 1958), appendix I, p. 366.

11 Edward Rowe Mores, *A Dissertation upon English Typographical Founders and Foundries*, reprint, eds. Carter and Ricks (Oxford, 1961), p. 32.

12 Richard Parr, *The Life of . . . James Usher* (London, 1686), p. 551.

13 Mores, *Dissertation*, p. 47.

14 Reed, *History of Letter Foundries*, op. cit., p. 220.

15 Ibid.

16 Ibid., p. 229.

17 Ibid., p. 223.

18 The auction catalogue is reprinted in the 1961 edition of Mores, *Dissertation*.

19 Reed, *History of Letter Foundries*, p. 229 fn.

20 Ibid., p. 229.

21 Mores, *Dissertation*, p. 98.

22 Edmund Fry, *Pantographia* (London, 1799), p. 167.

23 Reed, *History of Letter Foundries* (1887), p. 187.

24 A.F. Johnson's edition of Reed (London, 1952), p. 177.

25 Séamus Ó Casaide, "Irish Printing in Drogheda", *Irish Book Lover*, vol. XIX (May-June 1931), p. 80.

26 It was not uncommon for old or otherwise damaged steel shafts to be filed down and re-used for the cutting of new sorts.

27 Letter from Reed to Blades, 28 November 1883, contained in the Fry Specimen Book of 1795 at St Bride's Printing Library.

28 Letter from James Mosley to the author, 18 February 1986.

CHAPTER 5

1 Liam Swords, ed., *The Irish-French Connection 1578-1978* (Paris, 1978), p. 16.

2 Liam Swords, "History of the Irish College Paris", *Archivum Hibernicum*, vol. 35 (1980), p. 58.

3 *Epreuve des Caractères de Fonderie de Loyson et Briquet* (Paris, 1751).

4 Harry Carter, ed., *Fournier on Typefounding, The Text of the Manuel Typographique* (London, 1930), p. 264.

5 Andrew Donlevy, *The Catechism or Christian Doctrine* (Paris, 1742), p. xxv.

6 Carter, *Fournier on Typefounding*, p. 256.

7 Marius Audin, *Les Livres Typographiques des Fonderies Françaises* (Amsterdam, 1964), p. 64.

8 Jean Lottin, *Catalogue des Libraires-Imprimeurs de Paris* (Paris, 1789), p. 244.

9 Daniel Berkeley Updike, *Printing Types, Their History, Forms, and Use*, I, (Cambridge, Mass., 1962), p. 269.

10 Ibid., p. 274.

11 Bradshaw, "Printing in the Irish Character", art. cit., (1905), p. 27.

12 James W. Phillips, "A Bibliographical Inquiry into Printing and Bookselling in Dublin", unpublished thesis, Trinity College, Dublin, 15 April 1952, p. 348.

13 *Dublin Chronicle*, vol. 1, no. 14 (31 May 1787), p. 108.

14 Phillips, art. cit., p. 349.

15 *Dublin Chronicle*, vol. 2, no. 206 (21 August 1788), p. 385.

16 Phillips, art. cit., p. 350.

17 W. G. Strickland, "Typefounding in Dublin", *Bibliographical Society of Ireland*, vol. 2, no. 2 (1921), p. 31.

18 *Faulkner's Dublin Journal*, no. 4086 (21-24 June 1766).

19 Warburton, Whitelaw and Walsh, *History of the City of Dublin*, II (Dublin, 1818), p. 935.

CHAPTER 6

1 John O'Donovan, *A Grammar of the Irish Language* (Dublin, 1845), p. lix.

2 P. McElligott, "Observations on the Gaelic Language", *Transactions of the Gaelic Society of Dublin*, vol. 1 (Dublin, 1808), p. 30.

3 [William Halliday], *A Grammar of the Gaelic Language* (Dublin, 1808), dedication.

4 Ibid., introduction, p. xii-xiv.

5 Patrick Lynch, *Introduction to the Knowledge of the Irish Language* (Dublin, 1815), bound into back.

6 E. O'Reilly, *A Dictionary of the Irish Language* (Dublin, 1817), preface.

7 Séamus Ó Casaide, *Irish Book Lover*, vol. XXIII (May/June 1935), p. 72.

8 Alf MacLochlainn, *Irish Book Lover*, vol. XXXII, no. 6 (September 1957), p. 144.

9 John Watson Stewart, *The Treble Almanack* (Dublin, 1815, 1816, 1817).

CHAPTER 7

1 Warburton, Whitelaw and Walsh, *History of the City of Dublin*, II (1818), pp. 919,934.

2 Ibid., p. 930

3 John Owen, *The History of the Origins and First Ten Years of the British and Foreign Bible Society*, I (London, 1816), p. 463.

4 Henry Monck Mason, *Memoir of the Irish Version of the Bible* (Dublin, 1854), p. 65.

5 Edward O'Reilly, *Transactions of the Iberno-Celtic Society*, vol. 1, part 1 (Dublin, 1820), p. clxxx.

6 Warburton et al., *The History of the City of Dublin,* II (1818), appendix no. XII, p. lxxxv.

7 Warburton, *History*, II, p. 933.

8 Séamus Ó Casaide, "Patrick Lynch, Secretary of the Gaelic Society", *Journal of the Waterford Archaeological Society*, vol. 15 (1912), p. 58.

9 In 1790, "in concert with a barber of the town [Carrick-on-Suir], he procured some types, and by means of a bellow press, he set up and printed his first work with his own hands, and established the first printing press ever seen in that town": Warburton, *History*, II, p. 936.

10 Ó Casaide, "Patrick Lynch", p. 60. Ó Casaide quotes from an obituary notice which appeared in *Carrick's Morning Post* art. cit., (Dublin) 18 May 1818.

11 Reed, *History of English Letter Foundries*, op. cit., p. 363.

12 F. Ballhorn, *Grammatography: A Manual of Reference to the Alphabets of Ancient and Modern Languages* (London, 1861), printed by F.A. Brockhaus, Leipzig, p. 73.

13 John Alden of the Rare Books Department, Boston Public Library, brought this typeface to the attention of Alf MacLochlainn, who informed me of its existence.

14 *Irish Echo*, vol. III, no. 5 (July 1890), p. 67.

15 James Figgins, *Type Founding during the 19th century: A Short Review* (London, 1900), p.14.

16 Reed, op. cit., p. 308.

17 *The King's Letter*, trans. T. Connellan (London, 1825).

18 J. Johnson, *Typographia*, II (London, 1824), p. 477.

19 T.C. Hansard, *Typographia* (London, 1825), p. 403.

20 Thaddeus Connellan, "The Case of Thaddeus Connellan", referred to in John J. O'Kelly's account of "The House of Gill", Trinity College Dublin, MS. 10 310, p. 45.

21 *An Irish Primer*, compiled and published under the patronage of the Ladies Gaelic Society (Belfast, 1838).

22 Inventory Book of the Reed Letter Foundry (*c*.1905), p. 103. Stephenson Blake Holdings.

23 John O'Donovan, trans. and ed., *Annals of the Four Masters*, 1851, introduction, p. vii.

24 Séamus Ó Casaide, "Irish Printing in Drogheda", *Irish Book Lover*, vol. XIX, (May/June 1931), p. 78.

25 Warburton, *History of Dublin*, II, p. 934 fn.

26 Colm Ó Lochlainn, "Gaelic Script and Modern Type", *Progress in Irish Printing* (Dublin, 1936), p. 79.

27 Séamus Ó Casaide, "Irish Printing in Drogheda", art. cit., p. 78.

CHAPTER 8

1 John O'Donovan, ed., *The Book of Rights* (Dublin, 1847), prospectus bound in at the back of some copies. Colm Ó Lochlainn notes that his copy (which he states was John O'Daly's own copy), contained this insert, as does the Gilbert copy at Pearse Street Library.

2 Subscription Book for O'Donovan's edition of *The Annals of The Four Masters*, undated. Nat. Lib. of Ireland, Ir.941.A5.

3 Eugene O'Curry, *Lectures on the Manuscript Materials of Ancient Irish History* (Dublin, 1861), p. 160.

4 Editor's Note, "The Sick-bed of Chuculainn", *Atlantis*, vol. 1 (Dublin, 1858), p. 362.

5 John Gilbert, "The Celtic Records of Ireland, An Analysis of Dr O'Donovan's Edition of the Annals of the Four Masters", reprinted from *the Irish Quarterly Review* (Dublin, 1852), p.110 fn.

6 John J. O'Kelly, "The House of Gill": Trinity College, Dublin, MS. 10 310, p. 58.

7 The three sizes referred to by Gill were the earlier Petrie A pica, the later Petrie B long primer, and the later Petrie B brevier sizes. The earlier Petrie A long-primer type disappeared from use about 1852.

8 O'Kelly, "The House of Gill", letter from M.H. Gill to the Revd Evans, April 1853, p.61.

9 O'Kelly, "The House of Gill", p. 76.

10 "The Late John O'Donovan", *Freeman's Journal,* 28 December 1861.

11 George Petrie, "Domnach Airgid", *Transactions of the Royal Irish Academy*, vol. XVIII (Dublin, 1839), p.21.

12 George Petrie, "History and Antiquities of Tara Hill", *Transactions of the Royal Irish Academy*, vol. XVIII (Dublin, 1839), p.56.

13 *Dublin University Magazine* (March 1848), p. 359.
14 O'Kelly, "The House of Gill", letter from the Revd D. Foley to M.H. Gill, 17 April 1853, p.59.
15 Ibid., letter from M.H. Gill to the Revd D. Foley, 20 April 1853, p. 60.
16 Ibid., letter from M.H. Gill to the Revd Evans, 20 April 1853, p. 61. (The specimen 2 referred to was possibly the title page of the Annals.)
17 Ibid., letter from M.H. Gill to the Revd Evans, 22 April 1853, p. 62.
18 Ibid., letter from the Revd Evans to M.H. Gill, 29 April 1853, p. 63.
19 Ibid., letter from M.H. Gill to the Revd Evans, 15 November 1854, p. 65.
20 Account Book, Dublin University Press (1851-6), Trinity College Dublin, MS. MUN/DUP/22/2. I am grateful to Vincent Kinane of the Department of Early Printed Books, Trinity College Dublin for uncovering reference to this entry.
21 Riobeárd Ó Catháin, *Tiomna Nuadh* (Dublin: The University Press, 1858).
22 Lynam, 'The Irish Character', art. cit., p. 318.
23 James Todd, ed., *Leabhar Imuinn* (*The Book of Hymns*) Irish Archaeological and Celtic Society (Dublin, 1855), p. 2.
24 Vol. V (1853).
25 John J. O'Kelly, "The House of Gill", p. 51.
26 Ibid.
27 Lynam, art. cit. p. 318.
28 A.F. Johnson's edition of Reed, *Old English Letter Foundries* (London, 1952), p. 69.
29 Riobeárd Ó Catháin, *Tiomna Nuadh* (Dublin, 1858).
30 *Notes and Queries*, 3rd series, vol. VII (10 June 1865), p. 468.
31 Ó Lochlainn, "Gaelic Script and Modern Type", art. cit., p. 80.
32 John J. O'Kelly, "The House of Gill", Letter from Figgins' Typefounders to M.H. Gill, 11 June 1845, p.79A.
33 Liam Miller, "Irish Type and Gaelic Lettering", *Forgnán*, vol. 1, no. 2 (1962), p. 24.
34 Account Book, Dublin University Press (1851-6), Trinity College Dublin, MS., MUN/DUP/22/2.
35 Ibid., entry for 8 March 1854.
36 Editor's Note, "The Sick-bed of Cuchulainn", *Atlantis*, vol. 1 (Dublin, 1858), p. 362.
37 Letter from John E. Pigott to John H. Newman, 20 December 1856, reproduced

38 *The Bible of Every Land* (London, 1851), p. 1.
39 Letter from Anton Durstmuller to the author, 14 March 1986.

CHAPTER 9

1 Pigott refers here to the "Society for the Preservation and Publication of the Melodies of Ireland" of which Petrie was president. J.E. Pigott, Joseph Huband Smith, E. Curry and W.K. Sullivan were among the members of its council. Petrie published his *Collection of the Ancient Music of Ireland* in 1855; it was printed by Gill at the University Press. In it the 8 point later Petrie round type together with, to a lesser extent, the Fry type, was used for printing the Irish text. It is interesting that Petrie, who had prepared the designs for this type for Smith, was unable to acquire it from the University Press for outside use.
2 Letter from John Edward Pigott to John Henry Newman, 22 April 1856. This and the following three letters are reproduced by kind permission of the Very Revd Provost, Birmingham Oratory.
3 Letter from J.E. Pigott to J.H. Newman, 20 December 1856.
4 Letter from Pigott to Newman, 23 January 1857.
5 Letter from J. Fowler to Newman, undated.
6 Letter from Newman to W.K. Sullivan, 5 February 1858, in Charles Stephen Dessain, ed., *The Letters and Diaries of J.H.Newman*, XVIII (1968), p.249.
7 Ibid., Letter from Newman to Sullivan, 20 April 1858, p. 323.
8 Cardinal John Henry Newman, *My Campaign in Ireland*, part 1, printed for private circulation only (Aberdeen, 1896), p. 300.
9 *Atlantis*, vol. 1 (1858), p. 362.
10 Lynam, art. cit. p. 321.
11 *The Gael*, vol. XVIII, no. 1 (New York, March 1899), p. 8.
12 *The Gael*, vol. XIX, no. 2 (New York, February 1900), p. 48.
13 Ibid.
14 Ibid, vol. XIX, no. 4, p. 112.
15 Colm Ó Lochlainn, "Irish Script and Type in the Modern World", *Gutenberg Jahrbuch* (1932), p.19.
16 Photographs of Micháel O'Rahilly's drawings of both the alternative characters for Monotype Series 24, and for the new Plain

and Italic alphabets, Series 117, were kindly supplied by his son, Aodogán O'Rahilly.

17 Letter from American Type Founders to the author, dated 22 November 1985.

18 Lynam, art. cit. (1969), p. 323.

CHAPTER 10

1 R. Hunter Middleton, "Uncial Type-faces" in *Victor Hammer, Artist and Printer,* ed. Carolyn R. Hammer (Lexington, 1981), p. 112.

2 Ibid., p. 111.

3 Herman Zapt, "A Master Punch-Cutter", in *Victor Hammer* (1981), p. 114.

4 R. Hunter Middleton, in *Victor Hammer,* p. 112.

5 W. Gay Reading, "A Documentation of Hammer Types", in *Victor Hammer* (1981), p. 121.

6 Colm Ó Lochlainn, "A Printer's Device", *Irish Book Lover,* vol. XVI (January-Februrary 1928), p. 15.

7 Ó Lochlainn, "The Printer on Gaelic Printing", *Irish Book Lover,* vol. XVI (May-June 1928), p. 63.

8 Ibid., (July-December 1928), p. 87.

9 W. I. Burch, "Gaelic Printing", *Irish Book Lover,* vol. XVII (March-April 1929), p. 38.

10 Dara Ó Lochlainn, "Irish scribal work as an inspiration for new type design", *The Black Art,* vol. 2, no. 4 (1963), p. 102.

11 James Moran, "Stanley Morison 1889–1967", *Monotype Recorder,* vol. 43, no. 3, (Autumn 1968), p. 12.

12 I wish to thank Mr Dara Ó Lochlainn for giving me access to the unpublished correspondence between his father, Colm, and Stanley Morison, and for permission to quote therefrom.

13 Colm Ó Lochlainn, "An Irish Typographical Link with Germany", in *Book Design and Production,* vol. 7, no. 1 (Spring 1964), p. 34. Writing in 1964, it seems that Ó Lochlainn mistook the timing of some of the events recorded in this article, by three years in certain instances, e.g. he gives 1927 as the date in which he went to Germany with letters of introduction from Stanley Morison, while their correspondence would indicate that this took place in 1930.

14 Ibid., p. 37.

15 Klingspor Foundry, Letter to Ó Lochlainn, 26 September 1930.

16 Ó Lochlainn, "Irish Script and Type", art. cit. (1932), p. 12.

17 Ó Lochlainn, "An Irish Typographical Link with Germany", art. cit., p. 39.

18 Ó Lochlainn, "Gaelic Script and Modern Type", art. cit. (1936), p. 85.

19 Karl Uhlemann, in an interview with the author, 1986.

20 24 November 1933.

21 18 December 1933.

22 11 January 1934.

23 31 July 1934.

24 19 Feburary 1935.

25 I wish to thank Mr C. T. McCrea for giving me access to the unpublished correspondence between his uncle, H. E. Tempest, and Monotype; and also Mr Dara Ó Lochlainn for access to the correspondence between his father, Colm, and H. G. Tempest; and for permission to quote therefrom.

26 25 February 1935.

27 18 March 1935.

28 21 November 1935.

29 15 January 1936.

30 Ó Lochlainn, "Gaelic Script and Modern Type", art. cit. (1936), p. 85.

31 Dara Ó Lochlainn, "Irish scribal work", art. cit. p.112.

32 16 February 1939.

33 6 October 1942.

34 26 October 1942.

35 Dublin, 1940.

36 Seán Jennett, "Irish Types: 1571-1958", *British Printer,* no. 71 (1958), p. 54.

37 Letter from Ó Lochlainn to Karl Uhlemann, 19 March 1958.

38 E.W. Lynam, *The Irish Character in Print* (Shannon, 1969), p. viii.

39 Colm Ó Lochlainn, "Reviews", *Irish Book,* vol. 1 (1959-62), p. 54.

40 Dara Ó Lochlainn, "Design Style of the 1980's" *Irish Printer* (February 1986), p. 29.

CHAPTER 11

1 John Richardson, *A Proposal for the Conversion of the Popish Natives of Ireland to the Established Religion* (London, 1712), p. 5.

2 Francis Hutchinson, *The Church Catechism in Irish* (Belfast, 1722), preface.

3 Edward Lhuyd, *Archaeologia Britannica* (Oxford, 1707), p. 304.

4 O'Donovan, *A Grammar* (Dublin, 1845), p. lvi.

5 William Nicolson (bishop of Derry), "A Translation of the Irish Preface to Mr Lhuyd's Irish Dictionary", *The Irish Historical Library* (Dublin, 1724).

6 Horace Hart, *Notes on a Century of Typography at the University Press Oxford 1693-1794* (1900), reprint with an introduction by Harry Carter (Oxford, 1970), p. 72.

7 Walter Harris, *The Whole Works of Sir James Ware concerning Ireland*, revised and improved, II (Dublin, 1745), p. 21.

8 Ibid., p. 25.

9 Edward Rowe Mores, *A Dissertation upon English Typographical Founders and Foundries*, H. Carter and C. Ricks, eds (1961), p. 32.

10 Christopher Anderson, *Historical Sketches of the Ancient Native Irish and their Descendants* (Edinburgh, 1828), p. 55.

11 This rather crudely cut block is modelled on the Moxon Irish type. That it was not made up from type is evident from the facts that punctuation marks used do not conform with each other, and the letters are particularly badly aligned.

12 Note book of Talbot B. Reed, in the Reed collection at the St Bride Printing Library.

13 Christopher Anderson, *A Brief Sketch . . . the Holy Scriptures* (Dublin, 1818), p. 71.

14 "Abstract of the Report of a Sub-committee, relative to the printing of the Bible in the Irish Language and Character", *Hibernian Bible Society* (1823).

15 Ibid., p. 12.

16 Ibid.

17 Ibid., p. 26.

18 Ibid., p. 30.

19 Mason, *Memoir of the Irish Version of the Bible* (Dublin, 1854), p. 61.

20 *Gaelic Journal*, vol. 1, no. 2 (December 1882), p. 54.

21 Revd Jonathan Furlong, *An Irish Primer* (Dublin, 1842), preface.

22 Ulick J. Bourke, *The College Irish Grammar* (Dublin, 1856), p. 19.

23 Ulick J. Bourke, *The Aryan Origins of the Gaelic Race and Language* (London, 1875), p. 302.

24 Ulick J. Bourke, *Sermons in the Irish-Gaelic by the Most Rev. James O'Gallagher* (Dublin, 1877), p. 388.

25 T. Flannery, "Correspondence", *Gaelic Journal*, vol. 1, no. 4 (February 1883), p. 125.

26 "Correspondence", *Gaelic Journal*, vol. 1, no. 3 (January 1883), p.104.

27 Revd Edmund Hogan, *Irish Phrase Book* (Dublin, 1891), p. 6.

28 Ibid., p. 7.

29 Editor's Note, "Correspondence", *Gaelic Journal*, vol. 1, no. 9 (July, 1883), p. 292.

30 Standish H. O'Grady, ed., "A Collection of Tales in Irish", *Silva Gadelica*, vol.1 (London, 1892), preface, p. xxviii.

31 *Irish Spelling—a Lecture* (Dublin, 1911), p. 14.

32 Ó Cuív later states on p. 151 that the use of Roman type on this occasion was probably due to the limited amount and variety of type available rather than to a deliberate avoidance of Irish type.

33 "The Changing Form", *The Irish Language*, ed. B. Ó Cuív (1969), p. 26.

34 L. McKenna, *English-Irish Dictionary* (Dublin, 1935), preface, p. xi.

35 Mícheál Ó Murchú, "A Plea for Modern Rational Irish", *Irish Monthly*, vol. 59 (1931), p. 287.

36 Seán Jennett, "Irish Types: 1571-1958", *British Printer*, no. 71 (1958), p. 52.

37 Printed statement by William Britton announcing the new Irish type in 1964.

38 Note on drawings for 'Times Roman' Irish type, William Britton, 1963.

39 Letter from William Britton to the author, 15 May 1987.

40 Letter from William Britton to Pádraig Ó Mathúna, 9 December 1964, copy made available by W. Britton and permission to quote therefrom given by the recipient.

41 [Brian O'Nolan], *An Béal Bocht*, 3rd ed. (Dublin, 1964), publisher's note.

42 "New Face for Gaelic Type", *Sunday Independent*, 6 December 1964, p. 27

BIBLIOGRAPHY

BOOKS

Acts of the Privy Council of England, 1587–1588, XV, new series, London, 1897.

——, *1618–1619*, IV, London, 1929.

Anderson, Christopher. *A Brief Sketch of the Various Attempts which have been made to diffuse a Knowledge of the Holy Scriptures through the Medium of the Irish Language*, Dublin, 1818.

——. *Historical Sketches of the Ancient Native Irish*, Edinburgh, 1828.

Arber, Edward, ed. *Transcript of the Registers of the Company of Stationers of London 1554–1640*, I, London, 1875.

Asser, Menevensis. *Ælfredi Res Gestae*, London, 1574.

Astle, Thomas. *The Origin and Progress of Writing*, London, 1784.

Audin, Marius. *Les Livres Typographiques des Fonderies Françaises*, Amsterdam, 1964.

Bagster, Samuel, ed. *The Bible of Every Land*, London, 1851.

Ballhorn, F. *Grammatography: A Manual of Reference to the Alphabets of Ancient and Modern Languages*, London, 1861.

Bedell, William. *The A,B,C, or the Institutions of a Christian*, Dublin, 1631.

Bergin, Osborn. *Irish Spelling: A Lecture . . .* , Dublin, 1911.

Bernard, Nicholas. *The Life and Death of . . . Dr. James Usher*, London, 1656.

Berry, W. Turner, and A. F. Johnson, eds. *Catalogue of Specimens of Printing Types by English and Scottish Printers and Founders 1665–1830*, London, 1935.

Bible, *Tiomna Nuadh*, William Ó Domhnuill, trans., Dublin, 1602.

——, William Ó Domhnuill, trans., London, 1681.

——, Robert Kirke, trans., London, 1690.

——, Riobeárd Ó Catháin, trans., Dublin, 1858.

Bible, *Leabhuir na Seintiomna*, William Bedel, trans., London, 1685.

Bible, *The First Two Books of the Pentateuch*, 4th ed., Thaddeus Connellan, trans., London, 1820.

Birch, Thomas, ed. *The Works of the Hon. Robert Boyle*, London, 1772.

Bourke, Ulick J. *The Aryan Origin of the Gaelic Race and Language*, London, 1875.

——. *The College Irish Grammar*, Dublin, 1856.

Boyle, Patrick. *The Irish College in Paris from 1578 to 1901*, London, 1901.

Briquet, N. *Epreuve des Caractères de Founderie de Briquet*, Paris, 1757.

British and Foreign Bible Society. *Ninth Report*, London, 1813.

Brooke, Charlotte. *Reliques of Irish Poetry*, Dublin, 1789.

——, 2nd ed., Dublin, 1816.

Calendar of State Papers, Ireland, 1509–1573, etc., London, 1860–1912.

Carrigan, William. *The History and Antiquities of the Diocese of Ossory*, I and IV, Dublin, 1905.

Church of England. *Leabhar na nUrnaightheadh gComhchoidchiond*, William Ó Domhnuill, trans., Dublin 1608.

Clowes, William and Son. *Type Specimen Book*, London, 1931.

Colgan, John. *Acta Sanctorum Hiberniae*, Louvain, 1645; facsimile reprint, Brendan Jennings, ed., Dublin, 1948.

Conlan, Patrick. *St Anthony's College of the Franciscans, Louvain*, Athlone, 1977.

——. *St Isidore's College, Rome*, Rome, 1982.

Connellan, Thaddeus, trans. *The King's Letter in Irish and English*, Dublin, 1822.

——, trans. *The King's Letter*, London, 1825.

Conry, Florence. *Sgáthan an Chrábhaidh (Desiderius)*, Louvain, 1616.

——. *Sgáthan an Chrábhaidh (Desiderius)*, 1616; reprint, Thomas O'Rahilly, ed., Dublin, 1955.

[Crawford, Francis] *Erunda or An Investigation of the Elymons of Words and Names, Classical and Scriptural through the Medium of Celtic*, Dublin, 1875.

de Brún, Pádraig. *Cúpla Laoi as Edda*, Dublin, 1940.

Dee, John. *The Perfect Arte of Navigation*, London, 1577.

Dictionary of National Bibliography, London, 1908.

Dix, E. R. McC. *The Earliest Dublin Printing*, Dublin, 1901.

——. *Printing in Dublin prior to 1601*, 2nd ed., Dublin, 1932.

—— and Séamus Ó Casaide. *List of Books, Pamphlets, etc. printed wholly, or partly, in Irish from the Earliest Period to 1820*, Dublin, 1905.

Donlevy, Andrew. *The Catechism or Christian Doctrine*, Paris, 1742.

Dublin Alamanac, Dublin, 1841.

Egan, Bartholomew: see MacAogáin, Parthlan.

English-Irish Dictionary, Dublin, 1814.

Exhibitio Consolatoria Tabulae Emblematicae Serenissimae Principi Isabellae, Douai, 1622.

Faulman, Karl. *Das Buch der Schrift*, Vienna, 1880.

——. *Geschichte der Schrift*, Leipzig, 1880.

Figgins, James. *Type Founding during the 19th Century: A Short Review*, London, 1900.

Figgins, Vincent. *Type Specimen Book*, London, 1815.

Figgins, V. and J. *Type Specimen Book*, London, 1899.

Fossey, Charles. *Notices sur les Caractères Étrangers*, Paris, 1927.

Fournier, Pierre Simon (*le jeune*). *Manuel Typographique*, II, Paris, 1766.

——. *Manuel Typographique*, Harry Carter, trans. and ed., London, 1930.

France, Imprimerie Royale de. *Specimen des Caractères de l'Imprimerie Royale*, Paris, 1819.

Franciscan Fathers, eds. *Father Luke Wadding*, Dublin, 1957.

Fry, Edmund. *Pantographia*, London, 1799.

Fry, Edmund and Son. *Type Specimen Book*, London, 1820.

Full Report of the Irish Literary Festival, Dublin, 1897.

Furlong, Jonathan. *An Irish Primer*, Dublin, 1839.

——. *An Irish Primer*, 2nd ed., Dublin, 1842.

——. *Compánach an Chríosdaigh*, Dublin, 1842.

Garrett, Chistina Hallowell. *The Marian Exiles*, Cambridge, 1938.

Gearnon, Anthony. *Parrthas an Anma*, Louvain, 1645.

Gibson, Matthew. *A View of the Ancient and Present State of the Churches of Door, Home-lacy, and Hempsted . . .*, London, 1727.

Gilbert, John T. *The Celtic Records of Ireland, An analysis of Dr O'Donovan's Edition of the Annals of the Four Masters* (reprinted from *Irish Quarterly Review*), Dublin, 1852.

——, ed. "Dublin Assembly Roll 1613", in *Calendar of Ancient Records of Dublin*, III, Dublin, 1892.

——. *The Life and Labours of John O'Donovan* (reprinted from *Dublin Review*), Dublin, 1862.

——. "Queen Elizabeth's Primer of the Irish Language", in *Facsimile of National Manuscripts of Ireland*, part IV, no. 1, London, 1882.

Gilbert and Rivington. *Type Specimen Book*, London, 1875.

Green, David. *The Irish Language*, Dublin, 1966.

Greg, W. W. and E. Boswell, eds. *Records of the Court of the Stationers' Company 1576–1602*, London, 1930.

[Halliday, William]. *A Grammar of the Gaelic Language*, by E. O'C. [pseud.], Dublin, 1808.

Hammer, Carolyn R., ed. *Victor Hammer, Artist and Painter*, Lexington, 1981 .

Hansard, T. C. *Typographia*, London, 1825.

Harris, Walter, ed. *The Whole Works of Sir James Ware*, 3 vols., Dublin, 1745.

Hart, Horace. *Notes on a Century of Typography at the University Press Oxford 1693–1794*, 1900; reprint, Oxford, 1970.

Henkel, Willi. "The Polyglot Printing-Office" in *Sacrae Congregationis de Propaganda Fide Memoria Rerum 1622–1972*, II, Rome, 1973.

Hibernian Bible Society. *Abstracts of the Report of a sub-committee, relative to the printing of the Bible in the Irish Language and Character*, 1823.

——. *Thirteenth Report*, Dublin, 1819.

Hinds, A. B., ed. *Report on the MSS. of the Marquess of Downshire*, Jan. 1613–Aug. 1614, IV, London, 1940.

Historical MSS. Commission. *Fourth Report*, part 1, Franciscan MS. Material, Appendix, London, 1874.

——. *Report on Franciscan Manuscripts*, Dublin, 1906.

Hogan, Edmund. *Irish Phrase Book*, Dublin, 1891.

Hollingworth, Rodolph. *De Iustificatione ex Sola Fide Patrum et Protestantium Consensus*, Dublin, 1640.

Hutchinson, Francis. *The Church Catechism in Irish*, Belfast, 1722.

Irish Hibernian [Alphabet] *cut and cast from original drawings for Messrs. Hodges and Smith*, single sheet, 1844 (pasted in to O'Donovan's *Grammar*), British Library, 1332 f14(2).

Jackson, William A., ed. *Record of the Court of the Stationers Company 1602–1640*, London, 1957.

Jennings, Brendan. *The Irish Franciscan College of St Anthony at Louvain*, Dublin, 1925.

——, ed. *Louvain Papers 1606–1827*, Dublin, 1968.

——. *Michael O'Cleirigh and his Associates*, Dublin, 1936.

——, ed. *Wadding Papers 1614–1638*, Dublin, 1953.

Johnson, J. *Typographia*, London, 1824.

Kearney, John. *Aibidil Gaoidheilge agus Caiticiosma*, Dublin, 1571.

Keating, Jeoffrey. *Forus Feasa air Eirinn*, Dublin, 1811.

Kirkpatrick, T. Percy C. *Notes on the Printers in Dublin during the 17th Century*, Dublin, 1929.

Knox, John. *Foirm na Nurrnuidheadh*, John Carswell, trans., Edinburgh, 1567.

[Larcom, Thomas A.]. "The Parish of Templemore". *Ordnance Survey of County Londonderry*, I, Dublin, 1937.

Lascalles, Rowley, ed. *Liber Munerum Publicorum Hibernia*, I, 1852.

Lhuyd, Edward. *Archaeologia Britannica*, Oxford, 1707.

Lohf, Kenneth A. *The History of Printing from its Beginnings to 1930; The Subject Catalogue of the American Type Founders Company in the Columbia University Libraries*, New York, 1980.

Lottin, Jean. *Catalogue Chronologique des Libraires et des Libraires-Imprimeurs de Paris*, Paris, 1789.

Loyson and Briquet. *Epreuve des Caractères de la Fonderie de Loyson et Briquet*, Paris, 1751 .

Lynam, Edward W. *The Irish Character in Print 1571–1923*, reprint of his 1924 article in *The Library*, with introduction by Alf MacLochlainn, Shannon, 1969.

Lynch, Patrick. *Introduction to the Knowledge of the Irish Language*, Dublin, 1815.

MacAingil, Aodh. *Scathan Shacramunite na hAitridhe*, Louvain, 1618 .

MacAogain, Parthlan. *Graimeir Ghaeilge na mBráthar Mionur*, Dublin, 1968.

MacCurtin, Hugh. *The Elements of the Irish Language*, Louvain, 1728.

McKenna, Lambert, ed. *Philip Bocht Ó hUiginn*, Dublin, 1931.

Marcell, J. J. *Alphabet Irlandais*, Paris, 1804.

Mason, Henry Joseph Monck. *A Grammar of the Irish Language*, Dublin, 1830.

——. *A Grammar of the Irish Language*, Dublin, 1839.

——. *The Life of William Bedel*, London, 1843.

——. *Memoir of the Irish Version of the Bible* (reprinted from the *Christian Examiner*), Dublin, 1854.

Middleton, R. Hunter. "Uncial Type-faces", in *Victor Hammer, Artist and Painter*, ed. Carolyn R. Hammer, Lexington, 1981.

Molloy, Francis. *An Irish Grammar*, Rome, 1677.

——. *Lochrann na gCreidmheach*, Rome, 1676.

Mores, Edward Rowe. *A Dissertation upon English Typographical Founders*, London, 1706; reprint ed. by H. Carter and C. Ricks, Oxford, 1961.

Morison, Stanley and Harry Carter. *John Fell—The University Press and the Fell Types*, Oxford, 1967.

Moxon, Joseph. *Mechanick Exercises on the Whole Art of Printing*; rev. ed. Herbert Davis and Harry Carter, eds., London, 1958.

Myles na gCopaleen: see O'Nolan, Brian.

Neilson, William. *An Introduction to the Irish Language*, Dublin, 1808; Achill, 1845.

——. and Thaddeus O'Mahony, eds. *Ancient Laws of Ireland*, II, Dublin, 1869.

Newman, John Henry. *The Letters and Diaries of J. H. Newman*, Charles Stephen Dessain, ed., XVIII, London, 1968.

——. *My Campaign in Ireland*, Aberdeen, 1896.

Nicolson, William. "A Translation of the Irish Preface to Mr. Lhuyd's Irish Dictionary", *Irish Historical Library*, Dublin, 1724.

Nugent, Christopher. The Queen Elizabeth Primer of the Irish Language (MS. undated), facsimile reproduction, Dublin, 1888.

Oaster, C. L. *John Day—The Elizabethan Printer*, Oxford, 1975.

O'Begly, Conor. *English-Irish Dictionary*, Paris, 1732.

O'Brien, John. *Irish-English Dictionary*, Paris, 1768.

——. *Irish-English Dictionary*, Dublin, 1832.

O'Brien, Paul. *A Practical Grammar of the Irish Language*, Dublin, 1809.

O'Connell, John. *Críoch Deigheanach don Duine*, Drogheda, 1851.

O'Conor, Charles. *Rerum Hibernicarum Scriptores*, II, Buckingham, 1825.

Ó Cuív, Brian. "The Changing Form of the Irish Language" in *A View of the Irish Language*, ed. Brian Ó Cuív, Dublin, 1969.

O'Curry, Eugene. *Lectures on the Manuscript Material of Ancient Irish History*, Dublin, 1861.

O'Donovan, John, trans. and ed. *Annals of the Kingdom of Ireland by the Four Masters*, Dublin, 1851.

——, ed. *The Book of Rights*, Dublin, 1847.

——, ed. "The Circuit of Ireland", *Tracts Relating to Ireland*, I, Dublin, 1841.

——. *A Grammar of the Irish Language*, Dublin, 1851.

——. *Subscription Book, Annals of the Four Masters* (O'Donovan's edition), Dublin, undated.

——, ed. *The Topographical Poems of O'Dubhagain and O'hUidhrin*, Dublin, 1862.

O'Gallagher, James. *Sermons in Irish-Gaelic* (with memoir by Ulick J. Bourke), Dublin, 1877.

O'Gallagher, James. *Sixteen Irish Sermons*, Dublin, 1736.

O'Growney, Eugene. *Simple Lessons in Irish*, Dublin, 1896.

Ó hUiginn, Pilip Bocht. *Tuar Ferge Foighide Dhe*, Dublin, 1571.

O'Hussey, Bonaventure. *An Teagasg Criosdaidhe*, Antwerp, 1611.

——. *An Teagasg Criosdaidhe*, Rome, 1707.

Ó Kearnaigh, Seán: see Kearney, John.

Ó Lochlainn, Colm. "Gaelic Script and Modern Type", in *Progress in Irish Printing*, Dublin, 1936.

Ó Maolchonaire, Flaithri: see Conry, Florence.

O'Neill, Timothy. *The Irish Hand*, Mountrath, 1984.

[O'Nolan, Brian]. *An Béal Bocht*, 3rd ed., Dublin, 1964.

O'Reilly, Edward. *An Irish-English Dictionary*, Dublin, 1817.

——. *An Irish-English Dictionary*, John O'Donovan, ed., Dublin, 1864.

——, ed. *Transactions of the Iberno-Celtic Society*, Dublin, 1820.

Orpen, Charles Edward H. *The Claim of Millions of Our Fellow Countrymen of Present and Future Generations to be Taught in their Own and Only Language, The Irish*, Dublin, 1821.

Owen, John. *The History of the Origin and First Ten Years of the British and Foreign Bible Society*, London, 1816.

Parr, Richard. *The Life of the Most Reverend Father in God, James Usher*, London, 1686.

Pasteur, J. A. *Epreuves des Divers Caractères, Vignettes et Ornements de la Fonderie de J. A. Pasteur*, Paris, 1823.

Perkins, W. *The Christian Doctrine, or the Foundation of Christian Religion, Gathered into Six Principles, Necessary for every Man to Learn*, Godfrey Daniel trans., Dublin, 1652.

Perry, George Gresley. *Life of Robert Boyle*, London, 1865.

Petrie, George. *A Letter to Sir William Hamilton in reply to charges made by Sir William Betham*, Dublin, 1840.

Pierres, M. *Caractères de l'Imprimerie de M. Pierres*, Paris, 1785.

Plomer, Henry R. *Abstracts from the Wills of English Printers and Stationers from 1492–1630*, London, 1903.

Pollard, Graham, ed. *Catalogue of Typefounders' Specimens*, London, 1928; reprint, London, 1972.

Reading, W. Gay. "A Documentation of Hammer Types", in *Victor Hammer, Artist and Painter*, ed. Carolyn R. Hammer, Lexington, 1981.

Reed, Talbot Baines. *A History of the Old English Letter Foundries*, London, 1887.

——. *A History of the Old English Letter Foundries*, rev. ed. A. F. Johnson, London, 1952.

Richardson, John. *A Proposal for the Conversion of the Popish Natives of Ireland to the Established Religion*, London, 1712.

Rivington, Charles. *Short Account of the Worshipful Company of Stationers*, London, 1903 .

St Joseph's College, Roscrea. *An Fiolar*, Dublin, 1930.

Sall, Andrew. *A Sermon Preached at Christ Church, July 1674*, Dublin, 1675.

Shuckburgh, E. S., ed., *Two Biographies of William Bedell*, Cambridge, 1902.

Shaw, William. *An Analysis of the Gaelic Language*, Edinburgh, 1778.

Sibthorp, Christopher. *A Friendly Advertisement to the Pretended Catholickes of Ireland*, Dublin, 1623.

Stapleton, Theobald. *Cathechismus seu Doctrina Christiana*, Brussels, 1639.

Stationers Company, London: see Arber; Dix; Greg; Jackson.

Stewart, John Watson. *The Treble Almanack*, Dublin, 1815.

Strickland, W. G. *Type founding in Dublin* (The Bibliographical Society of Ireland, vol. II, no. 2), Dublin, 1922.

Strype, John. *The Life and Acts of Matthew Parker*, London, 1711.

Suim Riaghlachas Phroinsiais, Louvain, undated.

Swords, Liam, ed. *The Irish-French Connection 1578–1978*, Paris, 1978.

Teagasg Criosduighe, London, 1680.

Thom's Irish Almanac, Dublin, 1846.

Todd, James, ed. *Leabhar Imuinn* (Book of Hymns), Dublin, 1855.

Transactions of the Gaelic Society of Dublin, I, Dublin, 1808.

Updike, Daniel Berkeley. *Printing Types, their History, Forms and Use,* Cambridge, Mass., 1962.

Usher, James. *Britannicarum Ecclesiarum Antiquitates*, Dublin, 1639.

——. *Gotteschalci et Praedestinatianae Controversiae . . . Historia*, Dublin, 1631.

——. *Veterum Epistolarum Hibernicarum Sylloge*, Dublin, 1632.

Vallancey, Charles. *Collectanea de Rebus Hibernicis*, 6 vols., Dublin, 1770–1804.

——. *An Essay on the Antiquities of the Irish Language*, 3rd ed., London, 1818.

——. *A Grammar of the Iberno-Celtic or Irish Language*, Dublin, 1773.

Voet, Leon. *The Golden Compasses*, 2 vols., Amsterdam, 1972.

Wadding, Luke. *Scriptores Ordinis Minorum*, Rome, 1650.

Walsh, Paul. *The Four Masters and their Work*, Dublin, 1944.

Warburton, J., J. Whitelaw and Robert Walsh, eds. *History of the City of Dublin*, 2 vols., London, 1818.

Ware, James. *The Annals of the Affairs of Ireland*, Dublin, 1705.

——. *De Hibernia . . . Disquisitiones*, 2nd ed., London, 1658.

——. *S. Patricio . . . adscripta Opuscula*, London, 1656.

Watson, Samuel, ed. *The Gentleman's and Citizen's Almanack*, Dublin, 1779.

Webb, Alfred. *Compendium of Irish Biography*, Dublin, 1878.

Wright, Charles H. H. *A Grammar of the Modern Irish Language*, Dublin, 1855.

Zapt, Herman. "A Master Punch-Cutter", in *Victor Hammer, Artist and Painter*, ed. Carolyn R. Hammer, Lexington, 1981.

ARTICLES

Abbott, T. K. "Letters of Henry Bradshaw on Irish Typography", *Hermathena*, vol. XIII, no. 31 (1905), 515–24.

"Annals of Ireland, A Review", *Dublin University Magazine* (March, 1848), 359.

Bradshaw, Henry. "Printing in the Irish Character", *Bibliographical Register*, vol. I, no. 1 (1905), 6–13, 23–9.

Brady, John. "The Irish Colleges in the Low Countries: Exhibitio Consolatoria tabulae emblematicae serenissimae principi Isabellae", *Archivium Hibernicum*, no. 15 (1949), 66.

Buckley, J. "Irish Funeral Entries", *Irish Book Lover*, vol. IV, no. 5 (Dec. 1912), 82.

Burch, W. I. "Gaelic Printing", *Irish Book Lover*, vol. XVII (March-April, 1929), 38.

Carter, Harry. "Plantin's Types and their Makers", *De Gulden Passer* (1956), 121–43 .

An Claidheamh Soluis (1 November 1913).

Conchobhair, Clann [pseud.]. "Correspondence", *Gaelic Journal*, vol. I, no. 3, (January 1883), 104.

——. "The Sounds and Letters of the Irish Language", part 2, *Gaelic Journal*, vol. I, no. 3, (January 1883), 74.

Dickins, Bruce. "The Irish Broadside of 1571", *Transactions of the Cambridge Bibliographical Society*, vol. I (1949), 48–60.

Dix, E. R. McC. "A Dublin Almanack of 1612", *Proceedings of the Royal Irish Academy*, vol. XXX, sec. C (1912), 327–30.

——. "The Dublin Printers and the Guild of St. Luke the Evangelist", *Transactions of the Bibliographical Society*, vol. VII (1904), 80–5.

——. "The Earliest Dublin Printers and the Company of Stationers of London", *Transactions of the Bibliographical Society*, vol. VII (1904), 75–80.

——. "The Earliest Printing in Dublin . . .", *Proceedings of the Royal Irish Academy*, vol. XXVIII, sec. C (1910), 149–56.

——. "1608 Edition of O'Hussey's Catechism", *Irish Book Lover*, vol. XVIII, no. 6 (Nov.–Dec. 1930), 175.

——. "The Law as to Printing in Ireland before the Act of Union", *Irish Book Lover*, vol. XXII, no. 5 (Sept.–Oct. 1934), 110–13.

——. "William Kearney, The Second Earliest Known Printer in Dublin", *Proceedings of the Royal Irish Academy*, vol. XXVIII, sec. C (1910), 157–61.

Dublin Chronicle, vol. II, no. 206 (21 August 1788), 385.

Egan, Bartholomew. "Notes on Propaganda Fide Printing Press and Correspondence concerning Francis Molloy, OFM', *Collectanea Hibernica*, vol. II (1959), 115–24.

Faulkner's *Dublin Journal*, no. 4086 (21–24 June 1766).

Gaedheal, An [Sydney]. vol. VII, no. 5 (1929).

Gael, The [New York]. vol. XIX, no. 2 (February 1900), 48.

Gaelic Journal, "Letters", vol. I, no. 2 (Dec. 1882), 54.

Gaelic Journal, vol. I, no. 5 (1883).

Hammond, Joseph W. "The King's Printer in Ireland 1551–1919", *Dublin Historical Record*, vol. XI, (1949), 29–31, 58–64, 88–96.

Hogan, Edmund. "Fr. Francis O'Molloy and Lucerna Fidelium", *Irish Book Lover*, vol. XVIII, no. 1 (Jan.–Feb. 1930), 5–17.

Irish Echo [Boston]. vol. III, no. 5 (July 1890), 72.

Irisleabhar na Gaedhilge: see *Gaelic Journal*.

Jennett, Seán. "Irish Types: 1571–1958", *British Printer*, no. 71 (1958), 50–5.

Jennings, Brendan. "Irish Names in the Malines Ordination Registers 1602–1749", *Irish Ecclesiastical Record*, 5th series, vol. LXXVII (1952), 202.

Lynam, Edward W. "The Irish Charater in Print", *The Library*, series 4, vol. IV (1924).

McGrath, Kevin. "New Light on the Irish Press at Louvain", *Irish Book Lover*, vol. XXXII, no. 2 (July 1953), 36–7.

McNeill, Charles, ed. "Fitzwilliam MSS. at Milton", *Analecta Hibernica*, no. 4 (Oct. 1932), 300.

Madden, P. J. "Printing in Irish", *An Leabharlann*, vol. XII, no. 3 (1954), 74–85.

Maddison, R. E. W. "Robert Boyle and his Irish Bible", *Bulletin of the John Rylands Library*, no. 1 (1958), 81–101.

Matthews, Francis. "Brevis Synopsis Provinciae Hiberniae Fratrum Minorum", *Analecta Hibernica*, no. 6 (1934), 139.

Miller, Liam. "Author and Artist", *Books Ireland*, (April 1985), 47.

——. "Irish Lettering and Gaelic Type", *Forgnan*, vol. I, no. 2 (Feb. 1962), 22–4 .

Mooney, Canice. "Franciscan Library MS. A30.4", *Irish Book Lover*, vol. XXVII, no. 3 (May 1940), 202–4.

——. "St. Anthony's College Louvain", *Donegal Annual*, vol. VIII, (1969), 18–48.

Moran, James. "Stanley Morison 1889–1967", *Monotype Recorder*, vol. XLIII, no. 3 (Autumn 1968), 1–32.

"New Face for a Gaelic Type", *Sunday Independent* (6 December 1964), 27.

O'Brien, Felim. "Robert Chamberlain, OFM", *Irish Ecclesiastical Record*, vol. XL (1932), 264–80.

Ó Casaide, Séamus. "Irish Printing in Drogheda", *Irish Book Lover*, vol. XIX (May–June 1931), 78–81.

——. "Patrick Lynch, Secretary of the Gaelic League", *Journal of the Waterford Archaeological Society*, vol. XV (1912), 47–61.

O'Curry, Eugene, trans. "The Sick-bed of Cuchulainn" (Editor's Note), *The Atlantis*, vol. I (1858), 362–63.

"O'Donovan, John, the late", *Freeman's Journal*, vol. XCIV (28 Dec. 1861).

O'Grady, Standish H., ed. "A Collection of Tales in Irish", *Silva Gadelica*, vol. I (1892).

Ó Lochlainn, Colm. "Irish Script and Type in the Modern World", *Gutenberg Jahrbuch* (1932).

——. "An Irish Typographical Link with Germany", *Book Design and Production*, vol. VII, no. 1 (Spring 1964), 34–9.

——. "The Louvain Irish Type", *Irish Book Lover*, vol. XX, no. 5 (Sept.–Oct. 1932), 103–4.

——. "Notes and Queries", *Irish Book Lover*, vol. XXIX, no. 4 (March 1945), 89–90.

——. "A Printer's Device", *Irish Book Lover*, vol. XVI (Jan.–Feb. 1928), 15.

——. "The Printer on Gaelic Printing", *Irish Book Lover*, vol. XVI (July–Dec. 1928), 85–7.

——. "Reviews", *Irish Book*, vol. I (1959–1962), 54.

Lochlainn, Dara. "Design Style in the 1980's", *Irish Printer* (February 1986), 26–9 .

——. "Irish Scribal Work as an Inspiration for New Type Design", *Black Art*, vol. II, no. 4 (1963), 102–13.

Ó Murchú, Micheál. "A Plea for Modern Rational Irish", *Irish Monthly*, vol. LIX, (1931), 287.

Petrie, George. "The Domnach-Airgid", *Transactions of the Royal Irish Academy*, vol. XVIII (1839), 21.

——. "History and Antiquities of Tara Hill", *Transactions of the Royal Irish Academy*, vol. XVIII (1839), 56.

Plomer, Henry R. "On the Latin and Irish Stocks of the Company of Stationers", *The Library*, series 2, no. 8 (1907), 295.

Quinn, David B. "Government Printing and Publishing of Irish Statutes in the 16th century", *Proceedings of the Royal Irish Academy*, vol. XLIX, sec. C (1943), 45–127.

——. "Information about Dublin Printers 1556–1573", *Irish Book Lover*, vol. XXVIII, nos 5 and 6, (May 1942), 112–15.

Russell, Thomas O'Neill. "Letters to the Edltor", *The Highlander* (15 November 1873).

Steele, Robert. "The King's Printers", *The Library*, vol. VII, 4th series (1926), 321.

Swords, Liam. "History of the Irish College Paris", *Archivium Hibernicum*, vol. XXXV (1980), 3–233.

Wakeman, Geoffrey. "The Design of Day's Saxon", *The Library*, 5th series, vol. XXII no. 4 (1967), 283–98.

White, Philip. "The Printing Trade in Dublin", *Irish Printer*, vol. IV, no. 1– vol. V, no. 5, (August 1908–December 1909).

UNPUBLISHED MANUSCRIPT AND TYPESCRIPT MATERIAL

American Type Founders. Letter to the author, 22 November 1985. In author's possession.

Anthony, Frater. Letter from Frater Ant. to Fr. Brandon Ó Connor (23 Oct. 1638), MS.A30.4, Franciscan Library, Killiney.

Antwerp, Stadsarchieven. Certificate Boek 59, Antwerp, 1598, MS., City of Antwerp Public Records Office.

Avery, Duncan (Monotype Corporation). Letter to the author, 1 May 1985. In author's possession.

Corbanese Agostino. Letter to the author, 16 May, 1988. In author's possession.

Creswick, R. A. Letter to Marsh's Library, Dublin, 18 January 1933. (Inserted in MS. Z3.5.3 "Rudimenta Grammaticae Hibernicae.") Marsh's Library, Dublin.

de Burbure. Historische Nota's, MS. PK 2920,1,29. City of Antwerp Public Records Office.

Durstmuller, Anton. Letter to the author, 14 March 1986. In author's possession.

Fowler, J. Letter to J. H. Newman, *c.* 1857, Birmingham Oratory Archives.

Grosjean, Paul. Letter to Colm Ó Lochlainn, 12 Jan. 1936. Copy in author's possession.

Hammer, Victor. Letter to Colm Ó Lochlainn, 29 July 1932. Copy in author's possession.

Hodges and Smith, "Form of Requiring Entry of Proprietorship", 1844, copy.1.569. Public Records Office, London.

Lane, John A. Letter to the author, October 1987. In author's possession.

Lynam, Edward W. Letter to Marsh's Library, Dublin, 9 December 1932. (Inserted in MS. Z3.5.3. "Rudimenta Grammaticae Hibernicae.") Marsh's Library, Dublin.

Marini, I., Commissioner of the Pontifical Archives, Letter of Receipt to the Imprimerie Royale, 27 November 1815. Certified copy dated 14 August 1820, MS. Imprimerie Nationale, Paris.

Martineau, R. Letter to T. B. Reed, 20 December 1886, Reed collection, St. Bride Library, London.

Morison, Stanley. Letters to Colm Ó Lochlainn re Colum Cille type, 1929–1939. Copy in author's possession.

Mosley, James. Letter to the author, 18 February 1986. In author's possession.

O'Kelly, John J. "The House of Gill", typescript, *c.* 1955, MS.10 310 Trinity College Library.

O'Hussey, Bonaventure. Letter to Robert Nugent, 19 September 1605, State Papers Ireland, vol. 217,55., Public Records Office, London.

Ó Lochlainn, Colm. Letters to H. G. Tempest re Colum Cille type, 1935. Copy in author's possession.

——. Letter to Karl Uhlemann re Colum Cille type, 19 March 1958. Copy in author's possession.

——. Letters to Stanley Morison re Colum Cille type, 1929–1939. Copy in author's possession.

Phillips, James W. "A Bibliographical Inquiry into Printing and Bookselling in Dublin", unpublished doctoral dissertation, Trinity College Dublin, 1952.

Pigott, John E. Letters to John H. Newman re Irish printing, 1856. Birmingham Oratory Archives.

Plantin-Moretus Museum Antwerp Archives. Record of Accounts, 1601–1624, Arch. 118, 780, 781, 779.

Reed, Charles and Sons. Inventory Book, *c.* 1905. Stephenson Blake Holdings, Sheffield.

Reed, Talbot Baines. Letter to R. Martineau, 19 November 1886. Bound into British Library copy of W. Perkin's *The Christian Doctrine* . . . c.33.a.27.

"Rudimenta Grammaticae Hibernicae, Lovanii", MS. Marsh's Library, Dublin, Z3.5.3.

Tempest, H. G. Letters to Stanley Morison re Colum Cille type, 1935. Copy in author's possession.

——. Letters to Colm Ó Lochlainn re Colum Cille type, 1935. Copy in author's possession.

Tipographia Poliglotta Vaticana, Catalogue of punches received in 1909 from Propaganda Fide Press, *c.* 1937. Vatican Press Archives.

Trinity College Dublin. "Proposed terms of re-employment between Trinity College and William Kearney", 18 March 1596, MS. Trinity College Library.

United Kingdom, "Enrolled Accounts", A01/284, Public Records Office, London.

INDEX

Page number in italics refer to illustrations.